This book was published with the assistance of

The Louis and Minna Epstein Fund
of the American Academy for Jewish Research

and the Lucius N. Littauer Foundation, Inc.

Designed and Produced by Pini
Assistant to the Editor Doron Narkiss
Cover Design after the late Jan Białostocki
Copyright © 1990 by Rachel Wischnitzer
Printed on 115 gramme Zanders chrome paper
at HaMakor Press, Jerusalem, 1990
Typeset in 10 point Baskerville on a body of 13
by Astronel, Jerusalem
ISBN 3-900731-16-0
Jacket: The Messianic Fox and the Gate of Mercy
Double Mahzor (*Breslau, State and University
Library Cod.* Or. I. 1, fol. 89v).

TABLE OF CONTENTS

Selected Articles

(M. ...) Mayer, L.A. *Bibliography of Jewish Art*. Edited by Otto Kurz (Jerusalem: the Magnes Press for the Hebrew University, 1967). Mayer entries 2803-2877A, for Rachel Wischnitzer's works are appended, in parenthesis, to corresponding entries here.

(B. ...) "Rachel Wischnitzer: A Bibliography." Compiled by Rochelle Weinstein. *Journal of Jewish Art*, 6, Jerusalem 1979, pp. 158-65. Entries 1-344 are appended, in parenthesis, to corresponding entries here.

PREFACE

This volume is a tribute to Rachel Wischnitzer, an extraordinary scholar who celebrated her one hundred and fourth birthday on April 15th 1989. She died while this book was in press on November 20th, 1989.

This is not the first tribute to her. On her retirement from Stern College for Women in 1968 at the age of 83, she was honoured by a symposium on one of her favourite topics, the wall paintings of Dura Europos Synagogue, organised by Dean David Mirsky of Yeshiva University. A *Festschrift* dedicated to her on her ninety-fifth birthday was issued as a special double volume of the *Journal of Jewish Art* (6, 1979), edited by myself. Volume 11 of the *Journal of Jewish Art* (1985) was presented to her on her hundredth birthday. In February 1985 she received the Honor Award of the National Women's Caucus for Art Conference in Los Angeles. In 1988 the periodical *Artibus et Historiae* dedicated part of its Volume 17, edited by Józef Grabski and Vivian Mann, in her honour.

This volume is different, since it is a collection of articles written by Rachel Wischnitzer herself. Since it was impossible to collect all the 344 books, articles and entries into one volume, only a few of her most important scholarly contributions could be selected, and in choosing them we were helped by Rachel Wischnitzer herself. Her son, Leonard Winchester, helped to locate the material.

The idea of publishing this selection has been realised with the help of Professor Egbert Haverkamp-Begemann, of the Institute of Fine Arts, New York University, through whom we enlisted the support of art connoisseur Dr. Alfred Bader of Sigma Aldrich Chemical Company, Milwaukee. At this stage financial help was forthcoming from Rachel's family and the Center for Jewish Art. When we decided we should like to reset all the articles, rather than photo-print them and provide them with fresh photographs, the Irsa Verlag in Vienna, the American Academy for Jewish Research, the Lucius N. Littauer Foundation and Leonard Winchester extended their assistance, through the good auspices of Professors Shlomo Eidelberg and David Weiss Halivni, Mr. Abraham Kramer, Mr. William Lee Frost and Dr. Alexander Moldovan. Donations were forthcoming from Professor Meyer Schapiro, Mrs. Elaine Richter Sherman and Mrs. Cissy Grossman. We are grateful to them all for enabling this book to be published.

For me personally it has been a moving experience to sketch the life story of this amazing lady. I found that in many ways she was the epitome of Jewish life in Europe and America over the past hundred years; but on the other hand, her individuality and her reactions to public events were at times stronger than the horrifying events themselves. She was a survivor, one

who managed to survive thanks to the strength of her intellect and spirit. For Rachel Wischnitzer living meant reading, searching, studying, discussing, digesting, formulating, writing, publishing and critically reviewing. Such was the secret of her long and active intellectual life. I am proud to have met her.

In writing this sketch of her life, I have been helped by her own published memoirs, mainly "From my Archives" (No. 19 here), and by the published interview with Claire Richter Sherman, "Rachel Wischnitzer: Pioneer Scholar of Jewish Art" (*Woman's Art Journal*, vol. 1, no. 2, 1981, pp. 42-46). Further personal information was gathered in my talks with Rachel, mainly one in 1984 at which Ruth Jacoby was present and took notes, as well as from six lengthy tape-recorded interviews with the oral historian, Jean Lewit Shulman, in 1988. I am grateful to the latter, to Esther Goldman who enlisted her, as well as to Henry Voremberg, who assisted us financially with these interviews. Further assistance and information came from Rachel's son, Leonard, and from her students and friends Rochelle Weinstein and Cissy Grossman. Thanks are also due to Aliza Cohen-Mushlin, Carol Krinsky and mostly to Leonard Winchester, who read the text of my introduction and made many valuable suggestions, to Shalom Sabar who added a few items which were not included in Rochelle Weinstein's Bibliography, and to Christine Evans, who rendered my contribution readable, and prepared the Index to the book.

Bezalel Narkiss

RACHEL WISCHNITZER, DOYENNE OF HISTORIANS OF JEWISH ART

by *BEZALEL NARKISS*

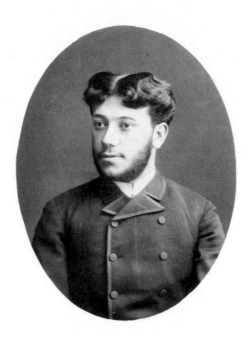

Fig. 1. Vladimir Bernstein, Minsk, 1888 (father of Rachel Wischnitzer).

At the age of 104, Rachel Wischnitzer can look back on a life of extraordinary activity and interest, the reflection of her special personality. It has not been an easy life, migrating from country to country during the Russian Revolution and two World Wars, especially harsh periods for the Jews and at times even harsher for her personally. This frail woman's courage, endurance and imagination supplied the strength for her continuous activity throughout this difficult era, during which she produced important works of scholarship and disseminated the knowledge of Jewish art by novel and exciting means.

Born Rachel Bernstein in Minsk, chief city of the province of Minsk in White Russia on April 14th 1885 (April 2, Old Style), she was the elder child of a well-to-do timber merchant, Vladimir Grigorievich Bernstein (Fig. 1).* Her father indulged her from childhood, and made it possible for her to develop her talents in whatever direction she wished.

Rachel was named after Vladimir's mother (Fig. 2) who died of tuberculosis in Minsk when Vladimir was a young boy, leaving his elder sister to bring him up. Rachel's grandfather, Gutman (Grigori) Bernstein (Fig. 2), had started the timber business which his son Vladimir inherited.

By the end of the nineteenth century the Jews of the Russian Empire, which included part of partitioned Poland, were experiencing major demographic, social and religious changes. As a result of the industrial revolution many Jews, like many other people in Czarist Russia, were

9

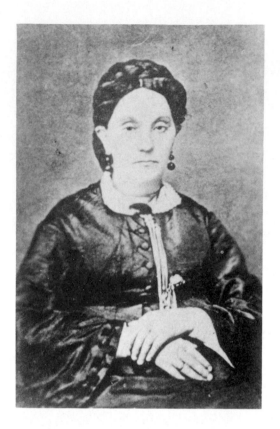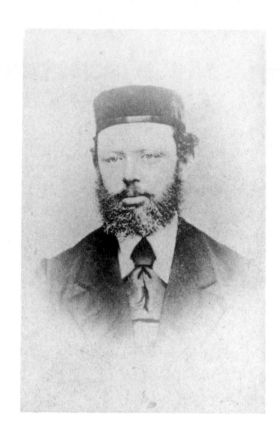

Fig. 2. Grigori Bernstein and Rachel Bernstein, Minsk ca. 1880 (grandfather and grandmother of Rachel Wischnitzer).

drawn from the countryside to the towns. The partial emancipation of the Jews allowed them to take up liberal occupations which had previously been forbidden to them; and as a belated development of the Enlightenment the Jews were admitted to universities and technical schools, soon excelling in their professions. Jealousy led to antisemitism, which, together with unemployment and the disappearance of the traditional Jewish occupations, stimulated emigration to western Europe and the New World.

Enlightenment and "progress" encouraged assimilation. Eastern European Jews became better acquainted with western secular civilisation and, as this process developed, gradually abandoned the traditional thought and customs of Jewish Orthodoxy. The late nineteenth-century phase of the Jewish Enlightenment (*Haskalah*) moved further away from the established Hasidic movement as well as from its adversaries, the *Mitnaggdim* ("opponents") of Lithuania. At that time, the "enlightened" Jews were split between three opposing trends: the first were the supporters of the more nationalistic aspect of the Enlightenment, namely the revival of Hebrew and the ensuing Zionist movement; the second were those who became totally assimilated into the European way of life, retaining only some traditional Jewish cultural traits, such as the use of some religious festival customs; while the third were Yiddishists, who saw Yiddish as an East European *lingua franca* and the focus of Jewish life.

Rachel Bernstein was born into this transitional period in Judaism. Her grandfather, Gutman Bernstein, was an emancipated merchant, though still an Orthodox opponent of Hasidism; his son Vladimir was more assimilated in his way of life. Vladimir's leaning towards the nationalistic Haskalah was manifested in his thorough knowledge of Hebrew and by observation of some traditional Jewish customs at home. He was, however, progressive and assimilated enough to prefer his daughter Rachel to his son Gustav, and to allow her to follow her intellectual bent. Vladimir, handsome, dark-complexioned (he was at times mistaken for

10

an Italian), and a ladies' man, was well travelled and open-minded. He did, however, still follow Orthodox tradition by letting his father arrange a marriage for him with Sophie Halpern of Bialystock, through the mediation of a matchmaker.

Sophie Halpern (Fig. 3), Rachel's mother, came from a similar, but more distinguished background at least as far as her mother's side is concerned. Sophie's mother Minna Landau (Fig. 5) of Brody, Austria, was the granddaughter of Moses Landau (Fig. 4). He, probably through Ezekiel's son Jacob Landau, rabbi and later a wealthy merchant of Brody, was a direct descendant of the famous Talmudic scholar and authority on Jewish Law, Ezekiel ben Judah Landau (1713-1793), chief rabbi of Prague and Bohemia from 1754 to 1793. Born in Opatów, Poland, Ezekiel was the eighth in an unbroken line of rabbis, and could trace his descent to Rashi (1040-1105). Ezekiel, while orthodox and opposed to Hasidism, favored a conservative form of Haskalah, mistrusting but not opposing Moses Mendelsohn's understanding of enlightenment.

Sophie's great-grandfather was an orthodox person as his photograph indicates. However, his son was sufficiently enlightened to let his daughter Minna Landau, Rachel's grandmother, marry Heschel Halpern of Bialystok, Poland, whose father Halpern of Kovno, in the Baltic Provinces or Lithuania, had extensive real estate holdings including houses in Kovno, Grodno, and Bialystok. The elder Halpern was married to a Korngold from Poland who spoke Polish. Rachel remembers her great-grandparents, who may have seen Napoleon I pass through on the way to Moscow.

Rachel is proud of her intellectual ancestry and stresses that her mother Sophie spoke French and German as well as Russian. As a result of the open-minded home of Heschel and Minna Halpern, Sophie and her sisters were educated at a *gymnasium* in Kovno where the language of instruction was German. It was therefore not strange that Rachel and her younger brother

Fig. 3. Sophie Bernstein, née Halpern, Minsk, 1888 (mother of Rachel Wischnitzer).

Fig. 4. Moses Landau, ca. 1860 (grandfather of Minna Halpern, descendant of Ezekiel Landau).

Fig. 5. Minna Halpern, née Landau, Bialystok, ca. 1875 (grandmother of Rachel Wischnitzer; wife of Heschel Halpern, grandfather of Rachel Wischnitzer).

11

Fig. 6. Rachel
Wischnitzer, née
Bernstein, Minsk, 1888.

Gustav received an intensive secular education from a tutor who taught them at home, rather than the son being sent to a *Ḥeder* in the traditional Jewish way and the education of the daughter being neglected.

It is significant that Rachel does not remember going into a synagogue before the age of 8, but does remember being taken to the theatre to see a comedy by Gogol. The Jewish religious holidays were mainly recreational events rather than spiritual ones for her family. The family, with the two small children, used to go to their Halpern grandparents in Bialystok to celebrate the Feasts of Passover and of Tabernacles (*Sukot*). Travelling by train from Minsk to Bialystok, sitting on a hard wooden bench, was especially memorable for the little girl (Fig. 6); and she clearly remembers her beloved Aunt Guta in Bialystok, who would sit praying in the living-room on *Yom Kippur*. The family was also sufficiently affluent to go regularly to the summer resort of Druskeniki on the Neman river near Grodno and later to Kranz on the Baltic Sea.

The Bernsteins' home in Minsk was in a comfortable block of flats with parquet floors in Peter and Paul Street (Pietra Paulskaya). There were a cook and a housemaid, and the two children had their own rooms. When grandfather Grigori died of tuberculosis in Meran, Tirol (a health resort antedating Davos and perhaps Assuan for tubercular patients), in 1888,

Vladimir inherited the house and remodeled it extensively. The family went to occupy the more desirable floor, renting out the other.

The first crisis in their lives came abruptly when Rachel was eight. The timber industry collapsed and her father Vladimir had to change his occupation, becoming an insurance agent based in Warsaw with an insurance company headquartered in St. Petersburg. Her mother Sophie with the two children, Rachel and Gustav, moved to Bialystok and stayed for a year with their maternal grandparents. Rachel's governess, Miss Patschke ("Fräulein"), who had brought Rachel's German to almost that of a native speaker, stayed with them in Bialystok for a year voluntarily without pay, and then went home to Königsberg to marry her fiancé. At that time also, in 1894, when he felt sufficiently established, Vladimir brought his family to Warsaw, where they lived in a beautiful six-room apartment in Maszalkowska Street. In Warsaw Rachel started attending the Second *Gymnasium* for Girls in 1895; she completed her studies there in 1902 with a gold medal first in her class every year except the first. Her main interests there were mathematics and natural sciences and her dream was to follow the famous Madame Curie — the Pole, Maria Sklodowska — in finding the cure for some dreadful disease.

The *gymnasium* was the first place where she came across antisemitism, and she became aware of being Jewish through the negative attitude of other children and their parents (she did not note this attitude in any of the teachers). Rachel and two other girls formed a close trio of friends who were always together, discussing books, and alternatives for adult life. One of them, Lucia Olkenickaia from Lodz, was Jewish, while the other was an Austrian Christian. Her mother was upset by the fact that her daughter was under the influence of Jewish girls and had her transferred to another school. At school also there were one or two Bundist girls (leftists). Rachel was struck by their arrogance and lack of tolerance for the views of others.

One indication of conditions in Russian Poland at that time is a certificate Rachel got in 1904 from her school, which operated under a Russian statute of 1866 governing girls' *gymnasiums* and pro-*gymnasiums* in the Kingdom of Poland. The certificate states that she graduated with the gold medal in 1902, and that on the basis of her studies and trial teaching sessions held at the school, which were found to be satisfactory, she received the right to teach. However, the title of Private Tutor allowed her to teach German Language and Arithmetic only in homes of her coreligionaries but without public rights of license or the right to be a private tutor to those of the Christian religion.

It seems that it was difficult for her to talk to her parents about these matters. Her father travelled most of the time and her mother was melancholic and suffered from migraines. However, her father's support was always there, and he paid for her to go to the famous University of Heidelberg, where she started her academic training in art history with Henry Thode and in philosophy with Kuno Fischer and Wilhelm Windelband. In Fischer's seminars she met a fellow student, the future leading Hebrew poet Saul Tchernichovsky, who later contributed to her journal *Rimon* in Berlin.

In Heidelberg she and Tchernichovsky also took drawing lessons, and she remembers drawing the head of the old messenger who used to stand on a street corner waiting for letters to be delivered within the city (there were no telephones at the time). She boarded with the Müllers, whose son and grandson emigrated to America and contacted her in the early 'forties. She was involved with a Jewish social group who discussed topics of Jewish and general interest. Here she met Max Eitingon, a good friend for many years who later was a psychiatrist in Berlin and emigrated to Palestine in 1933.

Of the free lectures which she attended at Heidelberg in 1903, she was most impressed by a course on the history of architecture. This influenced her more than all the rest of her studies,

and she decided to become an architect. It was no small matter at the time for a young woman to enter such a profession, but she persevered and with the help of her father obtained admission to the Académie Royale des Beaux Arts, École d'Architecture, in Brussels. There she met a few women who were studying painting and engraving, but she was the only woman student of architecture. When she passed the entrance examination to the third year in 1905, she realised that to be really professionally qualified, she needed to go to Paris where Émile Trélat had founded a modern architecture school. Her father again helped her, this time to go to Paris, supporting her until she obtained her diploma of Architecte Diplomée at the École Spéciale d'Architecture in 1907, when she was 22.

In her reminiscences about "La Spéciale", as the École Spéciale d'Architecture was known, published in a letter to the editor of the *Journal of the Society of Architectural Historians* (reprinted here as No. 19), Rachel Wischnitzer relates that she was the second woman to graduate from it, another Russian student, Lydia Issakovitch, being the first, in 1906. She mentions some other students who became famous architects, and stresses that Edmée Charrier took her case as a woman student into account in *L'Évolution intellectuelle féminine* (Paris, 1937).

Five years of independent life (1902-7) at the advanced schools of Heidelberg and the Schools of Brussels and Paris were the basis of Rachel's broad education, giving her strength of character as an academic and independence as a woman.

By 1905 her parents had moved to the Troitskaya Ulitza (street) in the Fantanka quarter in St. Petersburg. Her father, now an insurance inspector, could not work in the antisemitic atmosphere of Warsaw, intensified following the aborted revolution of 1905, and the move to the more liberal capital suited him better. After earning a diploma in 1907 from Alliance Française in Paris licensing her to teach French language and literature abroad, and working in an architect's office in Paris, Rachel Bernstein realised that a man's world had no place for her, and she answered her father's call to join the family in St. Petersburg. After living with her parents for about a year, doing drafting for a Finnish architect, studying at the Zuboff Institute of Fine Arts, and starting to write reviews on art, she persuaded her father to help her to go to Munich in 1909 to study art history for two semesters (1909-10). There she studied under Carl Voll and Fritz Burger, and wrote a major paper on baroque and rococo churches in Munich for Berthold Riehl's seminar. By adding the art historical discipline to her knowledge of architecture, she now had the best possible potential to become a leading historian of architecture. At the same time she was becoming more aware of being Jewish, and this led her to study the neglected field of synagogue architecture, in which she had already become interested in Munich, and which was to become her main subject when she returned to St. Petersburg in 1911 after extending her studies to two years. In 1911 in St. Petersburg she passed an examination in Latin at the Board of Education.

The capital of the Russian Empire was at that time very congenial to Jewish intellectual pursuits. In spite of official and popular antisemitism, the Jewish intelligentsia of St. Petersburg and other major Russian cities supported a very impressive literary and historical activity, which resulted in many publications. Not least among these projects was the ambitious undertaking of publishing the great Russian *Jewish Encyclopaedia* in sixteen volumes (*Yevreiskaia Entsiklopediia*, St. Petersburg, 1906-1913), which was influenced by the *Jewish Encyclopaedia* (12 volumes, New York and London, 1901-1906), still profound today, and which stressed the East European material which was missing from the latter. The outstanding editors of the Encyclopaedia, such as Simon Dubnow, Abraham Harkavy and Judah Leib Katzenelson, also included Mark Wischnitzer, a historian, who was the editor of the quintes-

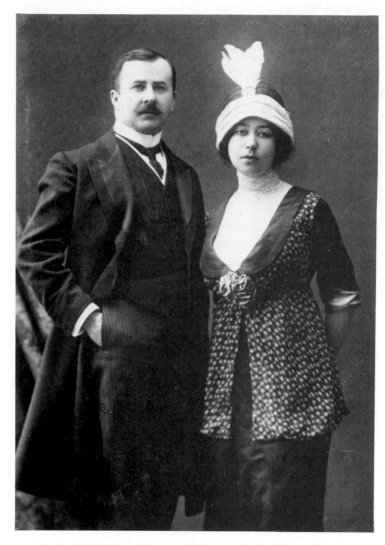

Fig. 7. Mark Wischnitzer and Rachel Wischnitzer, St. Petersburg, 1912.

sential part of the Encyclopaedia, the section on the Jews in Europe. From 1908 to 1912 he also lectured on oriental affairs and Jewish scholarship at the Baron David Gunzburg Institute for Oriental Studies in St. Petersburg.

When Rachel Bernstein came to St. Petersburg she was invited by one of the editors, Dr. Rodinsky, to write two major articles for the Encyclopaedia, one on "Synagogue Architecture" (*Sinagogalnaia arkhitektura*, vol. 14, pp. 265-273), and the other on "Ritual Objects" (*Utvar ritualnaia*, vol. 15, pp. 138-142). These articles were her first attempts at scholarly writing, and they pointed to her future. However, the main outcome of this commission was the meeting with the section editor, Mark Wischnitzer, whom she married in St. Petersburg in 1912 (Fig. 7), and with whom she led a very fruitful life. Although he was born in Rovno, Volhynia, Russia, where his mother was from, his father was from Brody, Galicia, Austria, and he and his parents were Austrian. Rachel thus acquired Austrian citizenship through her marriage. Another result of the work for the *Evreiskaia entsiklopediia* was her study of various synagogues in Poland and Russia.

The first article she published appeared in the Kiev magazine *Mir Iskusstvo* (*World of Art*, 1909 or 1910, not in her Bibliography, but in Claire Richter Sherman's article on Rachel

15

Wischnitzer in *Woman's Art Journal*, I, No. 2, 1980-81, p. 43). The subject was the avant-garde Italian artist Medardo Rosso, whom she met in Paris and who impressed her tremendously. Another early article was published in the newly founded *Novy Voskhod* (*New Dawn*, edited by Leopold A. Sev) and dealt with the stone synagogue of Lutsk, in Volhynia (*Starynnaia Sinagoga v Lutzke*, 4, No. 1, 1913, pp. 48-52), which was translated and is the first paper in this volume. In it she used her knowledge of the history of architecture, compared the building with Polish and Italian architecture, and analysed the structure and its function. It was a foretaste of many other papers to come from the pen of Rachel Wischnitzer-Bernstein, as well as of her two major books on European (1964) and American (1955) synagogue architecture. After 1938 she wrote as Rachel Wischnitzer.

In her brief memoirs "From my Archives", which I published as the opening article of the first Festschrift in her honour (*Journal of Jewish Art* 6, 1979, reprinted here as No. 18), Rachel Wischnitzer mentions briefly "a group of Jewish intellectuals in the pre-Revolutionary Russian capital, which included ... [a number] who were active in the fight for equal rights for the Jews", to which group she and her husband belonged. Among them was Leopold Sev (1867-1922), the editor of *Novy Voskhod*, who was active in "bringing people together for a worthy cause". Little has been written about this group, most of whom left Russia during or just after the Revolution, to become active elsewhere in the Jewish intellectual world.

Although from now on she was versatile enough to write on various topics of Jewish art in general, she still considered herself mainly a historian of architecture. With her husband as one of the editors of the intended *History of the Jewish People* in fifteen volumes, including five volumes on the history of the Jews in Russia, she published the comprehensive article "Art of the Jews in Poland and Lithuania" in the only volume of this ambitious project actually published (1914). (Included in her Bibliography as No. 291).

From 1912 to 1914 Rachel Wischnitzer published four review articles in *Russkaia Mysl* (*Russian Thought*) at the beginning of what was intended to be a long-term engagement, but World War I was to bring an end to this plan. (Only two of these, No. 2 and No. 3, are in her Bibliography.)

In the summer of 1914 Rachel's mother developed asthma, and went with her to Bad Harzburg, while Mark went to Vilna to do research in the archives. When war threatened Rachel alerted Mark, who proceeded at once to his Austrian Army reserve station at Lemberg via Bad Harzburg. Sophie returned to St. Petersburg by boat from a Baltic port, and Rachel went to live in a boarding house on the Trautenaustrasse in Berlin. The Bernstein and Wischnitzer families were to remain separated for most of World War I.

While in Berlin Rachel met the Hebrew writer, S.I. Agnon, later a Nobel Prize Laureate, who was born in Galicia and, being an Austrian citizen, could live in Berlin. She also made friends with Zalman S. Rubashov, who had been a student of Mark's in St. Petersburg and who was a student at Berlin University. He was by then an ardent Zionist speaker and later (as Zalman Shazar) became one of the important socialist leaders of the Jewish settlement in Palestine and then the third President of Israel. Frequent discussions with them made it easier for her to re-establish contacts during her second, longer, sojourn in Berlin (1921-38).

Because of the food shortage in Berlin, Rachel went to Vienna in 1916. There she was nearer to her husband who served with Austrian and German Army units at the Russian front for four years. He was promoted to Oberleutnant (first lieutenant) and was awarded the German Iron Cross as well as three Austrian decorations.

In Vienna Rachel was also closer to her cousin Alexander Lourié, from whom she heard about the Russian Revolution and about the famine in Russia. She then received a letter from

her father, via an acquaintance in Scandinavia, telling her about the conditions of starvation and imploring her to come to the aid of her parents.

After the Armistice in November 1918 and having an Austrian passport it was easy for her to get to Petrograd, where she soon helped her father to get over the border to Finland with a Finnish guide. Vladimir then went via Copenhagen to Paris where his son and family were living, and pleaded for his wife and daughter to join him. However, it took more than a year for Rachel to contrive to get an exit permit for her mother (based on her claiming to be an Austrian) and leave Russia by train and ship, finally reaching Paris via Finland and England. Her mother was in fact Austrian by birth, having been born in Brody in Galicia, which was Austrian from 1772 to 1919, but during the war she became frightened of being a foreigner and declared that she was Russian, but had lost her Russian passport. It took some time to persuade first her mother and then the revolutionary administration that she was not Russian but Austrian, before the two women were allowed to leave and join their husbands.

Even during the war years Rachel continued with her scholarly work. While in Berlin she published a chapter on the "Synagogues of the Former Kingdom of Poland" in *Das Buch von den polnischen Juden* (Berlin, 1916), edited by Agnon and Eliasberg (No. 292 in her Bibliography). While in Vienna she wrote a paper on art in the old Jewish cemetery (in *Der Jude*, 1917-18, No. 6 in her Bibliography). In London, where she joined her husband in June 1920 (he had been there since 1919), she felt free and secure enough to sit in the British Museum and the Bodleian Libraries in order to study Hebrew illuminated manuscripts, a medium which became one of her major topics of interest. While still in England she published a few articles in local periodicals on architecture and illuminated manuscripts (*Christian Science Monitor*, Nos. 8 and 10; *Jewish Guardian*, No. 9); and her first comprehensive article on Joseph Ibn Hayyim, the artist of the Kennicott Bible, appeared in 1921 (in the *Revue des Études Juives*, No. 11 in her Bibliography).

A major change in her life came in 1921, when Mark Wischnitzer was appointed Secretary General of the *Hilfsverein der Deutschen Juden* (Relief Agency of the German Jews) in Berlin, a post he held until they left Nazi Germany in 1938. These seventeen years were the most active in Rachel's life. She published scores of articles, edited the periodical *Rimon*, and published her first major book. Her articles were mostly in German, but also in French and English (the Yiddish and Hebrew publications being translated for her from the German), and were printed in many different periodicals all over the world. Her topics varied from reviews of exhibitions and books, through papers on artists and Jewish festivals, to important studies on architecture, illuminated manuscripts, paintings and special iconography, the most important of which are reprinted in this volume (Nos. 12-159 in her Bibliography). Most of them were published in the *Jüdische Rundschau*, the Berlin fortnightly periodical of the Zionist Organisation of Germany, almost up to its last issue on November 8th 1938, and the *Gemeindeblatt*, the monthly journal of the Jewish community in Berlin. However, the most important ones were published in the Frankfurt-am-Main monthly *Monatsschrift für Geschichte und Wissenschaft des Judentums* (Nos. 67, 69, 75, 76, 81-83, 129, 171 in her Bibliography), the Paris-based quarterly *Revue des Études Juives* (Nos. 11, 52, 77, 84, 85, 89, 90 in her Bibliography), and the English *Jewish Quarterly Review* (Nos. 16, 60, 70, 97 in her Bibliography). During this time she also wrote eleven important entries in the unfinished *Encyclopaedia Judaica* (Nos. 320-330 in her Bibliography), which appeared in ten volumes (A-M only, 1928-34) chief editor Jakob Klatzkin, editors Mark Wischnitzer and others. The publishers had at the same time begun to publish a similar Encyclopaedia in Hebrew, called *Eshkol* (אשכול אנציקלופדיה ישראלית). Naturally Rachel Wischnitzer participated in this one as well. However, only two volumes appeared, and

in them one entry, "Art in Israel" (אמנות בישראל), written by her (Vol. 1, Berlin, Jerusalem 1926, pp. 75-86). This entry appeared in German in the pamphlet publicising both Encyclopaedias (German side pp. 80-96), but was not included in Rochelle Weinstein's Bibliography.

These publications were the product of the constant intellectual atmosphere at the Wischnitzers' home, where cultural activity was a necessity and new pioneering ideas were realised thanks to the energy of both Mark and Rachel Wischnitzer. As far as art is concerned, their most important venture was the establishment of the literary and artistic periodical *Rimon* (in Hebrew) and *Milgroim* (in Yiddish) (1922-24). Mark was the chief editor, helped by Baruch Krupnik (later to become an important journalist in Palestine and Israel), while Rachel was the art editor. The creation of such an elegant journal was achieved with the help of their active old friend from St. Petersburg, Leopold Sev, who was by then living in Paris. Sev enlisted the interest of Ilya Paenson, a businessman of some means, a Zionist and an admirer and supporter of Jewish literature and art, who helped establish the new magazine.

By 1922 it was obvious, to quote Rachel, that the German language was "no longer the unifying cultural vehicle of the Jewish intelligentsia" ("From my Archives", reprinted here as No. 18). "We wanted to reach out to the Jewish groups in America and to the growing Jewish community in Palestine. Yiddish and Hebrew seemed to be indicated. There were to be two companion magazines, each with a literary and an art section." Six issues of *Rimon* and *Milgroim* (both meaning pomegranate) appeared, but publication ceased when the high inflation in Germany stopped. The dollars they received from the sale of the magazine in the U.S.A. no longer could pay for the production of a costly journal. After the second issue Ilya Paenson withdrew his support; and Leopold Sev died suddenly in Paris before the appearance of the first issue of *Rimon*, which carried his obituary. From the second issue on, the co-editor of the Hebrew *Rimon* was Moshe Kleinman, who was also editor of *Ha'olam* (*The World*), the Hebrew weekly of the Zionist Organisation.

The wealth of material which was gathered together in *Rimon* and *Milgroim* reflected the Wischnitzers' broad cultural interests. It covered not only Jewish art and literature, but also topics from other cultures of interest to Jewish intellectual society both in America and in Palestine at the time. Some of the most interesting artistic topics discussed in *Rimon* were highlighted by Rachel Wischnitzer in "From my Archives", already mentioned. There she outlines each one of the six issues, and deals in retrospect with subjects, people and incidents relating to later events. She took an active part in the actual production of the magazines, and influenced the covers and lay-out by providing elements from Jewish art objects and illuminated manuscripts for the artist Ernst Boehm. "The format and general appearance of our journals shows the influence of *Jar Ptitza* (*Firebird*), a Russian art magazine" published by Alexander Kagan, who was also the producer of the first two issues of *Rimon*.

The Hebrew titles were designed by "Franciska Baruch, a young girl" at the time, who died in Jerusalem September 3, 1989 at the age of 88). She later designed the "Schocken" typeface, modelled on the "Franc-Rihl" and "Stam" typefaces for the Schocken publishing house. In 1922, when the Wischnitzers called on Franciska Baruch to design their titles, she had already studied medieval Ashkenazi Hebrew lettering and written the text of the Passover Haggadah to accompany Jacob Steinhardt's woodcuts, published in Berlin in 1921 at the Fritz Gurlitt Publishing House in a limited edition of two hundred signed copies. The Haggadah was commissioned by the rich Berlin manufacturer Erich Goeritz, a well-known patron of the arts, at the peak of the renaissance of Jewish art and culture in Berlin in the twenties (see *Journal of Jewish Art*, 11, 1985, pp. 60-72). *Rimon* and *Milgroim* were an important part of this Jewish cultural renaissance and a pointer towards the future in Palestine and America.

As newcomers, the Wischnitzers had to live in sublet furnished apartments because of the housing shortage in Berlin after the First World War. Sometime before January 5th 1924, when their only son Leonard was born, they moved from the Hohenstaufenstrasse to a more comfortable furnished apartment in the Stierstrasse, but three months after he was born they moved to Auguste-Victoria Strasse in Berlin-Halensee to a larger apartment sublet from the famous sculptor Adolf Brütt of Husum. When the Brütts retired to Bad Berka near Weimar in 1930 Rachel finally replaced the furniture lost in Petrograd and they moved to a newly built apartment house in the Zähringerstrasse where the photograph in Fig. 8 was taken. In 1932 they moved to Emserstrasse.

The end of the publication of *Rimon* did not affect them financially, since Mark was Secretary General of the *Hilfsverein der Deutschen Juden*; Rachel did not have to work in an office, or do housework (thanks to Anna Deertz from Usedom, housekeeper at the Brütts' and later), and could pursue her research, which resulted in many articles. In 1927 she was elected to the committee of the Art Collection of the Berlin Jewish Community, which in 1933 became the Jewish Museum in Berlin. The Berlin community's large art collection included old ceremonial art and contemporary paintings and sculpture. Its fourth exhibition in 1927 was accompanied by a catalogue prepared by the librarian of the Jewish community, Dr. Moritz Stern (see W. Gross in the *Journal of Jewish Art*, 6, 1979, p. 135, Nos. 20, 24).

Rachel Wischnitzer collaborated with the various curators of the Berlin Jewish Museum: Karl Schwarz (1927-1933, when he went to Palestine to become the curator of the Tel-Aviv Museum); Erna Stein-Blumenthal, his assistant and successor, who stayed in her post until 1935, when she also moved to Palestine; and the latter's successor, but with the title of director, Franz Landsberger. At that time Rachel Wischnitzer became the honorary scientific adviser to the Museum, and helped in arranging the exhibit called *Unsere Ahnen* (Our Ancestors), in 1936, which brought together eighteenth and nineteenth century portraits of Berlin families.

Her second and third exhibitions were arranged by her under her own responsibility in 1937, both with a catalogue: the first (June 1937) on the works of the Spanish financier and commentator, Don Isaac Abravanel (Lisbon 1437 - Venice 1508); and the second (Hanukah 1937) on the collection, works and portraits of Rabbi Akiba Eger (1761-1837 Posen). Both exhibitions covered a broad sweep of the transitional periods in which their subjects lived, the first at the time of the Expulsion of the Jews from Iberia and their settlement in Italy, Turkey, Holland and North Africa; and the other the period of the Enlightenment, the Napoleonic Sanhedrin, Reform and Tradition. Rachel Wischnitzer helped to arrange the penultimate exhibition of the Jewish Museum in Berlin (December 1937-January 1938), a collection of Jewish art in the possession of Berlin Jews (*Hundert Jahre jüdischer Kunst aus Berliner Besitz*). The Museum's collection was confiscated or looted by the Nazis in November 1938, and only part of it retrieved after the Second World War.

Rachel was honoured twice by the Jewish Community of Berlin: In 1937 she was awarded the Eger medal which the Community had struck in honor of the 100th anniversary of Akiba Eger's death. And in early April 1938, at her farewell reception at the Jewish Museum, she was presented with an eighteenth-century wooden amulet holder by the Community (Fig. 2 in "Notre Art Sacré," *L'Univers Israélite*, January 20, 1939, Paris, pp. 306-7 [not in her Bibliography]).

Earlier in the thirties she conceived a project to catalogue and photograph the collection of Hebrew illuminated manuscripts in the Berlin Staats- und Universitätsbibliothek. With the help of the important art historian, Professor Adolph Goldschmidt of Berlin University, she managed to obtain the permission of the librarian, Dr. Karl Christ, for this and studied the

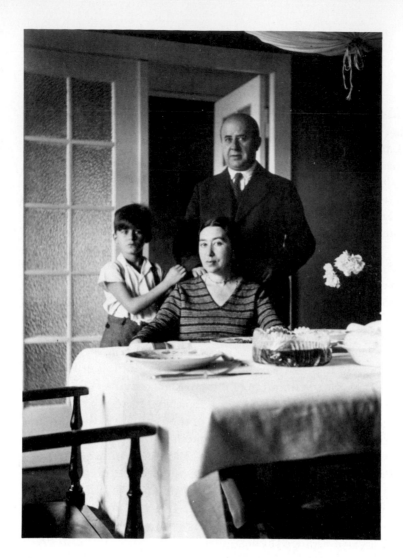

Fig. 8. Mark and Rachel Wischnitzer, and son Leonard, Berlin, 1930.

manuscripts, but when the Nazis came to power in 1933 Dr. Christ refused to communicate with her any more, and she, being Jewish, was later denied access to the Staatsbibliothek.

The tense atmosphere was felt everywhere. In March 1937 Rachel was sent by the Berlin community to investigate the state of the community and synagogue of Ellrich am Südharz near Nordhausen, in the province of Saxony. From the synagogue of 1730 in the Judengasse (then renamed Horst-Wessel-Strasse) she took to the community in Berlin for storage a Torah shield of 1769 and a standing Hanukah lamp, and managed to publish them in the final volume of the *Monatsschrift für Geschichte und Wissenschaft des Judentums* (No. 171 in her Bibliography).

The Wischnitzers' life in Berlin in the early 1930s had been very secure. Mark was earning a good salary as Secretary General of the *Hilfsverein* and pursuing his historical research; Rachel devoted herself to research, reading, writing, and visiting exhibitions; while their son Leonard was an excellent pupil at a private primary school in the Klopstockstrasse (Fig. 8). It was during the early thirties that Rachel's first major book was conceived. Through her increasing knowledge of Jewish art and culture, discussions with Jewish theologians, art historians and social historians, she formed the idea of summarising what was known about Jewish art at that date. The book, *Symbole und Gestalten der Jüdischen Kunst* (*Symbols and Forms in Jewish Art*, Berlin, 1935, No. 338 in her Bibliography), appeared following a series of lectures delivered during the winter of 1934-35 in the Jewish School (*Das Jüdische Lehrhaus*) in Berlin.

In eight chapters she set out to elucidate the special pictorial language of Jewish visual art by relating it to artifacts of different periods and to Jewish literature of all periods. She attached mystical and symbolic meanings to numbers, compositions and juxtapositions. Following the intricate iconographical methods developed by the study of Christian symbolism, she tried, with the limited knowledge available in the early 1930s, to trace similar Jewish symbolism. This study inspired many other attempts, culminating in Erwin Goodenough's *Jewish Symbols in the Greco-Roman Period* (Princeton, 1953-1968). Without a comprehensive knowledge of the Dura Europos Synagogue of 244 C.E. (discovered in 1932), she predicted in her first book the messianic tendency of most of the themes in Jewish art.

In 1935, the same year that her book was published, Mark Wischnitzer published his encyclopaedic book *The Jews in the World (Die Juden in der Welt)*. It was the time when the storm-clouds were starting to gather over the German Jews, and the Wischnitzers were aware of it. As Jews who had already experienced migration, they knew that there would come a time when they would have to move again. The real warning for them came in January of 1938 when Leonard, now aged 14, who had been skiing with a group in Italy, met his father in Switzerland. On the way home Leonard's passport was taken at the border. His father was told later in Berlin that the document would be returned only for emigration of the whole family. In February 1938 Mark started to work for the Joint Distribution Committee in Paris. He returned later for some farewell ceremonies, and in mid-April all three went to Paris. Leonard, who had been attending the American School in Berlin since 1937, transferred to the American High School of Paris.

They decided that Paris was a temporary situation and applied for visas to the United States. Although the Russian quota was unfilled it still took Rachel (who could include Leonard according to her birthplace) and Leonard over a year to get a visa. However, Mark because his birthplace, Rovno, had become Polish in 1918, could not get a visa at all because the Polish quota was filled up.

In the meantime they had Mark's salary from the Joint Distribution Committee, and they both continued with their research and publications, even sending articles to Germany as long as they could, until the outbreak of the Second World War in September 1939.

As soon as she arrived in Paris Rachel took a course at the École des Hautes Études of the Sorbonne on the Synagogue of Dura Europos with Comte Robert du Mesnil du Buisson, who together with Clark Hopkins of Yale had excavated the site on behalf of the Académie des Inscriptions et Belles Lettres and Yale University. Ever since then it has been one of her most interesting topics of research, teaching and publication.

Her social and community obligations did not diminish when Rachel came to Paris. On June 1st, 1939, she arranged a sale-exhibition on behalf of the *Keren Kayemet LeIsrael* (Israel National Fund), which took place in the Palmarium of the Jardin d'Acclimatation. The event was a great success, including exhibits from the most famous Jewish artists of the so-called École de Paris, such as Chagall, Ryback, Mane Katz, Menkes, Hanna Orlov, Max Band and Benn, with some newcomers from Hungary, Italy and central Europe. The great celebration after the opening was, however, ruined for Rachel by the fact that her mother committed suicide the day after the opening, on June 20th, 1939. She had at first been elated when Rachel arrived in Paris; however, she soon became depressed, knowing that the Wischnitzers planned to leave for the U.S., and feared the future. When the War started Rachel could foresee the German army entering Paris but did not say so, because this would have been a very unpopular thing to say at the time. Instead she redoubled her efforts to secure the necessary travel documents and was able to leave in December, 1939.

Rachel and Leonard reached the shores of the United States on January 8th, 1940. She was very well received by the academic community, going up soon to New Haven to see Karl Kraeling and Michael Rostovtzeff. She was particularly encouraged by her meeting with Meyer Schapiro, who helped her to publish her first article in the U.S., a review of *Les Peintures de la Synagogue de Doura-Europos* by Comte du Mesnil du Buisson, a copy of which she carried with her on the SS De Grasse from France (No. 174 in her Bibliography). Professor Schapiro also helped her to publish her first article on the Messianic Fox (No. 176, here No. 5). This early success may well have given her the confidance to continue her academic work in a new country.

Mark entered a French army detention center in the fall of 1939, and was released with pleurisy, after endless efforts made by Rachel to get him out. After that he seemed fairly safe at home in Paris. However, after leaving Paris just ahead of the German army he again was in and out of detention centers in southern France and almost did not make it across the border into Spain for lack of a valid exit visa. He reached America via Portugal in December 1940, but had to spend five months in the Dominican Republic before getting a visa. He came to New York to stay in May 1941.

In spite of the dificulties, the reunited family started to settle down in their new country. Mark continued in relief work for several years with the Council of Jewish Federations and Welfare Funds. Later, with his reputation as a scholar and author, he obtained a teaching position as Professor of Jewish History at Yeshiva University. Leonard was 16 when he reached New York, and after five months of prep school and 3 years of college he graduated with an engineering degree, worked in war industry, joined the U.S. Army in 1944 and reached the front lines in Bavaria in April 1945.

Rachel decided to go to university again to write a thesis on the Dura Europos wall-paintings. On the strength of her diploma in architecture from Paris and her studies in Heidelberg and Munich, she was admitted as a student of Karl Lehmann at the Institute of Fine Arts, New York University, and received the degree of Master of Fine Arts in 1944.

At the age of 59 she was progressing well in her regular studies and started to publish articles in American periodicals and the *Universal Jewish Encyclopaedia* (10 volumes, New York, 1939-43, Nos. 331-337 in her Bibliography).

As soon as Paris was liberated on August 25th, 1944, Rachel inquired about her father and her brother and his family. It transpired that at first they all escaped the Nazi persecution by going to southern France, only one niece, who had married a Christian, remaining in Paris. Rachel received a cable naming all as being all right, but omitting mention of Vladimir. Leonard learned on his way through Paris in April 1945 that Vladimir, age 81, had been arrested and deported from Drancy on May 20th, 1944. In Paris they still hoped that he had perhaps been liberated by the Russians, but some time after VE Day there really was no longer any hope. Vladimir had returned from southern France to Paris probably because it did not seem safe there either. Later a man from the Resistance was sent to Paris to guide him out, but he refused to go and asked that he not be corresponded with.

Rachel had been very close to her father, and while she did not often show how much his loss had affected her, the thought of what happened to him has haunted her ever since. She discontinued her studies, but did continue her research on Dura Europos, and in 1948 published her second book, *The Messianic Theme in the Paintings of the Dura Synagogue*. It gave her great satisfaction to hear from Professor Karl Lehmann, who invited her to lecture at the Institute of Fine Arts (December 10th, 1948, fig. 9), that her messianic interpretations were "quite plausible". In the book she analysed each of the panels painted on the walls of the

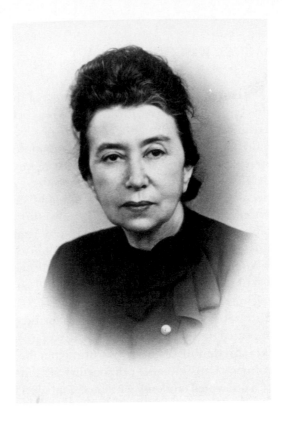

Fig. 9. Rachel Wischnitzer, New York, 1948.

synagogue and found messianic literary and theological themes related to most of the paintings.

One of the main memorable events of the 1950s was the thirtieth anniversary celebration of *Rimon* and *Milgroim*, which was organised by Stephen Kayser, the curator of the Jewish Museum in New York. On this occasion both Rachel and Mark drew a broad picture of the cultural climate in Berlin in the 1920s.

Rachel's third book, *Synagogue Architecture in the United States*, was due to be published in 1955 when the unexpected blow fell of Mark's death from a heart attack in Tel Aviv, on October 16th, 1955. They had been on a visit to Jerusalem at the invitation of a committee chaired by President Shazar to prepare a program for resuming publication of the *History of the Jews in Russia up to 1918* (interrupted by World War I). Rachel left Jerusalem first to go to Spain to do some research for her fourth book on *The Architecture of the European Synagogues* (1964, No. 344 in her Bibliograhy). Mark then left to go to Tel Aviv to meet with the publisher of a projected translation into Hebrew of his manuscript, "A History of Jewish Crafts and Guilds." They were to have met in Paris in order to return to New York together. Instead, Rachel went back alone, after returning for Mark's funeral.

Back in New York Rachel found that her book on the U.S. synagogues had appeared, and she now had to take up her daily and academic life again alone. It was a great help that President Belkin of Yeshiva University immediately (1955) invited her to join the faculty of Stern College for Women. Starting at the age of 71, she taught art at the College, including Jewish art and architecture, for twelve years. Her book on the European synagogues (1964) was dedicated to her students at Stern, who no doubt helped her to formulate her thoughts. She put out Mark's last book posthumously (*A History of Jewish Crafts and Guilds*, New York, 1965, with an introduction by Werner J. Cahnman), securing grants for a part of the cost. The translation mentioned above did not materialize. When she retired at the age of 83 a doctorate *honoris causa* was bestowed on her (July 13th, 1968), and she was honoured with a symposium

23

(November 6th, 1968) on the Paintings of the Dura Europos Synagogue. The participants in the symposium were Professors Meyer Schapiro, Morton Smith and David Sidorsky, of Columbia University; Blanche R. Brown, of New York University; and C. Bradford Welles, of Yale (No. 343 in her Bibliography). As stated in "From My Archives," Meyer Schapiro, who spoke last, defined the Dura synagogue murals as the earliest example of a type of art later developed in the great Christian basilicas and cathedrals. Rachel still continued with her research on the Dura paintings, and published four more articles on the subject, including an important note near the end of her memoirs "From my Archives". In 1973 she prepared Mark's bibliography and wrote his biography (translated into Hebrew). The Hebrew and Yiddish titles were introduced and listed by Shlomo Eidelberg (No. 286 in her Bibliography). Her own biography was included in the 1973 edition of *Outstanding Educators of America*.

Volume six of the *Journal of Jewish Art* (1979) was the first in a line of *"Festschrifts"* celebrating Rachel's achievements. It was "Dedicated to Rachel Wischnitzer, the doyenne of historians of Jewish Art, on her 95th birthday". Thirteen authors who dedicated articles to her appeared in this volume, but two, Cissy Grossman and Alexander Scheiber, which could not fit into this double volume, were printed in the next issue (volume seven, 1980). In the *Festschrift* volume of 1979 Rachel put together her long bibliography edited by Rochelle Weinstein, one of her devoted students who produced her Ph.D. thesis under Rachel's guidance after she had retired. Very few articles are missing from this bibliography, some of which were already mentioned in the Preface and in the Introduction. Professor Weinstein had also helped her in many ways with her work in recent years.

In anticipation of Rachel's 95th birthday, a celebration was held at the Jewish Museum, which she addressed. Her 95th birthday was also observed at a ceremony in the Yeshiva University Museum addressed by Colin Eisler and herself. The next year, 1981, she was elected a fellow of the American Academy for Jewish Research.

Did she stop there? How could she? For Rachel Wischnitzer living meant reading, researching, studying, discussing, digesting, writing, formulating, publishing, and critically reviewing. In 1985, at the age of 100, she published her observations on "Picasso's *Guernica*. A Matter of Metaphor" in *Artibus et Historiae* (12, 1985, pp.153-172, with 13 figures). Giving a new, imaginative interpretation to this famous picture, she hints at other comments to come on modern art. She had written the article in 1980, but upon a new paper coming out on the subject, she felt compelled to add the Epilogue (pp. 170-172), which she wrote in 1985.

Rachel's 100th birthday in 1985 was observed by a ceremony at Yeshiva University, where she was awarded the first centennial medal to be struck in honour of the impending 100th anniversary of the university's founding in 1886. Congratulations were read at the birthday celebration from President and Mrs. Reagan and government officials. Yeshiva President Norman Lamm spoke, and Rachel Wischnitzer stood and responded. She expressed the wish that conditions be created that would permit Jewish people to visit Syria to see the frescoes of the synagogue of Dura Europos at the Museum of Damascus. Another honor she received in 1985 was an award for outstanding achievement in the visual arts from the Women's Caucus for Art.

A second *Festschrift*, which I edited, was presented to honour her 100th birthday as volume eleven of the *Journal of Jewish Art* (1985). It included two contributions, which were of special interest to Rachel, and on which she wrote to me. One was on a Gold Glass with a Messianic Theme by Archer St. Clair and the other on Erich Goeritz, a patron of art in Berlin during the 1920s, by Abraham Gilam.

In her article "From my Desk", in which she honoured me on my 60th birthday (*Jewish Art*, 12-13, 1986/87 pp. 261-264), she makes pertinent comments on recent (1985-6) articles in the

fields of architecture and illuminated manuscripts, some of them bearing on her publications.

In 1987 Walter Cahn dedicated an article to her ("Moses ben Abraham's *Chroniques de la Bible*," *Artibus et Historiae*, 16, 1987 pp. 55-66) and she at once arranged for it to be cited in the Copernicus work mentioned below.

In 1988 the editor-in-chief of *Artibus et Historiae*, Dr. Józef Grabski, together with Dr. Vivian Mann and Prof. Joseph Gutmann, issued a third *Festschrift* (*Artibus et Historiae*, No. 17, Vienna, 1988) containing special articles in honour of Rachel Wischnitzer. In this issue Gabrielle Sed-Rajna says that Rachel in a 1931 article (Bibliography No. 327) predicted intuitively the existence of the synagogue paintings of Dura Europos, one year before the synagogue was discovered, by writing "Die Vorbilder für die figürliche Illustration findet die Haggada in der bestehenden Bibelillustration deren Kern einen jüdischen Bilderzyklus enthalten haben mag." (The Haggada took its models for illustrations with figures from existing bible illustrations whose core may have contained a Jewish picture cycle.)

But this is not all. In 1986, at the age of 101, Rachel completed her most imaginative study yet, on *Copernicus and the New Kingdom in Daniel represented on the Astronomical Clock of Strasbourg Cathedral, 1574*, a text of 150 typewritten pages with over 40 figures, based on research that began in 1966 and which will soon be published as a separate book.

At the age of 104 Rachel Bernstein Wischnitzer looked back to a life full of events and interests, the creative and unusual life of an extraordinary woman. But she does not live by looking back, although her ears and hands had lost some of their strength: an avid reader, she nourished her mind constantly, and discussed intellectual matters with anyone who attracted her interest.

On the 20th of November 1989 Rachel Wischnitzer died in New York at the age of 104. We were all hoping that she would be able to hold this bound volume of her collected articles in her hands. Alas we did not manage. We console ourselves with the fact that she did see a complete page proof set of the book, when I brought it to New York a month before her death. "A mirage!" she exclaimed fully aware and enjoying the occasion. Her life was completed.

She did not die old, although she lived long.

1. THE ANCIENT SYNAGOGUE OF LUTSK

The Lutsk synagogue built by one of the oldest Jewish communities of Volhynia is in many aspects a rare historical and architectural monument. Unlike other countries, in Russia wooden synagogues of the 17th and 18th centuries are much more common than stone ones. There are a few stone synagogues, mostly in Volhynia, Podolia, and Galicia, as distinct from the numerous wooden ones in the provinces which were formerly under Polish sovereignty. Apparently, only large and prosperous communities could afford and, what was more important, could count on receiving a license to erect a stone synagogue. The outward appearance of these stone synagogues bespeaks their having been built in times when security considerations were of overriding importance. The watchtowers and the crenels in the high attics of these buildings indicate that they had a function beyond purely religious needs. Incidentally, once this extra function was also characteristic of churches which used to be equipped with watchtowers; examples are: the Kiev Cathedral of St. Sophia[1], the Sutkovets church, and the Annunciation temple of the Supraśl monastery; such parapets could be built onto masonry dwellings, as is evidenced by a description of the no longer existing Bogdan Chmielnićki house in Subbotov[2]. The synagogues in Lutsk, Luboml, Zólkiew, and other towns[3] constituted a chain of borderline fortifications erected with the purpose of putting the fear of God into the Tatars. The Lutsk community petitioned king Sigismund III for a permit to build a new synagogue in place of the dilapidated old one. The permit was granted in 1626 and the requirements stipulated that the synagogue "be of the same height as the previous one and have a gunmount on the roof for defending it on all four sides; it is incumbent on the Lutsk Jews to procure a gun at their own expense and produce from their own ranks people capable of handling enemy attacks." It is to be assumed, however, that the Christian population of Lutsk, incited by the Dominican friars, put all conceivable obstacles in the Jews' way during the construction of the synagogue, for in 1628 the Jews had to specially appeal to the king for the privilege of completing the construction of their temple. Sigismund III confirmed the license, pointing out that the synagogue "cannot possibly disturb the Lutsk Dominican fathers' church at such a distance." In his letters patent, the king stresses the strategic importance of the synagogue: it is "essential for the defense of the town." Thus state considerations overcame the intrigues of the clergy. Still, a cardinal requirement was to be fulfilled during the construction of the Lutsk synagogue as of all other synagogues: its height was not supposed to exceed that of local churches lest it might outshine the Christian temple by its splendor and magnificence[4].

One has to keep in mind the above stipulations when discussing the Lutsk synagogue, as they are responsible for its specific features which found expression in the characteristic combination of architectural details. (Fig. 1). The requirements which this construction was to satisfy had in them something which ruled out the possibility of making it a pleasingly consistent whole. The structure had to serve as a fortress, which usually implies imposing dimensions and jagged towers, but at the same time it was not supposed to exceed the scope of synagogue construction restrained by stringent rules which hampered all movement sideways

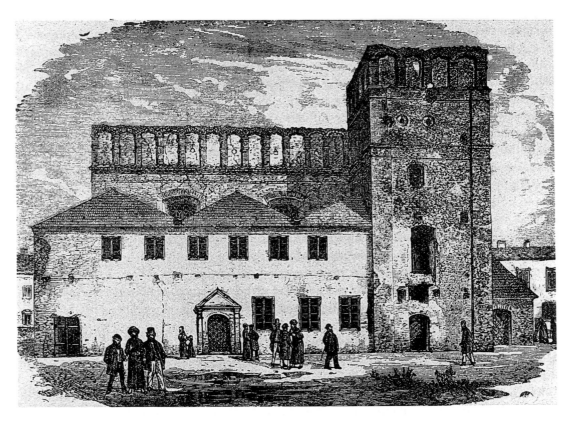

Fig. 1. Lutsk synagogue, 1626-28. (Photo courtesy of the author.)

and upwards. With these circumstances in mind, how can anyone blame the lack of scope on the Jewish builder? The air of constriction and dejection about the exterior appearance of our synagogues can be accounted for to a large extent by the restrictions imposed on the means of expression by synagogue architecture in olden times. Yet, the Lutsk synagogue, notwithstanding its not particularly impressive outward appearance which is forced rather than intentional, is not devoid of artistic values consisting of the well-proportioned structure, the low tetrahedral tower and the latter's vertical and horizontal segmentation. The high attic over the roof, whose function is bespoken eloquently by traces of embrasures, completes the building brightening it up with an elegant motif of the blind arcade composed of pilasters joined by little arches.

The integrity of the impression is not violated even by a 19th century annex which conceals the façade and truncates the large windows of the prayer hall. There is nothing casual about the fact that the little arches and tall pilasters, which adorn the attic, imitate forms of the Polish Renaissance, which is a specific mixture of the vernacular Gothic and elements of the Italian Renaissance cultivated in 16th-century Poland by architects such as Jan Maria Padovano, Pandrazzi, and Giovanni Batista. There is an inherent connection between *Sukiennice* (the market place) in Kraków, town halls in Kazimierz and Poznań, *Zamek Dolny*[5] in Vilna, pulled down at the end of the 18th century, and stone synagogues of Poland. Being unable, both due to the prohibitory law and for religious considerations, to make use of forms of church construction, the Jews naturally turned to samples of public architecture; the castle, even more so the town-hall architecture suited their requirements and tasks. The town hall which embodied the power of the magistrate, of the serried ranks of the burghers, mainly merchants and tradesmen, could certainly serve as a standard for the synagogue to follow. In the early 17th century, the

Die Amsterdamer Kupferhaggadah von 1695

Indem wir uns der Betrachtung der Haggadah mit Kupferstichen zuwenden, setzen wir voraus, daß der Bilderkreis der illuminierten handschriftlichen Haggaden bekannt ist. Die der Amsterdamer Kupferhaggadah vorangehenden Holzschnitthaggaden erfordern besondere Behandlung; soviel sei vorausgeschickt, daß sich ihr Bilderkreis stofflich und formal im großen und ganzen dem der handgemalten Haggaden des 15. Jhts. anschließt. Die Forschung hat erwiesen, daß die mittelalterliche figürliche Haggadahillustration von der christlichen Bibelillustration ausgegangen ist, von der sie sich erst mit der Zeit emanzipierte[8]. In meinem Aufsatz über die Haggadahillustration in der Enc. Jud. habe ich neuerdings auf die Existenz eines älteren Darstellungskreises hingewiesen, der aus den ornamental aufgefaßten Pessachsymbolen des Mazzah und des Maror bestanden hat. Diesem liturgischen Kern des Haggadahbilderkreises wurde die figürliche Illustration aufgepfropft. Die Haggaden übernehmen den christlichen Pentateuchzyklus als Anhang, als etwas Fremdes, banen aber gleichzeitig die liturgischen Symbole, die mit figürlichen Elementen durchsetzt werden, im Textteil aus und übertragen schließlich die biblischen Bilder, soweit sie zum Thema der Haggadah gehören, in den Text, während die übrigen biblischen Bilder, d. h. der ganze Anhang wegfällt. So entstand etws vollkommen neues: der Bilderkreis der Haggadah. In den spanischen Haggaden geht noch im 14. Jht. häufig beides nebeneinander her: die Textillustraiton und der Bilderanhang. In den Aschkenasischen Haggaden hingegen ist der Prozeß der Durchdringung und Ausgestaltung des Bilderkreises vollzogen. die Entwicklung findet auch in den Bildertiteln Ausdruck. Früher sind es dem Pentateuch entnommene Zitate, später Glossen zur Haggadah.

Die Illustration der Amsterdamer Haggadah bedeutet im Sinne der voraufgegangenen Entwicklung einen überraschenden Rückschritt, bei aller Ueppigkeit der Bildgestaltung einen Rückschritt: Reduzierung der liturgischen Bilder, Häufung der biblischen Bilder, Ueberhandnehmen der biblischen Auffassung. Daß dieser Rückschritt auch von den Zeitgenossen als solcher bald empfunden wurde, zeigen die Veränderungen, namentlich die Ergänzungen, die der Bilderzyklus der Haggadah von 1695[9] in der Ausgabe von 1712[10] erfahren hat. Man versteht, worauf es den Herausgebern der zweiten Ausgabe ankam, erst nachdem man sich mit der Illustration der ersten vertraut gemacht hat.

Die Haggadah mit Kupfern von 1695 ist die Nr. 48 der Bibliographie von S. Wiener. Der Folioband enthält ein Titelblatt, 26 Textblätter und eine Landkarte, die in der Mitte gefalzt und so beigebunden ist, daß sie zwei Blätter bildet. Im Druckvermerk auf dem Titelblatt ist zu lesen, daß die Haggadah, "im Hause und im Auftrage des Moses Wesel in Amsterdam im J. 5455 gedruckt wurde". I. Sonne[11] erwähnt Wesel nicht unter den Amsterdamer Druckern und nennt als erste Kupferstichhaggadah einen Amsterdamer Druck von 1692 von Kosmann Emmerich. Da der Aufenthaltsort von Exemplaren dieser Ausgabe nicht angegeben wird, konnte ich nicht feststellen, ob es sich hier um eine andere oder die gleiche Haggadah handelt. Die Frage bedarf noch der Klärung.

Die Bilder und die Titeleinfassung der Weselschen Haggadah sind von Kupferplatten gedruckt, zwei Blumenvasenvignetten von Holzstöcken abgezogen.

Die Titelaedicula besteht aus zwei geriefelten Säulen mit den Standfiguren des Moses und des Aaron davor. Zwischen den Säulen, die oben von einem drapierten Querbehang verhüllt sind, hängen an Schnüren sechs Rundmedaillons mit figürlichen Szenen: Im Medaillon oben Mitte: Vertreibung aus dem Paradies, darunter, zweite Reihe rechts: Sintflut, links: Noah mit der Arche, dritte Reihe rechts: Abraham und Melchisedek, links: Lots Töchter, zuunterst Mitte: Jakobsleiter.

Die Bilder im Text nehmen die untere Hälfte der Blätter ein. Dies ist die Reihenfolge der Bilder:

Fol. 1 recto Blumenvase.
 '' 4 recto Die Weisen in Bnei Brak.
 '' 5 recto Die vier Söhne (Abb. 3).
 '' 5 verso Abraham zerschlägt die Götzenbilder.
 '' 6 recto Abraham und die drei Engel (Abb. 14).
 '' 7 verso Moses erschlägt den ägyptischen Fronvogt.
 '' 8 verso Findung Mosis.
 '' 9 recto Moses und Aaron vor Pharao, rechts Schlangenwunder. (Abb. 2).
 '' 10 recto Froschplage.
 '' 10 verso Untergang der Aegypter.
 '' 11 verso Auszug aus Ramses.
 '' 12 recto Gesetzgebung.
 '' 13 recto Pessachlamm (Abb. 9).
 '' 17 recto Blumenvase.
 '' 18 recto David betend.
 '' 24 recto Tempel.
 '' 27 verso Karte Palästinas mit der Aufteilung des Landes unter die Stämme.
 '' 28 recto

Hinter dem Titel stehen auf dem Titelblatt auf hebräisch die Worte: "mit Beigabe des Zuges durch die Wüste bis zur Verteilung des Landes unter die Stämme und eines Bildes des Tempels. Gestochen von Abraham bar Jakob aus dem Geschlechte unseres Stammvaters Abraham". Die hebräische Signatur des Abraham bar Jakob ist auch auf der Landkarte, am unteren Rande von fol. 27 verso, unter einer kleinen Jona-Szene zu lesen. Auf fol. 1 recto steht oberhalb der Holzschnittvignette: Seder nach dem Minhag der Aschkenasim und Sefardim. In den darauffolgenden Zeilen finden wir eine Würdigung der beiden Bilddruckverfahren, des Holzschnittes und des Kupferstiches: "Früher, heißt es, wurden die Bilder in Holz geschnitten, was nicht so schön war, heute, wo die Bilder in Kupfer gestochen sind, sehen die Leute den Unterschied, er ist, wie zwischen Licht und Finsternis".

Diese Worte lassen sich so auffassen, daß in der vorliegenden Ausgabe der Kupferstich zum ersten Mal in der Haggadahillustration verwendet wurde. Die Verwendung des Kupferstiches in hebräischen Drucken ist im allgemeinen älteren Datums. Das Titelportal der Amsterdamer Haggadah ist eine Variante von Titeleinfassungen in früheren Drucken. Der Sefer Nizzachon des Lipmann Mühlhausen, ein Altdorfer Druck von 1644, enthält schon ein Titelkupfer[12], die 1679 in Amsterdam von Ury Feibusch b. Aaron ha-Lewi gedruckte Bibel mit jüd. deutscher Uebersetzung[1] enthält ebenfalls ein Titelkupfer. Beide sind mit dem der Amsterdamer Haggadah verwandt und gehen auf die gleiche Quelle zurück. Der Seder Berachot (Orden de Bendiciones), ein Amsterdamer Druck von Albertus Magnus, 1687, trägt auf dem Titelkupfer auch die Initialen des Stechers B. G. Nach Alb. Wolf[13] ist das der Jude Benjamin senior Godines[14]. Daß Abraham bar Jakob, der sich als Stecher des Tempels und der palästinensischen Karte ausweist (vielleicht hat er auch die übrigen Bilder gestochen, ohne dies ausdrücklich zu erwähnen), Jude von Geburt war, wird von Wolf wegen der eigentümlichen Redewendung "aus dem Geschlechte unseres Stammvaters Abraham" bezweifelt. Er hält ihn für einen Proselyten. Im Buchgewerbe sehen wir tatsächlich verschiedentlich Proselyten in dieser Zeit[15]. Ob allerdings, wie Wolf entgegengehalten werden kann[16], ein Proselyt nicht Sohn

des Abraham hätte heißen müssen, bleibe nicht unerwähnt. Unser Abraham nennt sich Sohn des Jakob.

Wenden wir uns nun dem Bilderkreis der Amsterdamer Haggadah zu. Daß er mit den Weisen in Bne Brak beginnt, ist auffallend, denn gewöhnlich stehen die Vorbereitungen zum Fest, das Wegräumen des Chomez, das Säubern der Gefäße und das Backen der Mazzot an der Spitze der Illustration. Unumgänglich scheint die Schilderung des Hausvaters zu sein, wie er die verschiedentlichen Segenssprüche sagt, und vor allem die Darstellung des Pessachmahles der Familie. Von all dem enthält die Haggadah gar nichts. Aber auch die Szene in Bne Brak hat nicht die übliche Fassung. Keine Jünger überraschen die alten Weisen, die sich die Nacht hindurch vom Auszug aus Aegypten erzählt haben, mit der Mitteilung, daß es schon Zeit sei, das Morgengebet zu sprechen. Was man sieht, ist eine Festtafel, eine zahlreiche Männergesellschaft, die von Wein einschenkenden und Gerichte auftragenden Dienern eifrig bedient wird. Ohne den erläuternden Titel wäre das Bild nicht zu verstehen.

Die vier Söhne auf fol. 5 recto (Abb. 3) sind in der überlieferten Weise charakterisiert, der eine als der kluge — in der Tracht des Gelehrten —, der andere als der böswillige, wie stets in Gestalt eines Kriegers, die zwei letzten, wie auch sonst, weniger prägnant: als tölpelhafter bzw. einfältiger Mensch. Neu ist, daß die vier Charaktere nicht einzeln, sondern auf einem Bild vorgeführt werden. Die vier figuren stehen, jede in der ihr eigentümlichen Haltung, ohne Beziehung zueinander, als ob sie aus verschiedenen Kompositionen herausgeschnitten worden wären. Die weiteren Bilder sind Illustrationen zu Begebenheiten aus den biblischen Büchern, sogar das Pessachmahl stellt nicht etwa die Erinnerungsfeier dar, die die jüdische Familie begeht, sondern die Israeliten, wie sie aus Aegypten auszuziehen im Begriffe sind.

Gerade diese Szene aber führt uns auf die Spur, die den Charakter des ganzen Illustrationskreises erklärt, denn es ist das nichts anderes als das Passahmahl aus den fünf Büchern Mosis in der Uebersetzung von Luther mit Holzschnitten Hans Holbeins d. J.[17] Auch die übrigen Bilder verraten Verwandtschaft mit den Bibelbildern des Holbein, und zwar mit seinen Holzschnitten in Historiarum veteris instrumenti icones ad vivum expressae[18]. Die einen tragen die Zeichen ihrer Abstammung deutlicher, manche weniger erkenntlich. Manchen liegt die Komposition einer gleichnamigen Szene zugrunde, andere benutzen die Vorlagen ganz willkürlich. Die Komposition von Abraham und die drei Engel ist die gleiche, der Untergang der Aegypter hat Vieles gemein mit den ertrinkenden Aegyptern sowie mit der Rotte Korah in den Icones des Holbein, der betende David hat die Haltung des vor Gott knienden Moses, die am Altar opfernden Götzendiener im Bild des Abraham fol. 5 verso sind den Verehrern des goldenen Kalbes in den Icones des Holbein nicht unähnlich, der Holbeinsche Turm zu Babel wiederholt sich in der Architektur der Fronstadt Ramses. Sogar die Karte Palästinas am Schluß hat ihr Gegenstück bei Holbein: das Bild der Stiftshütte, um die sich die israelitischen Stämme, jeder unter seinem Zelt, lagern.

Kompositionell besteht zwischen den Kupferstichen der Amsterdamer Haggadah und Holzschnitten aus den beiden Bibelbilderzyklen des Holbein eine unverkennbare Beziehung, stilistisch sind sie jedoch sehr verschieden. Die Frage ist, ob es möglich sein wird, nachzuweisen, daß die Amsterdamer Haggadah tatsächlich von der Holbeinbibel abstammt, denn es können ihr auch andere Quellen zu Gebote gestanden haben.

Wir wissen, daß Holbein die Kompositionen zu seiner Bibelillustration nicht selbst geschaffen hat. Seine erste Folge geht auf die Kölner Bibel des Heinrich Quentel um 1479 zurück; die zweite verrät Abhängigkeit von Italien. Die deutsche Bibelillustration hat ferner den oberitalienischen Holzschnitt beeinflußt.

Es soll hier nicht die Frage der Priorität aufgerollt werden, für uns ist von Bedeutung, daß als

Vorlage für den Abraham, der das Götzenbild zerschlägt, noch am ehesten Kain, der den Abel erschlägt, mit den im Hintergrund sichtbaren Altären der Brüder in Frage kommt, ein Holzschnitt aus einem venezianischen Druck — Bergomensis, Supplementum Chronicarum, 1486[19]. Kompositionell verwandt sind die Bilder der Haggadah mit Moses vor Pharao, dem Wandgemälde des Benozzo Gozzoli am Campo Santo in Pisa, mit dem Untergang der Aegypter des Cosimo Roselli in der Sixtinischen Kapelle, auch mit Abraham und den Engeln eines Raffaelschülers in den Loggien des Vatikans (1519). Der Bilderkreis wurde zuerst einmal in der venezianischen Malermi-Bibel 1492 im Holzschnitt schematisiert, nachher in den Stichen des Marc Anton u.a. nach den Schöpfungen der Generation des Raffael vervielfältigt, verflacht. Wenn dann hundert Jahre später und mehr ein Künstler den angesammelten Formenschatz verwendet, so ist es nicht leicht, den Knäuel von Einflüssen zu entwirren. Die Frage, ob die Amsterdamer Haggadah sich die deutsche oder die italienische Version der Bilder zu eigen gemacht hat, ist nicht mit aller Entschiedenheit eindeutig zu beantworten, wenn auch so manches Bild, besonders das Pessachmahl recht deutsch (im Sinne gotischen Stilgefühls) wirkt und für deutsche Ueberlieferung spricht.

Auch aus der kulturhistorischen Situation ergibt sich die Lösung nicht einwandfrei.

Die jüdischen Druckereien setzten im 17. Jht. in Amsterdam die italienische Tradition fort, deren Träger besonders die Sefardim waren. Zu beachten ist jedoch, daß unsere Haggadah sowohl für den Sefardischen als auch für den Aschkenasischen Ritus bestimmt ist. Betrachten wir die voraufgegangenen Holzschnitthaggaden, so beobachten wir schon dort eine eigentümliche Kreuzung deutscher und italienischer Einflüsse. Die Prager Haggadah von 1527 und die Mantuaner von 1560 charakterisieren diese Mischung. Ohne auf diese beiden Bilderhaggaden näher einzugehen, möchte ich nur darauf hinweisen, daß die Mantuaner Haggadah für einen der Weisen als Vorlage, wie schon J. v. Schlosser bemerkte, den Jeremias[20] von der Decke der Sixtinischen Kapelle des Michelangelo verwertet und für einen der vier Söhne, wie ich kürzlich entdeckte, eine Holbeinsche Figur zum LII. Psalm aus den "Icones".

Im Fall der Amsterdamer Haggadah ist die Identifizierung um so schwieriger, als die Bilder keine getreuen Kopien sind wie im letzten Beispiel, sondern Nachschöpfungen, die mit den Holzschnitten nur noch das kompositionelle Schema gemein haben. Die Stiche sind im Format erheblich größer, die figürlichen Szenen sind durch Nebenfiguren bereichert, das ganze ist in eine üppige architektonische und landschaftliche Staffage gesetzt. Die malerische Faltenbehandlung im Kostüm, die Effekte der Luftperspektive, die fein nüancierte Schraffierung des Kupferstiches bieten dem Bilddruck des 17. Jhts. Mittel genug, um seine Herkunft vom derben Holzschnitt zu verwischen.

Durch Zufall ist es gelungen, die unmittelbare Quelle, der die Amsterdamer Haggadah ihren Bilderkreis entlehnt hat, zu entdecken. Herrn S. Kirschstein wurde es bekannt, daß in einer Auktion ich glaube, im Auslande, eine Haggadah mit Merianschen Bildern ausgeboten wurde. Nähere Angaben waren über diese Haggadah nicht vorhanden.

Dieser Spur ging ich nach. Merian ist der Name einer größeren Künstlerfamilie schweizerischen Ursprungs, mit dem das vielbändige Theatrum Europaeum verknüpft ist. Es gab einem Matthäus Merian, den Aelteren (gest. 1650), zwei Söhne desselben, Kaspar (1686 in Holland gest.) und Matthäus, d. J. (gest. 1687), um nur die für uns in Betracht kommenden Mitglieder dieser Familie zu nennen, denn die Tochter, die sich mit Zeichnungen von Schmetterlingen einen Namen machte, scheidet wohl aus.

Mattäus Merian von Basel, wie sich der ältere Merian in seinen Werken noch nannte, als er den Verlag und den Buchhandel seines Schwiegervaters De Bry übernommen und sich in Frankfurt a. M. niedergelassen hatte, gab 1625/26 die Bilder zum Alten Testament, die "Icones

biblicae" mit Versen und Reimen in drei Sprachen heraus. Wenn man bedenkt, daß Merian kein Figurenzeichner war — seine Stärke lag in Stadtveduten, seinen Ruf erwarb er sich durch die Topographien von Stuttgart, Heidelberg u.a. —, wenn man weiter berücksichtigt, daß seine vollständige Hl. Schrift 258 Kupferstiche enthält und meist Gehilfenarbeit ist, so wird man den Anteil des Matthäus Merian an den Bibelbildern nicht überschätzen. Seine Söhne arbeiteten an seinen Verlagswerken mit. Merian feiert in einer Dedikation in den "Icones" Dürer, Lucas Kranach und Holbein, und er hatte diesen Meistern tatsächlich sehr viel zu verdanken, wenn er für italienische Einflüsse auch nicht unempfänglich war. Daniel Burckhardt[21] glaubt die Bedeutung Merians für die Kunstgeschichte gerade darin sehen zu müssen, daß der Basler Künstler so manche seither verschollene oder zerstörte Arbeit des Holbein d. J. in seiner Heimatstadt studieren konnte und durch seine Nachschöpfungen erhalten hat. Er spricht die Vermutung aus, daß Merian die Kupferplatten zu den fünf Büchern Mosis bereits in Basel vor der Frankfurter Zeit gestochen hat.

Für uns gewinnt Merian eine besondere Bedeutung, weil wir in seinen Bibelbildern das Vorbild der Amsterdamer Haggadah gefunden haben. Man kann manchmal von einer sogar heilsamen Verschüttung von Kulturwerten und Erkenntnissen sprechen; im Falle der Amsterdamer Haggadah ist die Verkennung der Zusammenhänge um so sonderbarer, als die Icones biblicae, oder noch mehr die spätere Ausgabe "Die gantze Hl. Schrift" ein ungemein volkstümliches Buch gewesen ist. Die Meriansche Bibel ist in unzähligen Auflagen und Ausgaben erschienen, zuletzt mit lithographierten Bildern, ganze Generationen in Deutschland sind mit ihr aufgewachsen. Goethe spricht im ersten Buch von "Wahrheit und Dichtung" von der dickleibigen Bilderbibel des Merian.

Daß sie den Weg nach Holland gefunden hat, braucht uns nicht zu überraschen. M. Merian hatte sich in den Niederlanden bereits 1616 aufgehalten. Das Querquartformat der Icones[22] soll, wie Burckhardt ausführt, gewählt worden sein, weil es in Holland beliebt war. Mit seinem knappen dreisprachigen Text (lateinisch, deutsch und französisch) war das Werk sicherlich in erster Linie für den Export bestimmt gewesen. Folioformat erhielt erst die spätere Ausgabe, die vollständige Hl. Schrift, die deutsche Lutherbibel[23], in die die Bilder der drei Teile der Icones als Textillustration aufgenommen wurden.

Beide Ausgaben, Quart und Folio, erschienen später auch in Holland, und zwar die Icones mit sechssprachigem, darunter flämischem und holländischem Text. Die Kupfer dazu wurden nach Merian von Pieter Hendricksz Schut, der um 1650—60 wirkte, nachgestochen[24].

Man wird zur Erklärung des Einflusses der Merianschen Bibel auf die Haggadahillustration geltend machen wollen, daß der ihr eigene puritanisch-protestantische Geist, der sich besonders in der Vermeidung von Darstellungen Gottes äußert, — an seiner Stelle sehen wir den Namen Gottes in hebräischen Lettern in der Strahlenglorie, — dem jüdischen Geist verwandt war. Dieses Moment mag gewiß von Bedeutung gewesen sein, jedoch sind in den Holzschnitthaggaden der Renaissance Entlehungen auch aus der Holbeinbibel, die die Gottesdarstellung nicht scheute, nachzuweisen. Die Haggadah hat, wie es scheint, schon immer (für das Mittelalter war es erwiesen) Anregungen aus der zeitgenössischen landläufigen Bibelillustration empfangen, hat sie mehr oder weniger selbständig verarbeitet. In der Amsterdamer Haggadah ist das Maß der Selbständigkeit allerdings gering.

Schon die erste Szene mit den Weisen in Bne Brak ist buchstäblich aus Merian übernommen. In den Icones biblicae[25] Teil 1, fol. 77 stellt sie allerdings Josef und seine Brüder dar. Jetzt verstehen wir auch, warum das Bild nicht genau zu dem haggadischen Stoff paßt. Kleine Abweichungen sind übrigens darin nachzuweisen, jedoch sind sie nicht stilistischer Art. Es fehlt die Aussicht ins Freie durch die drei Fenster im Hintergrund, die Stadvedute, mit der

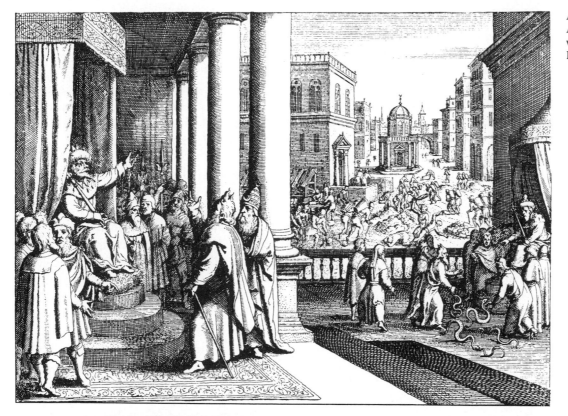

Abb. 1. Moses und
Aaron vor Pharao. Stich
von Merian, Icones
Biblicae, fol. 85.

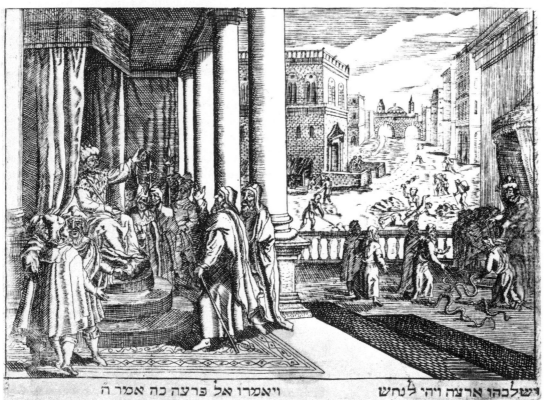

ויאמרו אל פרעה כה אמר ה וישלכהו ארצה ויהי לנחש

Abb. 2. Moses und
Aaron vor Pharao, Stich
aus der Amsterdamer
Haggadah, 1695, fol. 9r.

Merian so gern paradiert; die Fenster sind geschlossen. Die Findung Mosis ist keine genau Kopie der gleichnamigen Szene auf fol. 81 der Icones, dafür ist Moses und Aaron vor Pharao unverändert von fol. 85 übernommen (Abb. 1, 2). Das gleiche gilt für die Froschplage von fol. 87, für das Pessachmahl, von fol. 89 und für das Tempelbild von fol. 93, das in der Haggadah sich nur durch das Fehlen der Staffage-Figuren unterscheidet. Unwesentliche Abweichungen bietet der "Untergang der Aegypter", die darauf zurückzuführen sind, daß als Vorlage nicht der Stich aus den Icones, sondern der etwas veränderte Stich aus einer Bilderfolge des Merian zur biblischen und profanen Geschichte benutzt worden ist. Dieser Kupferstichfolge ist auch "Abraham und die drei Engel" entnommen.

Die Rekonstruktion des Tempels in dem Icones ist vielleicht nicht von Merian selbst geschaffen, sie ist insofern bemerkenswert, als sie bereits den Langhaustyp zeigt. Salom Italia sticht dem Tempel Salomonis nach den Entwürfen des Jacobo Jehuda Leone viel später. Der Langhaustyp wird wohl auf eine größere Reihe von Rekonstruktionsversuchen zurückgehen, die den Zentralbautyp jedoch nicht verdrängen konnten. Die ältere Vorstellung vom Tempel, den man sich in der Gestalt der Omarmoschee, nämlich als Kuppelbau dachte, weil die Kreuzfahrer diese Moschee für den alten Tempel gehalten hatten, findet man sowohl in christlichen, als in jüdischen Darstellungen vor, ein Thema, das hier nicht weiter behandelt werden kann.

Der betende König David der Haggadah ist der Pharisäer aus dem Bilde Pharisäer und Zöllner, das im Teil II fol. 75 sowie im 3. neutestamentlichen Teile der Icones des Merian enthalten ist. Der Haggadahstecher hat die architektonische Staffage und die kniende Figur beibehalten und nur den lustwandelnden Pharisäer weggelassen. Kleine Veränderungen erblickt man in der hinzugekommenen Leier auf der Altarstufe und dem Psalmenbuch auf dem Altartisch, das Ruach Hakodesch (Heiliger Geist) in der Strahlenglorie über dem Altar ist aber auch einer Vorlage des Merian entnommen, dieses Motiv, und zwar sogar mit hebräischen Lettern, verwendet der basler Stecher vielfach. Es ist besonders interessant zu sehen, wie der Haggadahillustrator bei dem Bilde der vier Söhne verfahren ist (fol. 5r, Abb. 3). Hier stand ihm keine passende Vorlage zur Verfügung. die vier Gestalten mußten aber überlieferungsmäßig charakterisiert werden, und so suchte er sich die Figuren von überall zusammen. Amüsant ist, "das Kind, das nicht zu fragen weiß", denn die Figur dazu bot "Hannibal, der den Römern ewige Feindschaft schwört" aus Merians Stichfolge zur alten römischen Geschichte (Abb. 4)[26]. Nicht ohne Witz ist der "Tam", das einfältige Kind, der in den Icones des Merian Teil II fol. 55 der von Samuel gesalbte Saul ist (Abb. 5). Mit geneigtem Kopf auf seinen Stab gestützt steht er scheinbar hilflos da, in Wirklichkeit aber, um das Salböl nicht vorbeitropfen zu lassen. Der "Böse Sohn" ist ein Krieger aus der Stichfolge zu der biblischen und der profanen Geschichte (Abb. 6) und der "Kluge Sohn" ist mit einigen Abänderungen in der Haltung der Arme eine Gestalt aus dem Hannibalbild (Abb. 4), oder vielleicht auch die getreue Kopie einer anderen Vorlage aus dem immensen Opus des Merianverlages. Auch der "Moses, der den Aegypter erschlägt" ist dem Zyklus zur römischen Geschichte entnommen, es ist das eine Kopie des Stiches: "Remus wird erschlagen".

Den figürlichen Schmuck der Palästinakarte, z. B. die kleine Jona-Komposition (Abb. 7), finden wir bei Merian in mehreren etwas abweichenden Varianten (Abb. 8). Auch die Figuren aus der Szene der Gesetzgebung entstammen Matthäus Merian, und es ist bemerkenswert, daß die Juden dort in türkischer Tracht erscheinen, wie wir sie auf einem Bilde "Bajazet II gibt ein Banquett" und in der "Belagerung Konstantinopels" sehen.

Neben der überwiegenden Zahl von Bildern, die der Haggadahillustrator unverändert, vollständig oder im Ausschnitt, Stichen des Merian entnommen hat, sehen wir bei ihm nur

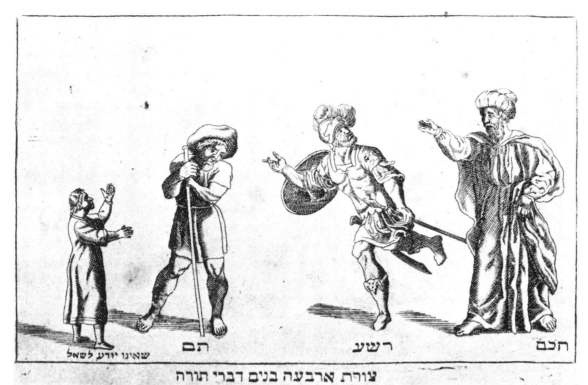

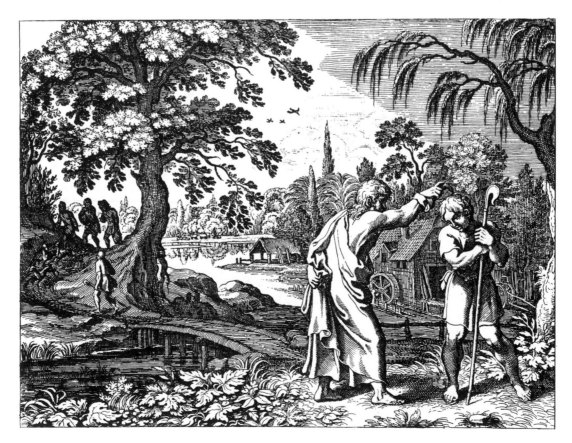

Abb. 3. Die vier Söhne.
Stich aus der
Amsterdamer Haggadah,
1695, fol. 5 recto.

Abb. 4. Hannibal
schwört den Römern
ewige Feindschaft. Stich
von Merian.

37

Fol. 12 verso Untergang der Aegypter.
Fol. 13 verso Auszug aus Ramses.
Fol. 15 recto Gesetzesgebung.
Fol. 15 verso Pessachmahl.
Fol. 21 verso David kniend.
Fol. 30 recto Tempel.

Ein Teil der Holzschnitte trägt das lateinische Monogramm NM. Die Kompositionen sind stark vereinfacht, wie in der Froschplage, wo die schwierige Diagonalansicht in die primitivere Frontalansicht umgewandelt ist. Die Initialenbilder, die im Text verstreut sind, gehen nicht unmittelbar auf die Holzschnittbilder der Venezianer Haggadah zurück, sondern sind nach den Kopien der Amsterdamer Ausgabe von 1712 geschnitten, von dort rühren die Sessel mit den hohen Rückenlehnen her, die summarische flüchtige Zeichnung der Figuren, die Veränderungen im Kostüm, sowie kleinere Abweichungen, in der Zeichnung des Flederwisches u. a.

Wir begegnen in der Haggadah einer eigentümlichen Entwicklung vom Holzschnitt zum Kupferstich und wiederum zum Holzschnitt. Dieser Holzschnitt des 18. Jhts. ist den alten gegenüber viel gröber. Auf dem Titelblatt ist der Name des Salomo Salman London genannt, der die "schönen Bilder, die Holzschnitte, hinzugefügt hat". Es ist schwer zu sagen, was unter Hinzufügung eigentlich zu verstehen ist. Am Ende des Druckes sind die Setzer und Drucker aufgezählt, die daran gearbeitet haben. "Durch den Setzer, der beschäftigt ist mit dieser hl. Arbeit, Eisik ben Moses Gans, Amsterdam, und den Setzer Manes ben Salomo aus Amsterdam und den Drucker Leiser Herz Segal aus Amsterdam, den Drucker Leib ben David, den Setzer Josef ben Salomo aus Falkenstein, den Drucker, den jungen Schemaja ben Benjamin Engelsch aus Amsterdam."

Der Amsterdamer Haggadah von 1765, die den Merianschen Bilderkreis in den Holzschnitt übertragen aufweist, sind Holzschnitthaggaden mit stark verkleinerten und schematisierten Bildern desselben Bilderzyklus zeitlich vorangegangen, wie die Offenbacher, die Fürther und andere. Jede gibt den Bilderkreis nur teilweise wieder. Diese Drucke bieten derartige Abweichungen, daß man sie nicht mehr als Ausgaben der Amsterdamer Haggadah betrachten kann. sie gehören in eine Darstellung der volkskunstmäßigen Abwandlungen der Amsterdamer Haggadah, die im 18. Jht. in verschiedenen Varianten aufgetreten sind.

In response to Wischnitzer's article on the Amsterdam Haggadah (no. 2 above), Dr. Grunwald, Kober, Erich Toeplitz and Isasia Sonne published the following remarks 2A. The answer of R. Wischnitzer was in two instalments, the first in 1931 (no. 2B) and the second in 1932 (2D). Erich Toeplitz added a short note (2C).

2A. ZUR PESSACH-HAGGADA

Zu dem Aufsatz der Frau Wischnitzer im letzten Heft haben wir mehrere Zuschriften erhalten.

Herr Rabbiner Dr. Grunwald in Wien schreibt: Ich habe bereits 1898 (vgl. Mitteilungen für Jüdische Volkskunde, 1929, S. 57) nachgewiesen, daß die Kupfer der Amsterdamer Haggada aus einer ebendort erschienenen Bilderbibel stammen, die ich in Hamburg im Besitz des Herrn Moses Mainz vorgefunden habe. Für die Annahme, daß der Drucker Proops diese Kupfer für seinen Zweck benutzt hat, spricht u. a. das Kreuz auf der Kirche im Hintergrunde des Bildes vom Besuch der Engel bei Abraham (das Kreuz ist in späteren Ausgaben weggefallen). Die Gruppe der vier Söhne stimmt bis in Einzelheiten mit den "vier Menschenaltern" bei Dryander, Der Arzney gemeiner Inhalt, Frankfurt 1542 (H. Boesch, Kinderleben in der deutschen Vergangenheit S. 6) überein. Weiteres in den "Mitteilungen" a. a. O.

Herr Rabbiner Dr. Kober in Köln bemerkt zu S. 311, daß die in Köln 1925 veranstaltete Jahrtausendausstellung ihren Niederschlag bereits im Katalog der Jahrtausendausstellung der Rheinlande 1925 gefunden hat: "Juden und Judentum im Rheinland", S. 315-339.

Herr Erich Toeplitz in Frankfurt a. M. weist darauf hin, daß er in der Zeitschrift Menorah, 1924, Heft 4, 6 und 7 den gleichen Gegenstand, und zwar in völlig abweichender Weise, behandelt hat.

Ferner erhalten wir folgende Zuschrift:

I. In ihrem sehr lehrreichen Artikel "Von der Holbeinbibel zur Amsterdamer Haggadah" (oben S. 282) wie auch in der EJ. VII, 811 bezeichnet Frau Wischnitzer die in Venedig 1629 bei Pietro, Aluise und Lorenzo Bragadina gedruckte Bilderhaggadah als die "älteste" erhaltene Venetianische Ausgabe. Diese Angabe bedarf einer Berichtigung. Es genügt, das Titelblatt dieser Ausgabe aufmerksamer zu lesen, um sich zu überzeugen, daß, was die Bilder betrifft, ein Nachdruck vorliegt. Denn es heißt ja ausdrücklich: "Hergestellt und erdacht vor ungefähr 20 Jahren durch den Greis..., der Weisheit erworben hat, Israel Zifroni... Nun wurde der Kommentar 'Zeli Esch' hinzugefügt. הכינה וגם חקרה זה כמו עשרים שנה זקן שקנה חכמה ...כמ״ר ישראל זפרוני ז״ל. ...ואלה מוסיף על הראשונים פירוש צלי אש In der Tat erschien im Jahre 1609 (also genau vor 20 Jahren) bei di Gara die Haggadah mit Uebersetzungen ins Spaniolische, Italienische und ins Jüdisch-Deutsche, welche bereits die Bilderzyklen der späteren Ausgaben enthält und ist bei Steinschneider unter Nr. 2689 verzeichnet (Wiener ist mir z. Z. nicht zugänglich). Neu ist in der Ausg. 1629 nur der Komm., dessentwegen der Satzspiegel von 23,5 × 17,5 cm auf 26,5 × 20,5 cm

erweitert wurde. Die Angabe daß Israel Zifroni "der Weisheit erworben hat" (gemeint ist wohl Fertigkeit in der Druckerkunst) zuerst diese Bilderhaggadah besorgt hat, scheint mir von nicht geringer Bedeutung zu sein. Israel Zifroni arbeitete zuerst (1567) bei Conti in Sabbioneta, nachher in Freiburg und in Basel, wo er an der Talmudausgabe (1578-81) teilnahm; ich habe an anderer Stelle darauf hingewiesen, daß Conti in seinen Ornamenten einen starken deutschen Einfluß aufweist. Der Aufenthalt Zifronis in Freiburg und Basel mußte diesen Einfluß bedeutend stärken. Wenn nun in der Venetianischen Haggadah gegen alle Gepflogenheit des ital. hebräischen Druckerstils Initialen auf einem Hintergrund von Genrebildern vorkommen, so wird es wohl diesem seinem Aufenthalte in Basel zuzuschreiben sein. Das hebräische Zieralphabet der ital. Druckereien des 16. Jahrhunderts hat als Hauptmotiv Vase mit Rankengeflecht und keine menschlichen Figuren (vgl. meinen Artikel "Zum Schicksal eines Zieralphabeths", Kirjath Sefer VI, 249-58), während das hebr. Zieralphabet in Basel in der zweiten Hälfte des 16. Jahrhunderts zum Teil mythologische Figuren als Grund hat (z. B. die Titelbll. der einzelnen Traktate, Aruch, Basel 1599 u. m.).

II. Da man aus der Darstellung von Frau W. den Eindruck gewinnt, als ob die Ausgabe von 1629 resp. 1609 die älteste venetianische Bilderhaggadah überhaupt (von dem sehr zweifelhaften Bilderblock abgesehen) darstellt, will ich noch kurz auf eine andere venetianische Bilderhaggadah, welche jener unmittelbar vorausging, die Aufmerksamkeit lenken. Es handelt sich um eine Ausgabe in 4°-Format, die das Bildermaterial der großen Mantuaner Ausg. (1560, 1568) verwendet. Auch der Kommentar des Josef Schalit wurde übernommen. Diese Ausgabe muß, bevor sie von der neuen mit Uebersetzung versehenen Bilderhaggadah verdrängt wurde, stark verbreitet gewesen sein. Ich hatte Gelegenheit, drei aufeinander folgende Auflagen dieser Haggadah zu sehen, und zwar: 1599, bei di Gara (St. 2685), 1601, bei Daniel Zanetti, 1603, wieder bei di Gara. Es ist wahrscheinlich, daß es noch spätere Ausgaben dieser sehr verbreiteten Haggadah gibt, und es ist naheliegend daß diese nicht ganz ohne Einfluß auf den neuen Bilderzyklus geblieben ist. Es wäre daher eine dankbare Aufgabe, diesen Spuren nachzugehen und genauer zu prüfen, wie weit die venetianische 4°-Ausgabe von der Mantuaner Vorlage abweicht, und inwiefern sie dann den neuen Bilderzyklus beeinflußt hat. Ich möchte bloß andeuten, daß das bekannte traditionelle "Hasenjagdbild", welches bereits in der Prager Ausgabe vorhanden ist, zum Teil auch in der Ausgabe 1609 u. 1629 in einem Initialbilde (Bl. 4 a, in ed. Ven. 1740 findet sich dieses Initialbild auf Bl. 16 a), anzutreffen ist, jedoch in einer modifizierten Form, die vielleicht auf die vorhergehenden venetianischen Vorlagen zurückzuführen wäre.

III. In dem Exemplar der Venetianischen Haggadah, welches Frau W. benutzt (nach ihrer Angabe aus dem J. 1760; jedoch vermute ich, daß es sich um die Ausg. Ven. 1740 bei Vendramin, auf Veranlassung von Mëir da Zara, mit rot-schwarzem Titel, handelt), sind einige Bildchen im Sederzyklus umgestellt; daher ist in der Gegenüberstellung von Venedig und Amsterdam (in der Reproduktion) im ersten Bildchen keine vollständige Uebereinstimmung wahrzunehmen. Dieses erste Bildchen nimmt aber in den Ausgg. 1609 und den gleich darauf folgenden, den elften Platz ein, und an erster Stelle steht das in der Ausg. 1740 die elfte Stelle einnehmende Bildchen, welches mit dem ersten Amsterdamer vollständig übereinstimmt.

IV. Noch einige Worte zur Frage, warum in der Amsterdamer Haggadah von 1712 die Initialbilder den Holzschnitt bewahren und nicht gestochen wurden. Der Grund wird wohl darin liegen, daß der Kupferstich sich vom gedruckten Text allzusehr loslöst. Und wenn es noch angängig erscheinen mochte, den ganzen unteren Teil einer Seite vom Texte loszulösen, so schien es nicht angebracht, die Initiale, die sich doch dem gedruckten Text einfügen müssen, zu stechen. Damit erklärt sich auch die "eigentümliche Entwicklung vom Holzschnitt

zum Kupferstich und wiederum zum Holzschnitt", was aber nicht nur von der Haggadah, sondern auch von den Titelblättern gilt. Das gestochene Bild wie auch Titelbl. konnte sich dem Ganzen nicht einfügen; es wurde als Fremdkörper empfunden, was daraus ersichtlich ist, daß man auf den gestochenen fast immer einen gedruckten Titel mit Holzschnitt-Vignetten folgen ließ. Und so war es nur natürlich, daß man den fremden Körper zu eliminieren suchte. Am besten läßt sich dieser Vorgang in den Titelblättern der Druckerei Tartas-Castro beobachten. In den sechziger Jahren sind die meisten Titelblätter Kupferstiche mit kleinen Bildchen aus dem Leben Davids, seit den siebziger Jahren werden allmählich dieselben Bildchen in Holz nachgeschnitten, um in den neunziger Jahren den Kupferstich fast ganz zu verdrängen.

V. Zuletzt ein Wort zur Verwendung des Kupferstiches in hebräischen Drucken überhaupt. Daß diese im allgemeinen älteren Datums als 1697 ist, bedarf keines besonderen Nachweises. In den sechziger Jahren ist, wie erwähnt, der Kupferstich fast in allen größeren hebräischen Druckereien Amsterdams vorherrschend. Außer bei Uri Feibusch finden wir bei Josef Athias in der Schulchan-Aruch-Ausg. 1663 einen Kupfertitel; von Castro Mendes ist die niedliche Pentateuchausg. aus dem Jahre 1666 mit schönem Kupfertitel bekannt, wie auch m. a. Ja, wie wir bemerkt haben, begann bereits in den neunziger Jahren eine Rückbildung zum Holzschnitt. Nicht ohne Interesse für unseren Gegenstand jedoch sind die vier Kupferstiche zu den vier Machsorteilen des span. Ritus. Diese Kupfer sind fast in allen Amsterdamer Ausg. der ersten Hälfte des 18. Jahrhunderts anzutreffen und zum Teil auch in Venedig, Florenz und Livorno nachgestochen. Ich konnte ihr Vorhandensein zuerst in der Machsorausgabe von Athias (1689) feststellen, wahrscheinlich aber dürften sie bereits in früheren Ausgaben vorkommen. Nun ist aber das dem Teil "Moadim" vorangehende Bild nichts anders als das Pessachmahl, und muß man sich wundern, daß es nicht mit demjenigen übereinstimmt, welches in der Haggadah verwendet wird. Von dem "Moadim"-Kupfer liegt mir ein losgelöstes Blatt vor, mit der Angabe des Stechers: "I. van Sasse fecit". Welcher Ausgabe es gehört, ist mir unbekannt, jedoch wahrscheinlich einer älteren als 1689, da in der letzten kein Name angegeben ist.

I. Sonne
Firenze

2B. ERWIDERUNG AN DR. SONNE

In Bezug auf die venezianischen Di Gara-Drucke von 1599 und 1603 scheint ein Mißverständnis vorzuliegen. Sie enthalten nicht den Bilderkreis der Venezianischen Haggadah, sondern den der Mantuaner, wie sich Herr Dr. Sonne selbst überzeugt hat.

Unter "Venezianische Haggadah" versteht man den Typ von Haggaden, die den Bilderkreis der venezianischen Ausgabe von 1629 enthalten, nicht aber jede in Venedig gedruckte Haggadah. Herr Dr. Sonne hat diesen Bilderkreis neuerdings in einem venezianischen Druck von 1609 festgestellt.

Für die Lokalisierung und Datierung des Bilderkreises ist mit der Kenntnis eines früheren Druckes und biographischer Daten über den Drucker einiges gewonnen, aber die Identifizierung des Urhebers der Illustration wird wohl erst durch die kunstgeschichtliche Erforschung des einschlägigen Bildmaterials gelingen. Das Bild der "Hasenjagd", das übrigens schon vor der Prager Haggadah im jüdischen Bilddruck nachweisbar ist, würde sich eben infolge seiner Verbreitung nicht als Ausgangspunkt der Untersuchung empfehlen.

Es ist möglich, daß sich in der Venezianischen Haggadah, ähnlich wie ich es in der Amsterdamer von 1712 nachweisen konnte, mehrere Bilderfolgen verschiedener Herkunft aufzeigen lassen werden. "Der Savonarola-Stuhl der Renaissance" hat als Datierungsbehelf gute Dienste getan. Das beweist nun das Vorhandensein des Bilderkreises im Druck von 1609.

Rahel Wischnitzer-Bernstein

2C. ZUR AMSTERDAMER HAGGADAH

Der Aufsatz in der Menorah enthält lediglich eine abweichende Meinung hinsichtlich der Bewertung, in diesem Sinne war dort auch die Einordnung eine andere, so daß in diesem Umfang von neuen Erfindungen die Rede sein konnte.

Erich Toeplitz

2D. ZUR AMSTERDAMER HAGGADAH

In meinem Aufsatz S. 269 ff. des vorigen Jahrgangs habe ich nachgewiesen, daß.

1. die Bilder der Amsterdamer Haggadah nach den Kupferstichen des Matth. Merian d. Ä. gestochen sind, und zwar zum Teil nach den Bibelbildern des schweizer Stechers und z. T. nach dessen Illustration zur alten römischen Geschichte, daß.

2. sich die Proopssche Ausgabe der Amsterdamer Haggadah von 1712 von der Weselschen von 1695 wesentlich unterscheidet, namentlich durch engere Anpassung der Merianschen Bilder an die neue Bestimmung und durch Ergänzung aus dem Holzschnittzyklus der Venezianischen Haggadah.

Zu meinem Feststellungen äußerten sich u. a. die Herren Dr. Grunwald und Toeplitz ebd. S. 465.

G. erklärt, daß er "bereits 1898 (vgl. Mitteilungen für Jüd. Volkskunde, 1929, S. 57) nachgewiesen habe, daß die Kupfer der Amsterdamer Haggadah aus einer ebendort erschienenen Bilderbibel stammen, die er in Hamburg im Besitz des Herrn Moses Mainz vorgefunden habe".

Auf eine persönliche Anfrage bei Herrn G. erfahre ich, daß sich seine Mitteilung auf Aufzeichnungen aus dem Jahre 1898 stützt, die er unter seinen Papieren gefunden hat, auf unveröffentlichtes Material also. Er erinnert sich jedoch, in den "Mitteilungen" die Amsterdamer Bilderbibel irgendwo erwähnt zu haben. Aus diesen Erklärungen des Herrn Dr. Grunwald geht hervor, daß er sich selbst nach dem Gedächtnis zitiert hat.

Es ist möglich, daß er an irgend einer Stelle die Merianbibel genannt hat, aber wohl kaum mit genaueren Angaben über den Druck (Name des Stechers bezw. Nachstechers für den holländischen Druck, Druckers, Erscheinungsjahr und -Ort), denn eine solche Mitteilung wäre nicht unbemerkt geblieben. In den von G. zitierten "Mitteilungen" von 1929 fehlt jede nähere Angabe über die Bibel. Es heißt da: "Der Herausgeber hatte eben aus praktischen Rücksichten die Kupfer einer bekannten christlichen Bilderbibel angekauft und unbedenklich in die Haggadah hinübergenommen."

Ich möchte berichtigend hinzufügen, daß eine "Hinübernahme" der Kupfer nicht stattgefunden hat. Sie sind meist gegenseitig. Die Stiche der Haggadah sind nicht von den Platten der Bibel gedruckt, sondern nachgestochen.

Für die vier Söhne der Haggadah nimmt G. nicht die christliche Bibel, sondern eine andere Quelle in Anspruch, und zwar das Bild der vier Menschenalter in "Der Arzney gemeiner Inhalt" von Dryander. Die Abstammung von diesem Holzschnitt muß ich entschieden bestreiten und verweise den Leser auf die von mir in meinem Artikel veröffentlichten Vorlagen des Merian zu diesen Bildern. Wer sie gesehen hat, bedarf keiner weiteren Beweisführung. Daß die Bilder des Kindes, das nicht zu fragen versteht, des einfältigen und des bösen Sohnes gegenüber den Vorlagen im Gegensinne erscheinen, ist auf die Tatsache zurückzuführen, daß die Stiche vom Plagiator eben nach dem Druck kopiert wurden.

Die Auffindung dieser Vorlagen war besonders schwierig, weil sie zum Teil im Bibelzyklus des Merian gar nicht enthalten sind, und das gesamte Kupferstichwerk des basler Künstlers

nirgends vollständig registriert ist. Glücklicherweise besitzt aber das Berliner Kupferstichkabinett Klebebände mit Stichen des Merian, in denen wir die Vorlagen feststellten.

Toeplitz teilt mit, daß er "den gleichen Gegenstand in völlig abweichender Weise behandelt habe." In seinem Aufsatz Menorah, 1924, Nr. 7, den er anführt, ist mir allerdings als völlig von mir abweichend folgende Behauptung aufgefallen: "Im übrigen sind die Bilder neue Erfindungen, die einen geübten Stecher verraten." Es bleibt unersichtlich, wieso Herr T. auf seinem irrigen Standpunkt verharrt, nachdem der Ursprung der Amsterdamer Haggadah nun als nachgewiesen gelten muß. Wie die meisten Forscher, wußte Herr T. überdies nicht, daß der Unterschied zwischen den beiden Haggadahausgaben von 1695 und 1712 nicht allein im Titelblatt und den Hintergründen der Bilder zu suchen ist.

Einige Mitteilungen, die mir persönlich zugegangen sind, behandeln die Frage, ob der Stecher Abraham bar Jacob Proselyt oder geborener Jude war, und ob Moses Wesels Verhältnis zur Amsterdamer Haggadah das eines Mäzens oder eines Druckherrn war.

Herr Professor D. Simonsen, Kopenhagen[1], bringt als Beweis für die Annahme, daß der Stecher Abraham bar Jacob Proselyt war, die Angabe von J. Chr. Wolf in Bibliotheca Hebraica, III, S. 39, Hamburg, 1727, wonach derselbe Pfarrer im Rheinland gewesen war, bevor er nach Amsterdam ging, wo er Jude wurde. Den christlichen Namen des Proselyten gibt Wolf nicht bekannt.

Herr Sigmund Seeligmann, Amsterdam, teilt mit, daß er die Erstausgabe der Amsterdamer Haggadah im Originaleinband besitze. Beide Herren bezeichnen Moses Wesel als Mäzen. Die Drucker Ascher Anschel b. Elieser und Issachar Baer b. Abraham, die die Offizin des Kosman Emmerich übernommen hatten, erscheinen demnach als die Druckherren.

Ich möchte noch meinerseits hinzufügen, daß Moses Wesel mit dem Vetter des Kosman Emmerich Moses Wesel nicht identisch ist, denn derselbe war schon 1686 tot. Der Förderer der Haggadahausgabe von 1695, "in dessen Hause" sie gedruckt wurde, ist offenbar Moses, Sohn des Josef in Wesel, der die Witwe jenes Moses Wesel heiratete. Näheres über diesen Mann geht aus der Darstellung in "Die Familie Gomperz" von Dav. Kaufmann und Max Freudenthal nicht hervor, so daß wir über sein Verhältnis zu der Druckerei des Kosman Emmerich nichts erfahren.

Rahel Wischnitzer-Bernstein

3. DIE MESSIANISCHE HÜTTE IN DER JÜDISCHEN KUNST

Das Motiv der messianischen Hütte hat seine Ausgestaltung im Machsor für Sukkot erfahren. Der Liturgiker verherrlichte das Gebot des siebentägigen Verweilens in den Laubhütten durch Herstellung einer ideellen Beziehung der Sukkot zu den Wolkensukkot des Exodus (Im Maarivgebet des 2. Festtages). Die Entsprechung war bereits in Lev 23₄₃ vorgebildet[1]. Eine besondere typologische Bedeutung gewann aber erst die Entsprechung, die für die Sukka in der Sukkat David gefunden wurde (Jozergebet des 1. Festtages), weil die Verheißung der Wiederaufrichtung der "verfallenen" Hütte, nach Amos 9₁₁, zur Anrufung des Messias aus Davids Hause hinüberleitete und weil die Hütte selbst als der von Salomo auf Davids Geheiß erbaute Tempel, nach 2. Chron. 3₁, aufgefaßt wurde.

Der typologische Kreis schließt sich mit dem Bilde der Hütte des Paradieses der Vorzeit, der Sukkat Eden (Maarivgebet des 2. Festtages). Aus der Urzeit in die Endzeit projiziert, wird die Paradieshütte in die Hütte der Frommen im messianischen Zeitalter umgewandelt. Die Verknüpfung der Laubhütte des Festes mit der messianischen Hütte vollzieht sich im Machsor in dem Sinne, daß die Beobachtung des Laubhüttenfestes den Anteil an der messianischen Hütte sichert (Maarivgebet des 2. Festtages). Der Gerechte, dem das künftige Leben verheißen ist, ist im Machsor Sukkot niemand anderes als eben der Fromme, der das Laubhüttenfest vorschriftsmäßig begeht.

So erscheint das uralte Fest, einst ein die Regenzeit einleitendes Fest, ein Fest der Weinernte, der Herbst-Tagundnachtgleiche, ein Naturfest[2], in der Liturgie, als eine Vorstufe der ewigen Seligkeit, die in der Paradieshütte der Frommen im messianischen Zeitalter genossen werden wird.

Ein Beispiel für die Durchdringung der Sukkotliturgie mit messianischen Gedankengut bietet eine bildliche Darstellung im Machsor der Universitätsbibliothek Leipzig, cod. V 1102. Die Handschrift ist in der 2. Hälfte des 14. od. Anfang des 15. Jahrhunderts in Süddeutschland entstanden und weist im Dekor manches Merkmal der Spätgotik auf. So sind die Kriechblumen und die Kreuzblumen darin bereits von ausladender, bewegter Zeichnung, das Maßwerk von feiner Gliederung, der Kielbogen und der abgeflachte Korbhenkelbogen machen sich bemerkbar. Beachtenswert ist die Behandlung der menschlichen Figur. Tierköpfige Gestalten, wie im Hammelsburger Machsor von 1348 (Darmstadt, Landesbibliothek, cod. or. 13) fehlen hier. Die Köpfe mit stark gelocktem Haar zeigen jedoch Gesichtsprofile von schematischer Zeichnung, Männer, Frauen, Kinder haben alle das gleiche Gesicht. Eine Kurve deutet Stirn und Nase an, ein einziger Querstrich bezeichnet Nasenloch und Mund. Das wenig anmutige, betont krummnasige Gesicht wird durch ein weitgeöffnetes Auge belebt, das gelegentlich durch einen Schattenstrich hervorgehoben erscheint. Die Figuren zeigen die gotische Biegung.

Im 2. Band der Handschrift, die den Machsor Sukkot und Jomkippur enthält, sehen wir auf Blatt 181 verso (Fig. 1) eine Illustration, die sich auf die Sukkotliturgie bezieht. Das Initial-

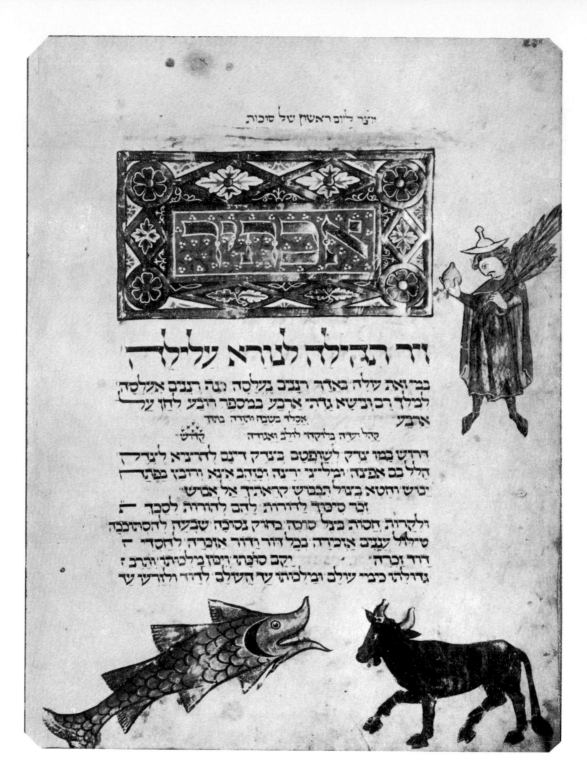

Fig. 1. Machsor Leipzig, Leipzig, Universitätsbibliothek, cod. V 1102, II, fol. 181v.

wort אכתיר (ich werde krönen), mit dem der Text auf dem Blatte beginnt, leitet das Jozergebet des ersten Tages des Sukkotfestes ein. In Goldmalerei auf Rankengrund in großer Quadrata geschrieben, steht es in einem rechteckigen mit Kreisen und Rauten gefüllten Rahmen. Am rechten Rand des Blattes ist ein Mann in Vorderansicht, stehend, den Kopf zur Linken geneigt, Etrog und Lulab in den Händen, dargestellt. Die Symbolpflanzen des Sukkotfestes sind sorgfältig gezeichnet. Der Vorschrift entsprechend (Talmud Sukka 45b), ist die Frucht und der Blätterstrauß mit der Spitze nach oben gehalten gezeigt. Auch in der Kennzeichung von Form und Zahl der einzelnen Pflanzen (ein Palmzweig, zwei Bachweidenruten, drei Myrtenzweige)

56

ist das Bestreben, der Vorschrift zu genügen, erkennbar. Wenn der Schwinger des Feststraußes den Etrog in der Rechten zu halten scheint (Suk. 37b fordert, daß man ihn in die Linke nehme), so darf hierin kein Verstoß gegen die Vorschrift erblickt werden. Vom Beschauer aus betrachtet, hält der Mann den Etrog in der Linken und den Lulab in der Rechten, und so ist die Darstellung vom Künstler auch gedacht.

Am unteren Rande des Blattes sieht man einen großen blauen Fisch und einen roten Stier mit goldenen Hörnern. Es sind das die beiden Urtiere, wie sie schon bei Hiob Kap. 40 als Meeres- und Landungeheuer auftreten. Es ist der Leviatan und der Behemot[3].

In welcher Beziehung stehen die sagenhaften Tiere der Bibel zur Gestalt des frommen Feststraußschwingers im oberen Teil des Machsorbildes? Die Antwort wird durch den Text des Machsor geliefert, der uns allerdings ohne Kenntnis der talmudischen Quellen nicht immer verständlich sein wird. Im Machsor (Kerobot für den 1. Tag Sukkot) heißt es, daß die Sukka der künftigen Welt eine "Hütte aus Haut" ist. Anschließend wird erzählt, daß der Fromme beim Beziehen der messianischen Hütte den Leviatan erblickt, wie dieser "mit Fischereisen herbeigezogen wird". Der Walfischfang mit Harpunen liegt dem Bilde zugrunde[4].

Nach Baba Batra 75a wird Gott "aus der Haut des Leviatan Hütten für die Frommen der ersten Rangordnung machen, Gürtel für die der zweiten, Ketten für die der dritten und Halsbehang für die der vierten". Weiter heißt es da, daß das Dach der Hütte der Frommen aus der Haut des Leviatan und die Speise der Frommen aus dem Fleisch des Leviatan hergestellt werden wird.

So wandelt sich der Leviatan der Bibel, ein wildes Seeungetüm, im Talmud in das dem Frommen dienstbar gemachte Tier. Auf diese Schilderung spielt der Machsor an. Jedoch tritt der Leviatan darin unter dem Namen "Bariach" auf (Jozergebet für Sabbat und die Halbfeiertage), nach Jes 27:1 לויתן נחש ברח (Leviatan, die flüchtige Schlange). Das Seitenstück zum Leviatan, der Behemot, fehlt im Machsor. Dafür erscheint der Sis (זיז), nach Baba Batra 73b, ein Riesenvogel. Ihn fand man Ps 50:11, wo unter זיז vielleicht "allerhand Getier" (Ges.-Buhl) zu verstehen ist; man bezog aber בהמות im vorhergehenden Vers (offenbar mit Unrecht) auf das märchenhafte Ungetüm und gab ihm זיז zur Gesellschaft. Nach der talmudischen Erzählung werden die Getreuen in der Sukka des künftigen Paradieses die drei Urwelttiere Leviatan, Behemot und Sis verzehren.

Der Illustrator des Leipziger Machsor interpretiert die Tiere nach der geläufigeren Auffassung als Fisch und Stier. Der Leviatan ist in den meisten Quellen ein Fisch und keine Schlange, so auch im Buche Rasiel[5]. Der Behemot ist immer ein Stier. Ein anderes, älteres Beispiel für die vom Künstler vertretene Auffassung liefert die hebräische Bibelhandschrift der Ambrosiana in Mailand, cod. 32 inf., aus dem 13. Jahrhundert, wo alle drei Urtiere auftreten und zwar als Fisch, Stier und Adlergreif[6].

Die Beziehung des Fisches und des Stieres zum Feststraußschwinger auf dem Bild des Leipziger Machsor ergibt sich nun ohne weiteres aus der eschatologischen Bedeutung der Tiergestalten. Immer wieder wird in der Liturgie des Sukkotfestes die Vorstellung heraufbeschworen von der Hütte, in der die Getreuen einmal versammelt sein werden. In primitiver, abbreviatorischer Darstellungsweise, im Stile der Wortillustration sind im Leipziger Machsor neben dem Frommen die Tiere des künftigen Festmahles gezeigt, Symbole der messianischen Seligkeit, die ihm verheißen ist. Sie ersetzen hier das Bild der messianischen Hütte.

Der Gedankenkreis des Sukkotfestes, der, wie wir aus den typologischen Entsprechungen sehen konnten, die grundlegenden religiösen Erfahrungen Israels aufgenommen hat, vermittelt uns die Erkenntnis der überragenden Bedeutung dieses Festes. Der Gestaltungsstoff des Machsor, dem biblischen Geistesgut entnommen, wurde vom Talmud, den Midraschim, den

Fig. 2. Goldglas aus der Katakombe der via Labicana, Vatikan Museum.

Pseudepigraphen entscheidend beeinflußt, dem Schrifttum einer Epoche, die die messianischen Ideenmotive mit besonderem Eifer ausgebaut hatte. Man wird daher versucht sein, in der Kunst der talmudischen Zeit selbst Ausschau zu halten nach Äußerungen der messianischen Auffassung des Laubhüttenfestes.

Auf das häufige Auftreten des Etrog und des Lulab auf den Goldgläsern der jüdischen Katakomben in Rom und anderen Gegenständen der Kleinkunst, ferner im Dekor der Katakomben selbst und der Synagogen ist verschiedentlich hingewiesen worden. Kein Festsymbol und kein Kultgerät erscheint neben dem siebenarmigen Leuchter in der Spätantike so oft dargestellt, wie die beiden Sukkotsymbole.

Ein Goldglas verdient wegen seiner noch nicht befriedigend gedeuteten Darstellungen in diesem Zusammenhang besondere Beachtung.

Es ist das das 1882 aufgefundene Goldglas aus der Katakombe ad duas lauros an der via Labicana in Rom[7], jetzt im Vatikan, das J.B. de Rossi zuerst veröffentlicht hat[8]. De Rossi faßte den auf dem Bild (Fig. 2) dargestellten Bau wegen der zwei freistehenden Säulen, die er als die Säulen Jachin und Boas deutete, als den salomonischen Tempel auf. Hugo Greßmann[9] erblickte in dem Bau den himmlischen Tempel, H. Lietzmann[10] den Idealen Tempel, der in Jerusalem wieder aufgebaut werden soll. E.L. Sukenik[11] betrachtete den Bau als eine Synagoge. Die Säulen faßte Sukenik als Stangen für die Vorhänge vor dem Schrein auf. Die Parochet fehlen auf unserem Bilde; auf Goldgläsern, die Vorhänge wohl aufzuweisen haben, fehlen jedoch wiederum die Stangen.

Die kleinen Bauten, die rechts vom Säulenumgang, teils von diesem überschnitten, im Hof sichtbar sind, wurden von De Rossi nicht beachtet, Greßmann[12] glaubte in ihnen Torbauten sehen zu müssen, ohne von dieser Deutung ganz überzeugt zu sein.

Wir fassen die kleinen Giebelbauten als Laubhütten auf. Man kann deutlich die lose gefügten Holzlatten der Dächer erkennen. Hinter den Bauten, bezw. auf den Dächern derselben ist je eine Palme sichtbar. Man weiß aus Neh 8:16, daß "jeder auf seinem Dache und in ihren Höfen und in den Höfen des Gotteshauses und auf dem Platz am Wassertor und auf dem Platz am Efraimtor" die Sukkot errichtete. Die Palme und die anderen zum Feststrauß verwendeten Pflanzen wurden, wie aus Neh 8:15 ersichtlich, vorerst für den Bau und den Schmuck der Sukkot selbst gebraucht.

In der Vorderzone des Bildes sehen wir auf dem Goldglas des Vatikans den siebenarmigen Leuchter und links vom Leuchter Lulab und Etrog. Etwas weiter links ist eine Vase mit zwei Halmen kenntlich, offenbar Pflanzen, die ebenfalls als Sukkotschmuck benutzt wurden.

Die beiden zweihenkligen Krüge rechts vom Leuchter möchte man als Weinkrug und Wasserkrug auffassen. Sie sind allgemein als Wein- und Ölkrug gedeutet worden. Jedoch ist zu beachten, daß nicht dem Öl, sondern dem Wasser beim Sukkotfest eine besondere Bedeutung zukommt. Sukkot ist die Zeit, in der der Wein gekeltert wird, und es ist der Beginn der Regenzeit, die durch den Brauch des Wassergießens feierlich eingeleitet wird. Diesem Brauch zufolge, der im zweiten Tempel geübt wurde, füllte man an jedem der sieben Tage Sukkot Wasser aus dem Siloah in einen goldenen Krug und goß daraus in eine eigens am Altar vorgesehene Öffnung, neben der Öffnung für die Weinlibation (Suk. IV, 1; 9-10). Diesen goldenen Krug sehen wir auf dem Goldglasbild neben dem Weinkrug.

In welcher Beziehung stehen nun die Laubhütten, die Sukkotpflanzen und das Sukkotgerät zum Heiligtum, das die Mitte des Bildes besetzt, was ist das eigentlich für ein Heiligtum? Laubhütten sind auf dem Synagogenhof ebenso denkbar, wie im Bereich des Tempels. Die in der griechischen Inschrift unseres Goldglases vorkommende Bezeichnung "Haus des Friedens"[13] findet eine Entsprechung im "bet menucha", Haus der Ruhe, das David für die Bundeslade des Ewigen zu bauen im Sinne hat (1. Chron 28:2), dem Tempel, den Salomo erbaute. Bei Haggai 2:9 heißt es jedoch auch in bezug auf den zweiten Tempel: "An diesem Ort werde ich Frieden geben." Wie Sukenik wiederum geltend machte, finden wir in einer Synagogeninschrift, in Kefr Birim, eine ähnliche Wendung: "Es sei Frieden über diesem Ort." Im Machsor für Schemini Azeret, das Schlußfest der Laubhütten (im Maarivgebet) wird die Bitte um Gottes Schutz an die Vorstellung von der Wolkenhütte, der Friedenshütte, sowie den "Schelom Jeruschalajim" geknüpft. Das Zukunftsbild der über das Volk Israel und über Jerusalem gebreiteten Friedenshütte findet sich im Abendgebet für Sabbat und Feiertage wieder.

Auch der Wein kann eine messianische Bedeutung gewinnen. "Wein wird gekeltert bei Weltbeginn", b. Ber. 34b. Der Weinsegenspruch sichert den Anteil am jenseitigen Leben, Berakot 51a. Der Wein des Festes, als Wein der Seligen umgedeutet, tritt uns auf dem Sarkophag des Nationalmuseums der Thermen des Diokletian in Rom[14] entgegen. Hier sieht man unter dem siebenarmigen Leuchter, der in einem Rundmedaillon steht, das Weinpressen, dargestellt durch drei junge Winzer, die die Trauben treten, — eine von nichtjüdischen Sarkophagen her bekannte bacchische Szene: der Thermensarkophag Nr. 971 weist sie auf. Franz Cumont[15] deutete sie dort als Anspielung auf den Wein der Seligen im Jenseits.

Der Weinkrug auf dem Goldglas des Vatikans kann auf den Wein der Seligen bezogen werden, der Wasserkrug, der auf das Wasseropfer hinweist, würde wiederum besser zum zweiten Tempel passen.

Wenn wir unsere Beobachtungen zusammenfassen, so erscheint das Bild auf dem Goldglas des Vatikans als Darstellung des wiederaufgebauten Salomonischen Tempels in den Tagen eines zeitlosen Laubhüttenfestes gut denkbar. Die Vorstellungen vom ersten und vom zweiten Tempel waren verschmolzen. Das mit dem Tempel verbundene Sukkotfest ist in die Zukunft projiziert worden, es versinnbildlicht die verheißene messianische Glückseligkeit.

Von dieser Deutung ausgehend, wird die bisher ungelöste Frage des häufigen Vorkommens der Sukkotsymbole in Verbindung mit dem Tempelleuchter auf den Goldgläsern der Spätantike und auf anderen jüdischen Kunstdenkmälern der Zeit zu behandeln sein; Sukkot deutet auf die Auferstehung hin. Die Sukkotsymbole sind die Symbole des Auferstehungsgedankens[16]. Die Auferstehung ist nicht immer im religiösen Sinne verstanden, denn die

Zukunftshoffnung, so religiös sublimiert sie auch auftreten mag, wird in jüdischer Auffassung stets gebunden sein an die Hoffnung auf die Wiederherstellung von Tempel, Tempelstadt, Land und Volk.

Auch in den Malereien der jüdischen Katakombe Torlonia in Rom treten uns Symbole der messianischen Hoffnung entgegen. Auf dem Kreuzgewölbe einer Grabkammer[17] sieht man im Mittelkreis den siebenarmigen Leuchter und um ihn herum, oben, unten, rechts und links in Halbkreisen je einen Delphin. In den Feldern zwischen den Delphinen bemerkt man dreimal den Etrog und einmal ein Horn (Fig. 3).

Lietzmann[18] betrachtete die Delphine dieses Katakombenbildes, die sich über den Dreizack schwingen, als beziehungslosen Dekor, Greßmann[19] deutete sie als Fische der Freitagabendmahlzeit. Jedoch dürften in dieser Nachbarschaft die Etrogim und das Horn Schwierigkeiten bereiten. Das Bild erhält einen tiefen und einheitlichen Sinn, sobald wir an das Horn der Auferstehung denken. Der Posaunenschall sammelt bei Jesaia 27$_{13}$ die Deportierten und die Ausgewanderten. Die Posaune wurde, dem Traktat Sukka V, 1-4 zufolge, beim Wasserschöpfen am Sukkotfest geblasen. Sie gehörte mit dem Etrog, dem Lulab, dem Leuchter zur Symbolik des im Tempel zu begehenden Sukkotfestes, und, in der uns vertrauten Entsprechung, gehört sie zum Symbolkreis der jüdischen Eschatologie.

Nicht umsonst tritt das Horn in Begleitung des Leuchters auf Epitaphien der jüdischen Katakombe am Monteverde in Rom fünfmal auf, eine Tatsache, die von Nik. Müller[20] mit dem Hinweis gestreift wurde, daß der Schofar "wie noch heutzutage, auch in alter Zeit vornehmlich am jüdischen Neujahr geblasen wurde". Auch er besitzt messianische Bedeutung, nach Jes 27:13, und so fassen wir als Posaune der Auferstehung auch das Horn neben dem Etrog auf dem Goldglas der Borgiana im Vatikan auf, das Garrucci[21] 1880 veröffentlicht hat. Wir sehen hier in der oberen Bildhälfte des Goldglases (Fig. 4) den von Löwen flankierten Schrein und in der unteren Bildhälfte zwei siebenarmige Leuchter. Den linksstehenden Leuchter umgeben zwei gewundene Hörner, die Mitte besetzt ein großer Lulab, dem links der Etrog beigegeben ist. Der rechts stehende Leuchter ist von einem zweihenkligen Krug und einem unkenntlichen Gegenstand flankiert, ob dem Wasserkrug oder einer Pflanze kann ich nicht entscheiden.

Die beiden Hörner lassen sich in den literarischen Quellen identifizieren. Der Überlieferung nach werden zwei Widderhörner aufbewahrt: das kleinere ist das Horn, das bei der Offenbarung am Sinai geblasen wurde, das größere Horn wird bei der Auferstehung geblasen werden[22].

Was hat nun aber der Delphin neben den Symbolen der Auferstehung auf dem Katakombenbild zu bedeuten?

In der heidnischen Sage ist der Delphin der Retter des Dichters Arion aus Seenot (600 v. Ch.). Auf dem christlichen Jonassarkophag des 2.-3. Jahrhunderts im Lateranmuseum in Rom[23] hat der Fisch, der Jona verschlingt, bzw. ausspeit, einen delphinförmigen Kopf und einen geringelten Leib. Im Jonasbild der Priscillakatakombe in Rom[24] hat der Fisch den gleichen geringelten Hinterteil und den Oberkörper eines Seepferdchens. Die Auffassungen schwanken. Jedoch setzt sich der Delphin mit dem Dreizack, dem Attribut des Neptun, und dem Anker in der christlichen Kunst durch, als Symbol der Errettung aus Seelennot. Der Delphin gehört zum Darstellungskreis der Erlösungssymbolik[25]. Es darf angenommen werden, daß er in der gleichen Bedeutung in die jüdische Katakombenmalerei übernommen wurde. Neben dem Horn, dem Etrog und dem Leuchter des wiederaufgebauten Tempels weist auch er auf die Auferstehung hin.

Wir wollen noch einen Schritt weitergehen und die Vermutung aussprechen, daß der Delphin am Dreizack mit dem Leviatan verwechselt wurde, den man sich, von einem Fischerhaken (nach Hiob 40:26) durchlöchert, in ähnlicher Weise vorstellen mochte. Der Delphin

Fig. 3. Malereien der jüdische Katakombe der via Torlonia, Rom.

Fig. 4. Goldglas aus der Katakombe am Monteverde, Vatikan Museum.

vertritt den Leviatan[26]. Er dient zur Ergänzung der messianisch verklärten Sukkotsymbolik.

Die Verspeisung der Urwelttiere durch die Frommen bot ein schwieriges Darstellungsproblem, das der Illuminierer der Bibel der Ambrosiana dadurch zu lösen suchte, daß er das Bild in zwei Felder aufteilte: im oberen führte er die Tiere vor, im unteren die Frommen beim Mahle. Der Illustrator des Leipziger Machsor löste das Bild in zusammenhanglose Randfiguren auf.

Die neuere Zeit suchte ein Ausdrucksmittel für die Darstellung der Leviatanmahlzeit in der Allegorie.

Auf dem Deckengemälde der Holzsynagoge in Mohilew am Dniepr aus dem 18. Jahrhundert sehen wir die Frommen, durch eine Storchfamilie versinnbildlicht (Storch hebr. חסידה = die Fromme), die Schlangen verzehrt[27]. Den Leviatan als Schlange haben wir im Machsor für Sukkot bereits kennengelernt. In einer Wasserlandschaft, die durch schwimmende Enten gekennzeichnet ist, steht rechts am Ufer neben einem Baum ein Haus auf Rädern (Fig. 5). Ein riesengroßer Storch fliegt über dem Haus mit einer Schlange im Schnabel, die sich um sienen Hals windet, zum Nest auf dem Baum. Dort sehen wir die Storchmutter und die Storchjungen sich ebenfalls an Schlangen gütlich tun. Tauben, Symbole des Friedens, fliegen am Himmel. Es ist das Paradies, denn der Baum, auf dem die Störche nisten, ist inschriftlich als Ez Hadat, als Baum der Erkenntnis bezeugt[28].

Der Bau mit seiner hohen, von Voluten gestützten, Attika, mit dem geschweiften Dach und dem Turm mit Zwiebelkuppel ist für die russische Prunkarchitektur der Barockzeit charakteristisch, es ist die Paradieshütte der Endzeit.

Neben dem Paradiesbild auf der Nordwestseite des Zeltdaches, rechts, befindet sich das Bild der Stadt Worms[29], das wir hier nicht näher behandeln können. Es sei nur bemerkt, daß der, ebenfalls inschriftlich bezeugte, Lebensbaum, der als der zweite Paradiesbaum, dieses Stadtbild schmückt, gelbe Etrogim trägt. Die Zytrusfrucht wird bekanntlich auch Paradiesapfel genannt.

In den horizontalen Zwickeln, die den Übergang des Vierecks zum Achteck des Zeltdaches vermitteln, sind außer dem Elefanten und einer nicht sicher identifizierten Ziege Behemot und Leviatan gemalt. Auf den Wänden sind die Geräte des Salomonischen Tempels dargestellt[30].

61

So kreist die Symbolik der Mohilewer Synagoge um die uns vertrauten Vorstellungen vom messianischen Tempel, der messianischen Hütte und der messianischen Speise der Gerechten.

Als neues Moment kommt hier noch das Bild des Bären hinzu, der einen Baum erklettert[31]. Das Motiv des Bären, der einen Baum erklettert, um das Bienenhaus auszuplündern, ist aus den russischen Volksmärchen gut bekannt, wo der Dummheit des Bären die Schlauheit des Bauern gegenübergestellt wird, der den Honig vor dem Zugriff des Bären zu schützen weiß. Hier ist es jüdisch umgedichtet. Der kostbare Honig deutet auf das von Milch und Honig fließende Land, um dessen Wiederaufbau im Maarivgebet des 2. Festtages der Laubhütten gebetet wird. Er kann aber in der typisch-jüdischen Umbiegung der Symbolik auf die Lehre angewandt verstanden werden. "Süßer Honigseim" ist die Lehre Gottes im Machsor Schabuot.

Der honigsuchende Bär und der schlangenverzehrende Storch sind uns vertraute, bis jetzt aber in ihr jüdischen symbolischen Bedeutung nicht erfaßte Bildmotive der osteuropäischen Synagogenmalerei, wie wir sie z. B. schon in der älteren Synagoge von Jablonow finden[32].

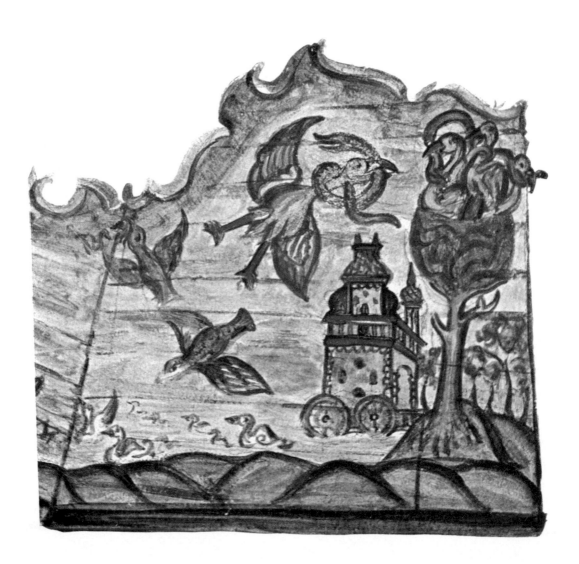

Fig. 5. Deckengemälde der Holzsynagoge in Mohilew am Dnieper, aus dem 18. Jahrhundert.

Die messianische Hütte der Frommen, die wir auf dem Deckengemälde der Synagoge in Mohilew nachweisen konnten, ist ein Seitenstück zu den Darstellungen der Stadt Jerusalem, das ebenfalls zum Stofkreis der Synagogenmalerei des 17. und 18. Jahrhunderts gehört. Die messianische Hütte und die Stadt Jerusalem sind typologisch identisch.

Um auch ein Beispiel aus Deutschland zu nennen, soll auf die Holzsynagoge aus Horb hingewiesen werden[33], wo auf der Schildwand der Tonne, links die Stadt Jerusalem gemalt ist.

Auch hier ist die Tempelstadt als die Hütte der Endzeit aufgefaßt. Rechts sehen wir neben Symbolen der Fruchtbarkeit der künftigen Zeit, den üppigen Weintrauben und Äpfeln, in Körben und Vasen, den in Rot und Gelb prangenden Etrog und den grünen Feststrauß des Lulab. Die Fredenstaube sitzt hoch oben auf dem Ölberg, auf einem Ölbaum. Löwen trompeten. An goldenen Ketten hängen zwei Hörner. Es ist das messianische Jerusalem. Die Beischriften bestätigen unsere Deutung. Rechts ist über denn Fruchtkorb und den Vasen der Anfang von Lev 23$_{40}$ zu lesen: "Und nehmt Euch die Frucht des Baumes Hadar, einen Palmzweig..." Die Frucht des Baumes Hadar ist der Etrog und der Palmzweig ist der Lulab. Oben im Scheitel des Rundbogens, neben den Schofarhörnern stehen die Worte: Mit Trompeten und Schofar haben sie posaunt vor dem Herrn und König. Offenbar ist hier an das Schofarblasen und Trompeten der Leviten beim Wasserschöpfen aus dem Siloa für das Wasseropfer am Laubhüttenfest gedacht. Es ist eigentlich ein Erinnerungsbild, dem die Laubhüttenbräuche aus der Zeit des zweiten Tempels zugrunde liegen. Aber der Tempel besteht nicht mehr, die Vorstellungen vom zweiten und vom ersten Tempel sind ineinandergeschmolzen, das Bild ist ein Wunschbild, eine Vision des messianischen Tempels im messianischen Jerusalem.

4. THE CONCEPTION OF THE RESURRECTION IN THE EZEKIEL PANEL OF THE DURA SYNAGOGUE

The Ezekiel Panel is among the most ambiguous of the wall decorations of the Synagogue of Dura-Europos. It has been discussed frequently.[1] Hitherto, however, the discussion has concerned itself not so much with the interpretation of the subject matter of the scene, which, as all agree, illustrates the "Vision of the Dry Bones," Ezek 37, but rather with the identification of the numerous figures portrayed and with the problem of direction in which the action is to be read. Following M. du Mesnil du Buisson and Clark Hopkins[2] the Ezekiel panel is generally read from left to right, a sequence indicated by the development of the action of the resurrection of the dead displayed in the panel. Let us examine the elements of this action.

Near the center of the panel (Figs. 1-2) there are to be seen two identical groups of dead, ranged on either side of a standing man. The bodies at the left are lifeless, while those at the right are being awakened to life by one of four Psyche-like winged genii descending from the sky. The dead are lying on the ground close to the foot of a mountain in parallel rows with their heads toward the right. It is apparent from this posture and from the fact that the revivification appears at the right that the action of the scene moves from left to right. It pictures the "coming together" of the bones (Ezek 37:7) and the breathing of the breath of life into the dead (Ezek 37:9), the Psyches being personifications of the four winds (Ezek 37:9). It is noteworthy, however, that the "dry bones" emphasizing the preliminary state of the dead are scattered over the whole area, so that the rightward motion is not sustained throughout. There are in addition other elements opposed to a clear rightward direction in the area of the central motif. The figure standing amid the dead bodies arrests attention and has a static, focalizing effect, while the Psyche reaching the ground turns in a pivoting movement toward the prostrate dead on whom she lays her revivifying hands and thus also checks the motion toward the right.

Let us now examine the right part of the panel (Fig. 2). Flanked by two almost identical figures of heroic proportions in frontal pose, a group of smaller figures ranged in three files is marching from the rear to the foreground. The men gesture toward the larger figure at the right which extends a protective hand toward them. The rightward movement, only slightly indicated by the gestures of the frontal figures, is arrested by the leftward gesture of the larger person. The dominant tendency of this group is toward frontality.

Most interpreters of the Ezekiel Panel agree in their identification of the two large figures flanking the crowd. Clad in the long hellenistic garments reserved in the wall decoration of the Dura synagogue for patriarchs and prophets, they both represent the prophet Ezekiel in two appearances.[3] As convincing as the identification is, it has usually been felt that the repetition

of the figure of the prophet at such short intervals requires motivation; yet none has hitherto been suggested. Before we attempt to offer an explanation let us point to an affinity between the Ezekiel and the Exodus Panel on the west wall, which latter also exhibits a marching crowd. There also four columns of men are to be seen, one of which represents the elders of the twelve tribes of Israel. The men are clad in long gray garments. Arguing from this analogy, nothing would appear more plausible than the conjecture that the ten marching men in the Ezekiel Panel, also clad in long gray garments, portray the same elders of the ten tribes, the ten lost tribes of which this would be the first representation hitherto known.

It has been emphasized by early Christian theologians, particularly of the Antiochian school,[4] that, while the resurrection anticipated by the Christian believers is concerned with individual salvation, the "Vision of the Dry Bones" of the prophet Ezekiel offers first a promise of the restoration of Israel and in the second place only the message of general resurrection. The book of Ezekiel is explicit on this point. Ezek 37:22 says: I will make them one nation in the land upon the mountain of Israel, and Ezek 37:17 forecasts, in the allegory of the two sticks representing the Kingdoms of Israel and Judah and joined together into one stick, the ultimate reunion of the northern and southern kingdom. Resurrection in terms of the visions of the prophet Ezekiel means rebirth of the nation of Israel.[5] The northern Kingdom having perished at a remote date (722 B.C.), the destinies of the deported population became legendary. Numerous stories dealt with the Ten Lost Tribes, some of them depreciative, others, like the one recorded in IV Ezra 13:41-50, emphasizing their allegiance to Judaism and their piety. The ten tribes were believed in some quarters to live beyond a river which, according to Midrash *Bereshith Rabba* (73:6), was the wondrous Sambation, that ceases to flow on Sabbath.

In our panel we see the elders of the ten tribes marching in files, an arrangement which seems to suggest that the men are coming from a distant place. They are being brought by the prophet Ezekiel to their native land, Israel. Although the ten tribes cannot be supposed to have preserved their identity in point of fact, they are, according to tradition, Reuben, Simon, Dan, Naphtali, Gad, Asher, Issachar, Zebulon, and two half-tribes derived from Joseph: Ephraim and Manasseh.

Let us turn now to the left part of the panel (Fig. 1). Here we see, beyond the mountain at the foot of which the resurrection of the dead is displayed, three men in nearly frontal posture, each one raising one of his hands towards the sky, where a hand of God appears to each of them separately. M. du Mesnil du Buisson assumes that all three men represent the prophet Ezekiel. He believes that the action of the panel begins at the left and that the figure of the prophet is repeated to bring out the three consecutive stages of the resurrection procedure. The first figure at the extreme left, grasped by the hair by the hand of God, would accordingly allude to Ezek 37: "The hand of the Lord was upon me... and set me down." The two other appearances of Ezekiel, however, can scarcely be motivated. If the three figures standing close together were meant to represent the same person, they would exhibit some functional elements characteristic of the successive stages of the action, but this is not the case. There is another troublesome point. As soon as we assume that the three men on the left side of the panel as well as the two others on the right side are representations of the prophet, we are bound to admit that Ezekiel appears three times in Parthian dress and twice in the long hellenistic garment, all in one and the same panel. Yet we know of no representation of a prophet in the synagogue in short Parthian tunic and trousers.

In our estimation, the three men are the elders of the tribes of Judah, Benjamin and Levi, the Benjaminite being the smaller person in the middle. The three tribes represent the southern Kingdom. The men wear the usual Parthian dress similar to that of the sons of Jacob in the

Fig. 1. Ezekiel Panel, left part. Resurrection of Judah with the Davidic Messiah on the right. From Du Mesnil, *Peintures*, Pl. XLII.

scene of the Blessing of Jacob on the west wall, in contradistinction to the representatives of the pious ten tribes who are characterized as saintly men and therefore clad in long garments of the prophets. The Vision of the Dry Bones is thus conceived in perfect keeping with the data of the Old Testament record, as an apotheosis of the restored tribes of Israel and Judah.

We have pointed out that the direction of the action from left to right was not sustained throughout the scene, being countered by diametrically opposed movements and above all by the dominating tendency toward frontality apparent in the figures of the tribal elders restored to life. We may say that the frontal and centered grouping of the revivified is inherent even in the Biblical narrative. What the pictorial representation offers is a literal rendering of the passage in Ezek 37:22, "I will gather them on every side." The men are actually seen stationed on either side of the "mountain of Israel." In early Christian monuments the theme of resurrection appears in abbreviated form. The flanking parts of the scene displaying the pageant of the tribes are dropped, and what is kept is just the middle section of the scene, the representation of the resurrection proper. This change is due to the christological interpretation of the prophecy of Ezekiel, Jesus being freely substituted for the prophet, who becomes an attendant if represented at all. In contrast, the group of the risen dead is gradually enlarged. But the dead continue to be at or come from the left, while the company of the Savior approaches from the right.

We return now to the image of the mountain which appears to be divided into two parts by a deep cleft (Fig. 1). The right part shows a house tumbling down, emphasizing, as it seems, the prophecy that the mountain will disappear in messianic times.[6] The significance of the mountain as an axis of the scene is stressed by the change in direction of the hands of God beyond this boundary. What lies to the right of the mountain, in Fig. 2, represents the resurrection of Israel; what lies to the left, in Fig. 1, the raising of Judah. In Fig. 2 Ezekiel is depicted twice. He appears at the right in his capacity as the leader of the ten tribes, whom he

66

brings back to the land of Israel, and again at the left of the group as the savior, the bringer of life. In his second role we see him pointing toward the Psyches, the vehicles of the heavenly spirit.

One other figure of the panel awaits explanation. It is the mysterious man standing among the dead bodies (Fig. 1, extreme right). Is he the Messiah himself? We note his elaborate pink tunic, and the singular place assigned to him. The "Vision of the Dry Bones," includes the figure of king David and we shall therefore have to assume that the man in the pink tunic is the Messiah, the eschatological David to whom Ezek 37:24 alludes as "the king" and "one shepherd." David, the shepherd, is represented again in the central panel of the west wall above the niche, in tunic, mantle and Phrygian hat. In the scene showing Saul surprised by David in the wilderness of Ziph David also wears a tunic, one of a shape similar to that in the Ezekiel Panel. The pink color may refer to the prophecy according to which the "garments of Messiah will be like the garments of him that presseth wine".[7] The number of the dead on the Ezekiel Panel lends support to the national and tribal interpretation of the vision of Ezekiel by the artist. There are, as we have mentioned, the two triads of male bodies (no women occur among the dead who are the leaders of the people and not just dead), and besides that eight scattered human skulls, i.e., fourteen dead in all, corresponding to the number of the raised, David included.[8] Prof. Emil G. Kraeling is inclined to interpret as the Messiah the figure in long garments usually believed to be Ezekiel in his second appearance. This interpretation would leave open the question of the indentification of the man in the pink tunic.

The transition from the Ezekiel scenes to those farther to the right is marked by a mountain (Fig 2. extreme right); however, both parts are included inside of one frame. E. L. Sukenik felt that for this reason there must be a connection between them, yet he failed to establish the nature of this relationship.[9] According to Professor Clark Hopkins the scene (Fig. 3) exhibits the seizure of Joab (left part) and the execution of Joab (right part).[10] We may add that the Joab

Fig. 2. Ezekiel Panel, right part. Resurrection of the ten lost tribes. From Du Mesnil, *Peintures*, Pl. XLIII.

67

Fig. 3. Ezekiel Panel, right end. At left, the seizure of Joab; at right, Joab slaying Amasa.

motif is not unrelated to the theme of the resurrection. On the contrary, there exists in talmudic tradition a controversy on whether Joab is to be denied resurrection on account of his guilt or not. The crimes of Joab, his murder of Absalom, the king's son, and of Amasa and Abner, captains of the Judaic and Israelitic soldiery and rivals of Joab, stirred the imagination of the pious. Numerous legends dealt with the misdeeds of Joab, some attempting to justify his conduct by personal entanglements. It was conjectured that Joab, having made expiation for his sins in this world, might be exempted from punishment in afterlife.[11] The Biblical narrative condemns Joab. He is denied the right of sanctuary, is dragged away from the altar and slain by order of King Solomon. It is significant that in the records of the crimes and the punishment of Joab, champion of King David, the moral implications for the house of David are particularly stressed. "Their (the victims') blood shall return upon the head of Joab... but upon David, and upon his seed, and upon his house, and upon his throne, shall there be peace for ever from the Lord." (I Kgs 2:33). Joab is thus portrayed as a counterpart of David.

Let us describe the scene proceeding from left to right (Fig. 3). As mentioned above, it includes two separate episodes. The first one shows a man in Parthian clothes with a scabbard at his belt, kneeling and clinging to an altar. A warrior seizes him by his shoulders. It is Benaiah seizing Joab (I Kgs 2:28). The second shows a man in Parthian clothes with a scabbard at his belt raising a sword and grasping by the hair a kneeling man. At the left above, a group of soldiers is viewing the execution. Everyone who with Professor Hopkins assumes that both parts of the scene deal with the punishment of Joab will have to explain why Benaiah is once represented as a warrior and another time in Parthian dress. M. du Mesnil attempts to avoid this difficulty by suggesting that Joab was seized by a soldier and slain by Benaiah.[12] But the Biblical text gives no support to this interpretation. We would suggest that the episode at the right represents Joab slaying Amasa, while the episode to the left portrays the punishment of Joab. The sequence of the scenes should accordingly be inverted. In support of this conjecture

68

we may point to the men looking at the execution. They are mentioned in II Sam 20:12 in connection with the murder of Amasa, but do not occur in I Kgs 2:34 where Joab's death is related. Moreover, the sword is a marked attribute of Joab (II Sam 20:8-20 and I Kgs 2:32). It plays a part in the legends about him.[13]

If our suggestion is correct Joab, characterized in both scenes by his sword and his scabbard, is the assailant in the episode at the right, and the one assailed in the episode at the left. It is true that the victims in both episodes wear clothes of a similar color scheme; red tunic and green trousers, but the shape of the tunics is not identical, nor are the faces of the kneeling men.[14] In conclusion, we may say that no matter which of the interpretations is correct, and whether the two Joab scenes portray two stages of his punishment, or, as we assume, his crime and retribution, the Joab-motif introduces into the discussion a significant problem, the problem of sin and redemption, and thus contributes a new element to the conception of salvation as illustrated in the Ezekiel Panel.

The Joab-Abner motif, parallel and almost identical with the Joab-Amasa motif, occurs as early as in the fourth century in the Quedlinburg Itala.[15] Both motifs are sometimes fused together in keeping with I Kgs 2:32, where both episodes are referred to. It is not impossible that there were originally two kneeling men to be seen in the Amasa scene of the synagogue at Dura, but this is difficult to ascertain now, as the panel is damaged at this point. In the English Tickhill Psalter, a Manuscript of the fourteenth century, the tombs of Amasa and Abner are represented on one and the same miniature as if to suggest their close relationship.[16] Another interesting feature of the illustration of the Psalter is that it includes the men looking at Amasa as he lies dead. It may be inferred from these instances that there once existed a certain iconographic convention for the representation of the Joab motif, going back, perhaps, to the Dura version.

Next to the Joab scene, on the adjacent east wall, the Dura synagogue decorations show David surprising Saul in the Wilderness of Ziph (I Sam 26).[17] It has been pointed out above that David appears in the Bible as a counterpart of Joab. The scene laid in the Wilderness of Ziph seems to convey an ideal image of David who spares his rival in antithesis to Joab who destroys his foes. If our suggestion is correct, the scenes in the lower register of the east and north walls ought to be read from right to left, beginning with David, the righteous man who is promised resurrection, proceeding to Joab, the type of the wicked whose salvation is questioned, and ending with the vision of the resurrection of the tribes of Israel and Judah. The action would thus move in the direction of the niche of the Torah in the west wall.[18]

It is instructive with regard to later developments in iconography to establish that vengeance is considered in the synagogue of Dura as the cardinal sin. The list of vices stressed is constantly undergoing changes in ancient and medieval art.[19] At Dura the emphasis is laid on the prophetic (and evangelic) ideal of human conduct as formulated by Jeremiah in Lam 3:30. The conception of the resurrection in the synagogue at Dura reveals several layers of thought. There is the basic vision of the restored tribes which is being considered in the light of the problem of merit, sin and retribution. The hopes for the restoration of Israel become vague as time goes on, and eschatolgial expectations soon triumph over the political aspirations of the exiles. The former culminate in the image of the Davidic Messiah, who appears here as the type of the righteous man, worthy of salvation, and as the ideal ruler.

5. THE MESSIANIC FOX

Faith in the impending resurrection, belief in the coming of the Messiah, and the salvation of the righteous, as proclaimed by Jewish religious doctrine, has found expression in Jewish art. As early as the middle of the third century we find the "Vision of the Resurrection of the Dry Bones," the figure of the ideal Ruler, as well as his Forerunner, and many other constituents of the eschatological symbolism, on the walls of a synagogue in Syria.[1] But the growth of this visionary, mystical art, vestiges of which are preserved also in Palestine, Greece, North Africa, and Rome, ends with the Islamic era. Already in the fifth and sixth centuries the cycle of eschatological images becomes schematised and conventional; it confines itself more and more to the vision of the restored Temple and the cultic objects of a transfigured celestial Feast of Tabernacles in which the pious is to participate in a world to come. We are familiar with this image from synagogue and catacomb paintings, synagogue mosaics, gilt glasses, lamps, etc.[2] Then, all of a sudden, we witness in the medieval Diaspora a revival of the most vehement messianic anticipations, accompanied by a renewed attempt toward pictorial representation, this time through the vehicle of manuscript illustration.

The liturgy of the synagogue, pervaded as it is with mystical rites invoking the glorious past of the Jewish nation, crystallizes in this period in the Prayer Book, the Mahzor for the religious year. And it is significant, in view of the prevailing reluctance to figurative representation, that the illustrator is allowed and, perhaps, even in a way encouraged in some quarters to amplify the implications of the text of the prayers. What he offers in terms of art to the imagination of the believer is often a most elaborate interpretation of the messianic allusions supplied by the rich inheritance of rabbinic literature and folklore, as well as by the Mahzor.

An image which we are able to identify in two different manuscripts is the *Fox*, whose symbolical significance has so far escaped attention. The fox, as such, is not unfamiliar to Hebrew manuscript illumination. We refer to the fox "who has stolen the goose" with the woman who is about to throw her spindle at him, a borderpiece in the Mishneh Torah of Maimonides, the famous manuscript of the Academy of Sciences in Budapest of 1296, signed and dated by the scribe and illuminator, Nathan ben Simon ha-Levi, of Cologne.[3]

The fox we are dealing with in this study is associated with the text of the Prayer Book and is meant to convey an image belonging to the symbolism of the Day of Atonement.

The earlier of the two manuscripts is the Mahzor of the Breslau State and University library, MS. Or. I. 1 (Former Cod. IV, f. 89), namely the second volume of the Mahzor, a huge and heavy codex which cannot be carried by one man alone. The first volume of the Prayer Book is missing. The prayers are compiled for the Ashkenasic ritual according to the usage of the German Jewish communities, with additions for various local rituals, such as that for Worms, and marginal versions for the Polish ritual. The codex numbers 300 leaves and measures 55,5 over 38 cm. The liturgy includes New Year, Day of Atonement, Tabernacles, Feast of Rejoicing in the Law, and divers Sabbaths.[4]

70

The colophon of the scribe on fol. 130 verso helps to place the manuscript. Without mentioning his name, the copyist calls himself a disciple of the poet, Meir ben Baruch, of Rothenburg, who is known to have died in 1293. Taking into consideration the bold treatment of the human body and, on the other hand, the somewhat less advanced architecture, we would assign the manuscript to the first half of the fourteenth century. The white parchment binding blindtooled throughout is a remarkable piece of work of the Renaissance. The codex is lavishly ornamented and shows an extraordinary variety in the treatment of the lettering. There are only a few illustrations. Fol. 46 verso exhibits the "Sacrifice of Abraham," accompanying the concluding prayer for the Second Day of the New Year service. On fol. 89 verso, there is a portal enclosing a portion of the Morning Prayer for the service of the Day of Atonement; another portal, on fol. 221 verso, encloses the Concluding Prayer for the Day of Atonement. On fol. 264 recto, commence the signs of the Zodiac which usually accompany the poem introducing the Prayer for Rain. We pass on now to the portal on fol. 89 verso (Fig. 1). The text reads: "Blessed be the Lord our God, King of the Universe, who opens the gates of mercy and brightens the eyes of the devout waiting for his pardon."

What the text means to convey is the vision of an "Open Gate." It is to be noticed that the portal is not an ordinary framing, but a real gateway with open flung wings. It is apparently the "Gate of Mercy" referred to in the prayer and already envisioned in the Talmud in the saying, "The Gates of Repentance are always open" (Pesikta XXV 157 b). The vision of the worshipper imploring God to open the gate is to be traced to Psalm 118, verse 19: "Open to me the gates of righteousness: I will go into them, and I will praise the Lord." This invocation occurs also in the Christian liturgy of Palm Sunday. In the Old Syrian service there is the similar prayer: "O Lord, I pray thee to open unto me." Whereupon the curtain is drawn aside to reveal the altar according to Bridgeman,[5] a symbol of the Heavenly Banquet.

In our miniature, the text is skillfully arranged within the area of the portal. The word "Baruch" (Blessed), in black ink, is set against a background of red scrolls with blue dots, in the tympan of the arch, while the word "Sha'arei" (Gate), in burnished gold, is painted lower down on a blue ground brightened with red dotted rosettes. Three fabulous animals are arranged in the space between the gold letters: on the right, a tall, green dragon with pink wings, on the left, a pink lion, his tail and feet ending in flourishes. Both look jubilant. In the middle of the ornamental piece is to be seen a yellow animal, his head uplifted toward the sky. Martin Plessner[6] believed it to be a squirrel or a fox.

Passing on to the round medallions which are substituted for keystone, capitals, and bases of the archway, they exhibit the following figures: an empty golden chair beneath a starred blue sky, an angel in pink and blue with a red halo, a pink eagle, a pink lion, and a pink ox. The angel and the animals all have yellow wings. The four figures known in Christian art as symbols of the four Evangelists retain in Jewish art their primary meaning. They are the four "living creatures" of the Temple Vision of the prophet Ezekiel, or the four Cherubim.

Similar figures enclosed in medallions (suggesting apparently the wheels of the Ezekiel vision) occur in a miniature of the Mahzor in the Leipzig University Library (Cod. V 1102, vol. I, fol. 31V). These four figures are associated in this picture with the image of a pair of scales. There is no portal.[7] The symbolical image alludes to the temple tax weighed on the scales. The Cherubim point to the religious significance of the tax which, in the Middle Ages, was still being collected and used for the maintenance of the poor in Palestine. The Cherubim are to be considered here as a *pars pro toto* for the Temple. In the Breslau Mahzor they hint at the mystical significance of the "Open Gate" conceived as a gate of the heavenly abode of God, and, in typological correspondence, as the entrance to the Restored Temple of Jerusalem.

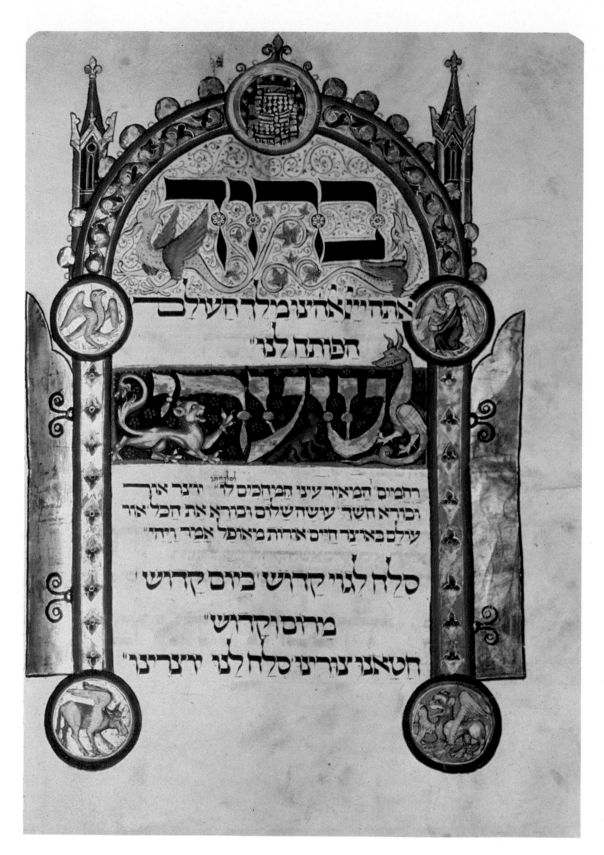

Fig. 1. The Messianic
Fox and the Gate of
Mercy
Double Mahzor (*Breslau,
State and University
Library Cod.* Or. I. 1, f.
89 v).

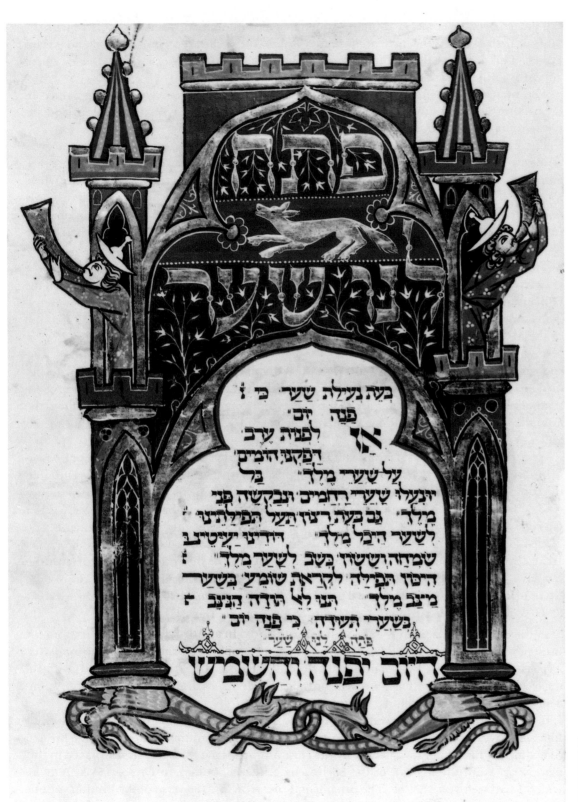

בַּמֶה נִגְלָה שַׁעַר כִּי וֹ
פְּנֵה יוֹב
אָן לִפְנוֹת עֶרֶב
דְּבָקְעוּ הַזְּמַנִּים
עַל שַׁעַר מֶלֶךְ בָּל
יִנָּעֲלוּ שַׁעֲרֵי רַחֲמִים וּנְבַקְּשָׁה פְּנֵי
מֶלֶךְ נֵב כְּעֵת רְצוֹן תַּעַל תְּפִלָּתֵנוּ
לְשַׁעַר הֵיכַל מֶלֶךְ הוֹדֵינוּ יַעֲטִיב
שִׂמְחָה וְשָׂשׂוֹן בְּשֵׁב לְשַׁעַר מֶלֶךְ
הִיכֹן תְּפִלָּה לִקְרַאת שׁוֹמֵעַ בְּשַׁעַר
מֵיטַב מֶלֶךְ תְּנוּ לֵאֵל תּוֹדָה הַנִּצָּב ז
בְּשַׁעֲרֵי הַשִּׁירָה כִּי פְּנֵה יוֹב
בְּרִיָּה לָנוּ שַׁעַר
חֲיוֹב יָפְנֶה יהוה וְשֶׁמֶשׁ

Fig. 2. The Messianic
Fox and the Gate of
Mercy
Leipzig Mahzor
(*Leipzig, University
Library, Cod.* V. 1102,
vol. II, f. 176 r).

The image of the empty chair in the uppermost medallion is apparently associated with the "thrones" in Daniel 7:9 which, according to Rabbi Akiba,[8] are kept, one for God and one for David. This is the chair for the eschatological King David, the Messiah ben David, whose advent is anticipated in a world to come.

The image of the enigmatic animal, squirrel or fox, will now have to be explained in connection with the mystical gate, the four cherubim, the throne of the Messiah, and the rejoicing fabulous animals represented on the miniature.

There is a legend in the Babylonian Talmud (Makkoth, fol. 24 b), about a group of sages going to Jerusalem. The city has been destroyed by Titus. The rabbis arrive at Mount Scopus, and reach the place of the Temple. All of a sudden they see a fox running from the place where formerly stood the Holy of Holies. At this sight they rend their clothes and weep bitterly. Only one of them, Rabbi Akiba, is smiling. Asked why he smiles, he tells his companions two prophecies from which it is to be inferred that on the place where foxes have dwelt the Temple will be restored.

This exquisite legend is an example of how faith transfigures symbols of evil augury into the reverse. This process of mystical reversion is typical for the working of Jewish legend. In the Old Testament the fox is a symbol of desolation. Ezekiel (13:4) points to the "fox of the desert." The Lamentations of Jeremiah (5:18) associate the foxes with the destroyed Temple. "Because of the Mountain of Zion, which is desolate, the foxes walk upon it."

We have here the very image on which the legend is built up, in its primary inception. The sponsor of the struggle of Bar Kokhba for the freedom of the Jewish nation, Rabbi Akiba, who died as a martyr, is the popular hero to whom tradition attributes the mystical inversion of the symbol of desolation into an augury of bliss. The controversial animal in our miniature is the *Fox*, the herald of the restoration of the Temple; the jubilant grotesques complete the messianic allegory.

We turn now to the second representation of the fox, which occurs in the Mahzor of Leipzig mentioned above (vol. II, f. 176 r.). The setting in which we meet him (Fig. 2) is very similar to the composition in the Breslau Mahzor. It is a portal design. The text enclosed in the framing reads: "Hold open the Gate until it is to be closed, for the day is drawing to a close." It is a passage of the Ne'ilah, the Conclusion Prayer of the service of the Day of Atonement. The "Open Gate" again is invoked. The architecture of the gateway, with its trefoil and bracket arches, is more elaborate, and points at least to the end of the fourteenth century. In the windows of the pinnacles appear the sounders of the shofar, the horn blown at the close of the Ne'ilah. The men wear white pointed hats, the so called *Judenhüte*. The Talmud (Yerushalmi, R. H. I 57 b) prescribes white for garments to wear on the Day of Atonement.

In the tympan of the arch is to be seen a running fox. In an attitude familiar to us from the Breslau Mahzor, he lifts up his head. It is the fox of the prophecy of Rabbi Akiba, the pious fox, a vision of cheerfulness and comfort to the devout, exhausted by a day of prayer and fasting at the close of Yom Kippur. The Gate is the heavenly abode of God and, in typological correspondence, the portal of the restored Temple.[9]

It was mentioned that the Mahzor of Breslau is incomplete. During my studies in various libraries, I was fortunate enough to discover the missing first volume. When I saw the Breslau codex for the first time, I was struck by the close affinity of the color scheme displayed in this manuscript with the Mahzor of the Sächsische Landesbibliothek in Dresden (MS. A 46 a), which I had seen years before. The ornamental pieces on folio 89 verso of the Breslau volume (the second), and on folio 132 recto of the Dresden volume (the first), are almost identical in color and design. There is the same effect of black lettering set against a pattern of tiny red

scrolls enlivened with blue dots and greenwinged yellow grotesques. Even the already familiar lion with flourishes is present. Numerous other instances point to the identity of the artist. Besides, the Dresden codex[10] numbers 293 leaves and measures 53 over 38 cm. The width is identical, and the slight difference in the height may be due to manipulations of the binder. The contents of the volume complete the Breslau Mahzor. We find there the missing service for Passover and Shabuot. The lavish ornamentation associated with the calligraphy is similarly a feature of the Dresden manuscript. It may be inferred from the close affinity of the ornamentation and the writing that the scribe and the illuminator were one person.

The few illustrations include (on folio 82 recto) "Haman and his sons hanging on a tree," (on folio 116 verso) a portal with the characteristic medallions, further on the signs of the Zodiac, this time accompanying the Prayer for Dew (they begin on folio 132 recto) and (on folio 202 verso) "Moses receiving the Law."

The manuscript includes, among other poetical pieces, an elegy by Meir of Rothenburg, whom the scribe calls his teacher, in the colophon in the second (Breslau) volume. We may assume that the "faithful" and modest disciple of Meir of Rothenburg not only compiled and copied the texts of the Prayer Book, but also illuminated the two volumes now in Dresden and Breslau. However faithful to the literary heritage of his teacher he has, apparently, ignored his attitude toward illustration which we happen to know. R. Meir of Rothenburg objected particularly to representations of animals and birds in Prayer Books. He expressed concern lest the pictures divert the worshipper.[11]

We are fortunate that, in the case of the Breslau Prayer Book, we are able to confront the theologian with the scribe and illuminator. It may be inferred from this example of prayer book illumination that the urge for pictorial representation was strong enough to overcome so serious an obstacle as the religious objections of a prominent rabbinical leader.

5A. THE FOX IN JEWISH TRADITION

By Paul Romanoff
Curator of Museum, Jewish Theological Seminary of America

In the March, 1941 issue of *The Review of Religion*, Rachel Wischnitzer-Bernstein presented a fascinating theory based upon the two Hebrew illuminations appearing in two manuscripts of prayer books for the High Holidays, in each of which appears a fox. This fox, according to the theory, represents the "Messianic Fox" in Jewish tradition. This implies that the Messiah is symbolized by a fox. The two illuminations, as well as others, are regarded by the author as having eschatological meaning, and depicting messianic ideas.

May we mention at the outset that there is no such Messianic animal known in Jewish tradition and, hence, not in Jewish art. The fox throughout Jewish literature is the animal symbolizing destruction, ruin, and devastation (cf. Judg. 15:4; Cant. 2:15; Neh. 4:3; Ezek. 13:4; Lam. 5:18). Its characteristics are craftiness, slyness, and deceit. These traits of the fox are also found in non-Jewish folklore. It is the animal of ill-omen, the witch and devil often taking the form of a fox.

The simile in Lam. 5:18 gave rise to the story in the Talmud about Rabbi Akiba and his colleagues, cited by Mrs. Wischnitzer. This talmudic motif represents the fox as an animal that visits and dwells in devastated places. It is the very symbol of desolation, and merely to add color to the story of R. Akiba and his friends, the fox was introduced.

The symbol of the fox in Jewish tradition is found even in modern Palestinian folk-songs of the Halutzim-Pioneers. In applying the biblical idea to modern song, they begin with the following words: "There are foxes (in Palestine), my dear child"; "Foxes are whining," etc.

The two instances presented by the author where foxes appear are not the only ones in Jewish illuminations. As a matter of fact, in an illumination reproduced by Rachel Wischnitzer (*Gestalten und Symbole*, Fig. 43) of a Mahzor of Worms, dated 1272, there is a part of a piyyut for Pentecost, beginning with the words: "The Loving Hind..." The illumination above this text is a scene of dogs pursuing an animal resembling a fox, which seeks safety by running up a mountain. The hind here is symbolic of the Torah (Law), and has no connection with the Messiah. The motif seems to have been taken from a hunting scene prevalent in illuminated art, such as fox hunting, for instance.

On an illumination of a Passover Haggadah of the fourteenth century (Brit. Museum, Add. 14761; see: *Encyclopaedia Judaica*, Eschkol, Berlin, vol. 7, frontispiece), is presented a Seder scene with the Hebrew legend: "This is the bread of affliction," on the upper part of the miniature. On the lower border are painted two animals facing each other, and strongly resembling foxes. It would be presumptuous to consider these two foxes as Messianic symbols.

It would be contrary to the spirit of the Talmud and Jewish tradition to regard the fox mentioned in the talmudic story as a "Pious Fox," and still less as a "Messianic Fox," and "the

controversial animal in our miniature" as "the herald of the restoration of the Temple." Likewise, it seems strange to regard the chair in the upper medallion of Plate I as that of the eschatological King David, and to associate the fox in the illumination with the fox in the story of the Talmud, seeing in it "the jubilant grotesque complete the messianic allegory."

It is evident that the fox as a Messianic symbol or Messianic harbinger must be eliminated. The presence of the animal still needs explanation, however. Thus, an interesting question in Jewish illuminated art has been raised: What is the significance of the animals appearing there, and do they have symbolic meaning? If so, they require study as to which of them belong to Jewish folk-lore and which ones were copied from or inspired by non-Jewish art. This study should be made upon examination of Jewish, Christian, and Oriental illuminations. Particular animal motifs should be likewise presented in their relation to the other animals found in the same illuminations.

The illuminations on Plate 1 of the Hebrew prayer book for the High Holidays (Breslau State and University Library Cod. Or. I, 1, fol. 89v), written in Germany in the fourteenth century and reproduced by the author, show a portal with a round arch. Four medallions form the bases and capitals of the columns, and a fifth medallion the keystone of the arch. A door on either side of each column suggests an open gate. In each of the four medallions is a figure: an angel, a winged lion, winged bull or ox, and an eagle. In the fifth medallion is a chair. The architecture of the portal and medallions shows distinct non-Jewish traces, and that the design was influenced by an allumination on a Gospel. As the medallions in the Hebrew manuscript show, the Evangelical symbols of an angel (man), lion, ox, and eagle originally represented St. Matthew, St. Mark, St. Luke, and St. John respectively. They ran clockwise as they appear in many Christian illuminations.

Because they bear resemblance to the four creatures in the vision of Ezekiel (chs. 1 and 10), which inspired the author of Revelation and which in turn inspired the Evangelical representations, these four medallions were reproduced in the Hebrew MS. The portion of the prayer, in the Hebrew prayer book where the illustrations appear, is an appeal to God to open the Gates of Mercy. Therefore, a similar design of an Evangelium could have been chosen for the motif.

The medallion at the keystone of the arch is a well-known motif in Christian illuminations designated for the Godhead, representing Jesus sitting on a throne or a throne alone, or picturing just his head. In the Hebrew prayer book, however, the Jewish copyist-illuminator drew only the throne, an empty golden chair set in heaven, as is suggested by the blue background dotted with stars.

In the attempt to establish her theory of the existence of a "Messianic fox," Mrs. Wischnitzer employs another passage in the Talmud concerning the "Heaven" in Daniel 7:9, according to which she sees the chair in the upper medallion designated "for the eschatological King David, the Messiah ben David." The passage in the Talmud, however, was regarding the term "chair" in Daniel 7:9, which appears both in singular and plural forms. Rabbi Akiba ventured that the plural form may suggest two chairs, one for God and the other one for David, or one for Judgment and the second for Righteousness, an opinion sternly objected to by his colleagues, and contrary to Ps. 89:14 and 97:2. It is very doubtful whether the illuminator took such a casual remark seriously.

The Jewish illuminator, copying the Evangelical motif, had in mind the four creatures in Ezekiel. The chair, in the keystone medallion, is obviously a symbol for God. In the Old Testament, God is pictured sitting on His throne (Ps. 11:4; 103:19; 47:8; Isa. 66:1; I Kings 22:19; II Chron. 18:18). In rabbinic literature this idea is often represented by the "Kissē ha Kabod,"

the "Seat (Throne) of Glory." So we find in the liturgical passages for the High Holidays which are included in the prayer book, expressions taken from the Bible and rabbinic literature, such as: "God sitteth on the throne of His holiness ... when he cometh to judge the earth"; (cf. also Ps. 9:4 and 7; Joel 4:12) "The habitation of His throne is righteousness and judgment," (cf. Ps. 97:2); or, "King who setteth his Throne for judgment." In Neilah service is the appeal, "May the cry of those who praise Thee rise to *Thy Throne of Glory*." In the third century in Palestine, the Armora Levy (Yoma 86 a) remarked: "Repentance is so great that it reaches the *"Throne of Glory*." This chair in the medallion is the "Throne of Glory" (of God) to which prayers are directed.

To treat Jewish symbolism from a non-Jewish approach would mean to apply an entirely different theory to it. For, if we want to find the correct meaning of the Jewish symbols, we have to see them the way the Jewish illustrators saw them, namely from the Jewish point of view and tradition.

The problem before us is an analysis of the architectural, decorative, human, and animal elements in Jewish art, their interrelationship and relation to the subject matter and texts, and whether or not they form an integral artistic composition. These, in addition, have to be examined in the light of Jewish tradition, a fact not to be overlooked.[1]

5B. A REPLY TO DR. ROMANOFF

I am grateful to my friend, Paul Romanoff, for having raised a few points regarding the interpretation of the fox in my article in the March issue of *The Review of Religion*. A debate will certainly help to clarify the problem. Dr. Romanoff points to the biblical conception of the fox, and also to the meaning the fox usually has in folklore. He has apparently overlooked the fact that on page 261 I have quoted Ezek. 13:4 and Lam. 15:18, and have referred on page 258 also to the fox "who has stolen the goose," a motive of folklore, in a Hebrew illuminated manuscript from Cologne. Other examples could be quoted, but it was not with these iconographical subjects that my article was concerned. I do not quite see the point in the reference to the hunted animal in the Worms Prayerbook. Dr. Romanoff seems to agree with me that it is a hind. The fox is always recognizable by his tufty tail.

The purpose of my article was to trace the evolution of a symbol. That the mystical reversion of the fox, originally a symbol of desolation, into an augury of bliss took place in the period of the oppressive Roman rule is significant enough. The religious leaders of the Jews at that time elaborated a conception of history according to which the cumulative disasters (destruction of the Temple in Jerusalem, failure of the movement of liberation) experienced by the Jewish people forecast the Restoration of Israel and the triumph of the righteous. N. N. Glatzer[1] points to the fox legend as illustrative of this talmudic conception. Joseph Klausner[2] considers the story of the fox walking upon the ruins of the Temple and Rabbi Akiba laughing at this sight as one of the few "messianic utterances" attributed to the tannaitic sage. I cannot therefore follow Dr. Romanoff, who maintains that "there is no such messianic animal in Jewish tradition and hence in Jewish art."

The implication that "the Messiah is symbolised by a fox" is obviously a misconstruction. The fox is, in the talmudic legend and the two mediaeval miniatures, an element of the messianic allegory of the Restored Temple. To maintain that the fox was introduced into the legend "merely to add color to the story" were to disregard not only the later talmudic interpretation, but the biblical conception of the fox as well, and thus to reduce a clearly defined and familiar symbol to the role of a meaningless decorative device.

That the authors of the prayerbook were conversant with the later version of the fox-motive may be gathered from the text of the prayerbook for the New Year, where the image of the foxes spoiling the vine (Cant. 2:15) is used to evoke the Egyptian bondage. Israel is identified there with the vine. The image of bondage and oppression culminates in the vision of the liberation of Israel. This association with the idea of Salvation is typical of the fox-motive in its later conception.

Turning now to the fox in the illustration of the prayerbook for the Day of Atonement, I should deem it advisable not to refer to Cant. 2:15 nor to Judg. 15:4, as these quotations introduce elements foreign to our pictures — the vine and Samson's stratagem. Even Neh. 4:3 is

somewhat misleading, as the passage refers to the opposition met at the rebuilding of the Temple, an episode hardly worth recalling in the vision of the Temple's glory.

I am now able to contribute another picture of the fox illustrative of my interpretation. It is to be found in the wall decoration of the Polish eighteenth century synagogue at Kamionka Strumilowa.[3] In the lower register of the wall paintings there is pictured a portal above which is seen Jerusalem portrayed as a walled city, with the temple in the center of elaborate buildings. In the foreground outside the wall, a flock of sheep is pictured on a mountain peak bordered with trees on either side. Beyond the trees are shown two foxes arranged as counterparts, each one holding a sheep in his mouth. The picture reveals several layers of thought. There is the folklore fox attacking sheep. There is — if we take into account that lost sheep are being identified with Israel (Jer. 50:6) — the fox, an enemy of Israel. There is, finally, the fox associated with the temple, not with the temple in ruins, which would point to the biblical conception, but with the radiant Temple in the restored Jerusalem.

In contradistinction to the eighteenth century painting, with its realistic view of a town, the medieval miniatures afford only a symbolical indication of the temple city, or the temple itself, in the image of a gate,[4] but a gate adorned with "the four living creatures" pointing to the temple vision of Ezek. I. I have emphasized in my article that the four figures have become, in Christian art, symbols of the Evangelists, whereas in Jewish art they have retained their original meaning as symbols suggestive of the presence of God. It would be in keeping with this original vision to interpret the empty chair in the clipeus of the keystone of the arched portal in the Breslau manuscript as the throne of God who is supposed, according to the Prayerbook, to sit again amidst his people in the Restored Temple in Jerusalem. The image is thus — and this I would like to emphasise — messianic, no matter for whom the throne is meant to be kept: for God or the Messiah. It is derived, of course, iconographically from the "empty throne" known from the representation on the triumphal arch in Santa Maria Maggiore and other early Christian churches, but if we admit this relationship we have, also, to point out clearly what this relationship implies. In Christian tradition the empty throne is supposed to be the seat of Jesus, not of God, and whenever an enthroned figure is shown in company of the symbols of the Evangelists it is Jesus, whereas God, if represented, appears as a half-figure above, a vision vaguely suggestive of the Revelation of St. John to be traced to Dan. 7:9. Now Dan. 7:9 was the source of Rabbi Akiba's speculations about the throne of the Messiah. It will not be denied that there is a line of Jewish tradition portraying the throne of David in terms of the "throne of fire" of God,[5] and associating the image of the enthroned David with the Day of Judgment. Louis Ginzberg[6] remarks: "As early an authority as Rabbi Akiba, Sanh. 38 b and parallel passages, speaks of the throne upon which David will sit on the Day of Judgment.... There can be no doubt that these legends about David are connected with the view that he is the promised Messiah."

Other discoveries of the throne motive in Jewish art will show whether and how far later typological speculations have influenced the original conception. The medieval illustration of the Prayerbook, the Passover Haggadah, and the Hebrew Bible offers ample evidence of modifications due to the evolution and migration of symbols.

6. THE THREE PHILOSOPHERS
BY GIORGIONE

Giorgione's *Three Philosophers*, in Vienna (Fig. 1), still presents an unsolved riddle. Some critics have questioned the propriety of the title of the painting and offered others according to their own interpretations of the subject. Other critics, while accepting the traditional title, attempted to associate the figures represented with various historical personages. None of the triads of names suggested has been felt, however, to conform to the apparent iconographic content of the painting.

New material for the study of the problem was made available in 1932 when the picture was x-rayed. The x-ray photographs revealed an underpainting which in some points disagrees with the final version[1].

In its present state Giorgione's painting shows in the right foreground a man with a flowing silvery beard, in arrested stride slightly to the left, the head in profile. Next to this figure a

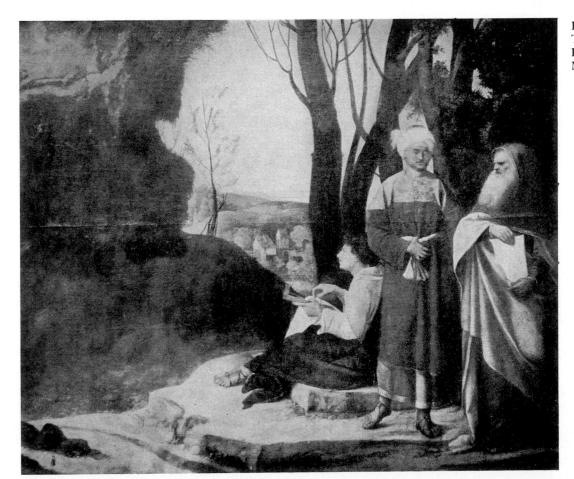

Fig. 1. Giorgione, The Three Philosophers, Kunsthistorisches Museum, Vienna.

younger man with a short brown beard steps forward. A third beardless figure is seated to the left of the group with profile facing left, uplifted.

The costumes of the figures are distinctly differentiated. The old man wears a long brown garment with a hood covering his head. A yellow cloak thrown about his body trails on the ground on his right. His face, hands, and the foot which protrudes from underneath his garment are of a robust brown flesh-tone. The man carries before him, with both hands, a stone shield on which are drawn a sun disk, the crescent of the moon, and a few signs. In his left hand he holds, in addition, a compass.

The man in the center of the group wears a white turban with mauve top. His ankle-free undergarment of bluish grey, appears from underneath a bright red tunic closely fitted at the waist and falling a little below the knee. A shouldercape of mauve moire fastened with golden clasps down the front, completes his dress. His sandals are elaborately laced. He holds his right arm bent at the elbow, his thumb stuck in a white waistband, the ends of which hang down the front. His complexion is an even pink.

The seated man is clad in a white garment with a wide turned down collar; the shoulder and back of the garment are embroidered in gold and white. A mantle of deep bottle-green slipping from his left shoulder, covers his left hip and wraps the outstretched left leg, with the foot, in a richly adorned sandal, showing from underneath. His complexion is a vivid red and pink; and the eye a grey brown. Abundant, curly brown hair covers his forehead, ear and neck. The man holds a square in his left hand and a compass in his right and seems about to take measurements on what may be an instrument or a paper placed on his raised right knee. Just which it is cannot be determined because of the position of the left hand which screens the object from the spectator.

The figures overlapping each other form a group slightly receding toward the center of the picture. The group is set on a low platform, a natural formation of the rocky ground, sharply outlined, with crumbling edges and a depression where the old man stands, so that he appears to be moving on a lower ground level than the middle figure. This effect is emphasized by the higher stature of the turbaned man. The bareheaded man sits on a step rising from about the middle of the platform.

The group is balanced by a huge rock on the left side of the scene, which recedes toward the middle distance where trees, extending to the right, form a backdrop for the figures. The landscape opens in a prospect of grey-green houses and low hills tinted blue, in the far distance. The setting sun, in the center background, colors the sky with changing shades of orange and pink and pale blue. The overhanging rock of opaque brown, with the effect of a wide greenish spot in the upper left, suggesting a groove momentarily lit by a stroke of light, is silhouetted on the right against a young slender tree and delicate foliage. Brown and green dominate in the trees behind the figures, and brownish grey in the platform and the small stones lying about.

In the underpainting uncovered by the x-ray, the figures are somewhat differently treated. The old man (Fig. 2) wears a diadem of long upright peaks, and glances upward. His silhouette is less bulky and does not overlap the left arm of the center figure, which would seem to imply that he wears no cloak. The center figure (Fig. 3) has the complexion of a Moor. This man glances toward the older one, while in the second version he gazes meditatively forward. The seated man (Fig. 4) wears a high cap. His high, wrinkled forehead and his grin, give him the appearance of a middle-aged person. A sheet of paper is spread on his right knee. The setting is the same except for the background where there are only two hills with a castle on the foremost one.

J. Wilde interpreted the differences between the two versions as typical of the departure from

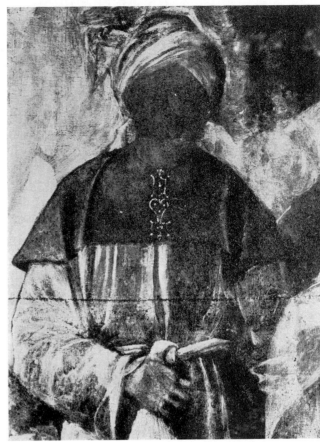

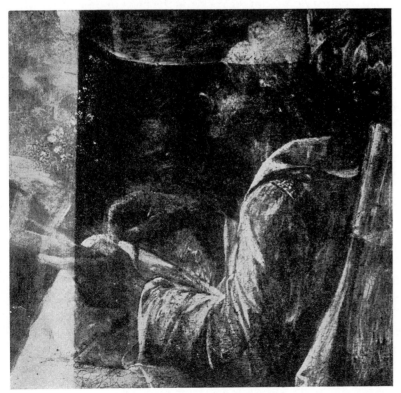

Fig. 2. Giorgione, The Three Philosophers, x-ray photo of right figure.

Fig. 3. Giorgione, The Three Philosophers, x-ray photo of middle figure.

Fig. 4. Giorgione, The Three Philosophers, x-ray photo of left figure.

the Quattrocento, with its descriptive interest in the human form, costume and setting, toward a broader and more sensuous conception of the Cinquecento. He dated the painting around 1506[2].

In replacing the exotic headdress of the old man with a plain hood modeling the head, and in removing the tapering hat of the younger man, Giorgione shows, indeed, a growing preoccupation with flowing lines and volume. The old man has thus been endowed with a noble dignity in posture and silhouette. Relaxed and humanised, as it were, appears the turbaned man who was originally conspicuously characterised by his facial type as an inscrutable Oriental. With his thumb stuck in the belt, a new gesture, his pose has acquired more stability and ease. In the overpainting, the man on the left gives the impression of a more harmonious personality. The grin has disappeared from the face. The way he looks at the mountain, and the effect of light upon it, conveys a fine sense of weighing and judging external evidence.

Wilde assumed that in its original, more picturesque concept, the scene represented the *Magi*. Later, Giorgione might have considered an allegory of the *Three Ages* or the three aspects of the *Vita Contemplativa*[3]. Before discussing this interpretation it will be proper to examine the evidence on which rests the traditional title of the picture.

In an anonymous diary of the XVI Century owned by the St. Mark Library at Venice (and published by its librarian, Jacopo Morelli, in 1800) there is an entry dated 1525 which reads: "In the house of Messer Taddeo Contarino: the canvas in oil, representing three philosophers in a landscape, — two of them standing up and the other one seated and looking up at the light (*raggi solari*) with the rock so wonderfully imitated —, was started by Giorgio di Castelfranco and finished by Sebastiano Veneziano"[4].

Since Giorgione died in Venice in 1510[5], the title of the painting, which fifteen years after the artist's death was still in Venetian hands, apparently goes back to Giorgione himself or at least to a workshop tradition. The anonymous diarist points out the rock and the light upon it as a matter of course, and one cannot help feeling that these accessories hold a significance perfectly understood in the circle of Giorgione's admirers. Just what they were believed to signify has never been established, and Justi[6] was the first to wonder what the author actually had found so wonderful about the rock as to give it special mention.

Where the picture went from Venice is not known. Some hundred years later it turned up in the collection of the Archduke Leopold Wilhelm of Austria, in Brussels, where the Archduke resided as Governor General of the Spanish Netherlands. In 1651 the picture was copied by David Teniers the Younger (Fig. 5)[7], along with other works of the gallery, and was engraved for the *Theatrum Pictorium* which appeared in 1660[8]. After the Archduke resigned his post and settled in Vienna, his collection was catalogued. In the inventory compiled by Joes. Antonius van der Baren in 1659[9], the painting appears ascribed to Giorgione under the title: *Mathematici, welche die Mass der Hoechen des Himmels nehmen.*

This description — in fact more specific than that of the *Anonimo Morelliano*, since it accounts for the square and the compass in the picture — shows that Giorgione's painting had more or less preserved its identity.

Cavalcaselle[10] suggested that the men might be astronomers, thus accounting for the astronomical figures displayed by the hooded man. The association of philosophy with astronomy is in conformity with the conceptions of the time. In Raphael's frescoes of the ceiling of the *Stanza della Segnatura* in the Vatican, *Urania Contemplating the Sphere* occupies a spandrel adjoining the medallion with the allegory of Philosophy, thus illustrating the most important aspect of philosophic speculation[11].

Lionello Venturi[12] believed that the three men might just as likely be astrologers. As a matter

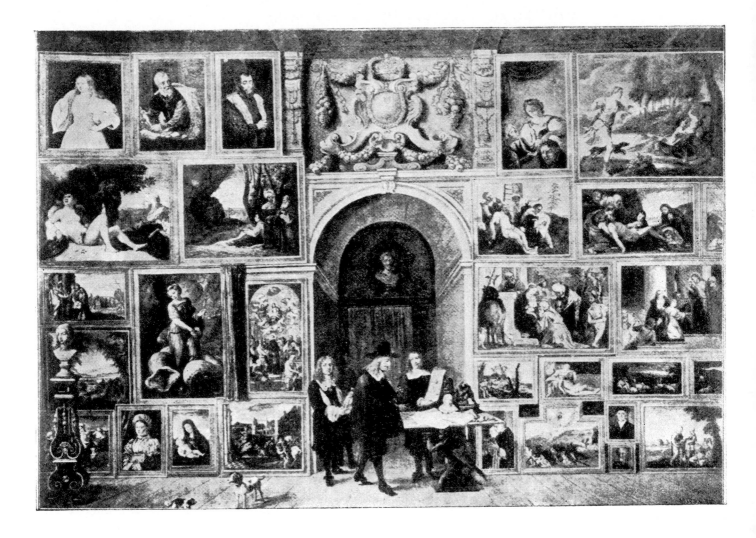

of fact, notorious astronomers of the Renaissance engaged in astrological operations which they executed with instruments devised for astronomical observations.

The question arises as to whether the three philosophers can be more precisely identified. It has occurred to many observers that the three men seem to personify three phases of scientific activity, as is implied by the emphasis on the difference in the ages of the figures. The idea of portraying scholars of different ages and trends of thought, as if engaged in some imaginary debate, was not new. The Roman mosaics of Torre Annunziate in Naples and the Villa Albani in Rome show the *Seven Sages of Antiquity* debating a subject brought up by the earliest of them, Thales of Miletos[13]. The motive has survived in a woodcut of Schedel's *Weltchronik*, published in Nuremberg in 1493[14].

H. Janitschek[15] advanced the theory that Giorgione's philosophers symbolize Antiquity, Middle Ages and the Renaissance. The old man he identified as Aristotle.

Ferriguto[16], a philosophy professor of Verona University, saw the three protagonists of philosophical thought in terms of an Aristotelian revival — the men representing medieval theology (the hooded man), Arabic-Latin proto-Renaissance and the humanistic Renaissance.

Parducci[17] suggested Aristotle, Averrhoes (the turbaned figure) and Vergil for the seated figure.

85

L. Baldass[18], curator at the Kunsthistorisches Museum in Vienna, where Giorgione's painting had been since 1891, proposed Archimedes, Ptolemy and Pythagoras for the seated figure.

Hartlaub[19], with a keen interest in the mystical trends of the Renaissance, interpreted Giorgione's philosophers as adepts of orphic lore who ascend from the stage of the neophyte — the younger man seated on the left — to higher and higher degrees of "Saturnian" initiation. This interpretation, interesting as it is, is disproved by the arrangement of the figures with the old man actually moving on the lowest level, while the middle and the left figures are set on respectively higher planes. If an ascension was meant to be conveyed in the picture, the evidence would point rather to a progression from right-to-left, from the old toward the younger man.

In this brief survey Wickhoff's[20] identification with a subject from the *Aeneid* and Schaeffer's[21] with a scene illustrating the education of Marcus Aurelius, should not be omitted.

It may appear quite conceivable that Wilde, when taking up the problem in 1932 — he was then scientific assistant at the Kunsthistorisches Museum and as such entrusted with the examination of the x-rays —, felt unable to adopt any of the numerous interpretations proposed. It occurred to him that old Christian von Mechel might be right with his *Magi* theory advanced in his Vienna Museum catalogue of 1783, a theory drawn on the mere evidence of the overpainting. It had only to be better worked out to fit into the concept of the picture.

As a matter of fact, the Gospel version of the *Magi* story does not exactly fit in. According to Matthew II, 1-2: "There came wise men from the East to Jerusalem saying: where is he that is born the King of the Jews for we have seen his star in the East, and are come to worship him". But, there is no star in the picture, and in the text no allowance is made for the rock. These, Wilde argued, however, are accounted for in an apocryphal version of the *Magi* story.

At closer inspection the evidence provided by the medieval version appears as highly hypothetical. We learn that a company of twelve magi for many years foregathered on the top of a wooded mountain, rich in vegetation and streams, to see a star rise over the Mons Victorialis as prophesied in a book of esoteric lore. Kehrer[22], from whom Wilde quotes the text, was himself at a loss in trying to point out a single picture illustrating the episode. G.M. Richter[23], while ready to accept the interpretation for the first version of the painting, admitted that "such a representation of the *Magi* would be without parallel in the history of art".

It is noteworthy that the star is not only missing, but actually should not be expected to appear in the setting of a picture where the rock is screening off the sky the very side toward which one of the figures is deliberately turned.

M.A. Schmidt, in his Vienna Museum catalogue of 1796[24], rejected the *Magi* theory on the ground that daytime is indicated in the canvas.

The *Anonimo Morelliano* emphatically points out, it may be recalled, the *raggi solari*, the effect of the sun rays on the rock, evidence which was not available to Mechel.

With the accumulated evidence in mind, the author of the Vienna catalogue of 1859[25], then reverted to the interpretation of the *Inventory* of 1659, just adding a point which accounts for the turbaned figure and dismisses, it would seem, once and for all, the *Magi* hypothesis. The picture appears there under the title *Les géomètres orientaux*.

However, for all its apparent weakness and ambiguity, von Mechel's thesis managed to survive. In the 1908 catalogue of the Kunsthistorisches Museum by W. von Wartenegg and Gustav Glueck[26] it turns up again. It is true that Glueck dropped it in his catalogue of 1928[27] where among the various identifications cited we find a reference to Baldass' interpretation of 1922.

With Wilde taking up the thesis once supported by Glueck, yet later abandoned evidently

under Baldass' influence, the discussion flared up again in 1932, this time carried on by staff members of the Museum, a situation which had the advantage that the object of controversy was close at hand.

G. Gombosi[28], in adopting Wilde's *Magi* hypothesis even for the overpainting, drew the logical conclusion that the canvas of the Vienna Museum was not the one described by the *Anonimo Morelliano*. In this belief he was supported by his conviction that the painting was throughout a work of Giorgione and showed no trace of Sebastiano del Piombo's collaboration.

In attempting to propose an interpretation of the figures of Giorgione's painting, I wish to stress that any explanation of the picture will have to draw upon an organic concept familiar in Giorgione's time and centering around some contemporary figure. This figure, once identified, will offer a clue for the choice of the other two.

Previous interpreters recurrently focussed their attention upon the old man in the picture, juxtaposing to him the turbaned figure as a protagonist of a different trend of thought. Names were proposed to substantiate this concept. However, no name has been offered for the young man facing the rock, which likewise might be associated with some distinct departure from older trends.

Whatever the man watching the light on the rock is meant to be doing, emphasis seems to be laid on the fact that he is handling a compass and a square. Since another figure in the group — the old man — exhibits astronomical figures and likewise a compass, we may tentatively assume that the young man is an astronomer.

The next thing is to find out who was actually regarded in Giorgione's time as the leading astronomer. A glance into the Cambridge *Modern History*[29] promptly provides the name. It is Johannes Mueller of Koenigsberg in Franconia, called Regiomontanus. Regiomontanus was an inventor of astronomical instruments, translator and editor of astronomical treatises of Greco-Roman antiquity, and compiler of calendars. His almanac, published in the Erhard Ratdolt press in Venice in 1484 and calculated for decades ahead, was no doubt in use in many a household in Venice and may have been familiar to Giorgione.

Regiomontanus' fame was later eclipsed by Copernicus, Tycho Brahe, Kepler and Newton, and his name today is known mostly to specialists. Thorndike[30] has ably evaluated the significance of Regiomontanus. He does not believe, as German authors[31] have tried to prove, that his tables of solar declination had been used by the great Portuguese explorers. The tables actually in use were, he points out, those of the *Almanach-perpetuum* by Abraham Zacuto, a Spanish-Jewish astronomer. It would seem that the first editions of Regiomontanus' *Epheme-rides* did not contain those tables. Thorndike ascribes the fame of Regiomontanus to his adherence to the humanistic movement and especially to the revival of Greek learning. It is quite interesting to note that Regiomontanus had been ordered the horoscope for L.B. Alberti[32]. Regiomontanus had compiled a Latin edition of Ptolemy's *Almagest*, the so-called *Epitoma*, a work begun by his teacher, Peurbach of Vienna University, under the auspices of Cardinal Bessarion, who, after Peurbach's death, entrusted its completion to the younger man. Bessarion, a Greek whose country was occupied by the Turks, was a humanist fond of classical literature, and an adept of astronomy. He took the young scholar to Italy where they visited Bologna, Viterbo, Ravenna and Rome. Regiomontanus was in Venice in 1463-64 and in 1464 he lectured at Padua University. In his opening lecture he surveyed the history of astronomy,

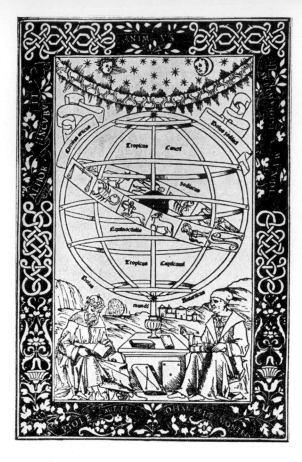

Fig. 6. Ptolemy and Regiomontanus, woodcut, From Regiomontanus. *Epitoma in Almagestum Ptolemaci*, Venice, Johannes Hammann, 1496.

beginning with Abraham and Moses, Prometheus and Hercules and dwelt on the *Liber Meteorum* and the *De Coelo et Mundi* by Aristotle. He discussed Claudios Ptolomaios, mentioned Thomas Aquinas and Avicenna. He did not, however, mention Averrhoes, obviously with intention, since Averrhoes had brought Aristotelism into discredit with the church, and it was Thomas Aquinas who had freed Aristotle from this unhappy association[33].

In the same year Regiomontanus accompanied the Cardinal to Rome where the papal conclave was about to meet to elect a successor to Pius II. But it soon appeared that the Greek cardinal was no longer able to do much for his protégé. In 1467 Regiomontanus was in Pressburg selecting an astrologically favorable moment for the official opening of the newly founded University where he was to teach. In 1468 Bessarion gave his valuable collection of manuscripts, among which there were a number compiled by Regiomontanus, to the Senate Library at Venice. In 1470 he tried to persuade Pope Paul II to entrust Regiomontanus with the calendar reform. He died in 1472 in Ravenna. Regiomontanus, after a brief lectureship in the Vienna University, went, in 1471, to Nuremberg where he had found a patron in Bernhard Walther. In 1475 the call from Rome finally came. Sixtus IV wished the Easter calendar improved and revised. Regiomontanus went to Rome where he died suddenly in 1476 at the early age of forty years.

A legend soon began to grow around his name. That he had been poisoned by the sons of the astronomer George of Trebizond, whose Ptolemy translation had been attacked by Regiomontanus, was perhaps not mere gossip. At any rate, the stories recorded in the XVI and XVII Century literature seem to attest the immense popularity of Regiomontanus. As fantastic as some of them sound, they probably rest on earlier sources[34]. Regiomontanus was spoken of as the inventor of mechanical toys, automatically moving birds and insects. It is not improbable that the monstrous birds and dragons in pictures such as the *Astrologer*, engraved by Giulio Campagnola[35], refer to the Regiomontanus myth.

We may, then, safely assume that Regiomontanus' name was known to Giorgione. The painter may have seen the *Epitoma*, the posthumous Venetian edition of 1496[36], and have examined the woodcut in the book (Fig. 6) showing the inscribed figures of Ptolemy and Regiomontanus seated beneath the armillary sphere. Regiomontanus is on the right holding a closed book and pointing to Ptolemy who is reading without taking notice of his later interpreter. Regiomontanus is clean-shaven and wears a cap which leaves his ear and neck free. Giorgione's seated figure in the underpainting also wears a cap. The embroidery on the front of Regiomontanus' garment in the woodcut may have inspired the elaborate treatment of the young man's garment in the painting. In the woodcut, Regiomontanus has the appearance of a middle-aged man. He looks the same age in the earlier version of Giorgione's painting. The landscape in the woodcut with its walled and towered structure in the background bears, for all its cursory character, some resemblance with the scenery in the canvas.

Ptolemy has some points in common with the central figure of the painting; they become more conspicuous if we transfer him to the right of Regiomontanus. His garment is buttoned down the front; his wide collar may have been the model for the shoulder-cape of Giorgione's figure which is likewise fastened down the front. Ptolemy's right arm is in much the same position. We know that in the overpainting, Giorgione changed the movement of the hand, introducing the device of the thumb stuck in the waistband, which was motivated by the standing posture of the figure. In the woodcut, where the figure is seated, the hand rests on the knee.

There are points in Ptolemy's woodcut portrait which do not appear in the painting, such as the crown and the long beard. The crown was as common an attribute of Ptolemy as the turban, with the difference that it characterised him more specifically in pointing to his name as identical with that of the ancient Egyptian royal dynasty. Raphael in his *School of Athens* in the Stanza della Segnatura, painted in 1509-1511, gave Ptolemy a crown. It served to distinguish Ptolemy, a back figure, from Zoroaster who carried a celestial globe easily confused with the terrestrial globe displayed by Ptolemy (Fig. 14).

Giorgione might have preferred a turban, which already appeared in the underpainting, in order to set off the figure from the older man who in the underpainting wears a diadem. A crown would not have served the purpose as well. The short beard is another expedient to mark off the turbaned figure from the man on the right with his long beard. In the woodcut, with its two figures, Ptolemy is juxtaposed only to the beardless Regiomontanus, he represents there the old man.

In changing the complexion of his turbaned figure from dark in the underpainting to pink, Giorgione may have wished to point out that Ptolemy, a Greek by birth, was not a pure Oriental[37]. In the *School of Athens* Ptolemy has a fair complexion and brown hair.

Having tentatively disposed of the two figures in Giorgione's painting — Regiomontanus and Ptolemy, the modern and the II Century astronomer — we turn to the old man who does not appear in the woodcut of the *Epitoma*. The fantastic diadem with the huge peaks — a sort of Indian headdress — which this old man is wearing, may well have been imagined for a Chaldean astrologer, or for Zoroaster, the Persian sage, whom Giorgione may have contemplated, when painting his first version of the scene, as a counterpart to Ptolemy. Later he dismissed the idea of the exotic figure. The diadem was abandoned for a hood, and a mantle of an antique philosopher was added.

There is little doubt that the ancient figure is meant to be "Aristotle, the philosopher", as Niccolo da Foligno, a XV Century humanist, commentator on Aristotle, called him[38]. The hood of the traveller is possibly meant to call to mind, in a playful manner, Aristotle's habit of

carrying on philosophic debates while walking. The robust brown flesh tone would likewise point to an outdoor way of life. The cartouche with the sun disk and the crescent suggests an actual book title, the *De Coelo* by Aristotle[39]. The portrait of Aristotle, with the high forehead of a bald-headed man, the drooping moustache, the narrow eyes, agrees with the type of this philosopher established by Renaissance tradition[40].

The hood of the Peripatetic was probably regarded by Giorgione as an important point serving to bring out the relationship of Aristotle with Ptolemy. The walking pose of Ptolemy, shown with the right foot raised at the heel, is meant to imply, it would seem, a similarity in habits between the two scholars or, to use a metaphor, Ptolemy's indebtedness to Aristotle in his concept of the universe. The higher ground level, however, on which Ptolemy moves and his higher stature, mark the progress achieved in science by the author of the Ptolemaic system.

Ptolemy, on the other hand, along with Aristotle, embodies the past, as contrasted with the young man who turns away from the two and ventures upon a personal observation of nature. In order to emphasize the significance of the seated figure as a champion of modern research, Giorgione removed the signs of mature age, typical of Regiomontanus, in the underpainting and the posthumous woodcut.

Passing on to the mountain, it should be noted that it was formerly even more conspicuous in the picture than it is now. This can be borne out from Teniers' copy (Fig. 5) and the measurements of the canvas. Since the measurements are given in the Inventory of 1659 with frame, an exact comparison with the present ones is not possible. They indicate, however, that the format has been considerably reduced in width[41].

It can be safely surmized that the rock has some function in the painting so full of allegorical allusions. The attitude of Regiomontanus, meditatively gazing at the mountain, conveys his relationship to it. The reader will have guessed what this relationship is. The mountain, of course, alludes to the name of Regiomontanus' birthplace. Following a common practice in the scientific world, the astronomer used to sign his works with a latinized version not of his name — the name "Mueller" could not easily be adapted, or did not sound pleasant enough — but a derivative of the name of his native town. In some cases he used an Italian version of that name. Thus his portrait in the *Epitoma* is inscribed de Monte Regio.

How fond Regiomontanus was of this name and its meaning may be gathered from his bookplate which shows the semicircle of a mountain topped with a cross flanked by two stars (Fig. 7). He used to draw it in pen and ink on the inner side of the cover or the endpage of books he owned. There still exist seventeen books with Regiomontanus' bookplate drawn by him[42]. The rock surmounted with a cross set against the starred sky was obviously meant to be the Mount of the King of Kings, the Christ.

The mountain in Giorgione's painting, then, is symbolic of Regiomontanus. Equally so is the ray of light upon the mountain, suggestive of the divine light emanating from the cross.

Regiomontanus gazes at the light. Does he actually measure it? Astronomers or geometers measuring altitudes by the shadows cast on a quadrant are often depicted in scientific treatises of the time. However, they are generally shown operating in standing pose. They use a compass but no square[43], a quadrant but no paper, which we know Giorgione actually had originally in mind but was careful to blot out in his final version.

It may be permitted to assume, taking into account the playful mood in which the allegorical portrait seems to have been conceived, that Regiomontanus is shown drawing with his compass the semicircle of the rock of his bookplate. The square is intended for drawing the straight lines of the cross.

Most of the interpreters of the Vienna painting have noted the effect of the orange disk of the

Fig. 7. Regiomontanus' bookplate.

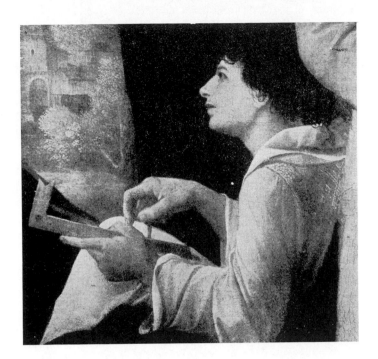

Fig. 8. Giorgione, The Three
Philosophers, Kunsthistorisches
Museum, Vienna. (Detail)

setting sun in the middle background[44]. It has not been noted, however, that this effect is inconsistent with the distribution of light and shade in the picture. The way Regiomontanus is exposed to the highest light implies a source of light on the upper left. The houses and shrubs in the farther distance are likewise lit from the left. The sun rays, falling in from the left, color the shield carried by Aristotle a golden yellow. Since the effect of the setting sun is not mentioned by the *Anonimo Morelliano* — an effect which would have interfered with the light effect on the mountain — we may suspect that it was added later, perhaps in connection with the cutting down of the picture at the expense of the rock and the lighted area upon it[45].

With the lighted area reduced in size and most likely in intensity, since the strongest accent may be supposed to have been on the extreme left, the canvas needed, it was probably thought, some new light effect in compensation. This may have induced the restorer to add the sun ball in the middle background. It did not occur to him, fortunately, that the lights and shades had to be altered accordingly. It is obvious that at the time of the restoration of the canvas the symbolical meaning of the light on the left was no longer comprehended, nor was it at the time of the compilation of the Vienna Inventory of 1659. However, the author of the Inventory must at least have known that the source of physical light was assumed to be on the left. This can be inferred from his interpretation of the scene.

In attempting to date the *Three Philosophers*, several factors are to be considered. If we center our attention upon the lay-out of the scene, with the figures drawn out in a row across the foreground and screened from the farther distance, we have to date the canvas pretty close to the Castelfranco Altarpiece and the Dresden *Venus*, which are similarly conceived[46]. Justi's date of 1504[47] would thus seem plausible. Wilde, we may recall, assigns the painting to a transition period, around 1506. Gronau dates it slightly later[48]. However, there is evidence in the picture of Giorgione's most advanced style. It is found in Regiomontanus' boldly foreshortened profile (Fig. 8). This head carries us directly to the organplayer in the *Concert* of the Pitty Gallery, in Florence, which Professor Richard Offner assigns to Titian because of its style going beyond Giorgione[49].

Fig. 9. Stefano della Bella, Aristotle, Ptolemy and Copernicus, etching. From Galileo Galilei, *Dialogo... sopra due massimi sistemi del mondo Tolemaico e Copernicano,* Florence, Gio. Batista Landini, 1632. *Courtesy David Eugene Smith Library, Columbia University.*

The head of Regiomontanus cannot well date from a period prior to 1508. In 1508 Giorgione was working on his frescoes on the façade of the new Fondaco de' Tedeschi in Venice[50]. His interest in the subject matter of the picture at that time is attested by the figures of *geometers measuring the globe* which he is said to have painted on the truncated corners of the German Warehouse. These façade decorations have perished[51].

The head of Aristotle, broadly agreeing with his ideal portrait current in the Renaissance, shows more specifically bellinesque characteristics. This does not necessarily imply an early date. The typical, rather short, face is found on the *St. Jerome* in Giovanni Bellini's St. Zaccharia Altarpiece of 1505[52] and on a Saint in the Altarpiece by the same artist, in St. Francesco della Vigna of 1507 (Fig. 15), both in Venice.

Giorgione's Ptolemy resembles, in addition, the St. Francis in the latter Altarpiece. We have in both the same short proportions of the face, the thin nose, the pinched upper lip, the broad cheekbones and the narrow chin.

It may be assumed, therefore, that the *Three Philosophers*, begun about 1504 or 1505 and left in an unfinished state, were taken up again by Giorgione some time in or after 1508 and reworked in a much different spirit.

What the part of Sebastiano del Piombo was in the work is indeed hard to tell. His collaboration may have been confined to the finishing touches made necessary when, after Giorgione's sudden death, there began a rush on the part of collectors for his pictures[53].

Since drafting this paper I have come upon an etching which shows a striking similarity to Giorgione's *Three Philosophers*. It is a frontispiece in Galileo's *Dialogus*, published by Giovanni Batista Landini, in 1632, in Florence. The volume is dedicated to Ferdinand II, Grand Duke of Toscana, a patron of Galileo. The etching is by the Florentine artist Stefano della Bella. It shows (Fig. 9) the inscribed figures of Aristotle, Ptolemy and Copernicus[54] engaged in a debate. Ptolemy, a turbaned figure, stands in the middle with Aristotle approaching from the left and Copernicus standing on the right. Aristotle, conspicuously bald, holds the staff of a traveller. Ptolemy carries the armillary sphere; Copernicus, his planisphere. While Aristotle and Ptolemy are clad *à l'antique*, Copernicus wears a dolman with "branden-

IOÁNNES REGIOMONTANVS

Fig. 10. Regiomontanus, woodcut, from Schedel, *Weltchronik*, Nuremberg, 1493.

Fig. 11. Regiomontanus, woodcut, from H. Pantaleon, *Prosographia*, Basel, 1565-66.

Fig. 12. Regiomontanus, woodcut, from J. Schoener, *De indiciis nativitatum*, Nuremberg, 1545.

Fig. 13. The Astronomer, woodcut, from Cecco d'Ascoli, *Acerba*, Venice, 1524.

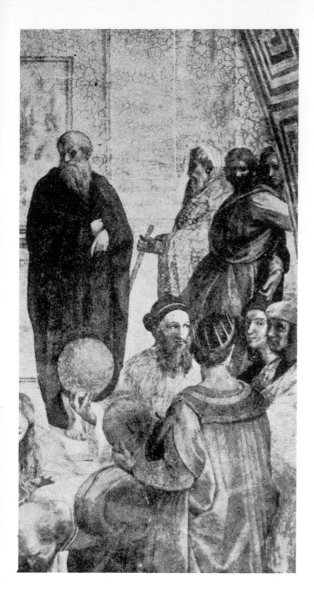

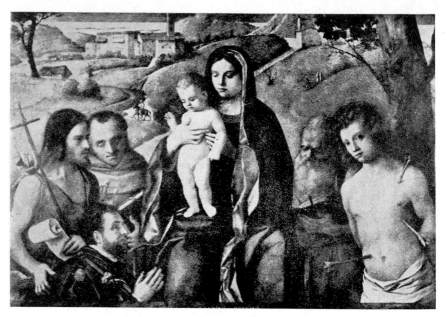

Fig. 14. Raphael, The School of Athens. Stanza della Segnatura, Vatican. (Detail.)

Fig. 15. Giovanni Bellini, Altarpiece. S. Francesco della Vigna, Venice, Italy.

bourgs" suggestive of his Polish origin. The figures stand on a ledge set against a maritime landscape.

In spite of the considerable divergencies, the etching shows an unmistakable dependence on Giorgione's picture. The differences are readily accounted for. The reversal of the figures is a common practice with engravers; the disappearance of the mountain, Regiomontanus' emblem, is due to his substitution with another figure. The presence of Copernicus, on the other hand, called for a setting suggestive in some way of his personality. Using Giorgione's device, della Bella portrayed in the background the waterside — the Vistula river, in fact — evocative of Torun on the Vistula, Copernicus' birthplace.

How older portraits used to be adapted for different personages is shown in the engraving in the *Harmonia Macrocosmica* of 1661[55], with Ptolemy and Copernicus seated on either side of the Copernican planisphere. The arrangement of the scene is the same as in the woodcut of the *Epitoma*. Ptolemy is seated on the left, while Copernicus is substituted for Regiomontanus. The Ptolemaic armillary sphere is replaced with the Copernican planisphere (Fig. 16).

This raises the question whether Stefano della Bella knew Giorgione's painting. He was only about twenty-two when he made the frontispiece for Galileo's volume. There is no

evidence in his biography that he had been in Venice[56]. He may have seen a reproduction of the painting, now lost. We may also conjecture that the painting was no longer in Venice. Was it in Florence at that time?[57]

An inspection of Regiomontanus' numerous portraits shows that they go back to several prototypes. The elderly man demonstrating a graduated circular instrument, labelled Regiomontanus, is found in Schedel's *Weltchronik* (Fig. 10). This model was used in the *Vrais portraits des hommes illustres* of 1584[58]. The youthful Regiomontanus with curly hair and profile to left looking upward — a more individualized likeness resembling Giorgione's *Regiomontanus* — is seen in an inscribed woodcut in H. Pantaleon's *Prosographia*, Basel 1565-66 (Fig. 11). It is a slightly modified version of a woodcut in Johannes Schoener's *De indiciis nativitatum*, Nuremberg, 1545 (Fig. 12).

An even more striking resemblance to Giorgione's *Regiomontanus* is revealed by the portrait of an astronomer in profile to left looking upward in the Venetian edition of 1524 of the famous *Acerba* by Cecco d'Ascoli (Fig. 13). The motive of the mantle slipped from the left shoulder and wrapping the leg is there; the sandalled foot, the platform with the step on it, the trees behind the figure, the hills and houses in the left background are all there. The engraver did not actually wish to copy his model. He converted Regiomontanus' portrait into a generic image of an astronomer and gave him a beard and the shield with astronomical or rather astrological figures as attributes of authority.

The *Acerba* edition of 1524 goes back, according to Pflaum[59], to an edition of 1510, from which we may infer that the woodcut also belonged to the earlier edition. If this is so, this woodcut of 1510 is a pretty early version of Giorgione's painting.

However, the Florentine etching of 1632 cannot be considered as having been drawn after any of the woodcuts discussed. None of them, in fact, gives the complete picture. Stefano della Bella is the only artist not only to have adopted Giorgione's concept of the philosophical triad[60], but also to have preserved the identity of two of the figures, with the third changed in a way that betrays a close knowledge of Giorgione's painting.

The Florentine etching is particularly valuable because it confirms, partly by implication, an identification of the *Three Philosophers* elaborated from entirely different evidence.

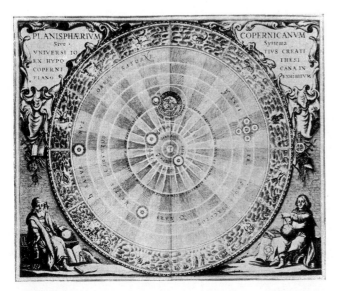

Fig. 16. Ptolemy and Copernicus, Engraving from Andreas Cellarius, *Harmonia Macrocosmica*, Amsterdam, 1661.

7. THE EGYPTIAN REVIVAL IN SYNAGOGUE ARCHITECTURE*

The Egyptian revival in art is usually associated with Napoleon's Egyptian expedition of 1798. However, it cannot be said that Napoleon "discovered" that ancient country. The publications of such eighteenth century travelers as Paul Lucas of France, Richard Pococke of England and Frederick L. Norden of Denmark, and the volumes of Count Anne Claude Philippe de Tubières de Caylus on Egyptian, Etruscan, Greek and Roman antiquities had appeared decades before Napoleon launched his campaign. It is significant to note that the interest in Egypt stimulated by these studies suggested the theme of the Académie des Inscriptions et Belles-Lettres for the competition of 1785: "What has been the state of architecture in Egypt and what have the Greeks borrowed from it?"[1] The prize-winning thesis of A. C. Quatremère de Quincy appeared in 1803 and thus antedated the volumes of the reports of the Napoleonic expedition which appeared in 1809-1828.[2]

The Egyptian structural forms of the pyramid and the obelisk had been known in Europe since the time of Augustus. They seemed to have been associated with classical vocabulary to the extent that with the classical revival in the eighteenth century they, too, regained popularity. From the 1790's on, architects in France and Germany were designing memorials in the shape of pyramids.[3] In this connection, mention also should be made of the story of the great seal of the United States. Whereas, Benjamin Franklin, Thomas Jefferson and John Adams, the members of the commission set up in 1776, proposed for the design of the seal such a theme as Moses and the Israelites at the Red Sea being pursued by Pharaoh, the device eventually adopted by the Continental Congress in 1782 exhibited a pyramid, symbolic of "strength and duration."[4]

In architecture, Egyptian motifs began to appear in the United States about 1812.[5] The most outstanding example was the Battle Monument in Baltimore, Maryland, with the batter walls, the sloping door jambs and cavetto lintels of its substructure. It was built in 1815-1825.[6] Another early Egyptian revival building was the *Mikve Israel* synagogue in Philadelphia, Pennsylvania. The guide-book *Philadelphia in 1824* gives a detailed description of the building which we cite in full because of the valuable information it contains:

A synagogue situated on the north side of Cherry Street above the Third Street. This building, recently erected, is 40 feet in front by 70 feet in depth, being two stories in height, built in the Egyptian style, of stone from the falls of Schuylkill.

The principal entrance is through an elevated doorway, formed with inclined jambs, supporting a large coved cornice, in which is sculptured a *globe and wings*.

The interior embraces two semi-circular blocks of seats, displaying to the north and south of the *ark and altar*. The dome is supported with Egyptian columns copied from the temple

at Tentyra, and is formed by semi-circular archivolts, joining in a richly panelled segment extending over the Ark and Altar.

In the center of the dome is a lantern which gives light to the altar.

The ark is situated in the east side, immediately opposite the altar, and is neatly decorated with pilasters supporting a coved cornice, enriched with a globe and the wings, together with a marble tablet, containing the ten commandments in Hebrew. It is approached by a flight of three steps between check blocks which support two handsome tripods crowned with lamps.

The galleries are semi-circular, extending round the north and south side of the building, and are supported by the columns which extend to the dome.

The building was designed by Mr. Strickland.[7]

From it we learn, then, that the synagogue was built in 1824 by William Strickland (1788-1854), a leading architect of early Philadelphia.

The layout of the building was very interesting. Situated on the north side of Cherry Street, the structure, forty feet across the front, faced the south. As the worshiper entered the prayer hall, he found the Ark located at the east wall on his right, — on one of the long sides of the auditorium. The seats, arranged in semi-circles, were on the shorter north and south sides, leaving free the area between the Ark and the *almemor*, — not infrequently found in Sephardic synagogues. The two galleries for women were likewise laid out in semi-circles. Since the transversal north-south axis was longer than the east-west axis, the columns supporting the galleries had been pushed back north and south so that the free area on the floor was oval in shape. This accounts also for the form of the dome carried by these columns. The dome consisted of a central hemispherical part cut short by two parallel arches which in turn were bordered by half domes.

This arrangement becomes much clearer when we examine an engraving of the interior of the synagogue (Fig. 1). It shows the "Egyptian columns" which were not exactly copies of

Fig, 1. Interior of the Cherry Street Synagogue, Philadelphia, 1824. *Engraving, 1850's* (Courtesy of the Reverend Leon H. Elmaleh)

Fig. 2. Architect's Elevation of the Cherry Street Synagogue, Philadelphia, 1824. [From *Dedication of the Synagogue of the Congregation Mikve Israel at Broad and York Streets* (Philadelphia, 1909)]

those of the temple of Dendera, but actually classical fluted shafts with palm-leaf or lotus-flower capitals for the Egyptian touch. The cavetto cornice of the Ark was decorated with the Egyptian winged sun.

The exterior (Fig. 2) was that of a rather comfortable residential building with two tall straightheaded windows and the doorway in the center approached by a flight of steps over a high basement, and three smaller square windows in the attic story, — the middle one being a blind window. The roof with gables toward the sides disguised the dome, allowing only for the lantern to show outside — a device not uncommon at that time. The Egyptian effect of the façade was conveyed by the sloping window trims and the winged globe carved on the cornice of the doorway. The triangular cap above the cornice with its Greek acroteria pointed up again the classical affinities. The building was typical of its time and of the work of William Strickland who was a pupil of the classicist, Benjamin Latrobe. It had the lightness and grace of Strickland's personal style and it reflected the fondness for elaborate vault designs of the period. The considerable space given to the synagogue in the Philadelphia guide shows that the building deserved consideration by the sightseeing visitors of the city.

The Mikve Israel synagogue was not large, but it compared favorably with its predecessor, the synagogue which had stood before on the site. The first Cherry Street synagogue (1782) was a one story building, thirty feet across the front and thirty-six feet in depth.[8] The synagogue of the Sephardic sister congregation, Shearith Israel in Mill Street, New York (1730) measured thirty-five feet square. The second (enlarged) Mill Street synagogue (1817) was thirty-six by

fifty-eight feet; the Crosby Street building in New York (1834), fifty-five by seventy-five feet.[9] The early churches in Philadelphia were likewise of modest dimensions. The Temple of the New Jerusalem (the Swedenborgian Church) built by Strickland in 1816-1817 was forty-four by fifty feet.[10]

What were the Jewish features of the Strickland synagogue? There was the marble tablet with the Ten Commandments which is seen on the engraving above the Ark with the Commandments arranged in two columns. The second Mill Street synagogue in New York already prided itself with the marble tablet of the Commandments.[11] Underneath the tablet, right above the winged sun, we see the perpetual lamp suspended on a bracket, an oil lamp of boat-shaped Grecian design. The tripods, carrying lamps on either side of the steps leading up to the Ark, are of the same type as those used by Strickland in front of his Chestnut Street Theater in Philadelphia built in 1822.[12] The chandelier was of a later date.

The cornerstone of the Cherry Street synagogue was laid on September 26, 1822. A copper plate was deposited bearing the names of the architect, William Strickland, the master mason, Daniel Groves, and the master carpenter, Samuel Baker. Actually four cornerstones were laid: on the southwest, southeast, northeast and northwest sides.[13] The laying of four cornerstones was a ritual already observed at the founding of the first Cherry Street synagogue of 1782. It is possible that the usage was introduced by the Reverend Gershom Mendes Seixas who had planned the programme of the dedication service.[14] A refugee from New York City upon its capture by the British, Seixas had served as minister of the first Mill Street synagogue before coming to Philadelphia. A number of years before Seizas' birth, at the laying of the foundation stones of the first Mill Street synagogue, the same ritual had been observed.[15]

No ground plan of the second Cherry Street synagogue has been preserved. From a casual remark of Henry Morais it appears that a room in the rear of the building was used by the ladies of the Hebrew Sewing Society (1838).[16] There were a number of rooms in the high basement. The identity of the second Cherry Street synagogue built in 1824 was somewhat obscured by Henry Morais' presentation of the history of the Cherry Street structures. Morais believed that the description in the Philadelphia guide referred to the first Cherry Street synagogue of 1782.[17] This was an incorrect assumption since Strickland was born in 1788. Then, too, he confused the guides which he had consulted, — due to a similarity of their titles which made it difficult to check the quotation cited by him.[18] The programme of the dedication of the synagogue of 1824, printed in Hebrew and English in New York, was rescued from oblivion by A. S. W. Rosenbach who reprinted the title-page of this rare booklet.[19] In her monograph on William Strickland, Agnes Addison Gilchrist has given the Cherry Street synagogue its due place in the work of the great Philadelphia architect.[20]

From Dr. Rosenbach's historical sketch of the Congregation it appears that the decision to have the Cherry Street synagogue rebuilt was made in 1818.[21] Strickland's services were engaged on September 6, 1822, twenty days before the cornerstones were laid.[22] The designs, then, must have been made some time before, and the year 1820 given by Joseph Jackson as the date of the synagogue designs is not unplausible.[23] Unfortunately Jackson does not name his authority.

The synagogue was dedicated on January 21, 1825. The Reverend Abraham Israel Keys officiated and was assisted by the Reverend Moses Levy Maduro Peixotto, Minister of the Congregation Shearith Israel of New York.[24] Among the guests were the Episcopalian Bishop, Dr. William White and members of the bench.[25] It is interesting to note that the Reverend Sabato Morais ministered to this Congregation from 1851 until it moved in 1860 to a new and larger edifice, on Seventh above Arch Street, which was built by the noted architect John

McArthur. The Cherry Street building was then torn down.[26] The present Mikve Israel synagogue on Broad and York Streets was built in 1909 by Lewis F. Pilcher (d. 1941) and William G. Tachau. The auditorium is a transverse (broad) hall like that of the Strickland synagogue.

If the Philadelphia synagogue of 1824-1825 belongs to the early period of the Egyptian revival in the United States and was the first American synagogue built in that style, it had a precedent in Europe. In 1798, the year of Napoleon's campaign, Friedrich Weinbrenner (1766-1826) built a synagogue in Karlsruhe, Germany, in the Egyptian style. The style was actually a blending of various artistic trends. Like Goethe, Weinbrenner was under the sway of Gothic architecture. Engaged in some work on the Strasbourg Cathedral, he tried to prevent alterations planned in connection with the conversion of the cathedral into a temple of reason.[27] On the other hand, again like Goethe, he loved classical purity, and the severity of Egyptian forms strongly appealed to him. It has been said that while studying in Vienna, Weinbrenner must have been impressed by the Egyptian settings of Mozart's "The Magic Flute."[28] However, Weinbrenner had studied at the Academy in Vienna only a short time and he left Vienna in November, 1790. "The Magic Flute" had its first performance in September, 1791. To be sure, Mozart's opera was not the first play with an Egyptian background and the Egyptian influence was not restricted to the stage. Among other factors, Freemasonry contributed a great deal to the romantic infatuation with Egyptian symbolism and Egyptian art.[29] Weinbrenner, who had French family connections, had been close to Berlin coteries and had travelled in Italy. He had an alert mind and a versatile talent. Back in his native Karlsruhe, he became the leading architect of the classicist city. The synagogue of 1798 was one of his earliest works. He treated the façade fronting on Kronenstrasse with a tall pointed gateway superposed with pointed windows. He flanked this central block with two Eygptian pylons capped by low hip roofs. The temple-like auditorium was in the rear and was approached through a hallway and a colonnaded court. The synagogue was destroyed by fire in 1871.[30]

Another classicist, Jean Baptiste Métivier (1781-1853), a pupil of Klenze, used Egyptian motifs in the interior of his synagogue building on Westenriederstrasse in Munich (1826). He treated the red marble columns which carried the galleries and the beautiful coffered Roman barrel vault with white palm-leaf capitals. The synagogue seated 320 persons. It was torn down in 1887 when the congregation moved to a new building constructed in the style of the Romanesque revival.[31] This building was destroyed by the Nazis.

The synagogues here under discussion were all built by non-Jewish architects. To what extent their designs were determined by the wishes of the congregations they served it is not easy to tell. It bespeaks the good taste of the building committees that they engaged talented architects and often commissioned younger men who then were beginning their careers as architects.

The story of the Kassel synagogue is particularly interesting because it affords insight into the attitude of the community toward the architect and sheds light on the problem of synagogue style. The Kassel synagogue project had attracted a number of prominent architects. The Jewish community had to choose from among a dozen designs submitted to the authorities and subject to the approval of the superintendent of public buildings and the Minister of the Interior of Hessen. One of the alternate designs proposed by the superintendent himself, Johann Conrad Bromeis, was conceived on Egyptian lines. The façade featured battered walls and sloping portal jambs, but also roundheaded windows and semi-circular transom windows. Bromeis' design precipitated a debate. August Schuchardt, a young architect of the province of Hessen, sharply criticized the incongruous combination of the most

heterogeneous styles. He pointed out in addition that the Jews were likely to associate Egypt with oppression and slavery.[32] Nor did he think that the temple of Solomon had been a sort of Egyptian temple as was assumed by Bromeis.

Eventually, Schuchardt gained the commission despite the views of the ministry which had greatly favored an Egyptian adaptation. Schuchardt built the synagogue in 1836-1838 in a moderately Romanesque style which the Jewish community found appropriate chiefly because of the unobtrusive character of the design. It should be observed that Schuchardt's assistant was Albert Rosengarten (1809-1893), a Jew, who obviously voiced the feelings of the community. He was to become later a noted architect and author of a handbook on architecture.[33] What had disturbed the leaders of the Kassel community was not so much the painful historical implication of the Egyptian style. This merely offered a plausible and respectable reason, a welcome pretext for the rejection of Bromeis' pompous and totally inadequate design. It was the unfamiliar style which they disliked, as they had disliked the unfamiliar in the "Moorish-Turkish" designs sent in by the court architect, Julius Eugen Ruhl. The Jewish community resented the idea of setting up a house of worship that would in appearance differ from "the other public buildings of the city."[34] The Egyptian fashion had not gained ground in German architecture.

The situation in the United States had been different. The Egyptian vocabulary had gained currency. The plates of the reports of the Napoleonic expedition were widely used. The second edition of that publication as well as Quatremère de Quincy's book were discussed in a lengthy review in the *American Quarterly Review*.[35] Colleges, courthouses, railroad stations, prisons, cemetery gateways seemed to call for a style expressive of stability. To Robert Mills, John Haviland, Isaiah Rogers (who had built the Touro memorial cemetery gateway in Newport, R. I.), Henry Austin, Thomas S. Steward, Minard Lafever, Thomas Ustick Walter, — to mention the major architects of the time, — Egyptian architecture had been at one time or another a source of inspiration. In fact, the simple spatial concepts of that architecture and the freedom from a rigid canon in the treatment of plant forms had a particular fascination for American architects in their search for creative expression.

William Strickland, the builder of the Philadelphia synagogue, used Egyptian motifs again in the First Presbyterian Church at Nashville, Tennessee (1849-50). Just as he had done in the synagogue, he placed the winged sun above the entrance of the church.[36] The sun was a fitting symbol of any house of worship or so it seemed to an American of the first half of the nineteenth century.

It testified to the prestige of the Mikve Israel synagogue that a younger congregation, the Beth Israel in Philadelphia,

> dedicated for the worship of the Supreme Being, in accordance with the Old German and Polish customs, and conducted on the principle of the Great synagogue in London,[37]

adopted the Egyptian style for its synagogue building. The Beth Israel Congregation in Philadelphia, founded in 1840, used for many years a rented hall for its religious services. Under the ministry of Gabriel Papé in 1847-1848 ground was broken for a building on Crown Street, on the east side, between Fourth and Fifth above Race Street. The new building was dedicated on March 29, 1849.[38] The Great Synagogue in London of 1790 represented the Ashkenazic congregation to which Beth Israel in Philadelphia looked for spiritual guidance. In matters artistic, however, local prototypes were followed inasmuch as the builder had to be chosen from among the local architects. The synagogue in Crown Street is described in the

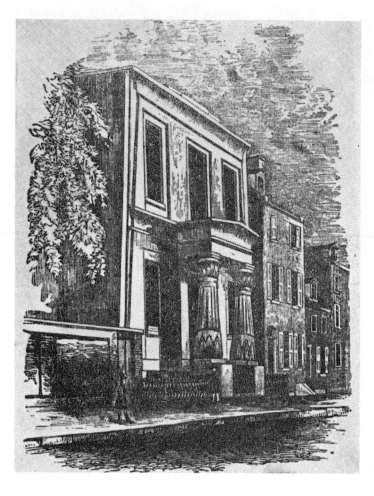

Fig. 3. Exterior of the Crown Street Synagogue, Philadelphia, 1849 [From *The Stranger's Guide in Philadelphia* (Philadelphia, 1854)]

Stranger's Guide in Philadelphia of 1852 as a "new and imposing building constructed of brown stone in the Egyptian style."[39] The name of the architect was not given.

The Crown Street synagogue (Fig. 3) was a two-story building with a straightheaded window on either side of the entrance fronted by a columnar portico, and three taller rectangular windows in the upper story. The sloping effect was produced by a simulated pylon slightly projecting from the corners of the façade. Conspicuously Egyptian were the two columns of the portico treated as bundles of papyrus stalks with details obviously copied from plates. Anyone could have designed them. In fact, similar columns are to be found in the main façade of the Odd Fellows' Cemetery buildings on Islington Lane near Philadelphia (1849) built by the architect Stephen Decatur Button[40] and in the Debtors Jail in Philadelphia built in 1832 by Thomas Ustick Walter (1804-1887).[41] The low parapet crowning the coved cornice of the synagogue is a motif widely used by Button whereas the projecting portico is found neither in Button's nor in Walter's buildings. In most of the adaptations of Egyptian models the central block of the structure is receding with the emphasis being placed rather on the flanks. Walter, however, has treated the central block of his jail in Philadelphia as a slightly projecting pavilion. This point may decide in favor of Walter's authorship of the synagogue. Moreover, (if we may rely on our source) the fact that Button established his practice in Philadelphia in 1848[42] argues against its attribution to him, since ground had already been broken for the

synagogue building in 1847. Finally, it is to be remembered that Walter had been a pupil of Strickland, the builder of the Cherry Street synagogue. The Beth Israel synagogue was located on the east side of Crown Street and consequently had its façade facing west. The Ark, then, was in the rear opposite the entrance. The three windows of the upper story gave ample light to the women's gallery which apparently ran along three sides of the hall. The Crown Street building was in use until 1894 and was sold when the congregation moved to a remodelled church building on Eighth Street.[43] Sharing the fate of the Cherry Street building, the Crown Street synagogue was torn down. Whether these two Philadelphia synagogues were the only ones built in the United States in the style of the Egyptian revival we do not know. It is hoped that this article will draw attention to an interesting phase in synagogue architecture and that more material will come to our notice. In closing, we wish to mention a graceful synagogue in Australia, apparently a frame building with characteristic Egyptian features.[44]

The Egyptian revival has lasted longer in the United States than in other countries. But by the middle of the 1850's the style had exhausted itself. Moreover, the associations that Egypt had evoked had begun to take a new direction. Originally, Egypt was thought of as the rich land generously fertilized by its river. "Egypt District" was the name given to the flatland on the left bank of the Schuylkill opposite Valley Forge.[45] The Mississippi was often called the "Nile of America." Memphis, Cairo, Thebes and Karnak, were named after the Egyptian cities.[46] With the advent of the abolition movement, Egypt began to be seen in a different light. No longer viewed as the land of the life-generating sun and river, it became metaphorically the country of Israel's bondage. Harriet Tubman, a Negro leader in the anti-slavery struggle, was called the "Moses of her people,"[47] and the pro-slavery Senator from Louisiana, "the brains of the Confederacy," Judah P. Benjamin, in 1858, was called by an opponent in Congress an "Israelite with Egyptian principles."[48]

One can speculate whether or not Egypt would have captured the imagination of the architects as it had done in the earlier decades of the century had its revival been attempted at the end of the 1850's. The ante-bellum simplicity and naïveté was gone. If the Eygptian experiment contributed to the enrichment of the vocabulary and freer use of classical forms in early Amercian architecture, in synagogue architecture it furthered the crystallization of the concept of a Jewish house of worship. The early American synagogue was in its exterior just emerging from the domestic type of building. The Egyptian trimmings gave it a measure of distinction and dignity which church buildings achieved with the use of towers, spires and domes.

8. THOMAS U. WALTER'S CROWN STREET SYNAGOGUE, 1848-49*

Joseph Jackson tentatively ascribed the "old Crown Street Jewish Synagogue" (Fig. 1) in Philadelphia to Thomas U. Walter (1804-1887), basing his attribution on the Egyptian style of the building Walter had employed in the Debtors' Apartment in Moyamensing, South Philadelphia. As an alternative he proposed Button, the architect of the entrance block of the Odd Fellows' Cemetery on Islington Lane in Philadelphia, likewise an Egyptian adaptation.[1]

The evidence in favor of the Walter attribution, which I came across after my study on Egyptian Revival synagogues had already appeared,[2] is a contemporary literary source. The Reverend Isaac Leeser, minister of Mikve Israel (Hope of Israel) on Cherry Street since 1829, attended the dedication of the Crown Street Synagogue on March 29, 1849. He published an account of the event in *The Occident*, of which he was the editor. We quote the article in part:[3]

Agreeably to announcement, the Synagogue Beth Israel of the Beth Israel congregation of our city was consecrated with the usual forms, on the afternoon of Thursday the 29th of March....

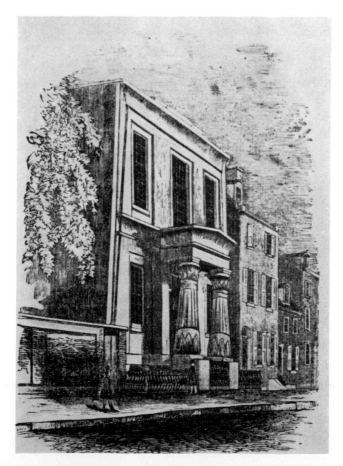

Fig. 1. The Crown Street Synagogue, Philadelphia, 1849, by Thomas U. Walter. (*The Stranger's Guide in Philadelphia*, 1854)

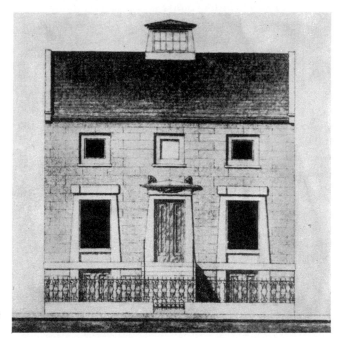

Fig. 2. The Cherry Street Synagogue, Philadelphia, 1824, by William Strickland. (*Dedication of the Synagogue of the Congregation Mikve Israel*, Philadelphia, 1909)

The building itself, of which we then saw the interior for the first time, struck us as really beautiful, and we cannot deny to the designers and promoters thereof the most unqualified praise for their zeal and perseverance in thus erecting a worthy house of prayer. The breadth is somewhat too contracted for its length, but therein they had to accommodate themselves to the size of the lot, which is, we think, about thirty-five feet. The ornaments for the capitals of the columns supporting the gallery, and those of the hekhal [ark], are of white and gold, and are in good taste. The centre dome, through which the light is admitted to the body of the Synagogue, and the windows back and above the ark, are of coloured glass of various hues, which give quite a pleasant effect. The gallery, as usual, is on three sides, terminating opposite the ark on the north and south....

The music too might have been better, had there been more time for preparation; but the whole period consumed from laying the foundation to the opening of the house for public worship cannot have exceeded six months, wherefore all was done which could be expected....

We would with pleasure give a description of the building, which is situated on the east side of Crown Street between Race and Vine; but we have not been furnished with the particulars, and we are not architect enough to do so from our own resources. Should the opportunity however offer, we may give the particulars hereafter; but we will mention here that the chandelier and gas fixtures in general are beautiful and highly appropriate, and in excellent harmony with the whole house. — The architect is the well-known designer of Girard College, Thomas U. Walter, Esq., and in saying this we give an assurance that the work deserves all praise. We heard something said about the style being Hebrew; but unfortunately for our reputation, there are no accesible remains of our ancient buildings, wherefore *our style* must be more in imagination than reality...

Leeser was well acquainted with problems of synagogue building, having reported in his magazine on a number of dedications of congregational buildings. His own synagogue (Fig. 2)

105

was built in the Egyptian style by William Strickland (1824).[4] Walter had been trained in Strickland's office. Leeser notes that Beth Israel (House of Israel) was located on the east side of Crown Street which implied a façade looking west and the ark for the Scriptures at the east and facing toward Jerusalem. Strickland had had a problem with his Cherry Street Synagogue. The plot there was on the north side of the street. To obtain eastern orientation for the ark he had to adopt a broad house plan and set up the ark against a long wall at right angles to the entrance. Leeser found the Crown Street building rather narrow, perhaps because he was used to the broad proportions of his own synagogue. The gallery for women on three sides was of the usual type. Strickland had departed from common usage in laying out his gallery in two semicircles.[5] The interior of the Crown Street building with the capitals of the columns supporting the gallery and enframing the ark in white and gold was evidently of a lighter, more cheerful effect than the brown stone exterior which *The Stranger's Guide in Philadelphia* of 1852 mentions in its brief description.[6] The wood engraving shows a two-storied, three-bay structure with tall straight-headed windows set in shallow rectangular recesses. The façade, a simulated pylon, was topped by a cavetto and a low parapet. The porch on two heavy columns, treated as bundles of papyrus stalks, was set on sturdy check blocks. It carried an architrave and a modified coved cornice which rose gable-like on the front side and continued across the façade.

The exterior of the building was meant to convey strength and solidity, qualities admired in Egyptian architecture. Strickland with his preference for slender forms had blended the Egyptian motives in his synagogue design with graceful Grecian elements. The Egyptian revival did not aspire to a faithful reproduction of ancient monuments, as did the Greek revival. Walter's synagogue was a free interpretation as was Strickland's. The dome of colored glass in the interior of the Crown Street Synagogue and the many-hued window panes were outright Victorian. We would have liked to know how the dome was framed and whether a sky-light or a lantern was used. The foreshortened view of the wood engraving does not give any indication. Strickland's Cherry Street Synagogue had a lantern over the concealed dome.

In paying tribute to the architect, Leeser was not over-enthusiastic about the style of the synagogue, however. He rejected the suggestion that ancient Jewish architecture may have been conceived in Egyptian forms. He was no less sceptical with regard to the Romanesque revival as a style for a synagogue since he was unaware of the Romanesque style of the twelfth-century synagogue at Worms in Germany.[7] In 1847 Leeser had attended the consecration of the Wooster Street Synagogue in New York, a remarkable work by Otto Blesch and Leopold Eidlitz which escaped the eye of Eidlitz' biographer Montgomery Schuyler. It belongs in the group of buildings in the "Romanesque before Richardson" to which C.L.V. Meeks has recently drawn attention.[8] Isaac Leeser referred to the Wooster Street Synagogue in *The Occident* in his characteristic cautious manner, "The style of the building is so new to us... that we have not yet been able to make up our mind, whether to approve it for a synagogue or not."[9]

As far as we know, Strickland's and Walter's synagogues were the only ones designed in the style of the Egyptian Revival in the United States.[10] A belated example in Canada is the Stanley Street Synagogue in Montreal of 1890 (the building is still standing, but no longer used as a synagogue). As I hope to show elsewhere, the Montreal synagogue building was influenced by the Egyptian trend in Philadelphia. Strickland's Cherry Street Synagogue was taken down in 1860.[11] Walter's Crown Street Synagogue remained in use until 1894.[12] It was the last of Walter's Egyptian-inspired designs,[13] and along with Strickland's First Presbyterian Church in Nashville, Tennessee, of 1849-50, was apparently the last Egyptian adaptation for religious worship in the United States.[14]

9. REMBRANDT, CALLOT, AND TOBIAS STIMMER

Rembrandt's architectural settings have received relatively little attention, and the discussion started by Carl Neumann[1] more than fifty years ago has not been resumed until recently.[2] That Neumann's interest should have been focused on Rembrandt's conception of the Temple of Jerusalem is only natural since this building appears in a number of Rembrandt's Old and New Testament scenes.

We can see the problem perhaps more clearly today owing to a better knowledge of the attempts of the sixteenth and seventeenth centuries to reconstruct the Temple. The question arises: was Rembrandt aware of these scholarly efforts based on the study of the literary sources and, if so, how did the new ideas affect his representations of the Temple?

The Jewish Temple at Jerusalem was portrayed in the fifteenth century as a radially planned structure owing to the belief that the Dome of the Rock, a seventh century Moslem shrine, was that ancient building. The octagonal, domed temple is to be seen, for instance, in Pietro Perugino's *Delivery of the Keys to Peter* (Sistine Chapel, 1482).[3] Bernard Breydenbach, anxious to obtain an authentic view of the Temple for his *Peregrinationes in Terram Sanctam* (Mainz, 1486), took along to Jerusalem the Utrecht designer Erhart Reuwich to have him draw the building on the spot.[4] The woodcut was widely copied.

It may be noted that with their vague notion of the Jewish Temple, the designers did not differentiate the Temple of Jesus' time built by Herod from the ancient Temple of Solomon. Thus the octagonal building is inscribed in Breydenbach's work "Templum Salomonis." The same type of structure stands for Herod's Temple in Perugino's fresco.

The pilgrims to the Holy Land anxious to locate the historic sites were faced with a problem. There were two buildings in Jerusalem on the temple grounds: the octagonal Dome of the Rock and the basilical el-Aqsa Mosque, another eighth century structure. The first was taken to be the Temple of the Lord, i.e., the Temple of Jesus' time. It figures as such in the pilgrims' reports. It is occasionally said to have been built by King Solomon.[5] However, the building chiefly associated with Solomon was the second one, situated to the south of the Dome of the Rock. It is referred to in the thirteenth century sources as the "Temple of Solomon,"[6] or the "Palace of Solomon,"[7] and in the late fifteenth century as the "Porch of Solomon."[8]

The association with Solomon evidently goes back to the references to a Solomonic Porch in the Book of Acts. One pilgrim, John of Würzburg (1160-1170), who is still vague in the designation of the south building — he calls it merely the "building of Solomon" — cites in the same context an episode from Acts 3, the healing of the lame man by Peter and John, where the Porch of Solomon is mentioned. From Acts was evidently derived also the name of the "Beautiful Gate" identified by John of Würzburg with a gate in the west from which the temple grounds were entered in his time.[9]

In Georg Braun's *Civitates orbis terrarum*,[10] a six-volume cartographical work with wood-cuts by Franz Hogenberg and others, three designs of temples are reproduced and no attempt is made to coordinate the different versions. The three-story building of piled-up, diminishing cubes in volume I is termed in the index the "antique and modern" temple. The octagonal structure with the legend "Templum Salomonis" in volume II figures in the index as the "modern" temple. The diagram in the shape of a broad rectangle in volume IV, is said to represent the Temple of the time of Christ.

The compiler of the map in which this rectangular temple form appears, the Dutch theologian Christian van Adrichom, placed to the south of the Temple the "Palatium Salomonis," a reminiscence of the pilgrim tradition, and among the gates leading up to the Temple on the east side the "Porta speciosa," the "Beautiful Gate" of Acts 3. John of Würzburg, we may remember, located the Beautiful Gate on the west side.

It is difficult to put a finger on the exact spot where the new concept of the Temple orginated, but it seems certain that it first appeared in the Bibles of the Protestants, and since the Temple of Solomon is described in the Old Testament, this Temple assumed a rectangular form first. We find the exterior of the Solomonic Temple conceived on the new lines in a Martin Luther Bible with woodcuts by Erhard Altdorfer (Lübeck, 1534).[11] In another Martin Luther Bible with woodcuts by the Swiss Jost Amman (Frankfort on the Main, 1566) the exterior and the interior of the rectangular Temple of Solomon are shown with the ceremonial furnishings and the two free-standing columns at the entrance as described in the First Book of Kings. These woodcuts at a reduced scale were brought out in Frankfort by the same publishers in *Bibliorum utriusque Testamenti Icones* in 1571.[12] The smaller Amman woodcuts were used also in a Louvain Bible re-issued in Venice by Nicolaus Bevilacqua in 1583.[13]

Summing up the scholarly investigations based on the study of the Bible and Josephus Flavius, two Spanish Jesuits, Geronimo Prado and Juan Baptista Villalpando[14] compiled an ambitious three-volume work on the Temple of Solomon which was illustrated with large-scale engravings, plans, elevations, sections, and details in a magnificent if somewhat dry Renaissance style. The success of this publication brought out in Rome was due to the superiority of the architectural drawings, which were highly valued by lovers of classical design. It became a source of inspiration for generations of biblical scholars and draughtsmen in Germany, Holland, England and France.

If we mention at this point a treatise by a Franciscan friar Bernardino Amico,[15] it is not because of any new contributions it offers toward the reconstruction of the Temple, but because a copy of the book was in Rembrandt's possession. This was established by Neumann,[16] who identified the volume as "Gantz Jerusalem van Jacob Calot" listed in the inventory of Rembrandt's art books.[17]

The attribution of the engravings and etchings in Bernardino's treatise to Jacques Callot has been confirmed by documentary evidence.[18]

Bernardino stressed the difference between the ancient Temple of Solomon (which is illustrated in the volume by an oblong rectangular structure) and the octagonal building, the "Tempio moderna," which appears in a large etching labeled "Jerusalem as it is today" (Fig. 1). The Temple of Herod, mentioned with a reference to Josephus' *Jewish War*, 1.21.1 (his 1.27.49), but not illustrated in the book, is called in the text a "renovatio" of the ancient Temple.

The three buildings are thus differentiated clearly enough, except that the caption on one plate showing the octagonal building on a larger scale separately and with its ground plan may be somewhat misleading. It runs: "Temple of Solomon used by the Turks for their worship."

The author points out in the text that the name "Temple of Solomon" was *usurped* by the octagonal building, but it takes some patience to read the text.[19]

Among the publications discussing the Temple in Rembrandt's time or merely illustrating it may be mentioned the *Icones Biblicae* with engravings by the Swiss Matthaeus Merian.[20] His view of Jerusalem with the Temple of Solomon was a most elaborate, amplified version of Jost Amman's schematic woodcut.

Jacob Jehuda Leon, a Spanish Jew, used the Villalpando designs in his *Retrato del Templo de Selomo*.[21] Leon moved in the 1640's to Amsterdam where his wooden model of the Temple of Solomon was a great attraction for many years. It was mentioned as late as 1664 in Philip von Zesen's guidebook of Amsterdam.[22] Leon placed the palaces of King Solomon and his queen on the south (left) side in his engraving of the Temple. Neither in I Kings 7, where the palaces are mentioned, nor in any other Jewish sources, is their location given. Leon must have adopted Villalpando's view about the southern location of the "Regia Salomonis"[23] or else have interpreted the "royal portico" of Herodian times in Josephus' *Antiquities of the Jews*, XV.11.5 as an ancient Solomonic structure.

A reconstruction of the Herodian Temple from data in Josephus *War*, V.5, was compiled by Thomas Fuller. His plan is T-shaped with the entrance hall in the cross bar. To the south of the Temple we see in the engraving the "Porch of Solomon." Commenting on this porch, Fuller points out that it was a separate structure, a cloister, not to be confused with the temple porch

Fig. 1. Jacques Callot, *Jerusalem* (detail). Etching (From Bernardino Amico, *Trattato delle piante et immagini de sacri edifizi di terra santa*, Florence, 1620).

proper. In his opinion this porch was located to the east of the Temple.[24] The discrepancy with the engraving, which shows the porch on the south side, was evidently due to the fact that the plate was made for another publication favoring the traditional southern location. Borrowing of plates was a not uncommon practice among publishers.

The two reconstructions, Villalpando's of the Solomonic and Fuller's of the Herodian Temple, were used by Wenzel Hollar in his engravings for the Brian Walton Polyglot Bible.[25] It is noteworthy that in Hollar's plan of the Temple of Herod the portico which runs along the south side of the temple area is called "porticus regia sive Salomonis," obviously a combination of *Antiquities*, XV.11.5 and Acts 3:11 and 5:12.

With this background in mind, we turn to Rembrandt's representations of the Temple or Temples of Jerusalem.

Rembrandt shows the Temple of Solomon in the *Prophet Jeremiah Mourning over the Destruction of the Temple* (1630).[26] The burning Temple in the left rear is a circular structure with a Baroque portal and a saucer dome.

In the *Reconciliation of David and Absalom* (1642)[27] there appears in the background a heavily buttressed polygonal clerestory building with a saucer dome on a drum. It is noteworthy that, unaware of the fact that the Temple did not yet exist in David's time, Rembrandt even placed the two free-standing columns in front of the building, a feature of the Temple of Solomon (I Kings 7:15).

Without the columns the centralized structure stands for the palace in Susa in Rembrandt's etching *The Triumph of Mordecai* (around 1640).[28]

In scenes set in the Temple's interior it is difficult to determine the form Rembrandt had in mind. He usually gives a fragmentary view of the setting suggested by an arch, a column, a flight of stairs, or a curtain. Wherever the shape of the enclosed space may be discerned, as in *Simon in the Temple* (1631),[29] it evokes a rounded interior rather than one defined by intersecting planes.

In one instance, *The Tribute Money*, an etching of about 1634,[30] a rectangular hall is possibly suggested in the shaded rear of the interior by lines running toward a vanishing point. Not much clearer is the architectural background of the *Tribute Money* of 1655, a painting.[31]

It may be concluded that Rembrandt preferred the traditional rendering of the Temple of Jerusalem as a round or polygonal building. He did not differentiate between the first or Solomonic Temple and the Temple of the time of Christ. In Bernardino's treatise he found the domed octagonal building on two plates and in view of the somewhat misleading caption on one of them, or because he had known the building from numerous other representations as the Temple of Jerusalem, he used it as his model.

Neumann, strangely enough, did not consider the octagonal building in Callot's etching of Jerusalem, the Dome of the Rock, as the prototype of Rembrandt's Temple representations. He picked out a little round pavilion outside the city wall shown on the right side of the print (Fig. 1) as Rembrandt's Temple model.[32] In fact, any of the circular buildings in Callot's plan of Jerusalem would do just as well. But the question is just where, if not from the Dome of the Rock and the Christian tradition associated with it, could Rembrandt have obtained the evidence that the Temple was a central-plan structure?

In connection with the problem of Rembrandt's Temple concept, it will be of interest to examine his etching *Peter and John at the Gate of the Temple Healing the Lame Man*, a late work dated 1659 (Fig. 2). By the time Rembrandt etched this Temple scene illustrating Acts 3:1-11, he may have come to feel more strongly the pressure of the new ideas about the form of the Temple.

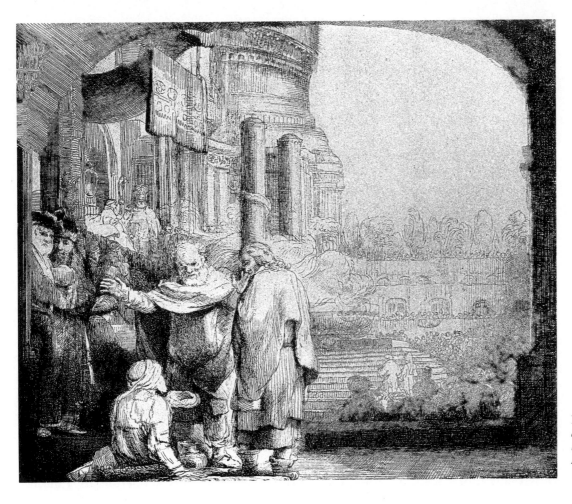

Fig. 2. Rembrandt, *Peter and John at the Gate of the Temple Healing the Lame Man.* Etching, 1659.

Franz Landsberger[33] in discussing the architectural setting of this etching, suggested that Rembrandt followed in his temple design the descriptions of the Temple of Herod in Josephus' *Jewish War* (V.5) and *Antiquities* (XV.11).

Landsberger pointed out that Rembrandt owned a German edition of Josephus' collected works. This one-volume Josephus illustrated by Tobias Stimmer was brought out in Strasbourg in 1574. Eight more editions, or rather printings, of the work had appeared up to 1609.[34] The inventory of Rembrandt's books lists a Josephus "met figueren van Tobias Timmerman."[35]

Landsberger holds that Rembrandt closely followed Josephus' descriptions of the Herodian Temple in his etching of the episode from the Book of Acts. His thesis is that wherever Rembrandt departed from the text in Josephus, he did it owing to the inaccuracies of the German translation, usually the missing of a qualifying word, which left him free to choose his architectural forms.[36]

Let us examine the scene (Fig. 2). On an elevated platform in the foreground we see on the left in back view the lame man half reclining on the ground before Peter, who is standing facing the spectator, and John, who is standing in side view facing left. The group, or rather the whole scene, is enframed by a dilapidated arched gateway that opens onto a court in middle distance on a lower level with a smoking altar occupying the center of the court. The smoke billows between two free-standing columns which front an open canopied porch on the left side. The porch leads to a structure with a roundheaded doorway farther to the left. Alongside this architectural group, in the rear, rises a huge tower.

Constrasted with the pile of buildings in the left part of the picture, we see extending to the right low, terraced walls with olive trees in the farther distance.

Landsberger interprets the tower as the castle Antonia; the lower of the terraces with a crowded tribune as the women's area, and the structure with the canopied porch as the Herodian Temple.[37]

The fortress Antonia is described by Josephus (*Antiquities*, XV.11.4; *Jewish War*, V.5.6) as a citadel protecting the Temple. Fortified by Herod, it was occupied after his death by a Roman legion.

We have to consider now what the building in the etching is meant to be in the light of the Book of Acts. In Acts 4:3 and 5:18 it is related how Peter was thrown into the prison for his unauthorized miracle cure.

The building, then, is a prison in the context of Acts. Its heavy mass looming in the background forecasts the dramatic development of the episode as presented in the Book of Acts. Important, too, for the interpretation of the scene is the view of the author of the Book of Acts that the prison was in the power of the Jewish priests, not the Romans. We shall discuss the shape of the prison tower in due course.

Turning now to the tribune with tiny figures at the parapet, we note that Josephus does not speak of an elevated area for the women. Moreover, according to Josephus (*Antiquities*, XV.11.5; *Jewish War*, V.5.2) the women's court was on the east side, opposite the Temple entrance. In the etching it is at an angle to the canopied building assumed to be the Temple. But more disturbing than this inconsistency is the incongruity of the canopied building itself. Examining it more closely, we note that it is a shallow exedra-like pavilion with no room for a cella and an adytum, i.e., the Holy and the Holy of Holies. The vista which opens behind its sharply foreshortened rear onto some more distant architecture suggested by a small-scale arch, shows how little expansion it has. Landsberger took great pains to interpret the canopied exterior porch as the curtained interior door of the Holy — Josephus speaks actually of two doors (*Jewish War*, V.5.4) — but the interpretation is not convincing.[38] Baffling too is the seated figure in back view inside this supposedly Jewish temple.

In reading carefully Acts 3:2-3, as Rembrandt must have read the passage himself, we obtain some idea of the topography of the scene: "And a certain man, lame from his mother's womb, was carried, whom they laid daily at the gate of the temple which is called Beautiful, to ask alms of them that entered into the temple who, seeing Peter and John about to go into the temple, asked an alms."

Rembrandt followed the text pretty closely. The lame man is seated at a gate, the arched opening that enframes the scene. Peter and John have entered the gate. The lame man, seated this side of the gate, faces everyone that enters. Seeing the two men, he stops them as they are about to go to the Temple. The Temple is not shown, it is behind the lame beggar and hence behind the spectator, beyond the picture plane.

By discarding the interpretation of the canopied porch as the Temple entrance, we invite a number of questions: what was the purpose of the canopied porch, what is the meaning of the Solomonic columns in front of the building which, by the way, do not appear in Josephus' description of the Herodian Temple, and what is the role of the High Priest standing near the porch?

The presence of the High Priest who does not figure in Acts 3 calls for an explanation in the first place. It is to be noted that the High Priest's appearance does not betray any knowledge on the part of Rembrandt of the detailed description of the High Priest's vestments in Josephus (*Jewish War*, V.5.7). The figure with mantle and high headgear is treated sketchily and the

crozier carried by an attendant is actually a Christian bishop's attribute. But reading Acts carefully, we come to understand that the presence of the High Priest is well motivated. In Acts 4:6ff., Annas, the High Priest, and his party gather to discuss the activities of the missionaries of the new sect. Troubled by their success, they forbid Peter and John to talk to anyone about the cure. Thus the figure of the High Priest, in very much the same way as the prison building, serves to foreshadow the dramatic turn of events.

The people who watch the scene with "wonder and amazement" (Acts 3:10) are represented by the two men who advance from the left with gestures of suspicion and apprehension. Their elaborate clothing suggests that they belong to the entourage of the High Priest. They obviously reflect the feelings of the priestly party as conveyed by the Book of Acts. The apostles, in contrast, are characterized by plain clothes and robust demeanor.

The episode in Acts 3 was clearly conceived by Rembrandt as a conflict between the Temple circles and the Christian sect. Rembrandt has based his interpretation not merely on the brief passage in the third chapter of Acts, but rather on the whole Book of Acts, which he had read carefully.

His ignorance of Josephus may be illustrated by the way he treated the altar. Since the altar is not mentioned in Acts, but is described in detail by Josephus, it was plausible to assume the derivation of the motif from Josephus. However, there is no evidence of such borrowing. The source must be sought elsewhere, unless we be satisfied with the explanation that the temple court and a priest readily evoke an altar by association. In his *Medea*,[39] an etching of 1648, Rembrandt uses the same accessories: a priest, an altar, the billowing smoke rising from the altar and the crowded tribune. The altar in our scene is round like a fountain basin in sharp contrast to the Herodian altar as described in Josephus.

Landsberger[40] attempted to excuse the divergence in pointing out that the word "square" is omitted in the German translation of the passage in *Jewish War*, V.5.6. However, the text (fol. 452a) is clear as it is: "Der Altar aber vor dem Tempel war 15 Elen hoch, 40 breyt und lang und gleichsam mit ausgereckten Hörnern in die vier Ecke gebawen."[41]

The data are: equal length and width and projecting horns in the four corners.

Rembrandt has ignored all of this. He has ignored also what Josephus says a little further in the passage about the access to the altar. There was an easy and gentle rise on the south side which the designers following Jospehus used to interpret as a ramp. Rembrandt surrounded his altar with steps.

The departure from Josephus cannot be accounted for by an inadequate translation.

Nor is the omission of the word "square" in the description of the fortress Antonia in *Antiquities*, XV.11.4 an excuse for the round shape of Rembrandt's prison building. In turning the page from the discussion of the altar on fol. 452a to fol. 452b, Rembrandt would have easily found the needed information: "Sonst war das Schloss Antonia wie ein Thurn gestaltet auch auff den Ecken mit vier anderen Thurnen bevestigt" (*Jewish War*, V.5.8). The data here are: a tower with four turrets at the corners. Rembrandt betrays no knowledge of this passage either.

Since Rembrandt, judging from what Joachim von Sandrart[42] had to say about the artist, did not know German, there is not much likelihood of his having been acquainted with Josephus' Temple descriptions.

But there is evidence that he carefully read the book of Acts. Like the mediaeval pilgrims, he must have pondered over the location of the "Beautiful Gate" of Acts 3:2 and the "Porch of Solomon." The location of the porch was not quite clear. Acts 3:8-11 could be interpreted as meaning that the people followed the lame man, now healed, into the temple porch. The

Fig. 3. Tobias Stimmer,
*The Temple before Its
Destruction*. Woodcut
(From Josephus Flavius,
Jüdische Geschichten).

Fig. 4. Detail of Fig. 3.

alternative was that they watched him from the "Solomonic Porch," i.e., from the outside as he was leaving the Temple,[43] Acts 5:12 confirms the impression that the so-called "Porch of Solomon," used as a popular gathering place, was a portico not attached to the Temple.

The pilgrims who believed in the authenticity of the extant buildings in the Temple area identified the Porch of Solomon with the south building (the el-Aqsa Mosque). We see the basilical structure in Callot's view to the left (south) of the octagonal building. In Bernardino's time it was the residence of the Franciscans ("luogo di frati Mri").[44] Bernardino must have lived there during his stay in Jerusalem. However, the pilgrim tradition regarding the Solomonic origin of the building was carried on, as has been seen, in sixteenth and seventeenth century cartography. Rembrandt, it may be noted, placed his canopied porch on the left side of the scene.

The subsequent phase of the story with the lame man walking and the people watching him from the Solomonic porch is not and could not be portrayed, but it is implied by what we do see. The porch is pointed out by the Solomonic columns evocative of its name and the people are actually gathered at the porch and outside it, close to the foreground scene.

To prevent a confusion with the Temple, Rembrandt placed inside the canopied building the incongruous figure seated back turned toward the entrance. The pedestal on which the figure is seated suggests a statue, an object one would not expect to find in a Jewish temple.

As has been noted before, the arch that enframes the scene is a gate leading to the Temple. It is identified as the "Beautiful Gate" of Acts 3:2-4 by the presence of the lame man and the apostles. Its dilapidated condition is clearly symbolic of the imminent downfall of the Temple. In Callot's plan of Jerusalem the "Porta Spetiosa" is the central of the three crenellated gateways on the west side, the one overlapped in part by the octagonal Dome of the Rock. We can easily imagine the lame man seated on this side of the gate with the Temple at his back. The southern building (on the left) would have to be shifted upward somewhat to agree with the location of the Solomonic porch in Rembrandt's etching (Fig. 1).

Was Rembrandt familiar with the tradition associated with that building? Or is it pure

114

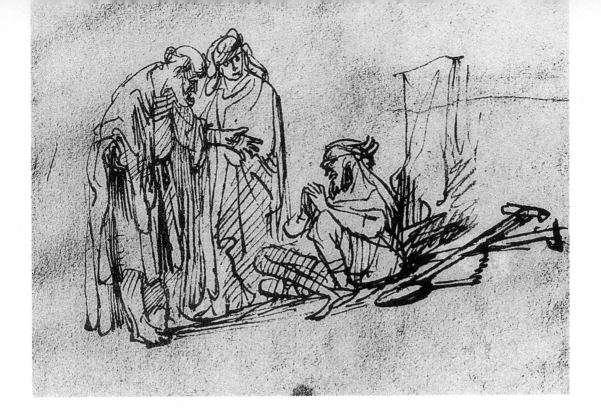

Fig. 5. Rembrandt, *Peter and John Healing the Lame Man.* Pen and bistre drawing. Darmstadt, Hessisches Landesmuseum (From Otto Benesch, *The Drawings of Rembrandt,* London, 1954).

coincidence that he placed the Solomonic porch on the left side? In fact, the arrangement of the scene with the main figure in the left foreground called for a backdrop on the left. Thus pictorial considerations alone could account *à la rigueur* for the emphasis on the left background. Not so easily accounted for is the question about the composition of the figure group with the lame man in the rather unusual back view.

Obviously Tobias Stimmer's woodcuts in the Josephus owned by Rembrandt come to mind in the first place.

Hofstede de Groot[45] considered in a general way the possibility of an influence of Stimmer's illustrations upon Rembrandt's work, but he could not discover any evidence of it. Perhaps with a specific work as a point of departure, the search would have been more rewarding.

In leafing through the volume one comes across a scene on fol. 475b which must have arrested Rembrandt's attention (Fig. 3). The woodcut, an illustration to *Jewish War,* V.3-4, represents the Temple before its imminent downfall. An apparition in the sky and other unusual happenings forecast the doom. A man in the foreground is lamenting the fate of the Temple. The episode — a literal portrayal of the narrative in Josephus — does not concern us here, nor is the Herodian Temple, only partially visible, especially interesting except that it seems to be a rectangular building. Emphasis is on the ascent to the Temple, a winding road with open gateways and people seen on different levels.

One group on the level just above the stepped foreground platform is particularly striking. It depicts a man, half reclining, in back view, with two others standing before him. The figure on the ground seems to be a sick man. His posture resembles that of another man, more prostrate, who is seen a little further to the left, beyond an entrance marked by a parapet and two armed guards. The men lying on the ground are evidently cripples or sick beggars expecting alms from the priests passing by. The two men standing closely together near the first beggar are priests, to judge from their long garments. One of them is facing the spectator, the other is shown in side view facing left (Fig. 4).

The position of the beggar and the priests in the woodcut readily evokes that of Peter, John,

Fig. 6. Rembrandt, Figure Study. Black chalk drawing. Dresden, Kupferstichkabinett (From Otto Benesch, *The Drawings of Rembrandt*, London, 1954).

Fig. 7. Rembrandt, *Peter and John at the Gate of the Temple Healing the Lame Man.* Etching.

and the lame man in Rembrandt's etching. It seems certain that Rembrandt derived the idea of presenting the beggar in back view from this woodcut.

He did not adopt this solution from the outset, however.

In a study for the etching, a pen and bistre drawing (Hessisches Landesmuseum, Darmstadt),[46] with the group in reverse (Fig. 5), the lame man is clearly in an early, experimental stage with tentatively sketched three legs. He is seated in ¾ view, facing left. The silhouette of the apostles resembles that of the priests in Stimmer's woodcut. It is Peter, not John who is shown in side view. He extends his arms in a familiar gesture which carries us back to Rembrandt's early period; it is found in his black chalk drawing of a single figure (Kupferstich-kabinett, Dresden) (Fig. 6) dated by Benesch about 1629.[47] Rembrandt knew the motif from the workshop of his teacher, Pieter Lastman, who had used it in the *Resurrection of Lazarus* (1622)[48] and other paintings.

Considerable advance in the composition of the scene is to be noted in an etching by

117

Rembrandt which because of its rough execution has been dated by Hind only slightly later than the chalk drawing in Dresden, i.e., about 1630.[49] However, the etching cannot antedate the Darmstadt drawing as a comparison of the two versions clearly shows (Figs. 5 and 7). The rapid, nervous, but firm lines, the impatient hatchings reveal an improvising hand, the inspiration of the moment. This may account for the poor execution. The apostles are now in the right position, shifted closer to the lame man, but the emphasis is not on them. In fact, the figure of John is wilfully smeared over. Interest in the setting is now introduced perhaps for the first time. There are no other preliminary sketches extant. The group appears upon a raised platform which, it may be recalled, is a feature of Stimmer's woodcut. The lame man turns toward a gateway, on the left, the "Beautiful Gate" of the Book of Acts. Two men, evidently worshippers, come up from the left where we have to suppose the stairs. The apostles have just arrived and are being stopped by the lame beggar on their way to the Temple. The Temple is not shown. It must be imagined on the right, opposite the gate, beyond the picture frame. A few sketched lines on the extreme right suggest some architecture, a columnar wing or a parapet.

It is worth noting that the representation of the Temple was not contemplated in this study.

The posture of the lame man is now determined by the presence of the gate, which is somewhat removed from the first plane. In order that he may face the gate, he has been turned a little toward the rear; his head appears in a lost profile, his right arm and right leg are no longer visible and we see more of his back.

We can easily understand what Rembrandt missed in the arrangement of the setting in this etching. The outlook from the foreshortened and partly screened gate down into the country was limited. By widening the gate and turning it around so that it would encompass the whole scene, a vast panorama could be unfolded offering room for the significant elements of the story: the Solomonic porch, the prison, the High Priest, not to speak of the various accessories, the altar, the tribune, the terraces, the crowds, and last but not least the olive trees.

Stimmer's posture of the beggar, which was then adopted, made this solution possible.

It seems that Rembrandt turned time and again to the woodcut in his Josephus discovering in it new points of interest as his work was maturing. There were the two worshipers in the earlier etching who became the two onlookers in the final version. The pairing of figures is typical of the groupings in Stimmer's woodcut. Anticipated by Stimmer was also the device of the figures overlapped by the platform. It proved very effective in the arrangement of the figures in the altar court. The altar itself could have been suggested by the sacrificial animals led to the Temple in the woodcut (Fig. 3).

Even the shape of the "Beautiful" archway which enframes the scene finds its counterpart in Stimmer's woodcut. Elliptical or three-centered arches were not so much in use in Holland in Rembrandt's time. Stimmer uses segmental arches in the Temple façade and an elliptical arch in the large gateway where it is rather awkwardly combined with pilasters and a pediment.[50]. The architectural setting is altogether a composite. Callot's view of Jerusalem with the long arcade running in the back of the Temple grounds (Fig. 1) has suggested the motif of the low terraces with the arched recesses which in Rembrandt's etching also close the Temple court. The pattern of the windows in the recesses was provided again by Stimmer's Temple. Stimmer's tower on a circular substructure evidently gave rise to the round prison tower in Rembrandt's etching. For circular buildings Rembrandt had in addition rich material in his collections of works on Roman antiquities. Neumann had already noted the resemblance of the building in the *Reconciliation of David and Absalom* with the so-called Temple of the Minerva Medica.[51] The Castel Sant'Angelo may have inspired the prison building in Rem-

Fig. 8. Matthaeus Merian, *Peter and John Healing the Lame Man.* Engraving (From *Biblia, Das ist die gantze Schrift*).

brandt's etching of 1659.[52] It was a favorite theme with Marten van Heemskerck, Willem van Nieuwland,[53] and other Dutch artists.

However, for all the resources at his disposal, Rembrandt returned time and again to Tobias Stimmer. A figure kneeling on the altar steps in the etching wears a curious bonnet with a long tail reaching down to the waist. In Stimmer's woodcut several figures display a headdress of this design (Fig. 3).

Ludwig Münz[54] has suggested that something like the engraving illustrating Acts 3 in Merian's Bible (Fig. 8) may have served as a model for Rembrandt's three principal figures. In our view, the comparison brings out the differences rather than the similarities in Rembrandt's interpretation. In Merian's engraving the porch of the Herodian Temple is in the back of all three figures, Peter, John, and the lame man. As though on a stage, the three figures are presented in their broadest, fullest view, with manneristic gestures, an arrangement that cannot convey the mutual relationship and the feeling of participation stirred up in the beggar. Then, too, the apostles are shown leaving, as it were, and not about to proceed to the Temple. In Rembrandt's interpretation, the beggar faces the apostles, but is withdrawn from our scrutiny. It is left to the spectator's power of imagination and empathy to sense the emotion of the man projected back through the apostles and thus conveyed indirectly.

To conclude then: Rembrandt had not read his Bernardino, nor had he read his Josephus, but he had examined carefully and repeatedly the pictures in these books. And above all else, he has tried to relive the episode recounted in the Book of Acts. The painstakingly compiled reconstructions of the Temple by Biblical scholars could offer but little to an artist of Rembrandt's temper intent on conveying a psychological situation in terms of pictorially significant form.

10. THE MONEYCHANGER WITH THE BALANCE: A TOPIC OF JEWISH ICONOGRAPHY

In the month of Adar people were streaming into the Holy Land from everywhere, from Greece, the Greek islands, from Egypt, even from Spain, and, of course, from the Babylonian communities to celebrate Passover. The Temple administration had set aside that month for the collection of the Temple tax, and they had the hands full with exchanging the foreign money for domestic currency and providing people with half-shekel coins.

The tax was not too high for those from abroad, and there was money in the land owing to the influx of pilgrims. However, for the very poor the tax was heavy, and one day a small group, mostly fishermen from around the Sea of Galilee, went to the Temple grounds and overthrew some of the change booths or desks. In the Gospel of Mark, xi, 15-17, where the incident is told, it would appear that the desks were inside the Temple but it is not related exactly where. They may have stood in the porticoes surrounding the courts, possibly in the so-called porch of Solomon where people used to meet, as we know from the Acts of the Apostles, iii, 11.

The exchange operations used to start in the provinces on the 15th of Adar and continued from the 25th onwards in Jerusalem (*Mishna, Shekalim* I, 3). For those who were behind in taxes, special "old shekel" desks were provided (*ibid.* VI, 5). By the first of Nissan the tax had to be turned in, and all was over.

To be sure, there were hardships, but the equal tax for all was established in ancient times (Exod. xxx, 13) when its money value was probably small. It was a token of allegiance to the Sanctuary — one Sanctuary, one people. The fact that contributions for the Temple were not being accepted from pagans and from the Samaritans (*Mishnah, Shekalim* I, 5), shows that the Temple tax still had that lofty symbolic meaning. With the destruction of the Temple the collection of the tax was suspended by the Jewish authorities.

And yet, the memory lingered on. A particular *Shabbath Shekalim* was dedicated to it. And we find in medieval *Machsorim* poems (*piyutim*) on the Temple tax shekel.

I have found miniatures depicting the shekel motif in two Ashkenasic *Machsorim*. Their meaning was not clear to me at the outset. The reader will see that they could be easily misinterpreted.

In the *Worms Mahzor* dated 1272, formerly in the old synagogue at Worms destroyed by the Nazis, now at the National and University Library, Jerusalem, the full page miniature (Fig. 1)[1] portrays a man in a red garment with curly hair, his face in profile summarily drawn. He holds a balance. The scale on the left tips, weighed by a heap of round objects. He stands in a roundarched romanesque portal painted in shades of pink and brown, set off with dark green

Fig. 1. The Moneychanger from the Worms Mahzor.

and white. The portal is topped with crenellations and profusely decorated with coupled arches, palmettes, and acanthus leaves. It displays in its tympanum the sun — a sixpointed rosette on a green and red background — and the crescent of the moon. A funny long-eared bearded masque, a jubilant lion and a lustily barking dog complete the picture of what seems to be the gate to some heavenly abode, possibly the heavenly Temple itself.

The bird-like profile of the man is characteristic for the avoidance of portraying the human face, a feature found in other figures of the Worms *Mahzor*[2] a well as in a number of medieval Ashkenasic *Mahzorim*. The balance, *moznayim*, suggests at the first glance the constellation "libra" for Tishri, and hence the Day of Atonement. That is how I originally interpreted it.[3] Goodenough[4] has adopted a similar interpretation associating the scene with the New Year and the Day of Atonement and seeing in the man holding the scales a judge. It was not before I became familiar with the contents of the prayer of which the four commencing lines in the Worms manuscript appear at the bottom of the page (Fig. 1) that the true meaning of the picture occurred to me. The prayer is the *Yoṣer* for the *Shabbath Shekalim*. It is missing in most *Siddurim*. High up in the tympanum of the portal flanked by the sun and the moon appears the word *El* (*alef* and an abbreviated *lamed* with a flourish), while the word *mitnasse* stands between the lion and the dog. The follow three lines in smaller lettering. The man, then, is the moneychanger holding a balance with coins, the coins intended for the Temple tax. The scene is connected with the month of Adar which precedes Nissan, the Passover month.[5]

The balance without the moneychanger is to be found depicted in a miniature of the fourteenth century *Mahzor* at the Leipzig University Library (Fig. 2). Here it is hung on a hook just above the initial word *El* which occupies the centre of a broad rectangular headpiece. Two circles, one above the other, are seen on either end of the panel. They display a man holding a book, a lion, an eagle, and an ox. Bruck[6] suggested the figures of the four Evangelists as a possible explanation. It is evident that the figures are the "four living creatures" of the Temple vision of Ezekiel, i, 5-10, whom the Church adopted as symbols of Matthew, Mark, John, and Luke. Here, too, we have the usual humoristic, sometimes satirical, medieval iconography. A dog is chasing a hare on the frame above and a dragon with a griffin try to tip the scales. We would be in doubt about the significance of the scene if it were not for the initial word *El* of the prayer for *Shabbath Shekalim* displayed in the headpiece and the precedent we have in the Worms *Mahzor*. The Temple is evoked here by association with the four creatures of the divine chariot and its wheels in Ezekiel's vision.

We meet the moneychanger with his balance again in the *Sefer Minhagim*, the Book of Customs. Best known is the Amsterdam edition brought out by Proops in 1723. Owing to the discovery of the illustrated edition printed by Di Gara in Venice in 1593 in the collection of Judah Joffe in New York, it was possible to date the woodcuts which appeared in the various later editions, redesigned with slight changes.[7] We bring the picture of the moneychanger from the Venice edition of the *Sefer Minhagim of* 1593 (Fig. 3). The woodcut is inserted in the text of *Parshat Shekalim*. It shows a man wearing a short cloak and a hat and pointing toward a balance set on a table on which coins are scattered, some arranged in little piles. There is a weight to be seen on the flat square scale on the right, the hollow left one is empty. The scene is taking place outdoors in a paved court. The hand of God extends from the clouds on the right with a finger pointing. This feature alludes to a charming story. As it is told in *Pirke de Rabbi Elieser*, 48,[8] God used each finger of his right hand to bring about some deeds of salvation. With the little finger He pointed out the ark to Noah, with the fourth He slew the Egyptians, with the middle finger He wrote the Ten Commandments upon the tablets, and with the second finger He pointed out to Moses the half-shekel to be given by every Israelite for his

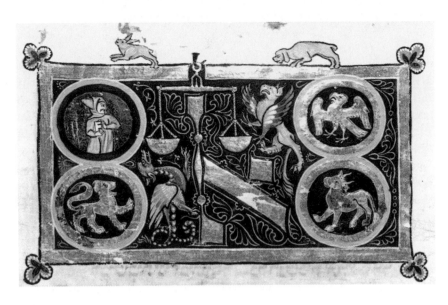

Fig. 2. Balance from the Leipzig Mahzor.

atonement. The pointing finger is spectacularly long in the woodcut of the Amsterdam edition of 1723 which shows how popular the story was, the more so as it is not even mentioned in the *Minhagim* book. The hand in the sky is by the way the left one due to the fact that the drawing appears in the print in the reverse.

The three versions of the shekel motif discussed above have two points in common: the balance and the symbol of divine presence.

The balance raises a question. Why has the artist persistently pointed out the weighing of the tax money? It is interesting to note that in El Greco's painting "Christ driving the money-

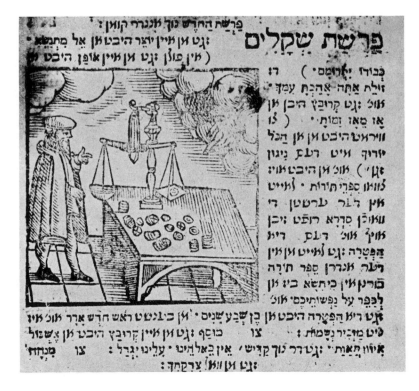

Fig. 3. The Moneychanger from the Venice *Sefer Minhagim.*

123

changers from the Temple", dating from about the time of the Venice edition of the *Sefer Minhagim* (1593), men are seen carrying off baskets and a box, obviously containers of money, but the balance does not appear.[9] The balance, then, was not felt to be an indispensable accessory of the trade of the moneychanger. It is, however, an important requisite in Jewish illustration as we have seen. Its importance may be judged from the fact that in the Leipzig *Machsor* it appears alone, without the moneychanger. The explanation is that the word "shekel" actually means "weight" and that the weighing of the money is referred to in the poem on the shekel tax. In the *Sefer Minhagim* it is not mentioned, but the word "shekel" in the title of the paragraph *Parshat Shekalim* was by itself evocative of the act of weighing.

Compared with the consistency in the use of the balance in the scene of the moneychanger, the symbols for the divine vary. We have the Temple gate, the Divine Chariot, and the Hand of God. These are variations on one theme derived from a basic conception, to be sure, but conveyed by different images which are independent from each other. They cannot be traced to a common pictorial prototype. It is evident that the iconography of the "Moneychanger with the Balance" was drawn upon the literary Hebrew sources and the literal meaning of the word "shekel".

11. EZRA STILES AND THE PORTRAIT OF MENASSEH BEN ISRAEL

Ezra Stiles, President of Yale College, had during his ministry at Newport, Rhode Island, become a great friend of the Jewish community there. He attended the opening of their synagogue in 1763; was interested in the religious ceremonies and customs of the group; undertook the study of the Hebrew language, and was able in a short time to read some Hebrew works in the original.

With this background in mind, we can understand why he was greatly pleased to receive a portrait of Menasseh ben Israel. In his *Diary*, he mentions the gift in an entry of October 3, 1775. He does not seem to have read any of Menasseh ben Israel's writings, but he remembered that Judah Monis (d. 1764), the instructor of Hebrew at Harvard College, had used Menasseh's works in his classes, and appears to have known that Menasseh, the "very learned Hocham and Philosopher was in great Reputation among the Christian learned in Italy."[1]

The latter remark has never provoked any comment, although it is striking that the Protestant clergyman should have put weight on Menasseh's reputation among scholars in Catholic Italy rather than in the Protestant countries, Holland, England and Germany, where Menasseh was undoubtedly much better known. We shall revert to this point later.

The reference to the portrait raises the question just which of Menasseh ben Israel's portraits was presented to Dr. Stiles.

The interest in Menasseh's portrait is due to the fact that the Amsterdam rabbi had been portrayed by Rembrandt. A portrait, an etching, dated 1636 and signed by Rembrandt, is extant. It is of full bust length, full face, with the body slightly to right, the lower border rounded (Fig. 1).

Menasseh was of "middle stature and inclined to fatness" as some people recalled who had known him in 1655-1656.[2] The tendency to stoutness is already noticeable in this portrait of 1636. Charles Ogier, a Frenchman who visited Amsterdam in 1636, and went to meet the famous rabbi concerning whom he had heard from a pastor Johann Möchinger in Danzig, noted in his "Diary" that Menasseh was "not of an advanced age."[3] This was a rather reserved characterization considering the fact that Menasseh ben Israel was only thirty-two. He probably looked older than his age.

A portrait in oils of Menasseh ben Israel by Rembrandt, dated 1636, is listed in John Smith's catalogue of 1836.[4] Smith neither gives the location of the portrait nor does he record its colors which indicates that he had copied the description from some exhibition or sales catalogue. The painting has never been found. It may have been, judging from the description of it, the original after which the etching was made. In a similar way, Rembrandt had painted in oils and etched portraits of the Jewish physician Ephraim Bueno.[5]

In addition, Smith mentions two engravings of Menasseh's portrait, an anonymous one and one by J.G. Hertel. The latter was "engraved in an oval."[6] Johann Georg Hertel, the 2nd,

Fig. 1. Menasseh ben
Israel. *Etching by
Rembrandt, 1636.*

Fig. 2. Menasseh ben
Israel. *Mezzotint, 18th
century.*

belonged to an engraver family in Augsburg, Germany. His father was still alive about 1760.[7] The son then was active in the later part of the eighteenth and perhaps the early nineteenth century. The catalogues mentioned six engravings and one etching by Hertel after works by Rembrandt.[8]

Furthermore there exists an eighteenth century mezzotint which is a modified version of Rembrandt's etching of 1636.[9] It is a softer, smoother version. A smile plays around the lips. A deep shadow charitably dissimulates the stoutness. Pleats add richness to the cloak. The grounding gives the mezzotint the characteristic velvety tone (Fig. 2). In some reproductions, this portrait appears with the figure turned to the left.[10]

A wood engraving, listed by Alfred Rubens, must also be mentioned.[11]

With this survey in mind, we will be able to examine with more profit the passage in Dr. Stiles' *Diary* which gives some data about the portrait. The passage reads:

> Mr. Isaac Mark, a learned Jew, gave me the picture of R. Menasseh Ben Israel who was aet. 38, A.D. 1642.[12]

The date actually eliminates Rembrandt, as well as Hertel and the mezzotint. An engraved portrait of Menasseh ben Israel bearing these dates turned up at the Anglo-Jewish Historical Exhibition in London in 1887.[13] Its legend reads on the lower left as follows: "Aetatis suae Anno XXXVIII," on the lower right: "Anno MDCXLII," and further down across the bottom "Salom Italia sculpsit" (Fig. 3). The "Domini" is omitted in the designation of the era. Salom Italia, son of Mordecai, was a Jewish engraver in Amsterdam. He came from Italy. Works of his are known, among them an engraved portrait of Jacob Jehuda Leon, the maker of a model of the Temple of Solomon, and a number of illustrated Esther scrolls.[14] Salom Italia often used the Hebrew era in the dating of his words.

126

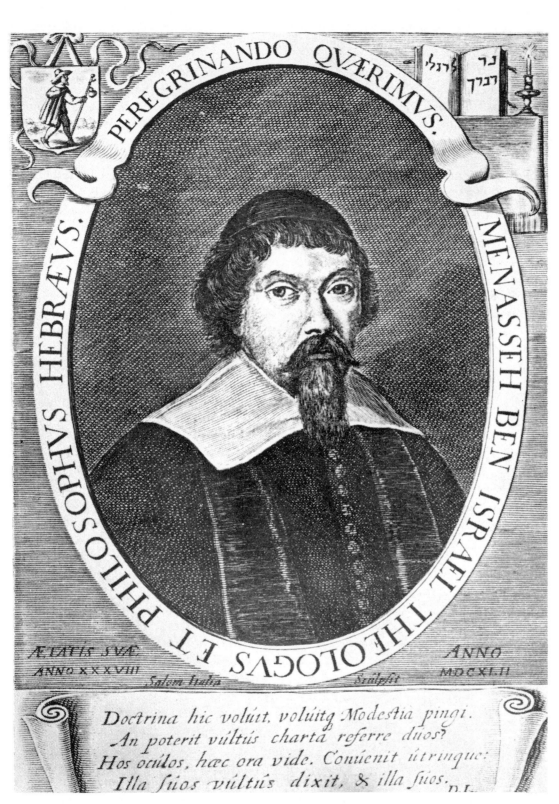

PEREGRINANDO QVÆRIMVS.

MENASSEH BEN ISRAEL

THEOLOGVS ET PHILOSOPHVS HEBRÆVS.

ÆTATIS SVÆ
ANNO XXXVIII

Salom Italia *Sculpsit*

ANNO
MDCXLII

Doctrina hic voluit, voluitq Modestia pingi.
An poterit vultus charta referre duos?
Hos oculos, hæc ora vide. Convenit utrinque:
Illa suos vultus dixit, & illa suos.

Fig. 3. Menasseh ben
Israel. *Engraving by
Salom Italia, 1642.*

Lucien Wolf, one of the organizers of the Anglo-Jewish Historical Exhibition, remarked in an article in the London *Jewish Chronicle* that Salom Italia's portrait of Menasseh ben Israel "resembled the famous etching by Rembrandt executed six years earlier."[15] This observation

127

shows the remarkably keen eye of a man who was a journalist, a political figure on the Jewish scene, but not an art expert. The resemblance is not as striking as that of the mezzotint and Rembrandt's etching. This is a much more reworked version by a copyist, anxious to produce a neat, conventional portrait. To be sure, the posture is the same, the manner in which the rounded border cuts the bust at the bottom is the same. We note, however, that the nose, rather fleshy, in Rembrandt's etching, has become thinner, more distinguished, the eyes larger and the eyelids less heavy. The moustache and the beard are here well trimmed and the full lips are shaded in order to appear less conspicuous. The heavy, broad brimmed hat is replaced by a skull cap which exposes the neatly combed dark curls. The skull cap was commonly worn indoors by scholars, clergymen and older men alike, as attested by Dutch portraits of the period. It was not an exclusive attribute of the Jew. Examining further Menasseh's attire in Salom Italia's engraving we notice that the square "pendent" or turned down collar lies neatly, almost flat on the shoulders. The range of buttons down the front of the doublet is even and straight, every suggestion of obesity being removed. The cloak is of a deep, dark shade and the facings of the cloak have acquired a silky sheen. The background is also shaded.

Speaking of the facings which in Rembrandt's etching are treated rather sketchily, we have to mention Landsberger's view that the scarf-like panels are actually a praying shawl.[16] This interpretation is unplausible for many reasons. A white *tallith* [prayer shawl] would have been rendered in a lighter shade than the garment. It would not have been worn underneath the collar, nor would it be reduced in size to a scarf as it sometimes is in modern times. Charles Ogier who, during his stay in Amsterdam had visited two synagogues, describes the *tallith* as a white *"peplum* made of camelot" in which one wraps oneself covering the head.[17]

Salom Italia, a contemporary of Rembrandt, interpreted the long panels framing the doublet as facings of the cloak emphasizing their silky texture.

A good example of a cloak trimmed with velvet is offered by the portrait of Ephraim Bueno by Jan Lievens.[18] Fur lined and fur edged cloaks were also the fashion.

Reverting to Salom Italia's portrait, we realize that the handsome man with the regular facial features and the gentle benign look is not the Menasseh ben Israel we know. This is not the "choleric, impetuous little man," as Cecil Roth characterizes him,[19] the man with a drive and imagination who will one day — in 1655 — go to London to plead with Oliver Cromwell "in behalf of the Jewish nation."

Rembrandt's early portrait can be readily associated with this image. But Menasseh had apparently no use for it. Salom Italia's was to be his official "effigy." He supplied the engraver with the descriptive matter for the legend. Around the oval border of the portrait run the words: *"Menasseh ben Israel, Theologus et Philosophus Hebraeus,"* accompanied with the motto *"Peregrinando Quaerimus"* [by our wanderings we seek]. This was the device of Menasseh ben Israel's printing press. The motto is illustrated by a pilgrim with staff and bundle in the upper left corner of the engraving. An open book and a burning candle appear in the upper right corner. The book is inscribed in Hebrew: "Thy word is the light for my feet," a variant of *Proverbs* VI:23. A scroll at the bottom displays an appropriate Latin epigram.

This is the portrait that was appended to some copies of the first Latin edition of Menasseh's *Hope of Israel*, published in Amsterdam in 1650.[20] A number of prints must have been taken from the plate engraved by Salom Italia. One such print was sent by Menasseh to the Christian mystic, Abraham von Franckenberg, in 1643.[21]

Another turned up more than a hundred years later in the hands of Isaac Mark, the "learned Jew" who gave it to Dr. Stiles. We wish we knew who Isaac Mark was and where he came from. He has left no trace in the annals of the Jewish community of Newport.[22]

We can vividly imagine Ezra Stiles bending over the portrait, examining the emblems and poring over the inscriptions. A portrait to his taste had to be more than a likeness of the sitter; it had to convey his intellectual pursuits and scholarly activities. Ezra Stiles describes in his *Diary* (entry of August 1, 1771)[23] a portrait of himself by Samuel King, a Newport painter, which had just been completed. He was particularly pleased with the background of the painting filled with books on shelves. Among the books displayed there he mentions Livy, a history of China, Ibn Ezra, Rashi and Maimonides' *Moreh Nebukim*.[24] The desire to be portrayed with one's favorite books was typical not only of scholars. The British painter William Hogarth (1697-1764) put in one of his self-portraits three books bearing the names of Shakespeare, Milton and Swift.[25]

To us today, familiar as we are with Menasseh ben Israel's biography, the legend in his portrait is self-explanatory for we know about the Hebrew printing press — the first in Amsterdam — which he established, and we know of the tribulations and vicissitudes that he and his family had gone through as Marrano refugees from Portugal and Spain.

To Ezra Stiles the "book and the candle" in the engraving were just attributes of the scholar, and the "pilgrim with staff and bundle" a symbol of the wanderings of the Jewish people in general. The name of the engrver in the print was an obscure one, but the surname "Italia" evoked associations. It pointed to the origin of the artist and suggested the provenience of the engraving. It could be easily inferred from the name and the dating according to the Christian era that there had been a demand for Menasseh's portrait in Italian literary circles. Hence, Dr. Stiles' remark in his *Diary* that Menasseh ben Israel was "in great reputation among the Chirstian learned in Italy."

This remark implies that the portrait carried the signature of Salom Italia. It was the portrait that Menasseh ben Israel liked and wished to be remembered by.

12. GLEANINGS: THE ZEENA U-REENA AND ITS ILLUSTRATIONS

Some problems, unsolved or partly solved, keep haunting you and following you wherever you go. In my study on the origin of the illustrations of the Amsterdam Haggadah for Passover of 1695 and its somewhat modified version of 1712, I was able to find their prototype in engravings by Matthaeus Merian of Basel.[1] This versatile engraver and book dealer who had taken over the publishing firm of his father-in-law, de Bry at Frankfurt-on-the-Main, had flooded the European marked with books illustrated with engravings, mostly the work of his sons and assistants. Particularly popular were his "Icones biblicae", sets of biblical pictures supplied with rhymed passages from the Old and the New Testament in several languages. In 1630 appeared a whole Luther Bible in folio with the same set of engravings, and in the 1650s the two editions were brought out in Holland.[2]

No wonder that the Merian engravings were widely known. Merian's bulky picture bible was still in use in the 18th century and it was associated by Goethe who mentions it in his "Dichtung und Wahrheit" with the most cherished memories of his youth.

With the discovery of the Merian engravings as the model of the engravings of the Amsterdam Haggadah in mind, I had no difficulty in recognizing the source of a picture in a Purim scroll written and illustrated by a Sephardi artist in Holland, Abraham de Chaves, in 1687. The only picture in this megillah, a drawing, was a much reduced and simplified copy of the scene "Esther pleading for her people before Ahasuerus" in the Merian Bible.[3]

It was clear that the Merian Bible was regarded as a treasury of biblical pictures to borrow from. The idea of plagiarism did not bother yet the artistic community. It could be expected that other copies or versions of the popular engravings would turn up and this assumption was to be confirmed soon enough. While visiting the Sholem Asch collection at the Yale University Library I was shown an edition of the "Zeena u-reena", published in Amsterdam in 1792[4]. Leafing through the volume decorated with woodcuts I came across the familiar picture of "Esther before Ahasuerus" which was nothing but a simplified and reversed version of Merian's engraving. (Fig. 1.) The kneeling queen was there, the king holding out his scepter to her, even his two courtiers were present. Of the two armed guards one only was shown and his figure was cut off by the edge of the woodcut. There were other omissions. But the gallows with the ladder, the hangman and the hanged as well as the crowd looking on, and the architectural setting, — everything was there, exactly as in the engraving, only reproduced on a smaller scale and in the coarser technique of the woodcut. (Fig. 2.)

My New Haven visit was unfortunately brief, but I promised to myself that I would follow up the trail and take up some time the "Zeena u-reena" for closer examination.

It so happens that only a few days ago I got around doing something about that matter. The library of the Jewish Theological Seminary in New York has in its large collection several

130

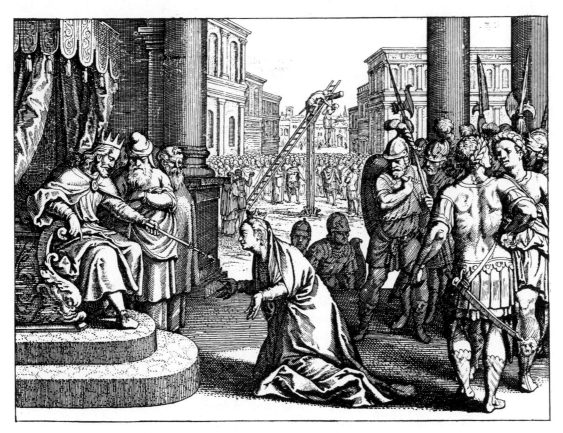

Fig. 1. Esther pleading for her people before Ahasuerus. Engraving by M. Merian. From the Dutch edition of the Icones Biblicae, about 1650.

Fig. 2. Esther pleading for her people before Ahasuerus. Woodcut. Signed N. M. From the Zeena u-reena, Amsterdam, 1792 Courtesy Sholem Asch Collection, Yale University Library.

מגילת אסתר תנ״ח

תירוץ ׀ מיז ׃ יזי זאגט אסתר מיך בין גיקומן פון) טמול הגולך (העביי׃ מול׳

וֹ שׁים אסתר טוט מין פוס פמל פר דען מלך אחשורוש מוז׳ המן הענגטן מן

גמלגן מיט זיין נעהן זין)

לֹ׃ן דמט פמלק זוערט פערט לורן ׀ דען מיז אין גבירד מך ניטט ׃ כלומר מיזן

אלך זון פחלק מיז ניטט ׀ ויאמר המלך הנה בית המן נתתי לאסתר ער ׃ מגט

)מחטורוט גו ארדלי(אסתר דים טרומרט זער זים גדענקט מיך זזיל דז פמלק

ניט וזיל זיין ׀ דרום זזג מיך דיר מיך האב גגעבן דט הוז פון)האן(גו אסתר׃

מוז׳ האן היוט און גהמנגן ׀ דם זזערן זיך מל דים מזזות פערלרטן ׀ דר זזיל ארדלי

מיז מין זמרטמלק גוימרן ׀ מוז׳ רט הוז פון האן המט און גגעבן גו אסתר ׃ דם

זין כון מל דים יהודים גוזזרניגזאו דיט מזה ׃ יזם זזזרו בזו רגט זז ני נ גרעטט

editions of the Zeena-u-reena, some illustrated.[5] I took up a Sulzbach print of 1785 after finding in its picture set the Esther scene I knew so well. The source of the other woodcuts was easily established. The "Zeena u-reena" is a paraphrase of the Pentateuch, the Five Scrolls and the Haftarot interwoven with Midrashic legend. The compiler of the book, Jacob ben Isaac of Janow (died in Prague in 1628) intended it for the women. It is written in Judeo-German.

The pictures follow, particularly in Genesis and Exodus, the biblical narrative pretty closely and hence the Merian cycle. Some episodes are omitted. While Merian begins with the "Garden of Eden" and "Adam naming the Animals", the "Zeena u-reena" illustrator begins with Merian's third picture, the "Fall." "Cain killing Abel" is the second scene in the "Zeena u-reena", whereas its is the sixth in the Merian Bible. Then too there are reversals in the sequence of the scenes. In the Merian Bible Noah is taking the animals into the ark, then comes the picture showing the flood subsiding. In the "Zeena u-reena" it is the other way round. As to the third and fourth Noah scenes, they follow the precedent faithfully. Noah sees the rainbow, token of the Covenant. He appears next lying on the ground, intoxicated by the wine of his vineyard, two of his sons solicitously covering him with a blanket. There is an interesting substitution. Merian has made of Abraham leaving Haran with his clan a charming family scene. Abraham and Sara lead Lot between them by the hand. This scene seems to have displeased the designer or the publisher of the "Zeena u-reena". The reason could be that the image was wrong somehow, for Lot never appears in the Bible or legend as a small child. The scene is replaced by another Merian picture, "Moses and the children of Israel leaving Rameses." Such arbitrary use of pictures was common practice. Nobody seems to have been disturbed by the fact that this picture appears with its original meaning in the Amsterdam Haggadah and its many popular versions.

There are 68 woodcuts in the "Zeena u-reena" and all we can do in this preliminary study is to point out one or the other striking feature.

Turning to Lot again, we see him after his escape from Sodom entertained by his two daughters. Just as in the Merian Bible, the girls are shown nude from the waist up. The sight and the implications did not seem to shock the pious readers.

In fact, the pictures supplied pretty romantic stuff with such heroines as Dina, Potiphar's wife, Ruth, Esther, Jael, Jephta's daughter, pointing up the quaint narrative. However, much was left to the imagintion owing to the small format and the schematisation of the figures and situations.

The illustration ends with Jonah sitting in the shade of the gourd with the peaceful view of the city of Niniveh spreading before his eyes.

The Merian Bible with over 150 engravings in its Old Testament part covers a much wider field. It includes besides the Old Testament proper most of the Apocrypha, also illustrated.

In summing up, we may say that the Merian Bible was a sort of a pattern book, a manual for illustrators. Its influence has been noted even in the work of Rembrandt. As a matter of fact, Merian himself had borrowed much from Hans Holbein the Y., particularly from Holbein's woodcut cycle in the "Historiarum veteris testamenti icones ad vivum expressae" printed in Lyons in 1538.

The designer of the woodcuts of the Sulzbach edition of the "Zeena u-reena" is not known. The Esther scene in the Amsterdam edition of 1792 is signed by the monogram N.M. in Latin letters. This monogram also appears in a late edition of the Amsterdam Haggadah (Amsterdam, 1765) in a number of woodcuts which here replace the engravings.[6]

I doubt that the "Zeena u-reena" originally was illustrated with copper engravings as was the Amsterdam Haggadah. It was from the outset planned as a popular inexpensive book.

The Merian Bible was not the only model of the illustrated "Zeena u-reena". A different bible inspired the Frankfurt edition of 1726 with 48 woodcuts of which there is a copy at the Jewish Theological Seminary.

By way of the folksy Yiddish book the Jewish women got their share in the enjoyment of the artistic culture of their time.

13. THE 'CLOSED TEMPLE' PANEL IN THE SYNAGOGUE OF DURA EUROPOS*

The "Closed Temple" was interpreted by Goodenough as a cult-less sanctuary of Mystic Judaism in contrast to the Tabernacle of the Aaronic Priesthood symbolic of a normative, legalistic Judaism. With this thesis in mind, Goodenough tried to explain away the seven-wall enclosure of the closed temple with pagan deities in its portal decoration. The present author supports and reinforces Du Mesnil du Buisson's interpretation of the closed temple as a solar temple and a pun on the name of the city Beth Shemesh by pointing to a biblical incident characterizing Beth Shemesh as a sinful city failing in reverence to the Ark. Goodenough defended his thesis with number symbolism derived from Philo's computations which are shown to be based on a faulty translation of biblical data in the Septuagint.

The figure standing with a scroll before the Ark is interpreted here as Nathan, the prophet, chronicler of the reign of David, the king who had brought the Ark to Jerusalem.

The buildings represented in the paintings of the Dura Synagogue are of the secular and the religious type. The crenellated masonry gate house with adjoining portion of a city wall found in a number of the scenes could designate any locality. It was identified in every case from the context.[1]

The religious buildings in the Synagogue frescoes, Jewish and pagan, are Roman columnar temples. Their character was also determined from the context. However, two of the temple buildings could be more closely identified by features of their design. Thus the tetrastyle, non-pedimented facade painted on the face of the niche aedicula flanked by the seven-branched candlestick and the scene of Abraham's Sacrifice was identified as the Temple of Jerusalem on the basis of the tradition that the temple was built on Mount Moriah (II Chron. 3:1), the site of the prevented sacrifice (Gen. 22:2). That it was the Herodian rather than the Solomonic temple, was proved by comparison with the temple design on the Bar Kokhba coin (132-135) (Fig. 1).[2]

The other building identified by its design, the "Closed Temple," will be discussed in due course.

Temples appear in all four panels of the middle register of paintings on the west wall which is oriented toward Jerusalem and is marked by a central niche and a triptych-like painted area above it. Beginning with the panel at the extreme left, we see there a two-column facade of a temple (Fig. 2). Ot is set at the head of a court in the center of which Moses directs twelve streams of water from a well toward the tents of the elders of the twelve tribes. The seven-branched lampstand and other cult objects front the temple which is open and empty. The temple in this scene was commonly interpreted as the Tabernacle of the Wilderness.

Goodenough dismissed the building as "an arch in which nothing can be seen."[3] Later, in his *Symbols* he defined it as a "temple or throne of the future which all good Jews passionately anticipated as the culmination of human existence."[4]

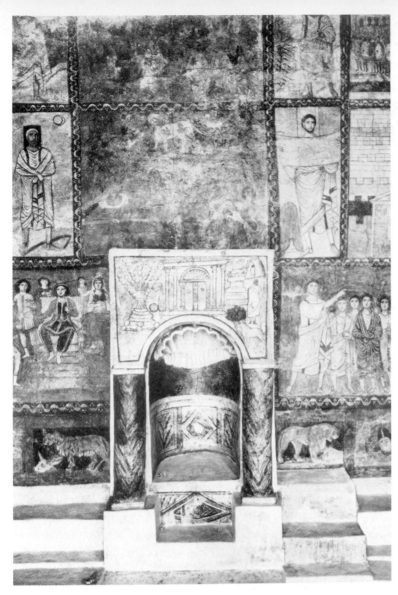

Fig. 1. Dura, Synagogue.
Central area with Torah niche.
All figures are from Carl H.
Kraeling. *The Synagogue*. The
Excavations at Dura-Europos,
Final Report, New Haven, 1956
Courtesy Professor A. Parry,
Yale University.

Fig. 2. Dura, Synagogue. The
Tabernacle. Moses at the Well.

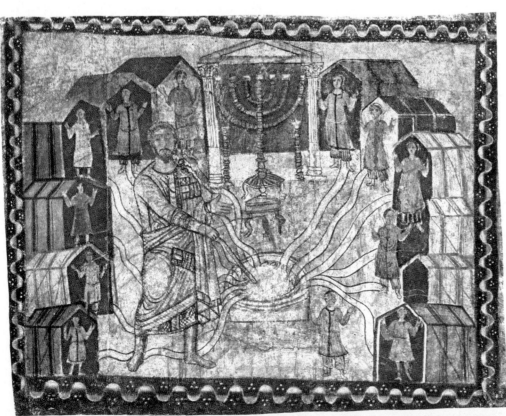

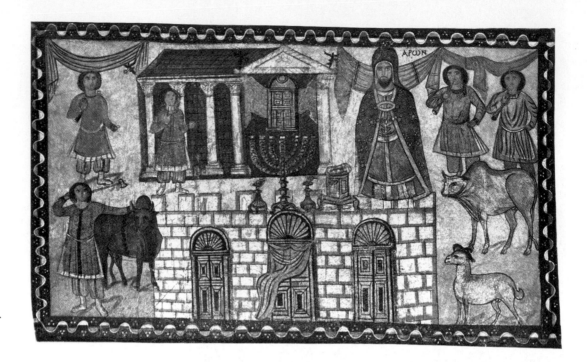

Fig. 3. Dura, Synagogue. The Tabernacle. Aaron with Attendants.

The second panel (to the right) shows the same two-column front with the side in view. The lampstand and other cult implements are here present too, and a sacrificial altar was added. The temple is flanked by Aaron, the high-priest (his name inscribed in Greek) and four attendants. A sacrificial priest stands outside the court enclosure, in the left foreground. The open temple displays in its interior the Ark, a cabinet for the Commandments (Fig. 3).

Goodenough accepted the interpretation of this building as the Tabernacle on the grounds that it exhibits the five columns mentioned in the Biblical account of the Tabernacle (Exod. 26:37). The Biblical passage refers, however, to the pillars (columns) of the entrance. In an unusual procedure Goodenough had added up the two columns of the facade and the three of the lateral side, thus obtaining five.[5] As evidence of the correctness of his interpretation he pointed to the number of the figures in the scene. There are five figures indeed,[6] but without counting the high-priest.

While a discussion of Goodenough's method of interpretation of the two panels must be reserved to a later point, we shall briefly comment here on the relationship of the two scenes. In the first the Tabernacle is a vision, a "pattern" shown by the Lord to Moses (Exod. 25:9) who conveys the divine message to the people symbolically by the distribution of the beneficent water.[7] In the second scene the Tabernacle is set up, the Ark installed, the service inaugurated.[8]

We now turn to the two panels on the right side of the middle register. The panel at the extreme right illustrates the dramatic fall of Dagon (Fig. 4). The Philistine temple, a six-column facade, stands at the head of a court strewn with cult vessels and broken statues. The Philistines had set up the Israelite Ark captured in battle in their temple alongside the Dagon statue, but the havoc its presence had caused made them change their mind. In the left portion of the panel we see the Ark mounted on a cart about to leave, driven by two kine, "on which there hath come no yoke." According to I Sam. 6:1-12, the Ark, sent away by the Philistines, landed in Judaic territory, in the city of Beth Shemesh. The six-column facade of the pagan temple is the largest among the temples represented in the synagogue decoration. Goodenough drew attention to the number six which, he pointed out, was regarded by Philo as a perfect number, chiefly on the grounds that it is the product of 2 and 3.[9] It is not clear what

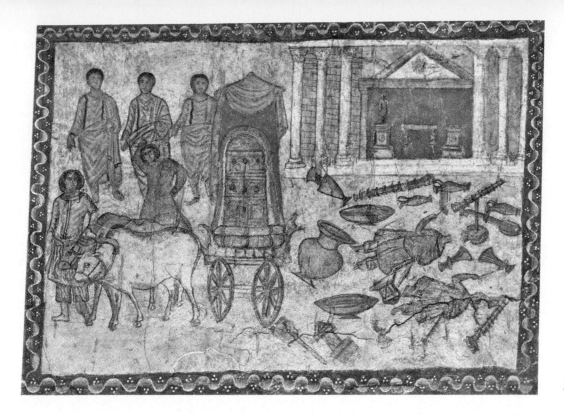

Goodenough wanted to imply by this reference to Philo, but it is evident that he attached significance to certain numbers.

The scene to the left of the Dagon panel exhibits the much debated "Closed Temple," the name of which was coined by Goodenough (Fig. 5). Actually, this is not the only temple in the synagogue murals with the door shut. The temple of Jerusalem painted on the niche is also closed. But that temple is qualified by readily understood elements of its locale. Its identity as a Jewish temple is unmistakable. The "Closed Temple" is to all appearances a pagan temple. It stands within an enclosure of seven ascending walls and displays in the decoration of the central door of its enclosure pagan figurative motifs. The ascending seven walls called to mind the ziggurats of Khorsabad and Borsippa. Du Mesnil du Buisson[10] discovered a quite close prototype in Herodotus' description of the palace at Ecbatana, Media (Histories, I. 98). There too, as in the "Closed Temple," the encircling walls rise gradually, each step not higher than one crenellation, and each wall painted a different color. The "Closed Temple" evoking of course the seven planets was interpreted by Du Mesnil as a solar temple. Struck by the name "Beth Shemesh," the name of the city in which the Ark sojourned, he recognized the picture as a pun on its name. Beth Shemesh literally means "House of the Sun."[11]

Du Mesnil noted that the word-image device was also used in the Dagon panel (Fig. 4). Inspired by the passage in I Sam. 5:3-4 which describes how the statue of Dagon fell, was picked up and fell again, losing its head in the second fall, the artist has represented Dagon by two identical figures lying on the ground, one headless.[12] Du Mesnil's interpretation of the "Closed Temple" was generally accepted with modifications. It was difficult to believe that the story of the Ark would end with the image of a pagan temple.

André Grabar[13] suggested that the building was the Temple of Solomon desecrated by heathen cults, but envisioned in messianic typology as the purified sanctuary restored to true worship by Josiah, the reform king. Pointing to the standing figure in the adjoining panel to the left (lower right-side panel of the triptych), Grabar interpreted it as king Josiah and the scroll in the hands of the figure as the book of Deuteronomy that was recovered in the Temple (II Kings 22:8ff.) (Fig. 1). This interesting interpretation does not account, however, for the

Fig. 5. Dura, Synagogue. The "Closed Temple," Beth Shemesh.

appearance of the figure which is clad in a draped himation. Kings wear Persian tunic and trousers in the Dura synagogue paintings, prophets and patriarchs the himation.

Kraeling[14] simplified Grabar's thesis in assuming that the assimilated Jews of Dura were apt to conceive the Temple of Solomon in terms of a syncretistic Graeco-Iranian sanctuary. He referred to the seven days' siege of Jericho, the seven trumpets which brought about its fall (Joshua 6:4ff.), — apparently in an effort to associate the number seven witrh a Biblical building — and to a late Midrash about the heavenly Jerusalem surrounded by seven walls.[15] Morton Smith speaking at the Symposium on the Paintings of the Synagogue of Dura Europos at Stern College, Yeshiva University, interpreted the building as the Temple of Solomon, inaccessible after its destruction in its archetype in heaven.[16]

It was clear that any interpretation of the "Closed Temple" would have to face the argument of the missing happy ending. Grabar had offered a way out of the dilemma in pointing to the connection between the "Closed Temple" and the adjoining triptych panel. If the story were to culminate in the panel of the standing figure, as he suggested, the happy ending might be found there, perhaps in a different version of the motif.

Turning to the Biblical narrative, we see that the sojourn of the Ark at Beth Shemesh was marred by an unfortunate incident. The inhabitants of the Judaic city failed to show reverence for the ancient shrine. They "looked into the Ark of the Lord" (I Sam. 6:19) for which they were severely punished.[17] Beth Shemesh then marks the climax of the Ark's misfortunes.[18] Taken to battle from the sanctuary of Shilo and captured by the Philistines (panels of the middle register of the north wall),[19] the Ark was held at the Dagon temple, and after being released, was humiliated by its own people at Beth Shemesh.[20] Then in the adjoining triptych panel (to the left) the Ark appears beautifully draped with crimson cloth in recovered splendor. Standing before the Ark, a prophet spreads a large scroll reading from it (Fig. 1).

The identity of the prophet was the subject of much debate. Sukenik and Goodenough suggested Moses.[21] Kraeling and Du Mesnil du Buisson thought of Ezra.[22] This author

138

proposed Samuel.[23] Our common mistake was that the main episode in the story of the Ark after its stay at Beth Shemesh and other places — its coming to Jerusalem, the new capital where it was solemnly brought up by King David — was not sufficiently taken into account.[24] Ezra, who seemed to some scholars to be the most plausible choice, would have to be discounted because the Ark was no longer extant in Ezra's time. After having been installed in the Temple of Solomon, the Ark disappears from the scene. Legend regards the Ark as one of the sacred objects to be revealed in messianic times.[25]

Standing on the ground, the Ark cannot be associated with the Temple of Solomon because it is shown without architectural framework. One would rather think of an episode in the reign of David. After having brought up the Ark to Jerusalem (II Sam. 6:12), David began thinking of building a temple for the shrine. In a colloquy with Nathan, the prophet, the king laments: "See, now, I dwell in a house of cedar, but the Ark of God dwelleth within curtains" (II Sam. 7:1). In answer to David's desire, Nathan receives in a vision a pledge from the Lord that David's kingdom will last forever and that the "House" will be built by his son (II Sam. 7:10-13).

The scene in the triptych panel would show then the Ark secure in Jerusalem beautifully veiled with the prophet Nathan proclaiming "all these words" (II Sam. 7:17), written in the scroll which he deploys in a solemn gesture (Figs. 1 and 6.).

The identity of the other three figures in the wings of the triptych was much debated. There was agreement on the upper two figures identified as Moses. Abraham[26] was generally accepted as the figure on the lower left juxtaposed to the enigmatic prophet on the lower right whom we have now interpreted as Nathan, the prophet. Goodenough saw all the four figures as Moses (Fig. 1): Moses at the Burning Bush (upper right), on Mount Sinai (upper left), and reading the Law (lower right).[27] The lower left scene he interpreted as the "Assumption of Moses."[28] In linking the Moses of this scene with the Moses of the "Well" scene which does not adjoin it, he became involved in the problem of sequence of the "Well" and the Aaron panels which we cannot deal with here.[29]

To revert to the "Closed Temple," Goodenough adopted Grabar's idea of the double meaning of the temple. He derived it from the numbers seven and ten. The seven stood for the seven walls, seven planets, and seven colors to which he added the seven metals.[30] The seven metals led to the mythical Iranian hero Gayomart whose body was made of the metals, and hence to the decoration of the central doorway of the enclosure of the temple. (Fig. 5). The figures in the panels of the door Goodenough interpreted as the primeval bull, the primeval man Gayomart, with his sons, the twins, and Spandarmat, his mother.[31] The temple then was a purely Iranian creation.

It had however also another aspect in Goodenough's view. The number ten revealed its Jewish identity. This number Goodenough had obtained by adding up the four columns of the facade of the temple with the six columns of its side.[32] Here too he believed to have found a confirmation of his numerological method, notably in the recurrence of the number ten in the ornamentation of the side doors of the enclosure (Fig. 5). The upper and lower panels of these double-winged doors display rosettes while the middle panels bear door pulls in the shape of lion masks. There are five rosettes to a panel, four filling the corners, one in the center. The decorative unit is five rosettes in a rectangle. To obtain the number ten, Goodenough counted the rosettes of two panels.[33] In search of further manifestations of the number ten, he thought to have found a link between the ten figures representing the ten lost tribes in the "Vision of the Resurrection of the Dry Bones" (lower register, north wall) and the ten columns of the "Closed Temple."[34] In summing up his observations, Goodenough pointed out:

We cannot consider the Closed Temple as a pagan one, now dissolved and discredited in contrast to the Aaronic worship. In contrast to the destruction and defiance of paganism, the inner shrine with its Victories here stands triumphantly intact at the top. The painting seems to refer to a type of piety which needs no actual bulls or rams, a piety in which man comes to victory through the metals or planets, a victory whose beginning can be characterized by the Persian symbols of cosmic, or hypercosmic structure, but which ends in the symbolism of the number ten as contrasted with the five of Aaron.[35]

Goodenough's concept of the "Closed Temple" differs from Grabar's in so far as he did not see it as a simultaneous image of destruction and renewal, rather he conceived the two aspects of the temple's meaning in terms of its dual structure: the temple proper ("the inner shrine") and the enclosure. The ten-column temple represents "piety without bulls and rams" (the rams refer to the Aaronic Tabernacle), whereas the seven-wall enclosure symbolizes paganism. The victories — actually acroteria on the temple's roof[36] — express the triumph of the temple over its precinct and over the Tabernacle, both with their condemned sacrificial cults.

The only evidence in support of the Jewish identity of the Temple proper Goodenough found in the number ten of its columns, but this number he had also noted in the rosettes of the pagan enclosure. As for the antithesis of 5 and 10, Goodenough refers to Philo. It is therefore in order to call to mind Philo's interpretation of the Tabernacle.

As a Greek by education, Philo tried to see the Biblical Tabernacle in familiar architectural terms. The five-column entrance (*propylaeum*) led directly, he noted, to the "Holy."[37] There was no portico. The "Holy" was the chamber where stood the implements of the cult and where the high-priest, the priests, and Levites officiated. Since there was no portico which usually served as a *pronaos*, Philo called the "Holy" the *pronaos* (antechamber),[38] eliminating the *naos* completely. The next area, the "Holy of Holies," separated from the "Holy" by a transverse range of four curtained columns, was the *adytum*,[39] an inaccessible, strictly isolated place where the Ark stood in darkness and stillness, attended to by the high-priest once a year.

The idea of a scale of values is conveyed already in the Biblical account by the different treatment of the pillars of the front which have bases (actually tenons and sockets) of copper (Exod. 26:37), while the other supports of the portable shrine have silver bases (Exod. 26:19). Copper being the less valuable metal, the entrance was evidently conceived as a semi-secular zone contrasted with the sacred zone of the two holy chambers. Philo, however, in regarding the "Holy" as an ante-chamber, sharpened the contrast between the "Holy of Holies" and the "Holy." Leading through the *propylaeum* directly out into the court, the "Holy" was exposed to the outside world, the world of matter. Philo compared the five front columns to the five senses,[40] channels of communication with the sense-perceptible world. The "Holy," the chamber of the Aaronic priesthood, belonged with the lampstand and the table of shewbread to this sense-perceptible world. The world of the mind, the conceptual, incorporeal, intelligible world, lay beyond the four-column partition in the realm of the "Holy of Holies" centering in the Ark.[41]

Goodenough seems to have formed his concept of a normative, legalistic Judaism as contrasted with a hellenized mystic Judaism on analogy with Philo's interpretation of the chambers of the Tabernacle. His method of counting columns of two adjacent sides of a building and attributing significance to that number he derived from Philo's computations of the columns of the Tabernacle. Carried away by the achievements in arithmetic by Pythagoras and his successors, Philo saw the universe in terms of numbers. He undertook to count all the supports in the Tabernacle structure, those of the perimeter and of the interior. Adding up the

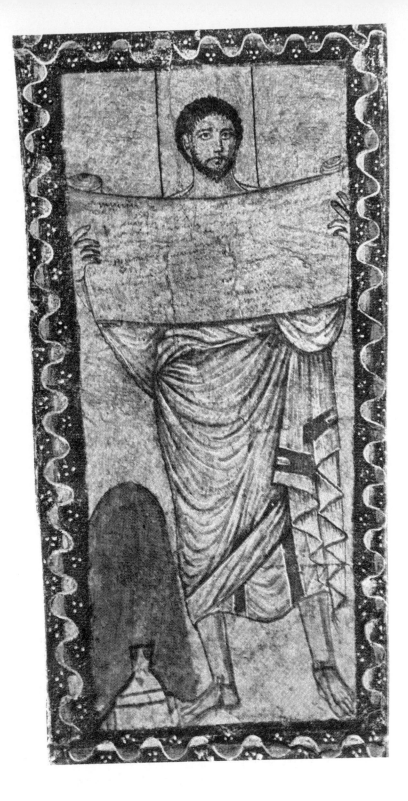

Fig. 6. Dura, Synagogue.
Nathan, the Prophet.

five columns of the entrance, the four of the interior, the forty supports of the two long sides, and the eight of the rear, he arrived at the number 57.[42]

The fact that the rear corner supports are mentioned in the Biblical specifications once separately (Exod. 26:23), and another time as included in the total of eight (Exod. 26:25), prompted Philo's ingenious remark that they were "hidden from view."[43] He was possibly alluding to the practice of counting corner columns twice. At any rate, he felt justified in subtracting the two corner uprights as non-existent. The number 55 he thus obtained was the

141

sum of the numerals 1 to 10. Ten was the Pythagorean "supremely perfect number."[44] By further subtracting 5 (the front columns) 50 was obtained which is the sum of the squares of 3, 4, and 5, graphically represented by squares of the sides of a right-angled triangle. Philo called this number "the original source from which the universe springs."[45] He believed to have demonstrated that the pattern of the Tabernacle was divinely inspired.

Philo's calculations were based on the assumption that the supports of the Tabernacle were all of the same dimensions. He uses the term *kion*[46] which Pausanias,[47] the second century Graeco-Roman writer, uses for designating columns of Greek temples. The Septuagint,[48] Philo's source, has also only one term — *stylos* — for pillar, post or column. However, according to Exod. 26:15-25 the three sides of the Tabernacle were built of boards tied up together. Only the entrance and the interior partition had what we may call pillars, columns or curtain rods (Exod. 26:37 and 32). The term *qereš* is used for the boards and *'ammūd* for the pillars. The boards were 10 cubits high and 1½ cubits broad (Exod. 26:16). The boards had two tenons for the sockets (Exod. 26:16, 17), while the pillars, those of the entrance as well as of the interior, had single tenons (Exod. 26:37 and 32). The breadth of the pillars is not given, but they were obviously narrower than the boards.

With these data once established, Philo's ingenious construction collapses. The 55, the 50, and the 10, a component of 55, have become meaningless numbers. The 5 still stands for the columnar entrance of the Aaronic Tabernacle, for the copper bases, and the implicit hierarchy of values.

But what can the 5 mean in terms of the Dura paintings? There is no Tabernacle design there exhibiting a five-column facade. Symbolic numbers, like any symbolic configuration, may change their meaning. To Goodenough the number five originally representing the Tabernacle's entrance, became a symbol of the Tabernacle *per se* or even of the Aaronic Priesthood in general. Numbers became abstract entities as for example in the suggested relationship between the "Closed Temple" and the ten figures representing the ten lost tribes in the Resurrection scene.[49] The two motifs belong to panels located on different walls in different registers. The only common link between the temple and the lost tribes Goodenough could muster was the number ten.

While the association of the number five with the Tabernacle was well documented, it remained to establish a literary tradition for linking the number ten with the ideal temple. The references to the Ten Commandments, ten plagues, etc. cited by Goodenough,[50] seemed to him himself unconvincing. Philo appeared to prefer the seven as an ideal number.[51] The concept of the ten Sephiroth of the Cabbala could not be dated as far back as the Dura period.[52] In contrast to the Tabernacle, the ideal temple seemed to have no basis in Jewish iconography.[53] And there was the problem of relating this temple to the "temple or throne of the future" which Goodenough had recognized in the little structure in the "Well" panel. He never reverted to it.

Criticism of Goodenough's *Symbols* was generally directed at his conception of the permanence of symbolic content.[54] We have been concerned with Goodenough's concept of symbolic form.

The tendency to spiritualize, symbolize every feature, every line of the design led Goodenough to some controversial observations. He asserted that in the design of the Tabernacle (Fig. 3) a ground line is indicated, whereas in the "Closed Temple" it is not (Fig. 5.).[55] This is not quite so. The figures in the Tabernacle panel cast shadows, thus creating little islands of horizontal ground around their feet, but the Tabernacle itself does not cast any shadows, nor is there a ground line to define its position. As to the "Closed Temple" its position is obscured by the stone courses of the enclosing walls. Here the question of the ground line does not come up

actually, because the court in which the temple stands is screened off by the walls. What Goodenough was driving at was that the Tabernacle firmly standing on the ground was represented as a symbol of the empirical world of "active cultus" while the temple, unattached to the soil, symbolized a "Judaism of immaterial reality."[56]

Perspective, he held, was similarly used to express the character of the buildings. "Bent" lines would suggest the three-dimensional environment of the down-to-earth Tabernacle, straight lines the abstractness of the "Closed Temple."[57] Actually attempts at foreshortening in the synagogue frescoes are very slight. The artist conveys volume in the design of the buildings by other means, in differentiating the fronts from the sides by an enlarged intercolumniation, pediment, and color. In the Tabernacle the facade is green, the side brown. The closed Temple's entrance is emphasized by a yellow door. The run of the columns interrupted by the enlarged intercolumniation of the facade can in no way produce the effect of a uniform range. In counting the columns of front and side as a unit, Goodenough imputed to the artist lack of a sense for uniform, self-contained pattern, a prerequisite of symbolic form. The fact that the figures in the Aaron panel do not form a uniform group — one figure standing on a different level — shows that their number was not meant to be symbolic, nor is the number of the rosettes in the doors of the temple's enclosure symbolic since Goodenough had to double it to obtain the desired ten.

In the final analysis, it is clear that the numbers singled out by Goodenough as symbolic were forced upon the pictorial material. The Dura designer had a perfect sense of symbolic form and he knew how to project symbolic numbers into images. He used the device of repetition in setting up the figures in a file in "Exodus" (the twelve patriarchs),[58] and in the "Anointing of David" (the seven sons of Jesse).[59] He attempted a circular scheme in the arrangement of the twelve tents in the "Well" scene (Fig. 2).[60]

The four temple designs in the Synagogue, the Tabernacle in the "Well" scene, the Tabernacle in the Aaron panel, the Dagon temple, and the Sun Temple standing for Beth Shemesh, follow a compositional scheme inspired by Roman historical and pictorial reliefs.[61] In distinction from some scenes in the synagogue decoration in which the narrative runs along the foreground plane, the action unfolds in these panels in depth.

A clearly visualized situation in a stable setting is what the artist wants to convey here rather than the progress of a story in a sequence of episodes. Figures and objects are set in map-like fashion: what is meant to be behind, is shown above. The temple is placed at the top, i.e. in the rear with the action spreading downward ("Well" panel, Dagon panel), or screened off in part or completely by a feature of added interest, such as the enclosure (Aaron panel, Sun temple panel). As for the number of columns and choice of view — front alone or front and side — these details of the setting could be contracted or expanded according to spatial considerations.

In the "Well" scene the Tabernacle, compressed by the flanking tents, was of necessity kept narrow. It could be extended in the Aaron panel. The Dagon temple facade received additional columns to correspond in breadth to the forecourt and mark as a block the separation from the adjacent frameless scene depicting the Ark's departure. The sun temple could be extended like the Aaronic Tabernacle owing to available space, but it had to be kept low to allow more height for the precinct wall with the pagan decoration of the huge portal (compare it with the so much smaller portal of the temple proper) which was intended to release the catchword: Beth Shemesh, House of the Sun.

Some scholars pointed out the balance between the "Closed Temple" (Fig. 5), which was interpreted as the Temple of Solomon, and its counterpart on the other side of the wall, the Aaronic Tabernacle (Fig. 3), both adjoining the triptych.[62] What was overlooked, however, was

lack of balance between the two other temples in the panels at the extreme right and left, the Dagon Temple (Fig. 4) and its counterpart on the other side of the wall, the Tabernacle of the "Well" scene (Fig. 2). This inconsistency challenges the interpretation of the "Closed Temple" as a Jewish temple. The ambiguity of meaning was removed with the identification of the "Closed Temple" as the sinful city of Beth Shemesh.[63]

With two positively charged scenes on the left (the Tabernacle in its two aspects) and two negatively charged scenes on the right (the Dagon and the Sun temples), a clear-cut antithesis was established between the two halves of the middle register of the west wall. While the lower register affords a vision of hope by a display of the leaders of the Salvation plan,[64] the middle register tells the story of the Ark from its glorious beginnings to its vicissitudes illustrative of the trials of the Jewish people.

The picture of the Ark, veiled and secure in Jerusalem, appears in the triptych above the niche. With this image of the Ark concludes the cycle of the three ages represented in the wings of the triptych by Abraham (lower left), Moses (upper right and left), and Nathan, the prophet (lower right) (Fig. 6). We have seen Nathan as the harbinger of the good news to king David, but he appears also as the chronicler of David's reign, author of a book on the "acts of David, the king" (I Chron. 29:29). With this role of the prophet in mind, we may see his image in more general terms epitomizing the reign of David, the king whose merit it was to have brought the Ark to Jerusalem. The large scroll in the prophet's hands with the closely written script showing through the translucent parchment may have been meant to be his Chronicle of king David's reign (Fig. 6).

14. MAIMONIDES' DRAWINGS OF THE TEMPLE

The first attempts to scientifically reconstruct the Temple of Solomon, as it was documented in the Bible, began in the fifteenth century. The study of the Temple of Herod (building begun 20 B.C.E.), described by Josephus and the Mishna Tractate *Middoth*, started somewhat later. From the seventeenth century, the reconstructed designs of the Herodian Temple became the basis for modern archaeological excavations.

When Claude Perrault (1633-1688), the architect who designed the famous eastern collonade of the Louvre, was called upon to contribute designs of the Temple of Herod for a Latin edition of Maimonides' *Mishneh Torah* (1180) it is clear that there already existed a whole line of graphic representations of the Jewish Temples of Jerusalem. Louis de Compiègne de Veil, a Hebrew scholar of Jewish origin,[1] in inviting Perrault to supply designs for his Latin translation of the Eighth Book of the *Mishneh Torah*, the Book on Temple Service, had chosen a man who, as a translator of Vitruvius and an architect would be able to understand the text and visualize the conceptual scheme behind the dimensional record which constituted the basis of Maimonides' Temple description.

Perrault produced a set of designs: a plan (Fig. 1), a front, and a side elevation. The engravings appeared in de Compiègne de Veil's *De Cultu Divino*, Paris, 1678.[2] They became better known through Blasio Ugolino's monumental *Thesaurus Antiquitates*[3], Perrault's original designs have been recovered from oblivion only recently by Wolfgang Herrmann who devoted an article to them followed by a full study of Perrault's work and biography.[4] Herrmann describes Perrault's plan of the main building in the Temple area as follows: "Three narrow-spaced parallel walls are joined in the Temple on the western side and two similar sets of six walls on the southern and northern sides."[5] In concluding, Herrmann remarks: "It is a strange structure recorded only by Maimonides."[6]

The description of the western side of the Temple in Maimonides' *Mishneh Torah*, Book VII. iv.4, actually reads: "There were four walls each inner to the other with three empty spaces between them. Between the western wall and its inner wall there were five cubits, between the second and third wall six cubits, and between the third and fourth walls six cubits."[7] The specifications are five, six and six cubits. The figures obviously refer to a sequence of wall-space-wall. Why, then, one may ask, does Maimonides speak of four walls and three empty spaces between them? The answer is that he was actually drawing a straight line and marking on it four notches. In inscribing the figures five, six, six in the three spaces he obtained the sequence solid-void-solid, *i.e.* two walls and one interspace. The description of the Temple's western enclosure should actually read: From outer to inner face of the first wall five cubits, from inner face of the first to outer face of the second wall six cubits, and from the outer to inner face of the second wall six cubits. The misleading use of the word *wall* for *face* resulted in the duplication of the walls which confused Perrault.

I detected the mistake in terminology while examining a photostat of Maimonides' Temple plan and discussed the discrepancy between text and drawing in a paper "The Description of

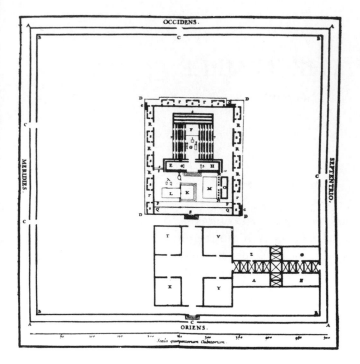

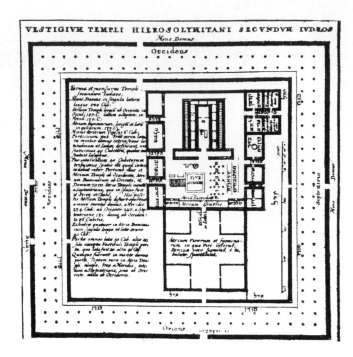

Fig. 1. Claude Perrault. Temple of Herod. Plan. De Compiègne de Veil, *De Cultu Divino*, 1678.

Fig. 2. Louis Cappel, Temple of Herod. Plan. Brian Walton Polyglot Bible, 1657. Courtesy New York Public Library.

the Temple of Jerusalem in the 'Code' of Maimonides and a Question of Nomenclature."[8] An author of the late nineteenth century who signed an article with the initials H.B.S.W. had anticipated my discovery. In what was the first English translation of the chapters on the Temple in the *Mishneh Torah*, this author stated: "These measurements [of the western enclosure] were essentially the same as those given in *Middoth*, IV.7, but by reckoning the thickness of a wall west of the Holy of Holies as space, and each face of the wall as a distinct wall, obscurity occasioned."[9] In the light of the text thus doubly checked and revised, we may proceed with a description of the Temple according to *Middoth* IV.7, Maimonides' source.[10]

The Holy of Holies at the western end of the Sanctuary and the Holy Place formed an oblong hall of which the Holy of Holies (twenty by twenty cubits) occupied one third and the Holy Place (twenty by forty cubits) the remaining two thirds. At the eastern end, the Holy Place opened into a vestibule, the porch, eleven cubits deep and one hundred cubits wide. It screened off the Temple by projecting fifteen cubits beyond it on both sides. The Temple was surrounded by a three-storied tract of storage chambers adjoining it on the south, west, and north sides. Lining this annex, another, narrower annex ran along the south and north sides. It served for communication with the chambers and for ventilation. It did not continue at the western end. As will be seen, Maimonides' drawing has at the western end, in agreement with *Middoth*, one annex running between the wall of the Temple and the external wall.

The lateral Temple enclosures are described in the *Mishneh Torah* VIII.iv.5, as follows: From north to south the Holy Place had six walls, each inner to the other with five empty spaces between them. Between the outermost wall and the second wall there were five cubits, between the second and third wall three cubits, between the third and fourth five cubits, between the fourth and fifth six, and six between the fifth and the innermost wall.

The specifications are five, three, five, six, six. Five measurements can only refer to wall-space-wall-space-wall, *i.e.* three walls and two annexes. The term *wall* meaning *face* was used here again incorrectly. The error in nomenclature is to be deplored all the more as the Bible uses the term *face* in Ezekiel 40:15 dealing with the measurements of other areas of the Temple.

146

The passage reads: "And from the face of the gate of the entrance unto the face of the porch of the inner gate were fifty cubits."[11]

Unable to place the storage chambers within the maze of six walls, Perrault assigned them space outside the walls surrounding the Temple. They form in his plan a series of pavilions running around the south, west and north sides of the Temple ground, at variance with Maimonides who interpreted them as an annex of the Temple, as in *Middoth*.

The double-shell enclosure buttressing the building with the interspace used for storage was an ancient feature of masonry construction recorded in the description of the Temple of Solomon (I Kings 6:5) and found in Assyrian temples,[12] as well as in excavations of the sites of Saul's citadel[13] and the Omri-Ahab palace at Samaria.[14]

The vestibule, or porch, as described by Maimonides, presented a difficulty to Perrault who adopted a design which he copied from Thomas Fuller's engraving in *A Pisgah Sight of Palestine*[15] or from the Brian Walton *Polyglot Bible* (Fig. 2).[16] It shows the porch of the Herodian Temple as a transversal hall. In order to understand Maimonides' conception of the porch we recapitulate the measurements.

Temple clear width	20 cubits
South enclosure	25 / 5+3+5+6+6 / cubits
North enclosure	25 cubits
Total Temple width	70 cubits

Jutting out by fifteen cubits on either side, the porch was one hundred cubits wide according to *Middoth* IV.7. Maimonides, however, conceived the Temple as one hundred cubits wide at every point throughout its whole length. In his view, the porch was not just an enlarged entranceway but, rather, a covered walk encompassing the Temple on south, east and north; in architectural terms a rectangular ambulatory rather than a transept. With the lateral wings of the porch added, the Temple measured in width 40 [15 + 25] + 20 + 40 cubits (*Mishneh Torah* VII, IV. 5). This interpretation of the measurements was in a way justified because *Middoth* IV.6 uses the formula one hundred by one hundred by one hundred for width, length[17] and height of the Temple without qualification. However, the figure of seventy cubits in *Middoth* IV.7 is supported in the same paragraph by a telling metaphor: "And the Sanctuary was narrow at the rear and wide in the front even as a lion is narrow behind and broad in front." Josephus' observation (*Bell*. V.v.4) that the porch had "as it were, shoulders on each side" agrees with *Middoth*. Maimonides' conception of the Temple as square in plan may have been inspired by the mosque in Fostat (Old Cairo) where he lived. The Amr mosque, erected in 827 C.E. and many times enlarged, was built as a walled-in compound around a rectangular squarish court.[18]

Maimonides had formed his idea of the Herodian Temple when he was working on his *Commentary on Middoth* (1168). In the chapters on the temple in the *Mishneh Torah* (1180) he summed up his findings. The earliest preserved manuscript of the *Commentary on Middoth* is Pococke 295 of the Bodleian Library.[19] It is written on paper in Arabic with Hebrew characters and illustrated with drawings. The manuscript was acquired by the orientalist Edward Pococke (1604-1691) in Aleppo from descendants of Maimonides and is regarded by some scholars as written by Maimonides in his own hand. Others hold that it is a copy made by a scribe for Maimonides.[20] Whether an autograph or not, the manuscript would date from the late 12th century. It contains two Temple plans and other designs pertaining to the Temple and its furnishings. The plan I became acquainted with first (fol. 295 recto) (Fig. 4) shows the Sanctuary with its cult implements and the forecourt with the altar. The plan on fol. 292 verso

Fig. 3. Maimonides. Temple of Herod. Plan. *Commentary on Middoth,* Bodleian Library, Pococke 295, fol. 292 verso. Courtesy Bodleian Library.

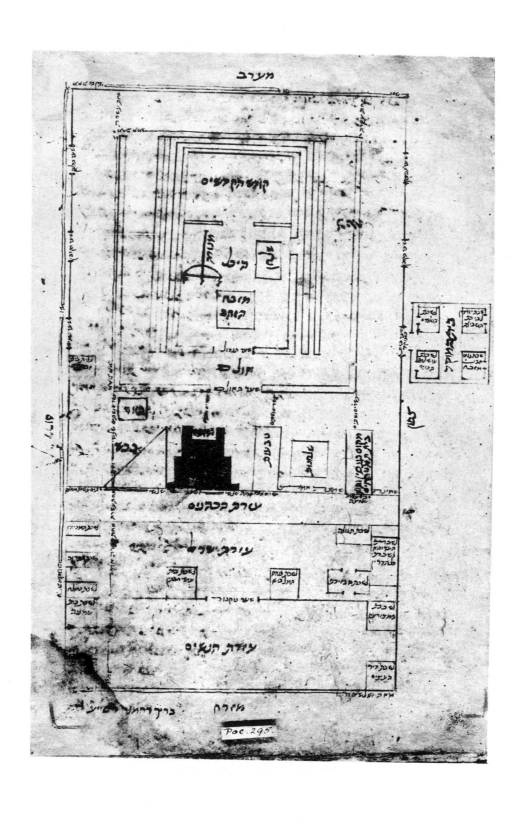

Fig. 4. Maimonides. Temple of Herod. Plan with cult furnishings. *Commentary*, Bodleian Library, Pococke 295, fol. 295 recto. Courtesy Moses Lutzki.

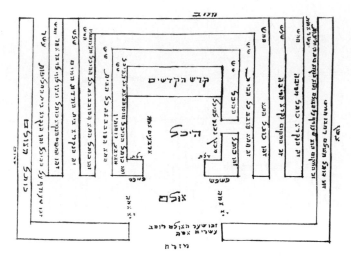

Fig. 5. Temple of Herod. Plan. Maimonides *Commentary*, dated 1386, Preussischer Kulturbesitz. After Fromer.

(Fig. 3) which shows the building alone is the more important one. The drawing starts rather informally directly under the text, almost touching the letters of the last line. We readily recognize the layout with the Holy of Holies in the upper third of the hall and the Holy Place in the remaining two thirds. The enclosure exhibits two walls in the rear and three on either side, alternating with annexes, one in the back and two on the sides. The porch extends from the entrance into the side wings. The width and length of the plan are equal as they should be according to Maimonides' view. There is some confusion in the design at the western end. The outer wall should have run there the whole width of the plan to receive the side walls which must abut upon it. This shortcoming was due to the inability to visualize the somewhat intricate configuration. As for the measurements, it is clear that we could not expect a scale drawing. James S. Ackerman has shown that even sixteenth century plans almost never included measurements. Instructions on measurements were often written down on the plans instead of being graphically rendered.[21] In the plan, fol. 292 verso, of the Pococke manuscript, the instructions run along the architectural elements identifying the walls, the chambers, the passageways, and the porch, some specifying their functions. What distinguishes Maimonides' Temple plan from other early architectural drawings is that it does not represent an existing or familiar type of building such as the famous plan of St. Gall's Monastery.[22] Maimonides worked without visual precedent and with measurements recorded in an abrupt and repetitious text.

In the plan on fol. 295 recto (Fig. 4) of Pococke, the main dimensions of width and length are kept equal, but the width of the Sanctuary interior is expanded at the expense of the lateral enclosures which are reduced to less than one fourth of its width. The designer obviously gave priority to the appurtenances of the Temple Service — the candelabra, the table of the shewbread, and the altar for incense which had to be properly accommodated within the Sanctuary.

The Temple plans in later medieval copies of the *Commentary on Middoth* reveal dependence on the Pococke designs, presumably transmitted through links now lost. The Temple plans in the *Berlin Commentary* dated 1386 (Fig. 5)[23] and the *Paris Commentary* of 1460 (Fig. 6)[24] are considerably expanded in width showing complete disregard on the part of the designer of the requirement of equal length and width. A sketch in an Ashkenasic *Mishneh Torah* of the Royal Library at Stockholm, Hoffan Collection, cod. or.1 (Fig. 7) shows a plan derived from a

150

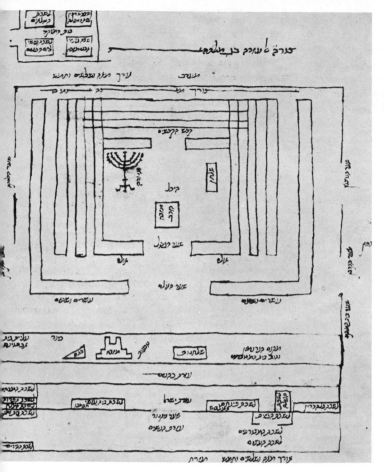

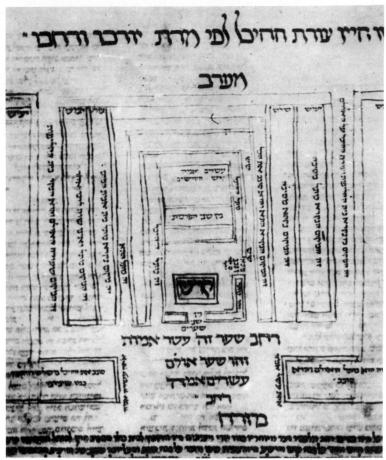

Commentary design in a state of disintegration contrasting with the fine penmanship in text and inscriptions.

The most amazing experience awaits the reader as he turns to the small designs in the text of the *Commentary* by Maimonides on *Middoth*. The drawings are an integral part of the text and in some passages the author addresses the reader with the words: "Here is the picture."[25] In Pococke 295, fol. 293 recto there is a rectangle with the lower part divided by six vertical lines into five bars (Fig. 8). These are the "six walls with five spaces between them" which puzzled Perrault in the *Mishneh Torah*. The bars are inscribed vertically from right to left: 1. Passage wall, 2. Passage, 3. Chamber wall, 4. Chamber, 5. Temple wall. The bars obviously represent a side-enclosure. Above the bars are two rows of five squares each. They are inscribed horizontally "chamber." The word "chamber" appears also inscribed horizontally on the bars. This means that the bars have a double function. They represent the enclosure, but are also part of the chamber setup. The *Mishneh Torah* VIII.IV.10 (*Middoth* IV.3) explains: There were five such cells surrounding the Temple on the north, five on the south, and three on the west. There were three stories, one over the other, thus making fifteen cells. On the west, however, there were eight cells, three over three and two on the story on top of them. Altogether there were thirty eight cells." In the corresponding diagram in the *Berlin Commentary* copied by Jacob Fromer (Fig. 9)[26] there are three rows of squares above the bars representing the chambers. Each diagram reads here separately. Maimonides' combined diagram reveals his capacity for simplification. The next grid on fol. 293 recto of the Pococke manuscript, a smaller one, is organized the same way as the first (Fig. 8). It reads two ways. The lower divisions read from right to left: 1. Chamber wall, 2. Chamber, 3. Temple wall. They represent the western enclosure. With the

Fig. 6. Temple of Herod. Plan. Maimonides' *Commentary*, dated 1460. Bibliothèque Nationale, hébr. 579, fol. 218. Courtesy Bibliothèque Nationale.

Fig. 7. Temple of Herod. Plan. Maimonides' *Mishneh Torah*, Stockholm, Royal Library, Hoffan Collection, Cod. Or. 1. Courtesy Dr. Elazar Hurvitz.

151

Fig. 8. Maimonides. Diagram, *Commentary*, Bodleian Library Pococke 295, fol. 293 recto. After *Commentarium in Mischnam*. Courtesy Bodleian Library.

Fig. 9. Diagram. Maimonides *Commentary*, dated 1386, Preussischer Kulturbesitz. After Fromer.

Fig. 10. Drawing. Maimonides *Commentary*, dated 1386, Preussischer Kulturbesitz. After Fromer.

lower divisions included, the whole diagram represents the western chamber arrangement of three below, three on the second floor and two on top.

The design at the bottom of Pococke, fol. 293 recto demonstrates how the annexes were anchored to the Temple walls. Just as in the Temple of Solomon (I Kings 6:6,7), no iron tools were used in the Herodian Temple to fasten the floor beams of the chambers on to the Temple walls. We use the Berlin drawing (Fig. 10) because the Pococke design is smudged and difficult to make out. It shows five superimposed horizontal bars which are inscribed from bottom up:

1. Chamber space 5 cubits
2. Floor beam 6 cubits
3. Chamber space 6 cubits
4. Floor beam 7 cubits
5. Chamber space 7 cubits

The stepped profile of the bars is that of the outer face of the Temple wall. As the wall recedes by one cubit at every floor, the respective beam which is longer by one cubit than the one below comes to rest on the setback of the wall. On the right is the outer chamber wall. The arrangement, described in *Middoth* IV.7 and in *Mishneh Torah* VIII.iv.9, and graphically represented by Maimonides for the first time, is perhaps not easily understood. We obtain a good idea of the setup from the perspective view of the Temple by Francois Vatable (1540) (Fig. 11).[27] The view is that of the Temple of Solomon, but the construction was the same in both

152

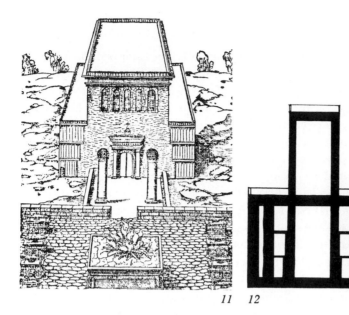

11 12

13

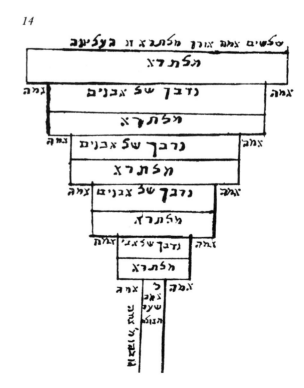

Fig. 11. François Vatable. Temple of Solomon. Elevation with three-storied annex. Woodcut, 1540. After W. Herrmann, "Unknown Designs... by Claude Perrault," Fig. 7.

Fig. 12. Carl Watzinger, Temple of Herod. Transverse Section. After Watzinger, *Denkmäler Palästinas, II.*

Fig. 13. Maimonides. Drawing of lintel. *Commentary*, Bodleian Library, Pococke 295, fol. 291 verso. After *Commentarium in Mischnam*. Courtesy Bodleian Library.

Fig. 14. Drawing of lintel. Maimonides *Commentary*, dated 1386. Preussischer Kulturbesitz. After Fromer.

14

temples. The chambers are seen here attached to the front; actually, they stopped short behind the porch which screened them off. The transverse section by Carl Watzinger shows the chamber arrangement in the Herodian Temple. (Fig. 12)[28]

Maimonides conceived architectural forms in terms of numbers. The figure five defines the arrangement of the side enclosure and of the lateral chamber setup in the first diagram. It recurs in the presentation of the construction of the three-storied chamber unit. Maimonides did not venture to visualize forms in their appearance in nature. He did not try to draw the Temple facade, although *Middoth* provides the dimensions of the front elevation and its main feature, the giant portal forty cubits high and twenty cubits broad. He chose, however, to draw the lintel of the doorway. *Mishneh Torah* VIII.iv.8, following *Middoth* III.7, describes it as formed of five carved oak beams interposed between courses of stonework. The beams diminishing in length from thirty to twenty two cubits and alternating with courses of stone-work spanned the portal relieving the load of the tall facade and the flat roof. Maimonides' drawing, fol. 291 verso in Pococke shows five parallel horizontal bars with no interval allowed for the courses of stonework. (Fig. 13). The *Berlin Commentary* designer interposed bars for the stonework in his lintel. He obtained nine bars (Fig. 14). One may wonder whether Maimonides omitted the bars representing stonework in order to preserve the figure "five" as symbolic of the Temple portal,[29] and of a numerological system culminating in the figure of one hundred, the dimension of the Temple's width, length, and height. Maimonides' conception of the porch was opposed in rabbinical literature. Israel Hildesheimer[30] rejected the idea of the porch extending beyond the front of the Temple (Fig. 15). He cited two articles with which he was in full agreement. They could not be located because of incomplete references. Jacob Fromer published the drawings from the *Berlin Commentary*. His comments were centered upon the philological aspects of the Arabic text and the Hebrew inscriptions of the drawings. He cited Hildesheimer's article,[31] but did not elaborate on the controversial porch. Moses Lutzki,[32] S.M. Stern,[33] and Solomon D. Sassoon[34] were concerned with the literary aspects of Maimonides' works, the question of dating and biographical data.

Maimonides' Temple plan anticipates reconstruction attempts by several centuries. His graphic work merits intensive scholarly research and should be included in the bibliography of medieval architectural design and the psychology of structural rather than visual perception.

Fig. 15. Rachel Wischnitzer's reconstruction of Herod's Temple. Dotted lines define porch extensions according to Maimonides' conception.

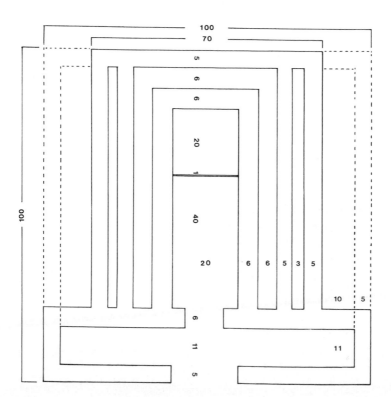

15. THE ORDEAL OF BITTER WATERS AND ANDREA DEL SARTO

Plagiarism is not one of the seven cardinal sins, nor does this violation of property rights appear among those mentioned in the Tenth Commandment. When we speak of the more innocent plagiarisms, we say that a work was "inspired" by another one. The most striking case of borrowing is perhaps that of Edouard Manet, who used a Renaissance engraving for the seemingly casual arrangement of figures in his "Luncheon on the Grass". When Manet's model was discovered decades after his death, art critics just chuckled.[1] It is quite another matter when the intention of the borrower is to deceive. Van Meegeren's "Vermeers", for example, were outright fakes, which were sold as genuine works. For this he was duly penalized.[2]

Ludwig Muenz once listed a few examples of borrowings from Rembrandt by "educated engravers".[3] One has to know well one's history of art to find a motif or figure which by its physical or emotional characteristics would fit one's theme. Thus, Rembrandt's "Bearded Old Man" became Plato for one engraver and Marcus Agrippa for another,[4] while Rembrandt's "Head of a Young Man" was converted into the chaste Joseph by one copyist and into the philosopher Epicurus by another.[5] Muenz felt that he could greatly expand his list.

We may add a few more items from Jewish iconography. Julius von Schlosser has already noted that the woodcut of Rabbi Akiba, in the Haggadah, Mantua, 1561, was a copy from Michelangelo's "Jeremiah" in the Sistine ceiling in the Vatican.[6] I have pointed out the "Simpleton" of this Haggadah who was the "Fool" of Psalm LIII in Hans Holbein's *Pictures of the Old Testament*, Lyons, 1538.[7] The "Sacrifice of Isaac" in the Haggadah, Venice, 1609, was inspired, as I have discovered, by Ghiberti's prizewinning relief (competition of 1402) of the same scene in Florence.[8] An inexhaustible source for illustrators of the Haggadah, the scroll of Esther, and the *Zeena Ureena* was Matthaeus Merian's Luther Bible with engravings published in Germany and Holland.[9]

I would like now to add another example which shows that form does not always follow function, as an idealistic architect believed. Form, all too often, follows form, a method that speeds production considerably.

There is an interesting large engraving in Johann Christoph Wagenseil's Latin translation of the Mishnah of the Talmudic tractate Sotah published in 1674.[10] The engraving which precedes the frontispiece of the volume is by Cornelius Nicolaus Schurtz who designed and engraved (*delineavit et sculpsit*) the plate in Nuremberg in 1674 for Wagenseil's publication. Schurtz is listed in Thieme and Becker,[11] though no specific place and time are ascribed to him. The engraving illustrates the Ordeal of Bitter Waters, one of the main themes of the tractate on adultery (see Fig. 1).

זה השער ליהוה נשים
טהורות תבאנה בו

DEI HÆC PORTA EST MULIERES CASTÆ INGREDIUNTOR.

ΕΞΩ ΑΙ
ΠΟΡΝΑΙ

Fig. 1. The Ordeal of
Bitter Waters. Engraving
by C.N. Schurtz in J.C.
Wagenseil, *Sotah*
(Altdorf, 1674).

The scene shows the woman accused of adultery as she is led by two priests through an impressive gateway to undergo the ordeal which is to prove her guilt or innocence. The procedure is described in detail in Sotah as a custom of the time of the Temple.[12] The suspected woman is taken to the Great Synhedrion at Jerusalem where the judges charge her with the crime. If she denies her guilt, she is brought to the East Gate of the Temple where she publicly undergoes the ordeal. A priest tears off her garment, uncovers her bosom and undoes her hair. If her bosom was beautiful she was not uncovered and if her hair was beautiful it was not undone.

156

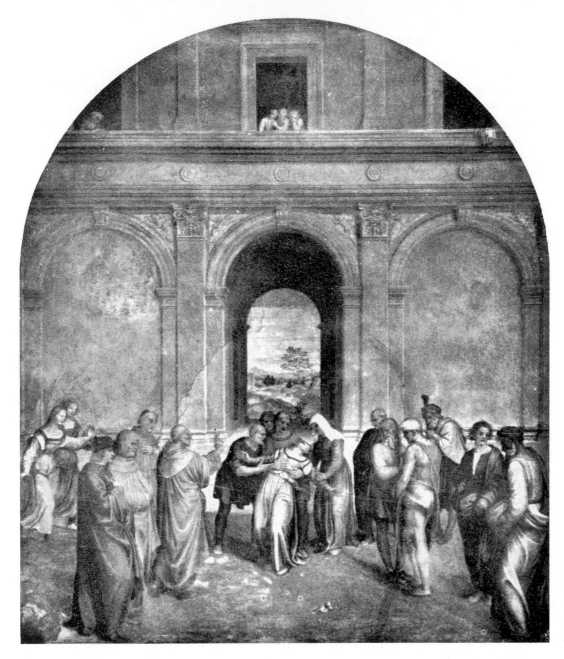

Fig. 2. The Cure of the Possessed Woman. Fresco by Andrea del Sarto, 1510. Florence, Forecourt of the Annunziata.

She was clothed in black garments unless these were becoming her. In that case they dressed her in a "mean" garment. They fastened the garment with a coarse rope. Gold ornaments, necklaces, earrings and rings were removed so as to make her look unattractive.

Everyone was permitted to attend the ordeal except her male and female slaves because it was feared she might become defiant. The bitter waters were an admixture of water (holy water according to Numbers 5:17) with dust from the floor. A scroll inscribed with a curse was immersed in the water. The water was expected to act as an effective lie detector. If the woman was "defiled", she would show unmistakable symptoms of sickness after drinking the water.

Reverting now to our engraving, we see the woman led by two turbaned priests, a third standing close by in the back to the right. She is bending backward, arms extended, obviously

agitated. Her garment is open down to the waist, a cord fastens it with a large bow. Before her on the floor we see a goblet and a scroll. Men and women are gathered on both sides of the steps which lead up to the Temple gate where the ordeal is taking place. One man in the crowd on the left, identifiable by his gesturing and pointing to the scene on top of the stair, explains the procedure to the audience. A Hebrew inscription on the parapet of the portal reads: "This is the Gate of the Lord. Pure women enter it". It paraphrases Psalm 118:20: "This is the Gate of the Lord. The Righteous shall enter into it". The inscription underneath is a Latin translation. Below that is a Greek inscription on a scroll over the keystone of the gate's arch which in drastic terms warns: "Harlots stay outside".[13] They gateway opens onto a court which is screened at the rear by a building approached by steps.

The posture of the woman bending backward readily recalls a similar, but more dramatic bearing of the "Possessed Woman" in a fresco in the forecourt of the Sanctissima Annunziata in Florence. The fresco is one of five scenes by Andrea del Sarto dedicated to San Filippo Benizzi, founder of the order of the Servi Beatae Mariae Virginis. The murals were commissioned in 1509 by the church and completed in 1510. They illustrate the life and miracles of the saint. The scenes show (1) San Filippo clothing the sick, (2) gamblers struck by lightning while mocking the saint, (3) the cure of the possessed woman, (4) the dead boy raised to life at the bier of the saint, and (5) healing with the saint's robe.[14]

The third scene had attracted the attention of the Nuremberg engraver (see Fig. 2). In the fresco the sick woman, knees bent and arms extended in a fit of convulsive shouting, is gently supported by a man and a nun while a woman in the back holds her firmly at the waist, pressing both hands to her body. Another man behind her completes this central group. The saint approaching from the left lifts his hand to make the sign of the cross. He is accompanied by three clergymen, dignified figures in long draped garments, like the saint's. Two young girls running from the extreme left to witness the scene joyfully anticipate the happy outcome of the cure. On the right, men in casual groupings, some quietly conversing with each other, appear confidently to wait for the saint to demonstrate his power. Some onlookers peer out of the windows above. The scene takes place in a courtyard before a beautifully designed facade with an arched opening in the center leading through a dark passage to the outdoors. The quiet serene landscape expands into the far distance with a river, a slim tree and a high sky carrying a promise of peace for the disturbed mind.

Schurtz took over the posture of the woman, but considerably attenuated it. That she bends to the left in the engraving instead of to the right as in the painting is a common feature in prints. The priests who support her look rather rigid, but this is partly due to their role in the scene. The man on the left in long draped garments, facing the viewer and gesturing, fills the saint's place, a back figure in the fresco. When he was left to his own devices, as in the design of the crowds, Schurtz reveals very poor draughtsmanship. He was a better architectural designer. Although taking over Andrea del Sarto's portal motif and the symmetrical setting of the scene, he entirely reworked the portal giving it the appearance of a Roman triumphal arch. His chief merit was his ability to find good models. He was an "educated" engraver.

16. REMBRANDT'S SO-CALLED 'SYNAGOGUE' IN THE LIGHT OF SYNAGOGUE ARCHITECTURE

The interest recently shown in Jewish quarters for Rembrandt's "Synagogue" (Fig. 1) was to a large extent due to our present much better knowledge of seventeenth century Amsterdam synagogues. The etching, dated 1648, was made by Rembrandt in Amsterdam where he permanently lived from 1632 on. The question most naturally arises, just which of the Amsterdam synagogues standing in 1648 may have inspired the artist.

Rembrandt lived in the Breestraat, in a section of the city mostly populated by Jews. He took up lodgings there, first with Hendrik Uylenburgh, a painter and art dealer, and in 1639 moved to the building next to Uylenburgh's which he had purchased.[1]

Rembrandt was acquainted with Manasseh ben Israel, the rabbi of the Sephardic Neveh Shalom synagogue. He etched his portrait in 1636. At that time the Spanish and Portuguese Jews had two more synagogues in Amsterdam. He did also a portrait of the Sephardi physician Ephraim Bonus. We do not know whom Rembrandt knew among the Ashkenasim, the Jews from Germany and Poland. His portraits of Jews, many of which are held to be portraits of rabbis, are not identified, but the bone structure and facial expression of some of these likenesses betray the East European origin of the sitters. It stands to reason that only the portraits of the Spanish and Portuguese Jews could have been commissioned works. A painted portrait was often reproduced in engravings and etchings. These prints had many uses. An author would include his engraved portrait in a book as a frontispiece or would present it to colleagues and admirers. A portrait of Manasseh has been used for such purposes.

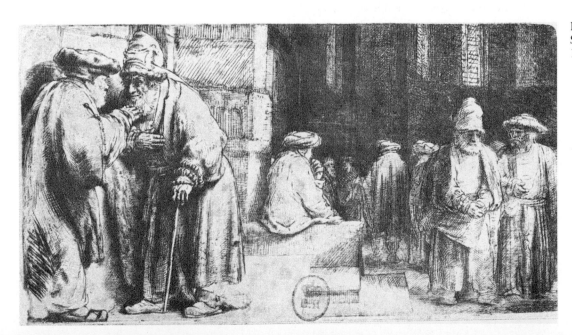

Fig. 1. Rembrandt, The Synagogue. Etching, 1648.

The Ashkenasim did not have the social ambitions of the more prosperous and more worldly Sephardim and those of them who may have sat for a small fee as models for Rembrandt probably did not care for the arts.

Since the social differences between the Sephardim and the Ashkenasim were reflected in their clothes, it should be possible to infer from the appearance of the figures in Rembrandt's etching what synagogue is represented. It could be expected that the architectural setting of the scene might supply additional evidence.

With these premises as a basis, Franz Landsberger set out to examine Rembrandt's etching.

In 1648, when Rembrandt made his etching, the Sephardim occupied jointly a building on the Houtgracht, remodeled in 1639.[2] Its exterior and interior have been preserved in engravings.[3] The interior shows a hall with columns supporting a gallery. No gallery is to be seen in Rembrandt's synagogue.

The Ashkenasim from Germany had worshiped in the Sephardi synagogues until 1635 when they had formed their own congregation.[4] There is no pictorial evidence of the prayer halls they occupied prior to erecting the impressive building of 1671, the "Groote" Synagogue which is still standing. This synagogue is also a galleried hall.[5]

With this situation in mind, Landsberger proceeded to examine the internal evidence of the picture, the type of the figures portrayed and their setting.[6]

The impression of the figures was that of sloppy, shabbily dressed men. None in the crowd is wearing the large broadbrimmed hat of the Dutch cavalier adopted by the Sephardim as attested by Rembrandt's portraits of Dr. Bonus and Manasseh ben Israel.[7]

Two of the men wear, Landsberger noted, the high fur cap of the Polish Jews. There were few Jews from Poland in Amsterdam until 1648 when refugees began to appear escaping the massacres accompanying the uprising of the Ukrainian Cossacks under Chmielnicki against the Polish landowners. The Polish Jews must have worshiped in private houses or have attended services in the German synagogues. If they did, they did it unofficially, for, when they applied to the municipal authorities for legal recognition of their group in 1673, they were advised to join the German synagogue upon which the Germans extended an invitation to them to become members and to be assigned seats.[8]

Besides the men wearing fur caps, there is in the picture one figure wearing a common beret as they were worn in Holland and probably were also adopted by the German Jews. Some of the men wear turbans characteristic of the Oriental Jews who were more likely to worship in a synagogue with Sephardi ritual.

Turning now to the architectural setting, Landsberger drew attention to the steps in the left foreground of the scene which lead down to the floor on which most of the figures appear. This difference in level seemed to be a significant point. One was readily reminded of the sunken floors of the Ashkenasic synagogues in Germany and Poland, a feature traceable to B. Taanit 23b, where Psalm 130, verse 1: Out of the depths have I called thee, O Lord, is invoked.[9]

The lowered floor, then, could be regarded as indicative of a German synagogue, the more so as the Polish Jews did not have a synagogue of their own.

Another point seemed to Landsberger to strengthen his position. Counting the figures, he found that there were ten men in the picture. Ten men — a minyan — is the minimum number needed for holding a public religious service.

In going over the figures with Landsberger's description in hand, we note, however, that the number was arrived at owing to an optical error. Landsberger sees "in the back of the picture a group of three men."[10] Actually there are only two men there. What he took for the head of a third figure is the hand of the man seated on the parapet of the stair. Thus, there are all in all

only nine recognizable figures. But I am willing to grant that there is a tiny light spot, not noticed by Dr. Landsberger, between the shoulders of the two men in the right foreground which could be the tip of a hat. This will hardly alter the situation, however, unless we assume that Rembrandt wanted to mystify a Jewish viewer making him seek the tenth man in the picture. He was not known to be given to that sort of jokes.

The emphasis on the presence of ten men would make sense if the paraphernalia of the scene and the attitudes of the figures would suggest a religious service. However, the accessories of a synagogue are lacking, we see no benches, no books, no lamps which should be visible even if the ark and the bima of the reader were supposed to be beyond the picture plane. The figures produce the effect of a milling crowd rather than of worshipers gathered for the service. Two men are standing on the left on a podium talking animatedly, two others on the right, also conversing, are walking forward, behind them two men, one in front of the other, move toward the rear. One man is seated back turned on the parapet, and there are two more men in the farther distance facing each other in conversation. The walking in opposite directions argues against a gathering for a definite common activity.

The only accessory of the synagogue the absence of which Landsberger was able to account for was the gallery. In synagogues in Germany the women worshiped in separate chambers. But then again there is the unaccounted for much too ambitious treatment of the steps, with their parapet and podium never found at the entrance into an Ashkenazic prayer hall, and the pillar of dressed stone, much too important for an interior.

But if there is nothing in the scene to suggest a synagogue, there still remains the problem, how to explain the title of the etching.

Ludwig Münz[11] had noted that the title had appeared for the first time in Gersaint's catalogue of Rembrandt's etchings published in 1751. Rembrandt had given no name to the etching. What none of the interpreters did notice, was that Gersaint was very cautious in his interpretation of the etching. He regarded the dark wall in the rear as the synagogue. To use his own words: "One notices in the back, on the right, a portion of a temple in perspective which seems to be a synagogue."[12]

Gersaint's tentative interpretation became a certainty with later writers and what he regarded as the exterior of a building had become with them the interior wall of a hall. Gersaint's title was "Synagogue of the Jews." Ludwig Münz who in his article, mentioned before, proposed a New Testament topic as the theme of the etching, listed it in his recent catalogue as "Jews in the Synagogue."[13]

The reason why Gersaint relegated the synagogue, figuratively speaking, to the rear, is clear enough. An agglomeration of Jews is readily associated with the synagogue, and since there was nothing in the scene to suggest a synagogue, it had to be found somewhere else in the picture.

If then the synagogue is the building in the rear, the space in which the figures are set is an outdoors. The steps are leading up to a stoop which fronts some other, not identified building. The large proportions of the pillar are justified if it is regarded as part of the facade of a building.

With the interpretation of the setting of the scene as a court surrounded by buildings, an interpretation going back to Gersaint, misunderstood by subsequent writers, we have actually discarded the whole problem of the synagogue, its interior arrangement and the denomination to which it may belong.

We have now to examine the figures and establish what makes them move and gesture the way they do.

The posture of the two men on the left standing on the stoop is the most expressive. The old man with an untrimmed beard and a careworn face wears the high fur cap of a Polish Jew. He leans heavily on his stick and presses his hand to his chest humbly protesting his honorability, as it were. The man wearing a beret extends a reassuring hand toward him. He holds on his left arm, which is not visible, a piece of fur or a furred garment which we see hanging down between the two men, almost reaching the pavement and trailing behind the left foot of the old man with the fur cap.

This detail, this piece of fur, has escaped the attention of the interpreters of the etching.

The men are obviously bargaining. The price offered by the beret man is found too low. The man with the fur cap, possibly a refugee from Poland — we are in 1648, the year of the Chmielnicki atrocities — is selling what is his most cherished possession. However, the other man, perhaps a middle-man, must make a buck on the deal. This most expressive group holds the key of the situation depicted. It is singled out by the pillar behind it, and the stoop on which it is standing. The two men on the right are a toned down version of the two on the stoop. Here, too, a man in a fur cap is the one being talked to. He listens with hands clasped and a subdued glance. The other man supports his argument with authority by a gesture of his right hand.

The man with a turban seated back turned on the parapet of the stoop raises his left hand to his chin in a gesture of preoccupation characteristic of a person waiting for someone.

The other figures in the receding space are less sharply characterized.

The long wall in the back with the windows looming in the dark has nothing to identify it as a synagogue. In examining it more closely, we come to the conclusion that it is an imaginary piece of architecture, intended as a backdrop for the figures. It accompanies them haltingly into the distance, curves out, like a niche, in the back of the frontal pair on the right, projects transept-like emphasizing the two single figures walking toward the rear, and protrudes in a second movement to accentuate the last pair in the background. In a final turn, parallel to the foreground, it closes the rear. The foreshortened windows indicate the changes of direction in this undulating screen.

The seated man fills the right angle between the pillar and the parapet, thus helping to soften the transition from the lighted area on the left to the darker one on the right.

The etching of 1648 is a sort of résumé of the numerous sketches Rembrandt had been doing from about the early 1630s of peddlers, musicians and other street types. Not all the peddlers he drew and etched were Jews and not all the Jews he portrayed were peddlers. He has used the Jewish face for expressing all registers of emotion, up to the most sublime, but he could also use it to communicate commonplace worries, everyday preoccupations.

"A scene in the Jewish Quarter of Amsterdam," as Rembrandt's etching of 1648 should be called, may be ranged thematically with Jozef Israels' "A Son of the Ancient People"[14] showing a man sitting in front of his secondhand clothes shop, and with Max Liebermann's "Jewish Quarter in Amsterdam,"[15] portraying an open-air market scene.

Of the three masters, Israels' gave the most pathetic sight of an old man in a state of dejection and hopelessness. The title contributes to the mood of the painting. Liebermann, the impressionist, was primarily interested in the overall effect of a busy street scene.

Rembrandt did not care to give his etching a name. To the beholder in his time the topic was self-explanatory. We look at the old refugee who must start his life in the new country as a peddler. We try to imagine Rembrandt's state of mind at the time. He was 42, in the prime of life, but he has known suffering: the loss of his young wife and the rejection of a major work, his "Night Watch." His art was becoming quieter, more mature and more "sublimely mov-

ing," to use Otto Benesch's words said with regard to another work of 1648.[16] They certainly apply to our etching.

With this work removed from the category of synagogue views by Dutch artists, we come to realize that the interest in the synagogue does not start before the later 1650s. The first synagogue in Amsterdam to be represented was the Portuguese one of 1639. However, its interior drawn by Jan Veenhuysen was of a much later date since Veenhuysen was active in 1656-1685.[17] The view of the exterior of that synagogue by Romeyn de Hooghe (1645-1708)[18] was drawn after the congregation had moved out of the building in 1675, as the title of the engraving "Geweesene Kerk der Joden" indicates. Pieter Persoy, who published the prints of it was born in 1668.[19]

The building which provoked a real avalanche of pictorial renderings was the Portuguese Synagogue of 1675. This goes to say that a view of a synagogue in Amsterdam dated 1648 would have to be regarded as an anachronism. While literary references to synagogues in Amsterdam appear early — we have in mind Sir William Brereton's travelogue of 1634-35[20] and Charles Ogier's diary of 1636[21] — pictorial records seem to have needed stronger stimuli than intellectual curiosity and interest in religious diversity.

What had attracted Rembrandt and had inspired his etching was the human experience he derived from his contacts with Jews of the humbler classes.

But it was up to the artists who specialized in the production of views of remarkable buildings in the Dutch skyline to discover the synagogue.

17. BERLIN, THE EARLY 1920ˢ

The opening on February 25 of the Russian Art Exhibition at the Hayward Gallery in London[1] brings to mind another Russian art exhibition. Arranged by the Soviet Government in 1922 in Berlin, it displayed precisely the works the Russian Government objected to in the present exhibit. Lazar Lissitzky (d. 1941), some of whose works have been now withdrawn from the London exhibition, designed the cover for the Berlin exhibition catalogue[2]. A typical work of his, reproduced in the Hebrew magazine *Rimon* (No. 3, 1923), was entitled "Construction". It was a configuration of blocks resembling a plan of a group of buildings[3]. The closeness of abstract art to architecture was not accidental. Theo van Doesberg, the initiator of the Dutch "De Stijl" movement (1917), was a painter and an architect. It was he who, in the words of Philip Johnson, introduced the idea of "asymmetrical balance" in architectural design[4].

Lissitzky too had been trained as an architect, but with little opportunities for work in his field in the years of World War I he turned to the graphic arts and produced a number of illustrated Yiddish story books[5]. His wife and biographer, Sophie Kueppers, failed to mention another work of Lissitzky's early period. It is possible that it slipped off his mind and he never talked about it. In the issue of the *Rimon* (1923) mentioned before, appeared Lissitzky's now so popular and much pirated copies of the paintings from the 18th century timber synagogue at Mohilev on the Dnieper river. In his accompanying article Lissitzky told the story of how in 1916 he and the painter Issachar Ryback went to Mohilev having heard so much about the frescoes still extant in the old synagogue there[6].

In 1922 Lissitzky brought his copies to Berlin and I only regret that we did not acquire these paintings and returned them to Lissitzky after having them reproduced in colour from the *Rimon*. They are now irretrievably lost. Lissitzky's article conveys his excitement and pride of discovery of a forgotten art, but to him it represented already a past thoroughly overcome. He had joined wholeheartedly the movement of abstract, non-objective art inspired by technology and out of an acute sense of social change.

Writing in the same issue of the *Rimon* Henryk Berlewi[7] contrasted the new art shown in the Soviet exhibition with Chagall's figurative work which was exhibited at that time in the Sturm Gallery. Chagall's paintings, the "Fiddler", 1914, and "To My Wife", 1915, were reproduced in the *Rimon* as illustrations of Berlewi's article. However, Berlewi did not analyse the paintings, nor did he review the Soviet exhibition. Instead, he picked out the works of David Sterenberg shown there as an example of the new style juxtaposed to Chagall's. The comparison did not work because Sterenberg stood at the crossroads and was not a true representative of abstract art[8]. Berlewi's confused thinking was due to his position at that time. He was undecided. Having studied art in Warsaw and other European academic schools, he had nothing more advanced to give us for the *Rimon* than a moderately stylized portrait of a young woman dated

1921[9]. However, in 1922/23 came the break, and his conversion to constructivism, or to what he called *Mechanofaktur*, a term he used in his exhibit at the Sturm Gallery in 1924[10]. It became his trade-mark.

Since 1928 settled in Paris, Berlewi exhibited mostly in Poland and Germany, where his work is represented in public collections. It is also to be found in Brussels, Antwerp, and Zurich. His great hour came when in 1965 he was invited to participate in the Exhibition *The Responsive Eye* at the Museum of Modern Art in New York. His only work shown there was *Construction in Six Squares*, dated 1963. He was honoured as one of the pioneers of abstract art. In bringing me a numbered copy of a publication on his art[11], he reminded me of my somewhat frivolous comments on his Sturm exhibit in 1924. He died in Paris in 1967.

18. FROM MY ARCHIVES*

Rachel Wischnitzer in
Berlin in the 1920s
(Photo Abraham).

This bibliography of mine prepared by Rochelle Weinstein I would have preferred to "see" appear posthumously.[1] It differs from the listings of my publications in L. A. Meyer's *Bibliography of Jewish Art*, 1967, in that it includes items on non-Jewish topics. I have always regarded Jewish art as part of the general creative process moulded inexorably by the times and the artist's personality, rather than by national characteristics. Patronage determined the choice of subject matter, but it was not a permanent factor.

As art editor of *Rimon* and *Milgroim* (Berlin, 1922-1924), I believe that I faithfully recorded the concerns of that time in promoting the discussion of Cézanne and Chagall, synagogue mosaics in Palestine, and a Babylonian cylinder. The artists from Soviet Russia who were in Berlin in those years talked about Giotto and El Greco. The German art critic Meyer-Graefe was debunking Velasquez, putting El Greco on the pedestal instead. I had come from England, bringing my copies and photos of illuminated Hebrew manuscripts from the British Museum, the Bodleian Library at Oxford and other collections. Lissitzky had brought his copies of the eighteenth-century paintings of the wooden synagogue in Mogilev on the Dnieper. The Middle Ages and the Baroque were the concern of the day.

It so happened that Leopold A. Sev, a friend of ours (Dr. Wischnitzer's and myself) from St. Petersburg (Leningrad), came to Berlin on a visit from Paris. He had been the editor of the St. Petersburg Russian language periodical *Novy Voskhod* (New Dawn). Our idea of publishing a magazine fascinated him. He enlisted the interest of Ilyia Paenson for our venture. Paenson was a Zionist, an admirer of Jewish literature and the arts, a business man with some means. That is how *Rimon and Milgroim* (Pomegranate) originated. Bringing people together for a worthy cause was characteristic of Leopold Alexandrovitch Sev (1867-1922). He had introduced Marc Chagall to L. S. Bakst who directed an art school in St. Petersburg. Sev belonged to a group of Jewish intellectuals in the pre-Revolutionary Russian capital which included the prominent lawyer Maxim Vinaver, A. I. Braudo, director of the *Rossica* Division of the Public Library in St. Petersburg, the historian Simon Dubnov and others who were active in the fight for equal rights of the Jews. After the Revolution he left Russia. We were in steady contact when he suddenly died in Paris at the age of 55, before the first issue of *Rimon* appeared. We

* I would like to thank Dr. Rochelle Weinstein for making a number of good stylistic suggestions.

166

published his portrait in the first issue of *Rimon* with an obituary by Solomon Posner, another member of the Petersburg group. For technical reasons, apparently, neither appeared in the *Milgroim*.

The first question we had to face when planning the magazines was the question of language. We realised that German, the language of Goethe, Schiller and Moses Mendelssohn was, after World War I, no longer the unifying cultural vehicle of the Jewish intelligentsia. We wanted to reach out to Jewish groups in America and the growing Jewish community in Palestine. Yiddish and Hebrew seemed to be indicated. There were to be two companion magazines, each with a literary and an art section. We published poems, stories and literary essays only in the original language, so that David Bergelson appeared only in the *Milgroim*, while Bialik and Agnon were to be found only in the *Rimon*. Saul Tchernichovsky, a leading Hebrew poet, gave us a poem, *Black was the Night*, in Yiddish. It was published in the *Milgroim*, while his Hebrew essay on Bialik and his Hebrew translation of the *Hymns of Akhnaton* appeared in the *Rimon*.

I knew Tchernichovsky in Heidelberg in 1903, where we both took Kuno Fischer's course in philosophy. We also both drew from life in a course at the University. One of the models was an old man, a public messenger who used to stand at a certain street corner taking letters for delivery, since there were no telephones in Heidelberg in 1903. We drew only his head, the models kept on their clothes.

I had known Agnon in Berlin during World War I. Born in Galicia, Agnon was an Austrian citizen and could live freely in Berlin. I was the wife of an Austrian officer who was with the army at the front. I lived in Trautenaustrasse in a boarding house. Agnon used to drop in, we talked about Buber. Agnon had mixed feelings about Martin Buber. He saw the Jewish past in more archaic terms.

Zalman Rubashov (Shazar) was also in Berlin at that time studying at the University. He was registered by the authorities as a Lithuanian (actually he was born in Mir, White Russia) which

167

permitted him to continue his studies. I remember him as a speaker for Zionist causes. During outbursts of oratory Rubashov would press his knuckles onto the lectern with such force that it rocked. I was always afraid it would fall.

While we had distinguished authors for the literary section, there were no Hebrew or Yiddish writers in the field of art. The Palestinian archaeologist Sukenik wrote his article on synagogue mosaics in Hebrew of course, Lissitzky wrote his article on the Mogilev synagogue paintings in Yiddish, illustrated with his own copies. All the other contributors on art topics, including myself, wrote in German. I believe that Olga Pevsner-Schatz wrote her article on Leonardo in Russian. We did not publish Boris Schatz. He was of the Antokolski generation, and he did not even have real talent. His flat portrait reliefs, full face, showed that he did not understand foreshortening. As an organizer and promoter of arts and crafts in Palestine, he was great.

Dr. Mark Wischnitzer was general editor of the magazines. Moshe Kleinman, who did the translations into Hebrew, was co-editor. Bergelson and Nistor were fiction editors for the first *Milgroim* issue. Baruch Krupnik prepared translations in Yiddish. The production of the first issue of the magazines was in the hands of Alexander Kogan, the publisher of *Jar Ptitza* (Firebird), a Russian art magazine. The format and general appearance of our journals showed the influence of *Jar Ptitza*. I was art editor, Ernst Boehm did the covers, head-and tail-pieces, for which we provided the material from Hebrew illuminated manuscripts and engravings. Franciska Baruch, a young girl, learned the Hebrew alphabet to be able to do by hand the lettering for the titles, using medieval Hebrew Ashkenazi script as models. I met her again in 1955 in Israel. Hebrew illuminated manuscripts were my chief concern. I had admired Franz Landsberger's book on the *Folchart Psalter* and invited him to do an article on attitudes toward the Middle Ages of the Renaissance, the Romantics, the Impressionists, and the Expressionists. As an illustration for the article in the second volume we provided illuminated pages from a Maḥzor at the Leipzig University Library, from Dresden and from the Rashi Synagogue at Worms. We published Landsberger's paperback, *Impressionismus und Expressionismus* (1920), in Hebrew and Yiddish editions (1923). They contained no examples of Jewish artists. Later, at the Hebrew Union College in Cincinnati, Nelson Gluck gave Landsberger the opportunity to devote himself entirely to research and he published a series of fine articles on Hebrew illuminated manuscripts. His book *Rembrandt, the Jews and the Bible* (1946), was a popular success. His rather weak articles on Rembrandt's so-called *Synagogue* and on an etching by Rembrandt representing the Temple were discussed in my articles in the *Abraham Weiss Jubilee Volume* (1964), and in the *Art Bulletin* (September, 1957).

Meyer-Graefe, who wrote for us on Cézanne, loaned us cuts of works of the French Impressionists and was helpful in many ways.

The Soviet Art Exhibition in Berlin (1922-1923), brought us opportunities to publish examples of Nathan Altman's stage designs and his "Jewish Ornament," Lissitzky's "Construction" and Sterenberg's landscape, a close-up view of a piece of earth with minutely designed plants (1923). Chagall's "Jewish Fiddler" (1914) and "To My Wife" (1915), came from the *Sturm* Exhibition, which took place in Berlin at the same time. The dreamy "To My Wife" revealed the impact on Chagall of the painter Wrubel who was worshipped by the Russian avant-garde of the period. In his *Diary* Chagall tells his dream about Wrubel. He saw him as though he were his older brother. When Wrubel drowned in the sea, Chagall's father said: "now that our son Wrubel has drowned, we have only one painter-son." A classic dream for the psychoanalysts.

The third issue (1923), brought in the Russians with their advanced work, in fact works

which they had produced on the eve of World War I and during the war. These included Lissitzky's copies of the paintings of the eighteenth-century synagogue at Mogilev which he made in 1916. In his accompanying essay Lissitzky said that the idea of going to the provinces in search of old synagogues was inspired by an exhibition of Jewish art in 1916 in Moscow. He and Ryback went first to Kopys where they were told that the synagogue had burnt down. From there they went to nearby Mogilev. A painting from the synagogue at Kopys has been published in my chapter in *The History of the Jews in Russia* (Moscow, 1914). I was not in Russia at the time. Also reproduced in that chapter in the *History* was a part of the Mogilev synagogue decoration which carried the inscription of the painter Ḥaim ben Itzhak Eisik Segal. Chagall, whose grandfather had changed the original name Segal to Chagall, believes that the Mogilev painter is an ancestor of his. However this may be, Lissitzky and Ryback obviously knew about the Kopys and Mogilev synagogue paintings from the *History of the Jews in Russia*, volume I, which appeared in Moscow in 1914. The ambitious project in which five volumes were planned, was discontinued because of the war. In 1955 Mark Wischnitzer, then professor at Yeshiva University in New York, was invited by the Hebrew University in Jerusalem to participate in the planning of what was to be a continuation of a history of the Jews in Russia. He died in October of that year in Tel Aviv, the night before leaving for Zurich on the way back to New York.

In the *Reconstructionist* (June, 1959) I told the story of how during a lecture I gave at the Herzl Institute in New York, a woman named Sylvia Baskin, told the audience that she was born in Mogilev, that her father had been *shamash* (sexton) of the old synagogue and that her brother remembered the picture of a city encircled by a huge serpent which everyone thought was the Leviathan.

Lissitzky interpreted the city, which was inscribed *Wirms* (Worms), as the "wicked city," to be contrasted with a structure on wheels which he interpreted as the Temple. He intuitively offered a correct interpretation. When I wrote the article which appeared in the *Reconstructionist*, I knew the legendary explanation of the reason why the city of Worms got its name. The story of the locksmith who saved the city from the huge snake, the *Lindwurm*, is told in Samson Rothschild's *Aus Vergangenheit und Gegenwart der Israelitischen Gemeinde Worms*. I got the little book, 4th edition, Frankfurt, 1909, from the Jewish Cultural Reconstruction Commission in New York which had received from Germany, well after the second World War, a collection of books the Nazis had taken from libraries and private collections in countries they had occupied. These books were made available to scholars. Professor Salo Baron who was chairman of that commission recently told me by phone that this was in the late 1940s—1950s. My copy of the Rothschild book carries the stamp in Russian of the Library of the *Society for the Dissemination of Enlightenment among the Jews in Russia. Kiev Division*. Along with the locksmith story, which derives the name of the city of Worms from the legendary *lindwurm* (huge worm), Rothschild relates a Jewish legend which sheds an ambiguous light on the attitude of the Jews of Worms toward Palestine. It is the story about Ezra coming to Jerusalem from the Babylonian captivity and inviting Jews of Worms to come to settle there. They decline the invitation. When I told the story to Professor Shlomo Eidelberg, he told me that the Yemenite Jews had a similar legend. He refers to it in an article to appear in *Solomon Goldman Lectures*, Spertus College of Judaica, Chicago. The way the Jews of Worms apologize for not coming, pointing out that they are well liked by the population and feel happy in Worms, has to me a rather humorous ring. Rothschild's reference to the source of the Jewish Worms legends — *Maasse Nissim* (Wondrous Tales) and to Juspa Shamash, author of one of them — made it easy to locate the book. It was published by Elieser Liberman, the son of Juspa

Shamash, in Yiddish translation from the Hebrew, in Amsterdam, 1696. The Hebrew Union College graciously sent me photostats from their copy printed in Amsterdam in 1723. Juspa Shamash, the sexton of the synagogue at Worms (d. 1678), believed that the calamities that befell the Jews of Worms were a punishment for their refusal to go to Jerusalem. Hence the reputation of Worms as the "wicked" city.

The search for the Worms legend and its origin seemed to have reached its end, when it took a new turn owing to a letter by Dr. Max Dienemann, rabbi of Offenbach, which I found in my husband's archives. In his letter of October 8, 1927, Dr. Dienemann asked permission to reproduce the "Worms" picture from the *Rimon* on behalf of a friend of his, who was working on the Nibelungen epic. He did not name the scholar and I do not remember how I found the name, nor do I recall the request for the picture.

Lissitzky's copy of this Mogilev painting reproduced in the *Rimon* and the *Milgroim* was pillaged without end. It appeared, unknown to me, in Eugen Kranzbühler's *Worms und die Heldensage*, published by Friedrich M. Illert in Worms, 1930, as a publication of the Worms Stadtbibliothek of which Illert was the director. Dr. Friedrich Illert deserves our gratitude for saving the medieval Maḥzor of the Worms synagogue by depositing it in 1943 at the Worms Cathedral. It is now at the National and University Library in Jerusalem, as we learn from Bezalel Narkiss' *Hebrew Illuminated Manuscripts* (1969, p. 92). Kranzbühler died on March 17, 1928. The Mogilev picture requested by Dr. Dienemann in October 1927 from Dr. Wischnitzer in Berlin may have arrived after Kranzbühler's death. Dr. Illert had the unenviable task of working out the text from several manuscripts and completing the footnotes. This accounts for the lack of reference to the source of the Worms picture. In a letter of January 29, 1964, Dr. Georg Illert, son of the late Friedrich Illert and the next director of the Worms Stadtbibliothek, informed me that the Library had sent to me on loan Kranzbühler's *Worms und die Heldensage*. He referred to Konrad Schilling in Cologne who apparently had served as intermediary. Schilling had arranged the memorable Exhibition *Monumenta Judaica, 2000 Jahre Geschichte und Kultur der Juden am Rhein*, 1963—1964, in Cologne. I still have to find out who had alerted Mr. Schilling to my search of the Kranzbühler book. However this may be, I got the book on loan to keep until early March.

Kranzbühler had established that, according to German legend, it was the "horned" Siegfried who had killed the *Lindwurm* in Worms. He cited the Jewish version from W. Grimm, *Die Deutsche Heldensage*, 3rd ed., 1889. Kranzbühler regarded the Jewish version as its most coherent rendering. I used the new material in my *Heawar* article. Needless to say, the time I had the book at my disposal was much too short. I owe it to Dr. Hannelore Künzl of the Martin Buber Institute of Jewish Studies at Cologne University that the copy of the University was photocopied for me. In my letter of June 9, 1967, I thanked her for the copy which was a gift of Cologne University.

I wish briefly to review the paintings which covered the interior of the dome of the Mogilev synagogue. They included besides the view of the city inscribed "Wirms," a moveable ark, standing for the Temple, a stork bringing a snake to his young which nested on the Tree of Knowledge, a Tree of Life near the city of Worms and a sailboat. The stork, known from Aristotle and Philo for his filial and parental love, is called *hassidah* in Hebrew, the pious one. The feminine term "ḥassidah" points to the virtue of piety, not directly to the pious man. In Messianic imagery the righteous will feast on the meat of the Leviathan in the world to come. The Tree of Knowledge, the forbidden tree of Genesis, is according to Enoch XXXII, the Tree "of which the Saints eat and acquire great knowledge." The sailboat alludes to the invitation to come. The Tree of Life marks the locality — the city of Worms. A fine subject for a

comparative study of the decorations of eighteenth-century East European synagogues.

In the 4th issue of the magazines *Rimon—Milgroim* we brought etchings from Rembrandt to Steinhardt. The latter's work "In the Family," done in dry point, does not yet suggest the somber mood of his *Haggadah* (1928). Meidner's self-portrait, an etching, had already appeared in the second issue. In the 5th issue (1923), Baal Machshoves' 25th anniversary was marked by a portrait, a drawing by Chagall (1918). The date of the drawing is mentioned in the caption, but the inscription on the upper part of the drawing was unfortunately cut off in the reproduction. This portrait had a strange story. I found it lately reproduced in the *Catalogue of the Israel Museum* (1965). Here the upper part of the background is showing. It carries an inscription in Russian which I give in transliteration: "Baal Machshoves v Rossii," which means "Baal Machshoves in Russia." Underneath is the date, 1918, and farther below, "Baal Machshoves" in Hebrew characters. At the bottom of the sheet is Marc Chagall's signature. The emergence of this portrait in the Israel Museum was a great relief to me. Some time before January 5, 1924, when my son Leonard was born, we moved from our furnished apartment on Hohenstaufenstrasse to another more comfortable furnished apartment. In the years after World War I, because of housing shortage, foreigners in Berlin could get only sublet apartments. Older German women used to rent large apartments and sublet them to foreigners, keeping for themselves a room or two. The morning after we had moved, I found that some drawings were missing. They were forgotten in a desk drawer. When I called our former landlady, a witch, she said that any papers left were thrown out by the cleaning women. I was horrified, but there was nothing we could do. It actually appears that the woman was quite smart and sold the drawings. Fortunately Chagall's portrait landed in a Museum where its presence was recorded, putting my worries at rest. Dr. Franz Meyer, Chagall's son-in-law, lists the drawing in Chagall's *Bibliography* as made by Chagall expressly for Baal Machshoves' 25th literary anniversary in Berlin. This is not so. The inscription shows that it was made in 1918 in Russia where both Chagall and Baal Machshoves were at that time.

The 6th issue of *Rimon—Milgroim* (1924) was to be the last. The inflation in Germany had stopped, and with the dollars we received for copies sold in the U.S. losing their astronomical value, the magazines had to be discontinued. This loss did not affect us financially, since Mark was the director of the *Hilfsverein der Deutschen Juden*. I was able to go on with research. In my article in *Osteuropa* (Volumes 4/5, 1925—6), I pointed out the Tatar and Turkish origin of a number of Russian architectural terms, adding evidence to the influence of the Tatars in Russian architecture. The famous church of Vasilii Blazhenyi in Moscow was built by Posnik and Barma, the second obviously a Tatar. Research in Russian architecture was of course not possible without the Russian libraries and archives. In 1927 I was elected to the Committee of the Art Collection of the Berlin Jewish Community. The *Dezernent* (Commissioner) for the art collection was Dr. A. Sandler. The collection had been until 1927 administered by the Librarian of the Jewish Community, Dr. Moritz Stern. Dr. Karl Schwarz was curator of what then became the Jewish Museum, from 1927 until his departure in 1933 for Tel Aviv. Erna Stein-Blumenthal, his assistant, who also went to Palestine, remained at her post until 1935, when Franz Landsberger became curator of the Museum and I became the scientific adviser of the Museum, an honorary position. We arranged a number of exhibitions. It was during our exhibition *Unsere Ahnen* (Our Ancestors) in 1936, which brought together eighteenth and nineteenth-century portraits, that Eichmann visited the Museum. Dr. Alfred Klee, the *Dezernent* for the Museum, and Heinrich Stahl, director of the Board of the Jewish Community, were present. I was showing Eichmann around. He said that American Jews who were Sefardi Jews are of a higher cultural standard than Ashkenazi Jews. Dr. Klee remarked that most

American Jews are of Ashkenazi descent. Eichmann asked me about my husband's book *Juden in der Welt* (1935). He was up-to-date on Jewish affairs.

The exhibition *Hundert Jahre Jüdische Kunst aus Berliner Besitz* (December 1937—January 1938), at the Jewish Museum was probably the last. In 1937 I had arranged two exhibitions of the type *exposition d'époque*, representing the protagonist not an artist, as set against his social and cultural background. For the *Don Jizchaq Abrabanel Exhibition* (June, 1937), the Community Library and the Lehranstalt für die Wissenschaft des Judentums, both in Berlin, and the Jüdisch-Theologische Seminar in Breslau, loaned early editions of Abrabanel's commentaries on the Bible, on the Passover Haggadah, and on Maimonides Commentary on *Mishneh Torah*. The earliest was the Haggadah with the Commentary *Zevah Pesah*, Constantinople, 1505. Also exhibited were two editions of the *Dialogi di Amore* by Leone Ebreo, son of Itzhaq Abrabanel, in an Aldus print, Venice, 1541 and in another Aldus print of Venice, 1549, loaned by Dr. Fritz Bamberger. A photo of Bronzino's portrait of Eleonora of Toledo, duchess of Florence, was exhibited with reference to Benvenida, Itzchaq Abrabanel's niece and daughter-in-law, who as governess of the duchess, was able to render services to her co-religionists.

The *Akiba Eger Exhibition* (Hanukka 1937) called to mind the periods of the Enlightenment, the Napoleonic Sanhedrin, Reform and Tradition. The Posen rabbi, 1761—1837, had been portrayed in the "Market in Posen," a huge painting by Julius Knorr (1837), which was in the old royal Residenzschloss in Posen. Reproduced in our exhibition in several photos, the canvas showed "tout Posen," the military, the bureaucracy, local celebrities, a Polish peasant wedding, a band playing, and the popular rabbi walking with Moses Landsberg, the *dayan* (member of the rabbinical court) and Jacob Calvary. According to Arthur Kronthal, *Werke der Posener Bildenden Kunst* (Berlin, Leipzig, 1921), the rabbi, who was nearly blind, was drawn secretly owing to his religious scruples. He died shortly after the portrait was finished. The Egers, a well organized clan, got us a number of portraits of Akiba Eger for the exhibition. There were three embroidered ones and also a likeness of an embroiderer, a young girl in a charming Victorian picture.

In that same year, in March, 1937, I made a trip to Ellrich am Südharz, in the Erfurt district, on behalf of the Berlin Jewish community. The people there were worried about the safety of their synagogue. It was located in Judenstrasse 7, which had been renamed Horst-Wessel Strasse, so that anything could be expected. The half-frame building stood in the back of the courtyard. An inscription over the portal on the outside gave the date in Hebrew characters: לפרט פדות (*lifrat pedut*) i.e., "the date of the Redemption," since *pedut* means redemption. This amounted to the Jewish date of (5)490, i.e., 1730. I took along to Berlin, for storage, the Torashield dated 1769 and the standing Hanukkah lamp. An excerpt of my report to the Berlin Community appeared in the *Gemeindeblatt* (November, 1937), with the photos of the two objects. A more detailed article appeared much later. Dr. Arthur Spanier who apparently was at that time the director of the *Monatsschrift für Geschichte und Wissenschaft des Judentums* sent the proofs from Holland to me in Paris. He was deported from Holland.

I learned much later that the issue of the *Monatsschrift* which contained my article did appear. Published by rabbi Leo Baeck, it was financed by the Jüdische Kulturbund, the only still functioning Jewish cultural organization.

A project which I had conceived with the help of Professor Adolph Goldschmidt of the Berlin University had actually never gotten off the ground. The *Handschriftenabteilung* (Manuscript Division) of the Berlin Staats- und Universitätsbibliothek had a small collection of Hebrew illuminated manuscripts. Extensively using this collection, I offered to the director

of the Manuscript Division, Dr. Karl Christ, to photograph and catalogue the manuscripts and to expand the collection by obtaining the support of Jewish collectors. I had mostly to do with Dr. A. Boeckler, Christ's assistant, who, I believe, had been a student of Goldschmidt. A circular letter was worked out with the signature of Professor Goldschmidt and the approval of Dr. Christ. Dr. Christ's last letter to me is dated February 20, 1933. Then came a day when I was denied entrance to the Staatsbibliothek.

Since my arrival in Paris in Spring, 1938 with Mark and Leonard, I remained in touch with Berlin. Among the articles I sent to the *Jüdische Rundschau* was a review of the exhibition *300 Years of Art in the United States* at the Musée du Jeu de Paume in Paris in May—July, 1938. The review appeared in August 12, 1938. The exhibition was organized in collaboration with the Museum of Modern Art in New York. Alfred H. Barr, Jr. supervised the organization and the compilation of the catalogue. Apart from paintings, sculpture, the graphic arts and architecture, the exhibition presented popular art, folk art, photography, and films.

In 1939 I arranged the *Vente-Exposition* for the *Keren Kayemet LeIsrael* which took place at the Palmarium of the Jardin d'Acclimatation in Paris. The exhibition was reported in *L'Univers Israélite*, the *Neue Presse*, *La Terre Retrouvée*, the *JTA News Agency*. Max Osborn wrote a long review of the exhibition in the *Jüdische Rundschau* (July, 1939). Osborn defined the exhibition as a cross-section of the creative work of the Jewish artists in Paris. Represented was the so-called School of Paris, with Chagall, Ryback, Mane Katz, Menkes, Hana Orlov, Max Band, Benn, to mention the most prominent names to come to mind. The newcomers were Richard Erdös from Hungary, Eugen Spiro, Floch, Victor Tischler from Central Europe, and Carlo Levi and Corrado Cagli from Italy. Much noted and immediately sold was Nina Brodsky's copy of the *Prophet with Open Scroll*, a drawing after a fresco from the third century A.D. synagogue of Dura-Europos on the Euphrates in Syria, excavated by Du Mesnil du Buisson on behalf of the Académie des Inscriptions et Belles Lettres and Yale University. The actual sale took place on the second and third day of the exhibition. Joseph Fisher, commissaire général of the *Keren Kayemet LeIsrael*, thanked me in a letter of June 23, 1939 in behalf of the *KKL*, and personally, for arranging the exhibition, and conveyed to me the condolences on the misfortune that had struck me, "the day after our festivity." My mother died on June 20, 1939. She had committed suicide.

I arrived in the U.S. on January 8, 1940 with Leonard. Owing to a different immigration quota (based on country of origin), Mark could not join us. I was taking along what was the first review copy of Du Mesnil's *Les Peintures de la Synagogue de Dura-Europos, 245—256 après J.-C.* (1939). I had attended his course on Dura at the Sorbonne. In New York my publications introduced me to two different milieux. Professor Meyer Schapiro showed me my *Symbole und Gestalten der Jüdischen Kunst* which he had in his Columbia University Library. Carl Kraeling, author of the *Preliminary Report* on the Dura Paintings (Yale, 1936), knew my work and the publications of Zofja Ameisenowa in Cracow (1897—1967), with whom, by the way, I had been in touch in the early 1930s. The *Milgroim* was well remembered by the Yiddish writers. I started to work on my thesis, the Dura Synagogue paintings, under Carl Lehmann at the Institute of Fine Arts, New York University. With an architect's diploma (1907), one of the three first in Europe earned by a woman, two semesters at Heidelberg and two semesters at Munich University (1911), I felt that studying again under Lehmann, was highly stimulating. Lehmann, a classicist, was interested in style rather than iconography, but he mentioned my Dura research in a lecture at the Metropolitan Museum and cited my *Symbole und Gestalten* in his "Dome of Heaven" (*Art Bulletin*, March 1945). There was a sort of intoxication in the way I felt. The Liberation of Paris (August 25, 1944) came as a sobering

shock. Leonard who had been with the American Army in Europe was coming back. But what had happened to the rest of my family? My father was 77 when I left Paris in January 1940 and he was very weak. I thought during all those years, that he must have died. He was a naturalized French citizen. What did we know of what was going on during the war in Europe! I sent a cable to my niece in Paris. A cable from her dated December 1, 1944, informed me that my brother, herself, her husband and their children were all right. Father had been deported. He was taken away with the last convoy from Paris July 31, 1944. I had three examinations ahead of me that week. I could not go. I had succeeded with great difficulty in getting my parents out of Russia, and this was to be their end.

The Dura book appeared in 1948. The Institute of Fine Arts, on this occasion, arranged a lecture for me with invited guests (December 10). Lehmann listening to me as I showed the slides, said that he was beginning to believe that my Messianic interpretation was quite plausible.

On the 30th anniversary of *Rimon* and *Milgroim* Dr. Stephen Kayser arranged at the Jewish Museum in New York an evening dedicated to these magazines (February 7, 1953). Joseph Opatoshu read a story that had been published in *Milgroim*. A poem of Leiwick, published in *Milgroim*, was recited. Emanuel Romano, whose two paintings had been reproduced in both magazines, reminisced about the art trends in Europe in the 1920s. Mark gave a picture of the cultural climate of the period and recalled Bialik, Tchernichovsky, Sukenik, Moses Gaster and Simon Dubnow. I told some episodes giving the inside story of the magazines. Samuel Niger-Charney presided. Lincoln Newfield sang *Psalm 130*, by Arthur Honegger, and *Galil*, by Julius Chajes. Mark died on our visit to Israel on October 16, 1955. When I came back to New York, my *Synagogue Architecture in the United States* had just come off the press. President Belkin of Yeshiva University invited me to join the faculty of Stern College for Women (1955) and I started teaching art history there in 1956. I dedicated my *Architecture of the European Synagogue* (1964), to my students at Stern. Retiring after twelve years of teaching, as Professor Emeritus of Fine Arts (1968), I received from Yeshiva University a doctorate *honoris causa* (July 13), and Stern College honored me with a Symposium (November 6, 1968). The theme was *The Paintings of the Synagogue of Dura-Europos*. The participants were Professors Meyer Schapiro, Columbia University, Morton Smith, Columbia, Blanche Brown, New York University, C. Bradford Welles, Yale University, and David Sidorsky, Columbia University. Dean David Mirsky read a note from Dr. Samuel Belkin, President of Yeshiva University who could not attend because of illness. In introducing the Symposium, Dean Mirsky mentioned the former dean Norman Frimmer who had started the preparations for the Symposium. I was the moderator.

A vast literature had grown around the problems of the Dura synagogue. Meyer Schapiro, who spoke last, defined the Dura synagogue murals as the earliest example of a type of art later developed in the great Christian basilicas and cathedrals, a type of art characterised by a highly systematized decoration of the interior of a sacred building with imagery based on liturgical or ritual ideas which finally depended on a sacred text. Seen from this perspective, the iconography of the paintings, the program for which the biblical scenes represented were selected, appeared to be of prime importance. The change of style from the illusionism and the three-dimensionality achieved in Roman art, toward frontality and superposition of pictorial elements for clarity of meaning, was illustrated with slides by Blanche Brown. The evidence of an ideological program in the Dura imagery was questioned by Morton Smith who pointed out the use of pagan figures such as Psyche, Victory, Orpheus and others in the paintings. Sidorsky admitted the existence of Jewish assimilationism, but noted that it stopped at

conversionism. The newly excavated synagogue mosaics from Gaza, published in 1968—1969, answer the question for Orpheus, at least. Sitting with his lyre and some listening animals, Orpheus is inscribed "David" in Hebrew in the poorly preserved mosaic. Goodenough's thesis of the impact of Philo on the conception of the Durene decorations found no support at the Symposium; Welles discussed the Greek inscriptions.

Of the tri-lingual inscriptions in the synagogue: Aramaic, Greek and Iranian, the latter are still a matter of debate among epigraphers. In the *Preliminary Report* (Yale, 1936) they were interpreted as the artist's inscriptions. Judging from the fact that these texts were found only in paintings in the lower part of the walls and from other observations, I regarded them (*Messianic Theme*, 1948) as visitors' scribblings. Bernhard Geiger (*Final Report*, 1956) also interpreted them as inscriptions of some visitors, identifying them as Iranians. More recently Christopher J. Brunner ("The Iranian Epigraphic Remains from Dura-Europos," *Journal of the American Oriental Society*, October—December, 1972), suggested that the visitors were Jews in Persian service. He pointed to the political significance of the Ezekiel panel which represents the Resurrection of the Jewish people. The other panels carrying Iranian inscriptions show Elijah reviving the Son of the Widow and the Esther scene with its Persian background. The Iranian texts contain the names of the visitors, the date of the viewing of the painting and invocations of peace. Andrew Seager's comparative analysis of the Dura and Sardis synagogue buildings sheds light on the different social standing of the two communities (See article in *The Dura-Europos Synagogue: A Re-Evaluation*, a collection edited by Joseph Gutmann, 1973). Seager notes that according to the inscriptions of the donors in the Sardis synagogue, they were city councilors and functionaries of the Roman provincial administration. In his view the Dura synagogue appears, in contrast, isolated and introverted. We may add that the Messianic character of the Dura synagogue decorations reflects the sense of insecurity and nostalgia of the Jews of Dura on the eve of the attack of Shapur I which brought the destruction of the city instead of the hoped-for liberation from the Roman occupation.

In his study "Dura Costumes and Parthian Art," in the aforementioned collection, Bernard Goldman says quite judiciously that is it not always possible to say why the Parthian or the Hellenistic costume was chosen by the protagonist. He believes that the choice of the costume depended on the artist who was ignorant of "the profound symbolic intricacies that have been ascribed to the murals." He points to David who wears once the trousered Parthian costume and another time the Hellenistic draped garment. There is nothing intricate in the picture of David on horseback wearing the trousered costume, nor is the symbolism obscure in the picture of David wearing a draped long garment at the ritual of his anointing by Samuel. As for the Ezekiel figure which Goldman mentions in the same context, he knows that there is profound disagreement in the interpretation of the Resurrection scene. It can be hardly helpful to use it in a generalising remark.

In discussing hypothetical models of the Durene iconography, Mary Lee Thompson takes into consideration illustrated manuscripts, earlier synagogues, now lost, and pattern books (see aforementioned collection). A pattern book would contain drawings of figures in usable postures and costume details. There may also be figure groupings of some memorable events. In a recent article (*Journal of Near Eastern Studies*, April 1, 1979), Dalia Tawil examined the Parthian Investiture scene and the Sasanian Triumph scene in Persian Imperial art as prototypes of the group of Mordechai, Haman and the bystanders in the Esther panel which is a triumph scene. We would like to mention in this connection the Hadad and Atargatis relief (fig. 1), as an antecedent of the Aḥasuerus and Esther group in the Esther panel (fig. 2). The relief was found in Dura in the court of the Temple of Atargatis. It must have been known to the

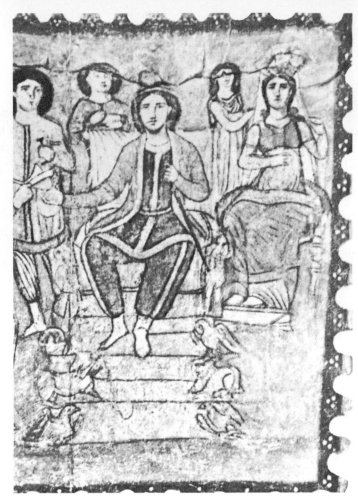

Fig. 1. Hadad and Atargatis. Stone relief from Dura Europos, 3rd century (after P.V.C. Baur, "Sculpture," in Dura Europos, Preliminary Report, 3rd Season. New Haven, 1932, pl. XIV).

Fig. 2. Ahasverus and Esther, detail from the Esther panel in the Dura Europos Synagogue, 3rd century (after Kraeling, Dura Europos, The Synagogue. New Haven, 1956, pl. LXV).

artist of the synagogue. P.V.C. Baur (*Preliminary Dura Report, Third Season*, New Haven, 1932, pp. 100f., pl. XIV), dates the relief to the third century. The work is crude but the subject is similar: an enthroned couple. The synagogue artist took from it the conception of the superiority of the goddess over her consort. Flanked by giant lion's heads, Atargatis, a powerful woman, is overwhelming in comparison with the illproportioned, small, awkwardly sitting male god. Esther could not be represented as sharing the throne of Aḥasuerus which, according to tradition (*Targum Sheni*), is the throne of Solomon. Her chair adjoining the throne is placed on a higher level, so that she appears to be taller than the king without being bigger. It may be noted that the identity of this Solomonic throne is *documented*. High above the Esther scene, in the uppermost register, King Solomon is shown sitting on a throne with the same alternating lions and eagles flanking its steps, exactly as in the design of the throne of Aḥasuerus. For the figure of Aḥasuerus we have to look into the synagogue repertory. His image is patterned on that of Pharaoh in the same register or vice versa. Both are derived from the same model. Esther has no prototype in the surviving panels of the synagogue decoration. There is no seated female figure to be found there. Her pose does not exhibit the Parthian frontality. She is sitting sideways. Only the upper part of her body and her face are shown full front. The model of Esther was a Hellenistic or Roman work schematized by the local Dura artist. I believe that the present trend to take into account the role of patronage, i.e., the political factor in the interpretation of a work of art, is favorable to a more realistic reconsideration of the few, but important pictorial elements of the Dura synagogue decoration still

regarded as controversial. In conclusion I would like to mention that along with the Dura paintings an equally challenging subject occupied my mind from the 1940s on: Giorgione's painting "The Three Philosophers," (*ca.* 1508). The interpretation of the youngest of the philosophers as Regiomontanus (*Gazette des Beaux-Arts,* April, 1945) led to my present study on Copernicus, the successor of Regiomontanus, the religious wars of the period, and the development of the secular portrait.

19. REMINISCENCES, ÉCOLE SPÉCIALE D'ARCHITECTURE, AND MALLET-STEVENS

To the Editor:

We live in a period of reappraisals and rediscoveries. On Robert Mallet-Stevens we have now Richard Becherer's "Monumentality and the Rue Mallet-Stevens," (*JSAH*, March 1981, 44-45). The street in Paris named for the architect of its buildings is a series of town houses of medium size built in 1925-1928. Becherer tells how the attacks on Mallet-Stevens by the influential architectural historian Sigfried Giedion for elitism, estheticism, formalism, etc. contributed to Mallet-Stevens' fall into oblivion. Referring to Mallet-Stevens' stay at Villeneuve-sur-Lot during the Hitler years — his self-imposed exile from Paris — Becherer speculates that one cause of the architect's descent was "biographical." What he means by this is not made clear. In explaining Mallet-Stevens' architectural development in the 1920s, Becherer makes a good point when he refers to the influence of Theo van Doesburg and the De Stijl movement. However, the early years are treated scantily.

As a colleague of Robert Mallet-Stevens at the Ecole Spéciale d'Architecture in Paris, I was particularly interested in his career, of which I heard only sporadically. After receiving my diploma in 1907, I worked for a year in a French architect's office before leaving Paris for St. Petersburg. After my husband and I settled in Berlin, I often visited Paris where my brother and my parents then lived. On one of these visits I went to see the Rue Mallet-Stevens. I have only vague recollections of my impressions, but one thing has remained in my memory. In one of the houses there was a circular staircase in the lobby and at the bottom of the stair the floor was of mirrored glass. I sometimes wonder what is the present condition of these houses in the Rue Mallet-Stevens and who lives in them. What a subject for a story in the style of Balzac!

Frondisi and Becherer both make errors in their discussion of Mallet-Stevens' early years. Mallet-Stevens graduated neither in 1905, nor in 1910. He received his diploma in 1906, the same year as Lydia Issakovitch, and a year before I received mine.[1] (I checked the dates with François Wehrlin, director of the ESA.)

The date of 1906 of Mallet-Stevens' graduation is important because it sheds light on his early years. In 1905, the Viennese architect Josef Hoffmann built the Palais Stoclet in Brussels. Adolphe Stoclet was an uncle of Robert Mallet-Stevens, and Mallet-Stevens knew the villa long before he went to Vienna to work in Hoffmann's office. According to Becherer, he went to Vienna in 1910 directly after graduation. Where he was between 1906, the year he graduated, and 1910 is apparently not known. At any rate, his coming to Vienna as a nephew of Adolphe Stoclet may account for his gaining entry to the higher echelons of Viennese society.

The Palais Stoclet had a great influence on Mallet-Stevens' style. (For two views, see Nikolaus Pevsner, *Pioneers of Modern Design from William Morris to Walter Gropius*, 1949, Fig. 112, and "Josef Hoffmann" in *Encyclopedia of Modern Architecture*, ed. W. Pehnt, New York, 1964, p. 148.)

The idea of shafts enveloping the corners of plain inarticulate façade walls was borrowed by Mallet-Stevens from Hoffmann. Acting like a picture frame, this device produced a flattening effect. An example of this motif is Mallet-Stevens' *Project for Workers' Housing* (Becherer, Fig. 6). A cubistic effect was achieved by Mallet-Stevens in *Maison Martel* (Becherer, Fig. 5). The corner shafts are omitted here.

I still remember Robert Mallet-Stevens, a tall, slender fellow. He died in 1945 at the age of 59. I remember a project of an apartment building he was working on at school — no Neo-Romanesque arches, tall straightheaded windows. His handwriting was uniform, like print. The three of us, Mallet-Stevens, Roederer (I hope I am spelling the name right) and myself had our own table in the cantine (cafeteria) at *La Spéciale*, as the *ESA* was called in the school's song.

<div align="right">

Rachel Wischnitzer
Yeshiva University, Emeritus

</div>

Editor's note:

Professor Rachel Wischnitzer-Bernstein, the oldest member of the Society of Architectural Historians (born 1885), offered this memoir.

RACHEL WISCHNITZER: A BIBLIOGRAPHY

COMPILED BY ROCHELLE WEINSTEIN

List of Abbreviations

AB *The Art Bulletin.*

AJHSQ *American Jewish Historical Society Quarterly.*

EJ *Encyclopaedia Judaica* (Berlin, 1928–34), 10 vols, "A–M".

GBA *Gazette des Beaux-Arts.*

Gemeindeblatt *Gemeindeblatt der jüdischen Gemeinde zu Berlin: Amtliches Organ des Gemeinde-vorstande.* Begun as monthly January 13, 1911; continued as weekly February 1934; ceased publication with volume 28, number 45, on November 6, 1938. See *JGB* variant title.

IF *Israelitisches Familienblatt.* Hamburg weekly begun 1898.

JB *Jewish Bookland.* Jewish Welfare Board Circle Literary Section edited by The Jewish Book Council of America.

JGB *Jüdisches Gemeindeblatt für Berlin: Organ des Vorstandes der jüdischen Gemeinde zu Berlin.* New title for *Gemeindeblatt* required by German authorities beginning May/August 1937. Half-title as of volume 28, number 1 (January 2, 1938): *Angemeldet beim Sonderbeauftragten des Reichsministers für Volksaufklärung und Propaganda betreffend Überwachung der geistig und kulturell tätigen Juden im Deutschen Reich.*

JJA *Journal of Jewish Art.*

JL *Jüdisches Lexikon* (Berlin, 1927–30), 5 volumes.

JQR *Jewish Quarterly Review.*

JR *Jüdische Rundschau: Organ der Zionistischen Vereinigung für Deutschland.* Berlin weekly begun 1905; continued as bi-weekly 1923; ceased publication with volume 43, number 89, on November 8, 1938.

JSAH *Journal of the Society of Architectural Historians.*

JSS *Jewish Social Studies.*

(M.) Mayer, L.A. *Bibliography of Jewish Art.* Edited by Otto Kurz (Jerusalem: The Magnes Press for the Hebrew University, 1967). Mayer entries 2803–2877A, for Rachel Wischnitzer, are appended, in parenthesis, to corresponding entries here.

MGWJ *Monatsschrift für Geschichte und Wissenschaft des Judentums: Organ der Gesellschaft zur Förderung der Wissenschaft des Judentums.* Frankfurt a.M. monthly begun 1851; continued as bi-monthly 1932; volumes 37–82 also called New series 1–46; ceased publication with volume 82, Heft 6 (November–December 1938.) Volume 83 (1939) comprises subsequent bound material in proof-sheets underwritten by the Berlin Jüdische Kulturbund.

REJ *Revue des Etudes Juives: Publication trimestrielle de la Société des études Juives* (Paris).

UJE *Universal Jewish Encyclopaedia* (New York, 1939–43), 10 volumes.

YB *YIVO Bleter: Journal of the Yiddish Scientific Institute* (YIVO Institute for Jewish Research, New York).

Articles in Periodicals and Newspapers

1. "Starynnaia Sinagoga v Lutzke (The Old Synagogue in Lutzk)." *Novy Voskhod,* January 1913, pp. 47–54.
2. "Dve Knigi o Barokko. Wölfflin i Fromentin (Two Books on the Baroque. Wölfflin and Fromentin)." *Russkaia Mysl,* June 1914, pp. 20–29.
3. Review of *Noa-Noa,* by Paul Gauguin. In: *Russkaia Mysl,* July 1914, pp. 34–37.
4. Review of *Novootkrytyie pamiatniki drevne-khristianskoi plastiki v Konstantinople* (New Discovered Monuments. Early Christian Sculpture in Constantinople), by Panchenko. In: *Russkaia Mysl,* July 1914, pp. 40–42.
5. "Julius Meier-Graefe. Impressionism, Manet, van Gogh, Pissarro, Cézanne." *Russkaia Mysl,* July 1914, pp. 268–69.
6. "Alte Friedhofskunst." *Der Jude,* 2, 1917–18, pp. 682–91 (M.2807).
7. "Jüdische Kunst in Kiev und Petrograd." *Der Jude,* 5, 1920–21, pp. 353–56 (M.2808).
8. "Wooden Roofs of Central Europe." *Christian Science Monitor,* London, January 1921, illustrated.
9. "Two Medieval Haggadahs." *Jewish Guardian,* April 22, 1921.
10. "Landmarks of Lithuania." *Christian Science Monitor,* London, July 22, 1921, illustrated.
11. "Une Bible enluminée par Joseph ibn Hayyim." *REJ,* 73, October–December 1921, pp. 161–72; 1 plate (M.2809).
12. "Di Neye Kunst un Mir (Moderne Kunst und Wir)." *Milgroim,* 1, 1922, pp. 2–7; 6 figures. This and subsequent articles translated into Yiddish from German original by Baruch Krupnik, and issued concurrently in: *Rimon,* in Hebrew, translated by Moshe Kleinman as "Haomanut Haḥadasha V'anahnu (Modern Art and Us)." *Rimon,* 1, 1922, pp. 2–5; 6 figures.
13. "Max Liebermann. Tzu dem 75ten Geburtstag." *Milgroim,* 2, 1922, pp. 29–30. Issued concurrently in: *Rimon,* 2, 1922, p. 21.
14. "Die Antviklung fun der Moderne Grafik. Di Litografiye (The Lithograph. A Chapter from the History of Graphic Art)." *Milgroim,* 2, 1922, pp. 17–21; 6 figures. (Issued under pseudonym R. Inbar). Issued concurrently as: "L'hitpatḥut Hagrafika Haḥadasha. Halitografiya." *Rimon,* 2, 1922, pp. 17–20; 6 figures.
15. "Guide to the Medieval Illuminations." *Milgroim,* 2, 1922, p. 48. Unsigned. Also issued in Yiddish as: "Tsu de Mitlalterishe Handshriftmolereyen." *Milgroim,* 2, 1922, pp. 46–47 (M.2812). Issued concurrently as: "L'tzyurim Ha'ivrim mimei Habeynayaim." *Rimon,* 2, 1922, pp. 47–48 (M.2811).
16. "Illuminated Haggadahs." *JQR,* N.s. 13, October 1922, pp. 193–218 (M.2810).
17. "Kunst un Literatur Kronik (also indexed as: Art and Letters)." *Milgroim,* 3, 1923, pp. 36–40. Signed R.V. Issued concurrently as: "Ba'omanut Ubasifrut." *Rimon,* 3, 1923, p. 48.
18. "L'hishtalshelut Bikoret Haomanut: L'filosofiat Ha'omanut shel Taine (also indexed as: On Taine's Philosophy of Art)." *Rimon,* 3, 1923, pp. 47–48.
19. "Der Toyer-Motiv in der Bukh Kunst (also indexed as: The Motive of the Porch in Book Ornamentation)." *Milgroim,* 4, 1923, pp. 2–7; illustrated (M.2814). Issued concurrently as: "Mare Hasha'ar Ba'omanut Hasefer." *Rimon,* 4, 1923, pp. 2–7; illustrated (M.2813).
20. "Antviklungen in der Kunstkritik: Max Nordau (also indexed as: Max Nordau as an Art Critic)." *Milgroim,* 4, 1923, pp. 29–31. Issued concurrently as: "L'hishtalshelut Bikoret Ha'omanut: Max Nordau." *Rimon,* 4, 1923, pp. 33–34.
21. "Kunst un Literatur Kronik (also indexed as: Art and Letters)." *Milgroim,* 4, 1923, pp. 46–47. Signed R.V. and H.B. Issued concurrently as: "Ba'omanut Ubasifrut." *Rimon,* 4, 1923, pp. 46–47. Signed R.V. and H.B.
22. "Der Leyb-Batzvinger in der Yiddisher Kunst (also indexed as: David and Samson Slaying the Lion)." *Milgroim,* 5, 1923, pp.

1—4; illustrated (*M.2816*). Issued concurrently as: "Hakarat Ha'ari Btziyurei Ha'ivrim." *Rimon*, 5, 1923, pp. 1—4; illustrated (*M.2815*).

23. "Kunst un Literatur Kronik (also indexed as: Art and Letters)." *Milgroim*, 5, 1923, pp. 39—40. Signed R.V., B.M. and K. Issued concurrently as: "Ba'omanut Ubasifrut." *Rimon*, 5, 1923, pp. 38—40. Signed R.V. and B.M.

24. "Mark Chagall." *Jewish Life*, April 1923, p. 4.

25. "Shestov and Gershenson. Two Russo-Jewish Thinkers of the Present Day." *Jewish Guardian*, January 18, 1924, p. 1.

26. "Tzu di Minkhener Hantshriften (also indexed as: Hebrew Illuminated Manuscripts in Munich)." *Milgroim*, 6, 1924, pp. 2—3; 2 figures (*M.2818*). Issued concurrently as: "L'kitvey Hayad shel Minkhen." *Rimon*, 6, 1924, pp. 2—3; 2 figures (*M.2817*).

27. "Emanuele Glitzenshteyn (also indexed as: Emanuele Glicenstein)." *Milgroim*, 6, 1924, pp. 4—6; illustrated. Issued concurrently as: "Emanuele Glitzenshteyn." *Rimon*, 6, 1924, pp. 4—6; illustrated.

28. "Antviklung in der Kunstkritik: Hipolit Teyn (also indexed as: On Taine's Philosophy of Art)." *Milgroim*, 6, 1924, pp. 27—28.

29. "Kunst un Literatur Kronik (also indexed as: Art and Letters)." *Milgroim*, 6, 1924, pp. 38—39. Unsigned. Issued concurrently as: "Ba'omanut Ubasifrut." *Rimon*, 6, 1924, pp. 38—39.

30. "Max Nordau's Views on Art." *Jewish Forum*, New York, March 1924, pp. 196—197; with portrait.

31. "Mechanofaktur. Henryk Berlewis Ausstellung im 'Sturm'." *JR*, August 8, 1924.

32. "Yosef Israels." *Haolam*, Berlin, no. 7, 1924, p. 139. Translated from the German to Hebrew by Moshe Kleinman.

33. "Mechanofaktura." *Haolam*, no. 36, September 5, 1924, p. 724. Translated from the German by Moshe Kleinman.

34. "Die Machsorillustration." *Gemeindelbatt*, no. 14 (?), September 1924, 2 pages; 2 figures. Illustrations from *Machsorim* of the Bodleiana, Oxford and Worms (*M.2819*).

35. "Jüdische Frauen Gestalten." *Die Welt*, no. 13, 1924? 1925?, p. 6. Translated from German into Yiddish by Moshe Kleinman.

36. "Lev Samoilovitsch Bakst." *JR*, January 9, 1925.

37. "Die Berliner Ausstellung des 'Americanischen Joint Distribution Committee'." *Jüdische Rundschau* (?), no. 2363, September 19, 1925.

38. "Orientalische Einflüsse in der russischen Architektur." *Osteuropa: Zeitschrift für die gesamten Fragen des Europäischen Ostens*, 1, Heft 4/5, 1925—26, pp. 252—55.

39. "Neuere russische Kunstliteratur." *Osteuropa*, 1, Heft 11, October 1926, pp. 678—81.

40. "Zur Aufführung des Ewigen Juden." *JR*, November 2, 1926.

41. "Der Zauber der Volkskunst." *Menorah*, Vienna, 5, January 1927, pp. 57—64; 4 figures (*M.2820*).

42. "Jüdische Kunsteindrücke in Paris." *JR*, March 1, 1927, 2 pages.

43. "Max Liebermann's achtzigster Geburtstag." *Selbstwehr: jüdisches Volksblatt*, Prague, 21, July 15, 1927, 2 pages.

44. "Max Lieberman on his Eightieth Birthday." *Canadian Jewish Chronicle*, July 22, 1927, p. 6.

45. "Der Interpret des jüdischen Voklslieds: M.O. Eppelbaum in Berlin." *JR*, Winter 1927.

46. "Pariser Brief." *Menorah*, Vienna, 6, March 1928, pp. 159—64; illustrations: Pailes, A. Kosloff, Mane-Katz, A. Feder.

47. "Das Buch Asatir." *JR*, March 13, 1928.

48. "On the First Evening of the Moscow Jewish Theatre." *JR*, April 17, 1928. Correspondence.

49. "Die Ausdrucksmittel des Moskauer Jüdischen Akademischen Theaters." *JR*, May 16, 1928, 2 pages.

50. "Erich Mendelsohn Ausstellung." *JR*, June 4, 1928.

51. "Henriette May (Persönliche Erinnerungen)." *JR*, September 6, 1928.

52. Review of *Mittelalterliche Synagogen*, by Richard Krautheimer. In: *REJ*, 86, no. 172, October—December 1928, pp. 216—20.

53. Review of *Die Juden in der Kunst*, by Karl Schwarz. In: *JR*, December 18, 1928.

54. "Ausstellung von Kinderzeichnungen (in der Kunstsammlung der Jüdischen Gemeinde)." *JR*, February 15, 1929.

55. "Thoraschrein, Almemor und Vorbeterpult." *Menorah*, Vienna, 7, 1929, pp. 619—24; 3 figures (*M.2826*).

56. "Der Machsor der Leipziger Universitätsbibliothek." *Gemeindeblatt der Israelitischen Religionsgemeinde zu Leipzig*, March 15, 1929; 3 illustrations (*M.2827*).

57. "Note on an Old Portuguese Work on Manuscript Illustration." *JQR*, N.s. 20, no. 1, July 1929, p. 89. Discussion of a treatise published by D.S. Blondheim (*M.2828*).

58. "Habimah und Palästina." *JR*, December 20, 1929.

59. "Der Stammbaum der Chanukkahlampe." *IF*, December 27, 1929, 2 pages.

60. "The Jews in Art." *JQR*, N.S. 20, no. 3, January 1930, pp. 279—80. On *Die Juden in der Kunst*, by Karl Schwarz.

61. "Esther." *Gemeindeblatt*, March 1930, 2 pages; 3 figures.

62. "Ausstellung von Kinderzeichnungen." *JR*, April 8, 1930.

63. "Henryk Glicenstein 60 Jahre Alt." *JR*, May 27, 1930.

64. "Moritz Posener." *JR*, May 30, 1930.

65. "Zwei Künstlerschiksale. Kolnik und Judowin." *JR*, July 1, 1930.

66. "Synagoge Prinzregentenstrasse, Berlin." *JR*, September 19, 1930.

67. "Der Estherstoff in der jüdischen Illustration." *MGWJ*, 74, September—October 1930, pp. 381—90. *Inter alia* on Sally Kirschstein Esther scroll with 35 scenes declared a fake by R.W., 385 (*M.2833*).

68. "Das Problem der antiken Synagoge." *Menorah*, Vienna, 8, November—December 1930, pp. 550—56; 4 figures. A. Plassart's view that the remains of a building in Delos belonged to a synagogue was later questioned — R.W. (*M.2834*).

69. "Menschen mit Tierköpfen." *MGWJ*, 74, November—December 1930, pp. 463—64. Addenda by various authors to *MGWJ*, 74, 1930, pp. 381—90; rejoinder by R.W. (*M.2833*).

70. "L'origine de la lampe de Hanouka." *REJ*, Cinquantenaire de la Société, 89, nos 177—78, 1930, pp. 135—46; 7 figures (*M.2829*).

71. "Strassburger Judenhistorie auf einem Gemälde." *IF*, December 18, 1930; 1 figure.

72. "Eine Tagung für jüdische Kunstpflege: Sitzung der 'Arbeitsgemeinschaft für Sammlungen jüdischer Kunst und Altertümer' in Mainz." *IF*, January 15, 1931.

73. "Besprechungen." *MGWJ*, 75, January—February 1931, pp. 69—74. Reviews of *Biblja Hebrajska*, by Zofja Ameisenowa; *Hebraica*, preface by Henri Guttmann; Catalogue of Exhibition of Hanukah Lamps in Bezalel National Museum, by Mordechai Narkiss; *EJ*, 6; *JL*, 4².

74. "Gegenwartsfragen der jüdischen Kunstpflege." *IF*, February 12, 1931.

75. "Von der Holbeinbibel zur Amsterdamer Haggadah." *MGWJ*, 75, July—August 1931, pp. 269—86; 13 figures (*M.2835*).

76. "Zur Encyclopaedia Judaica." *MGWJ*, 75, July—August 1931, pp. 306—07. Colloquy between I. Sonne and R.W. regarding printed illustrated Haggadot discussed by Sonne in: *EJ*, s.v. "Druckwesen."

77. "La Catacombe de la Villa Torlonia." *REJ*, 91, no. 181, July—September 1931, pp. 102—07. On *Die Jüdische Katakombe der Villa Torlonia in Rom*, by H.W. Beyer and H. Lietzmann.

78. "Organisierung der jüdischen Kunstwissenschaft. Die Mainzer

BIBLIOGRAPHY

Tagung." *Mitteilungen der Grossloge für Deutschland,* U.(nab-hängiger) O.(rden) B.(nei) B.(rith), 8, August 1931, p. 31.

79. "Z Dziejów powstania żydowskiej sztuki ludowej." *Miesiecznik żydowski,* 1, 1931, pp. 222–30. Translated from the German (*M.*2836).

80. "Lesser Ury, Bojownik." *Miesiecznik żydowski,* 1, November 1931, pp. 461–64. Polish, translated from the German.

81. "Zur Pesach-Haggadah." *MGWJ,* 75, November–December 1931, pp. 465–67. Referring to *MGWJ,* 75, "Holbeinbibel" by R.W.: addenda by various authors; rejoinder by R.W. (*M.*2835 alludes to this).

82. "Zur Amsterdamer Haggadah." *MGWJ,* 76, March 1932, pp. 239–42 (*M.*2841).

83. "Zur jüdischen Kunstforschung." *MGWJ,* 76, September–October 1932, pp. 522–23. Additions to *MGWJ,* 74, 1930, pp. 381–90.

84. Review of "Venetian Printers of Hebrew Books," by Joshua Bloch, *Bulletin of the New York Public Library,* 36, no. 2, 1932, pp. 71–92. In: *REJ,* 93, October–December 1932, pp. 221–22.

85. Review of "Jüdische Kult- und Kunstdenkmäler in den Rheinlanden," by Elisabeth Moses (Cologne), in: *Aus der Geschichte der Juden im Rheinland,* Rheinischer Verein für Denkmalpflege und Heimatschutz, 24, Heft 1, 1931, pp. 99–201. In: *REJ,* 94, no. 187, January–March 1933, p. 112 (see *M.*1782).

86. "Das jüdische Museum." *JR,* January 27, 1933.

87. "Kunstausstellung der Berliner B.(nei) B.(rith)-Logen." *JR,* February 17, 1933.

88. "Die Haggadah Heinrich Heines." *Gemeindeblatt der Israelitischen Religionsgemeinde zu Leipzig,* April 7, 1933, p. 2; 1 figure.

89. "Autour du mystère de la Haggada de Venise." *REJ,* 94, no. 188, April–June 1933, pp. 184–89; 3 figures (*M.*2842).

90. "La Basilique et la Stoa dans la Littérature Rabbinique." *REJ,* 97, nos 191–92, January–June 1934, pp. 152–57. On: "The Basilica and the Stoa in Early Rabbinical Literature," by H.L. Gordon, *AB,* 13, September 1931, pp. 353–75 (*M.*2843).

91. "Kunstgeschichtliche Betrachtungen." *JR,* March 2, 1934.

92. "Nachklang zum Wormser Gedenktag. Zwei wichtige Zeugnisse jüdischer religiöser Kunst im Wormser jüdischen Museum." *IF,* August 2, 1934.

93. "Mittelalterliche Buchbildnisse von Juden." *JR,* August 7, 1934; 1 figure.

94. "Die Bühnenbilder zum 'Jeremias'." *JR,* October 19, 1934. On: *Jeremiah,* by Stefan Zweig.

95. "Die Synagogen von Priene und Milet. Zum 70. Geburtstag von Theodor Wiegand." *JR,* November 2, 1934.

96. "Note on the Philo-Lexikon." *JR,* November 27, 1934.

97. "Documents on Jewish Art." *JQR,* N.s. 25, January 1935, pp. 301–06.

98. "Kulturdenkmäler Palästinas: Ein Führer durch die Ausgrabungen." *JR,* January 4, 1935. On: *Denkmäler Palästinas,* by Carl Watzinger.

99. "In Memoriam: Salli Kirschstein," *JR,* February 8, 1935. Jewish art collector, died November 1, 1934.

100. "Jeremias und Zedekiah." *Blätter des Jüdischen Frauenbundes,* Berlin, February 1935.

101. "Purim 1935. König Salomo in der Esther Erzählung." *Gemeindeblatt,* March 17, 1935, 2 pages; 1 figure.

102. "Mose ben Maimon. Eine hebräische Bilderhandschrift aus dem 15. Jahrhundert." *C.(entral)-V.(erein) Zeitung,* Berlin, March 30, 1935, 2 figures. In: Maimonides Festbeilage.

103. "Die Handschriften des Maimonides." *Gemeindeblatt,* March 31, 1935, 2 pages; 9 figures.

104. Review of *Die Josefslegende in aquarellierten Zeichnungen eines unbekannten russischen Juden der Biedermeier Zeit,* intro-duction by Erna Stein, accompanying Yiddish subscriptions translated by Martin Buber and Franz Rosenzweig. In: *JR,* April 2, 1935. Aquarelle series, dated by R.W. to *ca.* 1820, last in Berlin Jewish Museum.

105. "Die Parabel von den Vier Söhnen in der Haggadah." *Gemeindeblatt,* April 14, 1935, 2 pages; 6 figures.

106. "Erna Stein Blumenthal, zu ihrer Übersiedlung nach Palästina." *JR,* May 7, 1935.

107. "Neuerwerbungen des Jüdischen Museums." *Gemeindeblatt,* June 23, 1935, pp. 3–4; 5 figures.

108. "Les manuscrits à miniatures de Maimonide." *GBA,* 14, July–August 1935, pp. 47–52; 5 figures (*M.*2847).

109. "Aethiopien in der jüdischen Legende." *JR,* September 13, 1935.

110. "Die Waage und der Schofar." *Gemeindeblatt,* September 29, 1935, 2 pages; 6 figures.

111. "Marc Chagall heute." *JR,* November 5, 1935, 2 pages, 4 figures.

112. "Ein Amulett im Jüdischen Museums in Berlin." *Gemeindeblatt,* November 10, 1935; 1 figure.

113. "Hillels Vermächtnis." *Gemeindeblatt,* December 22, 1935, p. 4; 3 figures.

114. "A Shir-hama'alot in Berliner Yiddishen Muzuem." *Heften far Yiddisher Kunst,* 1, 1936, pp. 14–16; 1 figure. In Yiddish (*M.*2850).

115. "Eine Mendelssohnbibel mit Kupfern." *Gemeindeblatt,* January 12, 1936; 4 portraits.

116. "Die kleine Quelle, die zum Strom wurde." *Gemeindeblatt,* March 8, 1936. On the Book of Esther.

117. Review of *Denkmäler Palästinas,* by Carl Watzinger. In: *JR,* March 13, 1936.

118. "Brauchen wir Kunst? Eine Sammlungs-Aktion für Palästina." *JR,* March 13, 1936.

119. "Die Haggadah. Die Handschriften der Renaissance." *Gemeindeblatt,* April 5, 1936, p. 4; 1 figure.

120. "Das schöne Bildnis." *Gemeindeblatt,* May 3, 1936; 3 portraits.

121. "Das Erntefest in jüdischer Darstellung." *Gemeindeblatt,* May 24, 1936; 2 figures. On the illustrated Omer book of Röderheim: J. Lehrberger 1860.

122. "Der Film der Jugendalija." *Gemeindeblatt,* May 31, 1936, p. 20.

123. "Ein jüdischer Künstler, Ludwig Schwerin." *JR,* July 3, 1936; 1 figure.

124. "Lea Halpern." *JR,* July 7, 1936.

125. "Jemej Bialik." *JR,* September 8, 1936, pp. 1, 2, 3, 6; 2 figures. Review of exhibition organized by S. Tschertok.

126. "Der Schofarbläser und der Hund (Aus einem mittelalterlichen Gebetbuch)." *Gemeindeblatt,* September 16, 1936; 2 figures.

127. "Öffne das Tor! " *Gemeindeblatt,* September 27, 1936, p. 3. With illustration from: *Leipzig Machsor.*

128. "Sukka gestern und heute." *Gemeindeblatt,* September 30, 1936, p. 5; 3 figures.

129. "Die Messianische Hütte in der jüdischen Kunst." *MGWJ,* 80, September–October 1936, pp. 377–90; 5 figures (*M.*2849).

130. "Von jüdischem Familienporzellan." *Gemeindeblatt,* October 25, 1936; 1 figure. Cup and saucer. Because of dedication on saucer to Bernburger Landesrabbiner Salomon Herzheimer by his students, portrait was held to be his own.

131. "Jacob Plessner." *JR,* October 27, 1936.

132. "Der Biedermeiermaler Meyer Michaelson. Zur Ausstellung jüdischer Familienbilder im Berliner Jüdischen Museum." *JR,* November 3, 1936, p. 14; 2 portraits. Includes Michaelson self-portrait and oil-on-pewter portrait of Braunschweig Landesrabbiner Samuel Egers.

133. "Ein Rabbinerbildnis. Von der Ausstellung 'Unsere Ahnen' in

Berliner Jüdischen Museum." *JR*, November 6, 1936; 1 figure.

134. "Zur Ausstellung 'Die Ahnen'." *Gemeindeblatt*, November 22, 1936; 5 portraits. With portrait of Landesrabbiner Samuel Egers, two versions of which appeared in exhibition: "Unsere Ahnen," 1936, as basis, R.W. was able to identify cup portrait (see no. 130) as that of Egers. It was reproduced on the cup dedicated to Herzheimer because latter held commemorative speech for Egers at Rabbinical Assembly in Braunschweig, apparently in 1843, the date on saucer inscription.

135. "Vom jüdischen Kunsthandwerk in Osteuropa." *IF*, December 3, 1936, 2 pages; 3 figures.

136. "Vom den Makkabäerbüchern." *Gemeindeblatt*, December 6, 1936, pp. 5–6; 2 figures.

137. "Neue Arbeiten von Ludwig Schwerin." *JR* (?), January 12, 1937; 1 figure.

138. "Okzident und Orient." *Gemeindeblatt*, January 17, 1937.

139. "20 Jahre Jüdisches Museum." *JR*, February 12, 1937, 2 pages.

140. "Das Pessachmahl in einer Mischne-Thora-Handschrift." *JR*, March 26, 1937; 1 figure.

141. "Das böse Weib und die holde Frau. Zu Illustrationen der Haggadas." *Gemeindeblatt*, March 28, 1937; 3 figures.

142. "Lag Baomer." *JGB*, May 2, 1937; 1 figure.

143. "Um eine Israels Anekdote." *JR*, May 7, 1937, p. 5; 3 figures.

144. "Die Münchener in der Ausstellung des Sekretariats für Bildende Künste." *Blätter des Jüdischen Frauenbundes*, Berlin, May 1937.

145. "Die Welt der Abrabanel." *JGB*, June 20, 1937; 2 portraits. On Jewish Museum: exhibition arranged by R.W. about Abrabanel family including Moses, Leone Ebreo, Maurice de Abrabanel and others.

146. "Um die Abravanel-Ausstellung in Berlin." *Jüdisches Gemeindeblatt für das Gebiet der Hansestadt Hamburg*, July 16, 1937.

147. "Jüdische Kunsteindrücke in Budapest." *JR*, September 3, 1937, pp. 8–9; 2 figures (M.2853).

148. "Ein jüdischer Buchmaler des 15. Jahrhunderts." *Jahrbuch für jüdische Geschichte und Literatur*, 30, 1937, pp. 85–94; 1 figure (M.2855).

149. "Illustrationen zum Machsor." *JGB*, September 5, 1937; 3 figures.

150. "Das Bildnis des Rafael Levi Hannover." *IF*, October 14, 1937, p. 17; 1 portrait. On the mathematician and Leibniz' interest in him.

151. "Das Bildnis Akiba Egers." *JGB*, October 24, 1937; 1 figure. Detail of *Markt in Posen*, by Julius Knorr, begun 1837, representing, among other citizens, Posen Rabbi Akiba Egers.

152. "Jüdische Kunstbücher." *JR*, November 2, 1937. Reviews of: *Coins of Palestine*, by M. Narkiss; *Aus dem Berliner Jüdischen Museum*, by M. Stern; *Hebräische Bilderhandschriften in Italien*, by E. Munkacsi.

153. "Hinterglasmalerei, ein verschollenes jüdisches Hausgewerbe?" *JR*, November 26, 1937, p. 5; 2 figures (M.2852).

154. "Alte Synagoge in Ellrich." *JGB*, November 28, 1937, 3 pages; 2 figures (M.2854).

155. "Rabbiner Freimanns letztes Gutachten." *JGB*, January 2, 1938.

156. "Die Lehre Abravanels." *JGB*, January 30, 1938.

157. "Der Hilfsverein berichtet." *JGB*, February 20, 1938.

158. "Rudolf Hallo zum Gedenken." *JGB*, March 27, 1938.

159. "Josef, ein schwaches Reis." *JR*, April 15, 1938; 1 figure. Enameled bronze incense burner inscribed with name: "Joseph."

160. "Jüdische Kunst in Paris." *JR*, May 31, 1938.

161. "Irene Kolsky," *JR*, June 17, 1938.

162. "Jüdische Kunst in Paris." *JR*, July 22, 1938.

163. "300 Jahre Kunst in USA. Jüdische Künstler in einer Pariser Ausstellung." *JR*, August 12, 1938.

164. "Jüdische Kunst in Paris." *JR*, September 2, 1938.

165. "Notre art sacré." *L'univers israélite*, January 20 1939, pp. 306–07; 3 figures.

166. L'an prochain." *L'univers israélite*, March 31–April 7, 1939, 2 pages; 2 figures.

167. "Les Hagadas Séphardies." *Le Judaïsme séphardi*, Paris: Fédération séphardite mondiale, O.s. 8, April 1939, pp. 51–53; 2 figures.

168. "L'art religieux juif." *La Revue Juive*, Geneva, 7, May 1939, pp. 376–79.

169. "Jüdische Künstler in Paris." *JR*, May 26, 1939. "Written in Paris after leaving Berlin forever."

170. "Les fouilles de Sheikh Abreiq." *L'univers israélite*, August 4, 1939.

171. "Die Synagoge in Ellrich am Südharz." *MGWJ*, 83, December 1939, pp. 493–508. Published in final volume of *MGWJ* (M.2857).

172. "Amerikanische Jüdinnen. Bela Spewack." *Aufbau*, July 5, 1940. Under pseudonym: Ilona Neri.

173. "Amerikanische Jüdinnen. Mrs. David de Sola Pool." *Aufbau*, September 20, 1940. Under pseudonym: Ilona Neri.

174. Review of *Les Peintures de la Synagogue de Doura-Europos, 245–256 après J.-C.*, by Comte du Mesnil du Buisson, introduction by Gabriel Millet. In: *JSS*, 3, January 1941, pp. 89–90.

175. "The Conception of the Resurrection in the Ezekiel Panel of the Dura Synagogue." *Journal of Biblical Literature*, 60, no. 1, 1941, pp. 43–55; 3 figures (M.2861).

176. "The Messianic Fox." *Review of Religion*, 5, March 1941, pp. 257–63; 2 figures (M.2860).

177. "The Medieval Haggadah." *Hadassah Newsletter*, April 1941, 2, pp. 13–14; illustrated.

178. "The Samuel Cycle in the Wall Decoration of the Synagogue at Dura-Europos." *Proceedings of the American Academy for Jewish Research*, 11, 1941, pp. 85–103; 6 figures (M.2862).

179. "Symbolism in Jewish Art." *The Y.M.H.A. Bulletin*, 43, no. 3, October 3, 1941, p. 2.

180. "Paintings of the Synagogue of Dura." *Bitzaron*, 5, January 1942, pp. 289–92. In Hebrew, translated from the English.

181. "A Reply to Dr. Romanoff." *Review of Religion*, 6, January 1942, pp. 187–90. Reference to: "The Fox in Jewish Tradition," by Paul Romanoff, *Review of Religion*, 6, January 1942, pp. 184–87.

182. "A New Interpretation of Titian's *Sacred and Profane Love*." *GBA*, 23, February 1943, pp. 89–98; 8 figures.

183. "Some Aspects of Jewish Art." *Jewish Family Almanac*, 1, 1943, pp. 228–31; 7 figures (M.2863).

184. "Reply to Walter Friedlaender." *GBA*, 24, October 1943, p. 256. Reference to Friedlaender's letter to *GBA*, 23, June 1943, p. 382.

185. "Some Reflections on Jewish Art after World War I." *The Jewish Review*, 2, July–October 1944, pp. 202–08.

186. "Die Alte Yiddishe Shuln in Poiln." *Eynikeyt*, November 1944, p. 33. In Yiddish.

187. Review of *The Arts and Religion*, edited by Albert E. Bailey. In: *JSS*, 7, January 1945, pp. 84–85.

188. "*The Three Philosophers*, by Giorgione." *GBA*, 27, April 1945, pp. 193–212; 16 illustrations.

189. Review of *Proust and Painting*, by Maurice E. Chernowitz. In: *GBA*, 27, May 1945, pp. 318–19.

190. "Studies in Jewish Art." *JQR*, N.s. 36, July 1945, pp. 47–59. Dura-Europos; alleged representation of medieval Regensburg synagogue; prints as models for engraved pewter dishes and for majolica (M.2864).

191. "Among Jewish Artists." *The Chicago Jewish Forum*, 4, no. 1, Fall 1945, pp. 49–54.

192. "Art and the Jewish Home." *The Reconstructionist*, February 8, 1946, pp. 18—21.

193. Review of *Prelude to a New Art for an Old Religion*, by A. Raymond Katz. In: *YB*, 27, Spring 1946, pp. 174—76. In Yiddish, translated from the English.

194. Review of *Proust and Painting*, by Maurice E. Chernowitz. In: *YB*, 27, Spring 1946, pp. 176—77. In Yiddish, translated from the English.

195. Review of *Rembrandt, the Jews and the Bible*, by Franz Landsberger. In: *The Jewish Review*, 4, July—September 1946, pp. 147—49.

196. "Peretz in a kreisl Varshever Gimnazistkes (Peretz at a Circle of School Girls in Warsaw)." *YB*, 28, 1946, pp. 206—07. In Yiddish, translated from the English by Mrs. Tcherikover.

197. Review of *A History of Jewish Art*, by Franz Landsberger. In: *Hadassah Newsletter*, June—July 1946, p. 16; illustrated.

198. "Is There a Jewish Art?" *Commentary*, 2, August 1946, pp. 194—96. Review of: *A History of Jewish Art*, by Franz Landsberger.

199. Review of *Rembrandt, the Jews and the Bible*, by Franz Landsberger. In: *JB*, September—October 1946.

200. Review of *Light from the Ancient Past, the Archeological Background of the Christian—Hebrew Religion*, by Jack Finegan. In: *GBA*, 31, January 1947, p. 63.

201. Review of *Burning Lights*, by Bella Chagall, translated from the Yiddish by Norbert Guterman. In: *JB*, January—February, 1947.

202. Review of *The House of God*, by Desider Holisher. In: *JB*, January—February 1947.

203. "Esther in Art." *Hadassah Newsletter*, March—April 1947, pp. 18—20; illustrated.

204. "The Problem of Synagogue Architecture." *Commentary*, 3, March 1947, pp. 233—41. See discussion provoked by this article, by Franz Landsberger, Ely Jacques Kahn, Eric Mendelsohn and Paul and Percival Goodman, in: *Commentary*, 3, June 1947, pp. 537—44.

205. "Mizrakh-Marevdike Bindungen in der Shuln-Arkitektur fun Tzvelftn biz Akhtzentn Yorhundert (Mutual Influences between Eastern and Western Europe in Synagogue Architecture from the 12to the the 18th Centuries)." *YB*, 29, Spring 1947, pp. 3—50; 35 figures. In Yiddish, translated from the English original which appeared later: see *YIVO Annual*, 2/3, 1947—48 (*M.2865*).

206. "Jewish Art in New York." *Hadassah Newsletter*, June—July 1947, pp. 8—10; illustrated. On the history of the Jewish Museum.

207. Review of *The Hebrew Bible in Art*, by Jacob Leveen. In: *JQR*, N.s. 38, July 1947, pp. 107—08.

208. Review of *The Paintings of the Dura-Europos Synagogue*, by Otto Naphtali Schneid. In: *JB*, November—December 1947.

209. "Mutual Influences between Eastern and Western Europe in Synagogue Architecture from the 12th to the 18th Centuries." *YIVO Annual of Jewish Social Science*, 2/3, 1947—48, pp. 25—68; 35 figures (*M.2866*).

210. "Paintings of the Synagogue at Dura-Europos. The upper register." *GBA*, 33, May 1948, pp. 261—66; 5 illustrations.

211. Review of *One Hundred Contemporary American Jewish Artists*, by Louis Lozowick. In: *JB*, May—June 1948.

212. Review of *25 Dessins by Aria Merzer*, text by L. Pougatch. In: *JB*, September—October 1948.

213. "The Dura Synagogue." *JQR*, N.s. 39, January 1949, pp. 297—300. On *The Synagogue of Dura-Europos and its Frescoes*, by E.L. Sukenik.

214. Review of *The Synagogue of Dura-Europos and its Frescoes*, by E.L. Sukenik. In: *Journal of the American Oriental Society*, 69, April—June 1949, pp. 94—95.

215. Review of *The Resurrection in Ezekiel 37 and in the Dura-Europos Paintings*, Uppsala Universitets Årsskrift 11, 1948, by Harald Riesenfeld. In: *Journal of Biblical Literature*, 68, December 1949, pp. 393—94.

216. Review of *Jewish Artists of the 19th and 20th Centuries*, by Karl Schwarz. In: *JB*, January 1950.

217. Review of *The Rusurrection in Ezekiel 37 and in the Dura-Europos Paintings*, Uppsala Universitets Årsskrift 11, 1948, by Harald Riesenfeld. In: *Journal of Religion*, 30, October 1950, pp. 305.

218. Review of *Max Weber*, by Lloyd Goodrich. In: *JSS*, 12, October 1950, p. 407.

219. Review of *A Short History of Jewish Art*, by Helen Rosenau, preface by Edward Carter. In: *JSS*, 12, October 1950, pp. 416—17.

220. Review of *Jewish Artists of the 19th and 20th Centuries*, by Karl Schwarz. In: *JSS*, 13, January 1951, pp. 94—95.

221. Review of *Chagall*, with notes by the artist and introduction by Michael Ayrton. In: *JB*, March 1951.

222. Review of *Ancient Hebrew Seals*, by A. Reifenberg. In: *JB*, April 1951.

223. "The Egyptian Revival in Synagogue Architecture." *AJHSQ*, 41, September 1951, pp. 61—75; 3 figures (*M.2871*).

224. "The Unicorn in Christian and Jewish Art." *Historia Judaica: A Journal of Studies in Jewish History, Especially in the Legal and Social History of the Jews*, 13, Part 2, October 1951, pp. 141—56; 2 figures (*M.2870*).

225. Review of *Marc Chagall*, by Isaac Kloomok. In: *JB*, January 1952.

226. Review of *Roman Sources of Christian Art*, by Emerson H. Swift. In: *JSS*, 14, October 1952, pp. 366—68.

227. Review of *Treasures of a London Temple* (Ceremonial Objects, Bevis Marks Synagogue), by A.G. Grimwade *et al.* In: *JB*, November 1952.

228. Review of *Chagall*, Masterpieces of French Painting, introduction by Jacques Lassaigne; and *Soutine*, Masterpieces of French Painting, introduction by Raymond Cogniat. In: *JB*, December 1952.

229. "Jewish Art Books and Albums." *Jewish Book Annual of the Jewish Book Council of America*; for the National Jewish Welfare Board, 11, 1952—53, pp. 129—35.

230. Review of *The Paintings of J.H. Amshewitz*, by Sarah Briana Amshewitz. In: *JB*, January 1953, p. 8.

231. Review of *The Hebrew Impact on Western Civilization*, edited by Dagobert Runes. In: *GBA*, 41, February 1953, pp. 61—62.

232. "Jacopo Pontormo's Joseph Scenes." *GBA*, 41, March 1953, pp. 145—66; 13 figures.

233. Review of *Churches and Temples*, by Paul Thiry, R.M. Bennett and H.K. Kamphoefner. In: *JB*, May 1954.

234. Review of *Myer Meyers: Goldsmith 1723—1795*, by Jeanette W. Rosenbaum. In: *JB*, September 1954.

235. "The Meaning of the Beth Alpha Mosaic." *Bulletin of the Israel Exploration Society*, 18, nos 3—4, 1954, pp. 190—97; 4 figures.

236. Review of *Jewish Symbols in the Greco-Roman Period;* by Erwin R. Goodenough, vols 1—3. In: *JB*, November 1954.

237. "Thomas W. Walter's Crown Street Synagogue." *JSAH*, 13, December 1954, pp. 29—31; 2 figures.

238. Review of the *Hebrew Union College Annual 75th Anniversary Publication, 1875—1950*, volume 23, parts I and II, pp. 710 and 772. In: *JSS*, 17, January 1955, pp. 66—68.

239. "The Beth Alpha Mosaic: A New Interpretation." *JSS*, 17, April 1955, pp. 133—44.

240. Review of *Jewish Symbols in the Greco-Roman Period*, by Erwin R. Goodenough, volume 4. In: *JB*, May 1955.

241. Review of *Churches and Temples*, by Paul Thiry, R.M. Bennett

and H.L. Kamphoefner. In: *JSS*, 17, October 1955, pp. 346–47.

242. "The Sources of the Architectural Historian." *AJHSQ*, 46, December 1956, pp. 114–119 (*M.*2874).

243. Review of *Jewish Symbols in the Greco-Roman Period*, by Erwin R. Goodenough, volumes 5 and 6. In: *JB*, April 1957.

244. "Rembrandt, Callot and Tobias Stimmer." *AB*, 39, September 1957, pp. 224–30; 8 figures.

245. Review of *The Synagogue. The Excavations at Dura-Europos conducted by Yale University and the French Academy of Inscriptions and Letters. Final Report*, by Carl Kraeling. In: *Judaism*, 6, Fall 1957, pp. 378–80.

246. "The American Synagogue." *World Over: A Magazine for Boys and Girls*, December 1957, pp. 3–4; illustrated.

247. "Passover Art and the Italian Renaissance." *The Reconstructionist*, April 4, 1958, pp. 8–10; 3 figures.

248. Review of *Jewish Ceremonial Art*, edited by Stephen S. Kayser, associate editor Guido Schoenberger, foreword by Louis Finkelstein. In: *JSS*, 20, April 1958, pp. 112–13.

249. Review of *Israel*, edited by Nicolas Lazar and IZIZ. In: *JB*, September 1958.

250. Review of *Eric Mendelsohn*, by Arnold Whittick. In: *JSAH*, 17, Fall 1958, pp. 35–36.

251. "Leonid Pasternak." *The Reconstructionist*, November 14, 1958, pp. 19–24; 3 figures.

252. Review of *Jewish Symbols in the Greco-Roman Period*, by Erwin R. Goodenough, volumes 7 and 8. In: *JB*, February 1959.

253. "The Wise Men of Worms." *The Reconstructionist*, June 15, 1959, pp. 10–12; 3 figures.

254. "The Moneychanger and the Balance. A Topic of Jewish Iconography." *Eretz-Israel: Publications of the Israel Exploration Society: Archaeological, Historical and Geographical Studies*, 6, 1960, pp. 23*–25*; plates XLIV–XLV (*M.*2876).

255. Review of *My Life*, by Marc Chagall, translated from the French by Elisabeth Abbot. In: *JB*, September 1960.

256. Review of *Light from Our Past. A Spiritual History of the Jewish People*, expressed in twelve stained glass windows designed by Louise D. Kayser for Har Zion Temple, text by Rose B. Goldstein. In: *JSS*, 23, January 1961, pp. 62–63.

257. Review of *Mané-Katz*, by Alfred Werner. In: *JB*, September 1961.

258. "Ezra Stiles and the Portrait of Menasseh Ben Israel." *AJHSQ*, 51, December 1961, pp. 135–42; 3 portraits.

259. Review of *Modigliani, the Sculptor*, by Alfred Werner. In: *JB*, February 1963.

.60. Review of *Jüdische Zeremonialkunst*, by Joseph Gutmann. In: *JB*, September 1963.

261. Review of *Jewish Symbols in the Greco-Roman Period*, by Erwin R. Goodenough, volumes 9, 10 and 11. In: *JB*, September 1964.

262. Review of *Wooden Synagogues*, by Maria and Kazimierz Piechotka, introduction by Jan Zachwatowicz, translated from the Polish by Rulka Langer, introduction to the English edition by Stephen S. Kayser. In: *JSS*, 26, October 1964, pp. 252–53.

263. Review of *Charlotte: A Diary in Pictures*, by Charlotte Solomon, commentary by Paul Tillich, biographical note by Emil Straus. In: *JB*, January 1965, p. 1.

264. "The Workings of Folk Art." *Papers of the Fourth World Congress of Jewish Studies*, Jerusalem 1965, 2, pp. 135–36; 4 illustrations. Jerusalem; for the World Union of Jewish Studies, 1968.

265. "Gleenings. The Zeena u-reena and its illustrations." *Zeitschrift für die Geschichte der Juden*, Tel Aviv, 3/4, 1965, pp. 169–73; 2 figures. Reprinted from: *Sefer Hayovel Dr. N.M. Gelber*, pp. 266–70 (XXXV–XXXVIII, 266); 2 figures. Edited by Israel Klausner, Raphael Mahler, Dov Sadan. Tel Aviv: Olamenu, 1963.

266. Review of *Monumenta Judaica: 2000 Jahre Geschichte und Kultur der Juden am Rhein*, 2 volumes (Katalog und Handbuch), edited by Konrad Schilling. In: *JSS*, 28, January 1966, pp. 48–50.

267. Review of *Jewish Symbols in the Greco-Roman Period*, by Erwin R. Goodenough, volume 12. In: *JB*, October 1966.

268. Review of *Contemporary Synagogue Art. Developments in the United States, 1945–1965*, by Avram Kampf. In: *JSAH*, 26, March 1967, pp. 78–79.

269. Review of *The Sacred Portal: A Primary Symbol in Ancient Judaic Art*, by Bernard Goldman. In: *JSS*, 29, July 1967, pp. 185–86.

270. "Custom and Costume." *Judaism*, 16, Fall 1967, pp. 505–8. Review of *A History of Jewish Costume*, by Alfred Rubens.

271. "To the Editor." *Congress Bi-Weekly*, December 18, 1967, p. 21. On: "The Jewish Museum: Victim of Confusion," by Arthur A. Cohen, *Congress Bi-Weekly*, November 16, 1967; opinion of R.W. written at invitation of *Bi-Weekly*'s editor Herbert Poster.

272. Review of *Monumenta Judaica: 2000 Jahre Geschichte und Kultur der Juden am Rhein:* Fazit (Balance): Supplementary volume, edited by Maria Garding. In: *JSS*, 30, January 1968, pp. 56–57.

273. "The Decorations of the Synagogue of Mohilev on the Dnieper." *Heawar: Devoted to the History of the Russian Jews*, Tel Aviv, 15, May 1968, pp. 251–53; 4 figures. Translated to Hebrew from the English by Baruch Krupnik.

274. Review of *Le Juif Médiéval au Miroir de l'Art Chrétien*, by Bernhard Blumenkranz. In: *JSS*, 30, July 1968, pp. 181–82.

275. Review of *Marc Chagall*, by Howard Greenfeld. In: *JB*, December 1968.

276. Review of *The Bird's Head Haggadah in the Bezalel National Museum in Jerusalem*, edited by M. Spitzer, with contributions by E.D. Goldschmidt, H.L.C. Jaffé, B. Narkiss and an introduction by Meyer Schapiro; 2 volumes (Introductory volume, Facsimile volume). In: *Judaism*, 18, Summer 1969, pp. 382–83.

277. "Jewish Art." *Commentary*, 57, August 1969, p. 12. Correspondence.

278. Review of *Old Testament Miniatures*, by Sidney C. Cockerell, preface by John Plummer. In: *JB*, February 1970, pp. 6–7.

279. Review of *The Ancient Synagogues of the Iberian Peninsula*, by Don A. Halperin. In: *JSAH*, 29, October 1970, pp. 279–80.

280. "The 'Closed Temple' Panel in the Synagogue of Dura-Europos." *Journal of the American Oriental Society*, 91, July–September 1971, pp. 367–78; 6 figures.

281. Review of *Chagall: Watercolors and Gouaches*, by Alfred Werner; and *Chagall*, by Jean-Paul Crespelle. In: *JB*, April 1971.

282. "On Jewish Art." *Judaism*, 20, Winter 1971, pp. 126–27. Review of *Hebrew Illuminated Manuscripts*, by Bezalel Narkiss, foreword by Cecil Roth.

283. Review of *Beauty in Holiness: Studies in Jewish Customs and Ceremonial Art*, edited by Joseph Gutmann. In: *Judaism*, 20, Winter 1971, p. 127.

284. "The Jewish Year in Art and Anthology. A Retrospective Survey." *Judaism*, 21, Spring 1972, pp. 239–42.

285. Review of *The Tree of Light. A Study of the Menorah: the Seven-branched Lampstand*, by L. Yarden. In: *Conservative Judaism*, 27, Summer 1973, pp. 94–95.

286. "Bibliography of the Works of Dr. Mark Wischnitzer." *Heawar*, 20, September 1973, pp. 303–06, 312–26. Listing does not include works in Hebrew and Yiddish which are listed by Shlomo Eidelberg in *Heawar*, 20, September 1973, pp. 306–11.

BIBLIOGRAPHY

287. "Maimonides' Drawings of the Temple." *JJA*, 1, 1974, pp. 16—27; 15 figures.

288. "A Special Kind of Jewish Art." *Judaism*, 24, Summer 1975, pp. 369—72. Review of *La Haggadah Enluminée. Etude iconographique et stylistique des manuscrits enluminés et décorés de la Haggada du XIIIᵉ au XVIᵉ siècle,* by Mendel Metzger, preface by René Crozet, volume 1.

289. Review of *Haggadah and History: A panorama in facsimile of five centuries of the printed Haggadah,* by Yosef Hayim Yerushalmi. In: *JB*, October 1975, pp. 1, 4.

290. "Guido Schoenberger (1891—1974)." *JJA*, 3/4, 1977, p. 132.

Works in Collections

291. "Iskustvo u evreev v Polshe i na Litve (Art of the Jews in Poland and Lithuania)," in *Istoriia Evreiskogo Naroda: Istoriia Evreev v Rossii (History of the Jewish People: History of the Jews in Russia).* Volume 1, sole issue of projected 5-Volume History of the Jews in Russia, also called Volume 11 of projected 15-Volume History of the Jewish People; the latter never published beyond volume 1. Volume 11 a.k.a. volume 1, pp. 390—405. Edited by A.I. Braudo, M.L. Wischnitzer, J. Gessen, S.M. Ginzburg, P.S. Marek and S.L. Zinberg. Moscow: Mir, 1914. Illustrations in article and elsewhere in volume (M.2805).

292. "Synagogen im ehemaligen Königreich Polen," in: *Das Buch von den Polnischen Juden,* pp. 89—105; 8 pen drawings by R.(W.)B. after photos. Edited by S.J. Agnon and Ahron Eliasberg. Berlin: Jüdisher Verlag, 1916 (M.2806).

293. "Jüdische Legendenstoffe bei Benozzo Gozzoli," in: *Festschrift zum 70 Geburtstage von Moritz Schaefer zum 21 May 1927,* pp. 271—73. Edited by Friends and Students. Berlin: Philo Verlag, 1927.

294. "Jüdische Kunstgeschichtsschreibung. Bibliographische Skizze," in: *Festschrift zu Simon Dubnow's siebzigstem Geburtstag,* pp. 76—81. Edited by Ismar Elbogen, Josef Meisl and Mark Wischnitzer. Berlin: Jüdischer Verlag, 1930 (M.2832).

295. "Der Siddur der Altstädtischen Synagoge in Rzeszow," in: *Festschrift für Aron Freimann zum 60. Geburtstage,* pp. 77—80. Edited by Alexander Marx and Hermann Meyer. Berlin: for the Soncino-gesellschaft der Freunde des jüdischen Buches, 1935 (M.2845).

296. "Der Streiter des Herrn, eine Miniatur des Leipziger Machsor," in: *Occident and Orient. Gaster Anniversary Volume,* pp. 539—41. Edited by B. Schindler. London: Taylor's Foreign Press, 1936 (M.2848).

297. "Yiddishe Kunst. Geshichtleche Antviklung fun der Yiddishe Kunst," in: *Algemeyner Antsiklopedia,* 2, pp. 469—537; 79 figures. New York, 1940. Translated from the English, for which see 301 below: M.2872 (M.2858).

298. "The Sabbath in Art," in: *Sabbath, the Day of Delight,* pp. 319—34; illustrated. Edited by Abraham Milgram. Philadelphia: Jewish Publication Society of America, 1944.

299. "The Esther Story in Art," in: *The Purim Anthology,* pp. 222—49, 519—20; illustrated. Edited by Philip Goodman. Philadelphia: Jewish Publication Society, 1949 (M.2869).

300. "Judaism in Art," in: *The Jews, their History, Culture and Religion,* 2, pp. 984—1010. Edited by Louis Finkelstein. Philadelphia: Jewish Publication Society, 1949. Reprinted 1955, 1960 (M.2868).

301. "Jewish Art. A Survey from the Ancient Period to Modern Times, Including the United States and Israel," in: *The Jewish People: Past and Present,* 4 volumes, 3, pp. 268—323; illustrated. Edited by Jewish Encyclopedic Handbooks. New York: for the Central Yiddish Culture Organization, 1946—55. Volumes 1—3, according to Preface: "based principally on the

3-Volume *Yidn* (1939—42), integral part of the *Algemeyner Antsiklopedia* (General Encyclopedia) in Yiddish." Irregularly issued, non-alphabetically arranged, Paris—New York, 1934—1950s. Wischnitzer entry in Yiddish translation is 297 above: M.2858. English entry is M.2872.

302. "Omanut Batey Haknisyot (Synagogue Art)," in: *Haḥinukh V'hatarbut B'ivrit B'eyropa beyn Shte Milḥamot Haolam* (Hebrew Education and Culture in Europe between the Two World Wars), pp. 523—30; 5 figures. Edited by Dr. Zevi Scharfstein. New York: Ogen for Histadruth Ivrith of America, 1957. In Hebrew, translated from the English.

303. "Omanut Hatziyur Hayehudit B'tkufat Hatalmud," in *Ha'omanut Hayehudit,* pp. 209—46; figures 81—99. Edited by Cecil Roth. Tel Aviv: Massadah, 1957. Revised, 1959, as pp. 165—98; figures 74—96, 1 plate. Translated from the English, for which see 306 below: M.2877 (M.2875).

304. "The Temple," in: *Congregation Habonim 20th Anniversary Issue 1939—1959.* 2 pages.

305. "Ruskie evrei v zhivopisi i skulpture (Russian Jews in Painting and Sculpture)," in: *Kniga o ruskom evreistve ot 1860-kh godov do revolutsii 1917 g* (Book of Russian Jewry from the 1860s to the Revolution of 1917), pp. 438—51. New York: Distributed by Gregory Lounz for the Union of Russian Jewry, 1960.

306. "Jewish Pictorial Art in the Classical Period," in: *Jewish Art: An Illustrated History,* pp. 191—223; figures 76—86, 1 plate. Edited by Cecil Roth. Tel Aviv: Massadah/New York, Toronto, London: McGraw-Hill, 1961. Revised edition by Bezalel Narkiss, Greenwich, Connecticut: New York Graphic, 1971. Hebrew translation, see 303 above (M.2877).

307. "Passover in Art," in: *The Passover Anthology,* pp. 295—324; illustrated. Edited by Philip Goodman. Philadelphia: Jewish Publication Society, 1961.

308. "Gleenings, The Zeena u—reena and its Illustrations," in: *Sefer Hayovel (Jubilee Volume) Dr. N.M. Gelber,* pp. 266—70 (XXXV—XXXVIII, 266); 2 figures. Edited by Israel Klausner, Raphael Mahler and Dov Sadan. Tel Aviv: Olamenu, 1963.

309. "The Ordeal of Bitter Water and Andrea del Sarto," in: *For Max Weinreich on his Seventieth Birthday: Studies in Jewish Languages, Literature and Society,* pp. 265—68; 2 figures. Edited by Lucy S. Davidowicz, Alexander Erlich and Joshua A. Fishman. The Hague: Mouton & Co., 1964.

310. "Rembrandt's So-called 'Synagogue' in the Light of Synagogue Architecture," in: *The Abraham Weiss Jubilee Volume,* pp. 129—37; 1 figure. Edited by Samuel Belkin *et al.* New York: for the Abraham Weiss Jubilee Committee, 1964.

311. "Jüdische Kunstgeschichtsschreibung. Bibliographische Skizze," in: *Wissenschaft des Judentums im deutschen Sprachbereich: Ein Querschnitt,* Schriftenreihe Wissenschaftlicher Abhandlungen des Leo Baeck Instituts, 16, 2 parts, vol. 2, pp. 635—40. Tübingen: J.C.B. Mohr for Paul Siebeck, 1967. Reprinted from *Festschrift zu Simon Dubnow,* 1930 (see 294 above, M.2832).

312. "The Present State of Studies in the History of Jewish Art in the United States," in: *Hagut Ivrit Ba'Amerika. Studies in Jewish Themes by Contemporary American Scholars,* 2 parts, vol. 2, pp. 451—62. Translated to Hebrew from the English. Edited by Dr. Menahem Zohori, Prof. Arie Tartakover and Dr. Haim Ormanian. Tel Aviv: Yavneh for Brit-Ivrit Olamit, 1973.

313. "Berlin, the Early 1920s," in: *Studies in Jewish History Presented to Professor Raphael Mahler on his 75th Birthday,* pp. 84—86. Edited by Sh. Yeivin. Merhavia: Sifriat Poalim and Tel Aviv University, 1974.

314. "Number Symbolism in Dura Synagogue Paintings," in: *Joshua Finkel Festschrift,* pp. 159—71. Illustrations not included for technical reasons: for references to illustrations see notes. Edit-

ed by Sidney B. Hoenig and Leon D. Stiskin. New York: Yeshiva University Press, 1974.

315. "Mutual Influences between Eastern and Western Europe in Synagogue Architecture from the 12th to the 18th Centuries," in: *The Synagogue: Studies in Origins, Archaeology and Architecture*, pp. 265–308; 35 figures. Selected, with a prolegomenon by Joseph Gutmann. New York: Ktav, 1975. Reprinted from: *YIVO Annual*, 2/3 (see 209 above, *M.2866*).

316. "The Egyptian Revival in Synagogue Architecture," in: *The Synagogue*, pp. 334–50; 3 figures. Selected by Joseph Gutmann, 1975. Reprinted from: *AJHSQ*, 41 (see 223 above, *M.2876*).

Entries in Encyclopediae

Evreiskaia Entsiklopediia (Jewish Encyclopedia), 1912.

317. S.v. "Sinagogalnaia arkhitektura (Synagogue architecture)," vol. 14, pp. 265–73, 2 figures (*M.2803*).

318. S.v. "Utvar ritualnaia (Ritual objects)," vol. 15, pp. 138–42, 2 figures (*M.2804*).

Jüdisches Lexikon. Berlin, 1927–30. 5 Vols.

319. S.v. "Grabsteine, Jüdische," with A. Grotte, vol. 2, pp. 1253–61, 12 figures, 2 plates (*M.2822*).

Encyclopaedia Judaica. Berlin, 1928–34. 10 Vols "A–M."

320. "Almemor," vol. 2, cols 374–84, 7 figures (*M.2821*).

321. "Architektur. Nachbiblische Periode," vol. 3, cols 226–36, 2 plates (*M.2823*).

322. "Aron ha-Kodesch," vol. 3, cols 390–94 2 figures, 1 plate (*M.2824*).

323. "Buchschmuck," vol. 4, cols 1133–44, 3 plates (*M.2825*).

324. "Chanukaleuchter," vol. 5, cols 295–98, 1 figure (*M.2830*).

325. "Esther-Rolle in der Kunst," vol. 6, cols 810–14, 2 figures, 2 plates (*M.2831*).

326. "Grabsteinformen," vol. 7, cols 631–34 (*M.2837*).

327. "Haggadah-Illustration," vol. 7, cols 794–813, 19 figures (*M.2838*).

328. "Josef ibn Chajim, Illuminierer des 15.Jhts., vol. 8. col. 323, 1 figure (*M.2839*).

329. "Schmuck der Ketuba," vol. 9, cols 1186–91, 11 figures (*M.2840*).

330. "Leuchter und Lampe," vol. 10, cols 820–29, 12 figures (*M.2844*).

Universal Jewish Encyclopedia. New York, 1939–43. 10 Vols.

331. "Dura-Europos," vol. 3, pp. 609–11, 1 figure.

332. "Haggadah, Passover. II: Illustration, a. Haggadah Manuscripts, b. Printed Haggadahs," vol. 5, pp. 157–64, 8 figures, 1 plate.

333. "Illumination of Manuscripts," vol. 5, pp. 539–42, 7 figures (*M.2859*).

334. "Kethubah (in Art)," vol. 6, pp. 367–72, 6 figures, 2 plates.

335. "Megillah," vol. 7, pp. 438–40, 5 figures, 1 plate (frontispiece).

336. "Menorah," vol. 7, pp. 487–90, 3 figures, 1 plate.

337. "Museums," vol. 8, pp. 44–46, 2 figures.

Books and Exhibition Catalogues

338. *Symbole und Gestalten der jüdischen Kunst.* Berlin: Schöneberg, 1935. viii, 160 pp., 82 figures, 6 plates (*M.2846*).

339. Exhibition Catalogue: *Jüdisches Museum in Berlin: Gedenkausstellung Dón Jizchaq Abrabanel: Seine Welt, sein Werk.* Introduction by R.W., curator of exhibition with Dr. Josef Fried, books curator; preface by Dr. Alfred Klee of the Jüdische Gemeinde, Dezernent for the Museum. Berlin: M. Lessmann, June 1937, 16 pp., 4 plates. On the 400th anniversary of his death (*M.2851*).

340. Exhibition Catalogue: *Jüdisches Museum in Berlin: Akiba Eger Ausstellung.* Introduction by R.W., curator of exhibition with Dr. Eugen Pessen, books curator; preface by Dr. Alfred Klee of the Jüdische Gemeinde, Dezernent for the Museum. Berlin: M. Lessmann, Hanukka 1937. 19 pp., 2 plates. Portraits, ritual objects, etc., ex-collection Rabbi Eger, died 1837 (*M.2856*).

341. *The Messianic Theme in the Paintings of the Dura Synagogue.* Chicago: University of Chicago Press, 1948. xii, 135 pp., 50 figures (*M.2867*).

342. *Synagogue Architecture in the United States: History and Interpretation.* Philadelphia: Jewish Publication Society, 1955. xv, 204 pp., 149 figures (*M.2873*).

343. Exhibition Catalogue: *The Illustrated Jewish Book Through the Ages.* New York: for Stern College of Yeshiva University, 1968. In connection with Symposium: The Paintings of the Synagogue of Dura Europos, moderated by R.W., participants: Professors Blanche Brown, NYU; Meyer Schapiro, Columbia; David Sidorsky, Columbia; Morton Smith, Columbia; C. Bradford Welles, Yale.

344. *The Architecture of the European Synagogue.* Philadelphia: Jewish Publication Society, 1964. xxxii, 312 pp., 246 figures (*M.2877A*).

NOTES TO THE TEXT

* It will be recalled that before the First World War the Russian Empire included the Kingdom of Poland and the Grand Duchy of Finland, in both of which the Gregorian or New Style Calendar was used for civil purposes; West Russia, including the provinces of Minsk, Grodno, Volhynia, etc., and the Baltic Provinces including Kovno, where the Julian Calendar (Old Style) applied. Ethnic nationalism was discouraged by not referring to White Russia (Byelorussia) or Lithuania. Even the word Poland was avoided for a time after 1867, the Czar, Alexander II, referring to Poland as the Vistula Provinces. But, of course, the inhabitants referred to White Russia, Lithuania, and Poland as such.

1. THE ANCIENT SYNAGOGUE IN LUTSK

[1] Pavlutsky, "Stone Church Architecture in the Ukraine," in A. Grabar (ed.) *A History of Russian Art* (in Russian), p. 890.

[2] Pavlutsky, "Public Architecture in the Ukraine," Ibid, p. 412.

[3] Cf. R. Wischnitzer, "Synagogue Architecture," *Jewish Encyclopedia* (in Russian), Vol. 14, pp. 265 on.

[4] Mathias Bersohn, *Dyplomataryusz dotyczacy Zydóv w dawnej Polsce* (Materials Concerning Jews in Ancient Poland, in Polish), Warsaw, 1911, Nos. 227 and 228.

[5] A drawing by Fr. Smuglewicz, which portrays it, was preserved and printed in the magazine *Litwa i Ruś* (Lithuania and Russia), Vol. 2, Issue 1, Vilna, 1912.

[6] The photographs of the exterior and interior of the Lutsk synagogue, which appeared in the original Russian publication and are not available now, have been taken from the collection of the Jewish Historico-Ethnographic Society, St. Petersburg.

2. VON DER HOLBEINBIBEL ZUR AMSTERDAMER HAGGADAH

[1] Mitt. f. jüd. Volkskunde, 1902, Heft 9.

[2] Ost und West, 1904

[3] Mitt. d. Ges. z. Erforsch. jüd. Kunstdenkmäler, 1909, 5/6.

[4] Chad Gadja, 1914.

[5] Heft 3, 4 und 5.

[6] Soncino-Blätter, 1925.

[7] Publikation 7, 1927.

[8] J. v. Schlosser hat dies besonders am Beispiel der Haggadah von Sarajewo, einer spanischen Hs. des 14. Jhts., im gleichnamigen Werk gezeigt. Ich habe diesen Entwicklungsgang in Illuminated Haggadahs, Jewish Quarterly Review, XIII, 1922, an den spanischen Haggaden verfolgt, die ich teilweise anders als Schlosser datiert habe. In der "Darmstädter Haggadah" von B. Italiener, A Freimann und August Mayer, wo meine Korrekturen berücksichtigt worden sind, sieht man die weitere Entwicklung am Aschkenasischen Material besonders deutlich. Die Entlehnungen aus dem christlichen Bibelbilderkreis brauchen nicht auszuschließen, daß es in hellenistischer und frühbyzantinischer Zeit einen jüdischen Bibelbilderkreis gegeben hat. Jedoch wird er sich im islamischen Kulturkreise derart zurückgebildet haben, daß die Juden in Spanien im 13. Jht. bei der christlichen Bibelillustration Anschluß suchen mußten.

[9] Ich benutze das Exemplar von Herrn Salli Kirschstein, Berlin.

[10] Ich benutze das Exemplar der Bibliothek der Jüdischen Gemeinde Berlin.

[11] Druckwesen, Enc. Jud. Band 6.

[12] Abb. Jewreiskaja Encyclopaedia, B. 14, Art. Typographie, russisch.

[13] op. cit. S. 57.

[14] Abb. Jüd. Lexikon, B. 1, Art. Beracha.

[15] Vgl. Artikel Druckwesen von I. Sonne in der Encyclopaedia Judaica, B. 6.

[16] Diese Einwendung verdanke ich Herrn Jeh. Gutmann.

[17] Das Alte Testament, gedruckt bei Adam Petri 1523. Basel. Mit Holzschnitten des Hans Holbein und des Urs Graf. Benutzt ist das Exemplar des Kupferstichkabinetts, Berlin. Ich danke an dieser Stelle Herrn Dr. Rosenberg vom Kupferstichkabinett, der mir bei der Feststeilung des Holbeinschen Anteiles an der Baseler Ausgabe behilflich war.

[18] Gedruckt bei Melchior und Caspar Trechsel, Lyon 1538.

[19] Leo S. Olschki, Le Livre Illustré au 15e s. Florenz, 1926, Abb. 216.

[20] Daß Schlosser den Moses von Michelangelo nannte, ist natürlich ein Flüchtigkeitsfehler. Gemeint hatte er den Jeremias.

[21] Matthäus Merian, Basel 1907—1909.

[22] Der erste Teil ist 1625, der zweite 1626 und der dritte 1630 in Straßburg bei Zetzner erschienen. Teil I und II in einem Band befindet sich im Kupferstichkabinett, Teil III in der Preuß. Staatsbibliothek.

[23] Bei Zetzner 1630 erschienen. Ein Exemplar befindet sich in der Preuß. Staatsbibliothek.

[24] Die holländischen Ausgaben sind bei Nicolaus Visscher erschienen. Die Universitätsbibliothek Breslau besitzt ein Exemplar der Quartausgabe, das weder Druckort, noch Druckjahr aufweist. Die Universitäts-Bibliothek Göttingen besitzt ein Exemplar der Folioausgabe, gedruckt in Amsterdam, ohne Jahr.

[25] Ich benutze das Berliner Exemplar.

[26] Ein Exemplar derselben besitzt das Kupferstichkabinett.

[27] Bibliothek der Jüdischen Gemeinde Berlin, Nr. 20999.

[28] Zu der von Alb. Wolf aufgeworfenen Frage, ob Abraham bar Jakob nicht Proselyt gewesen ist, sei noch bemerkt, daß die Signatur des Abraham bar Jakob auf dem Titelblatt zu Horowitz, Schene Luchot ha-Berit, 1698 — einem Stich des Künstlers, auf den Wolf bereits hinwies, — diese Annahme nicht bestätigt. Im Gegenteil, die Abbreviatur "ba'r" (ר״ב), wie sie dort geschrieben ist, besagt nach freundlicher Mitteilung von Herrn Jehoschua Gutmann, der sie Signatur nach dem Exemplar des Rabiner-Seminars in Berlin überprüft hat, daß Abraham "Sohn des Rabbi" Jakob war. Diese Titulatur bezeugt, daß er von einem jüdischen Vater stammte.

[29] Benutzt ist das Exemplar von Herrn Salli Kirschstein, Berlin, Nikolassee. Ich möchte dem liebenswürdigen Sammler, sowie dem Direktor der Bibliothek an der Jüdischen Gemeinde in Berlin, Herrn Dr. M. Stern für die mir zur Benutzung wiederholt überlassenen Haggadahdrucke an dieser Stelle herzlichst danken.

ZUR AMSTERDAMER HAGGADAH Note to p. 54

[1] Kurz vor Fertigstellung dieses Heftes ist der hochverdiente Gelehrte dem Judentum und der Wissenschaft entrissen worden. Ehre seinem Andenken!

<div align="right">Die Schriftleitung.</div>

3. DIE MESSIANISCHE HÜTTE IN DER JÜDISCHEN
KUNST Notes to p. 55

[1] Nach Sukka 11b bestanden die "Hütten" Lv 23:43 aus "Wolken der göttlichen Herrlichkeit".

[2] H. Torczyner, Die Bundeslade und die Anfänge der Religion Israels, Kap. X: Sukkot und Mazzotfest, 2. Auflage 1930; M. Grunwald, Zur Vorgeschichte des Sukkotrituals, Jahrb. f. jüd. Volkskunde, 1923.

³ Die Bilder des Machsor der Leipziger Universitätsblbliothek sind bei R. Bruck, Die Malereien in den Handschriften des Königreichs Sachsens, 1906 unter Nr. 77 beschrieben, aber ikonographisch nicht identifiziert. Von den vor mir identifizierten Bildern dieses Machsor habe ich veröffentlicht: das Brautpaar des Hohenliedes, aus dem 1. Band der Handschrift fol. 64 verso, und die Gesetzesübergabe, B. 1, fol. 130 verso, beides abgebildet in meinen "Symbolen und Gestalten der jüdischen Kunst", 1935, Abb. 30 und Abb. 2; ferner Abrham im Feuerofen, B. 1, fol. 164 verso, abgebildet EJ, I, 377 und im Leipziger isr. Gemeindeblatt, 1929, 15. März. Dort habe ich auch den Feststraußschwinger reproduziert, jedoch ohne die Tiere vom unteren Rand des Blattes. Zofja Ameisen hat diese Tiere neuerdings als Leviatan und Behemot gedeutet: MGWJ, 1935, S. 409 ff. Da sie aber die Figur auf der Miniatur als Ährenlesenden verstanden hatte (nach Bruck, der sie als "Ähren tragend" schildert), ist ihr der Zusammenhang zwischen dem Mann und den Tieren nicht ganz klar geworden. Dieser hat sich erst aus der Gegenüberstellung unserer beiden Teildeutungen ergeben.

⁴ Die Schilderung des Leviatanfanges klingt übrigens an Hiob 40:25-26 an, wo es heißt: Du ziehst den Leviatan am Hamen, und senkst in die Angelschnur seine Zunge. Wirst du den Maulkorb legen vor seine Nase und mit Haken sein Kinn durchlöchern?

⁵ M. Soloweitschik, EJ. X unter Leviatan.

⁶ Abb. bei Z. Ameisen, a. O.

⁷ Farbig wiedergegeben in R. Wischnitzer-Bernstein, Symbole und Gestalten, Taf. V.

⁸ J.B. de Rossi, Un verre représentant le Temple de Jérusalem, Archives de L'Orient Latin, 1884, B. II.

⁹ H. Greßmann, Jewish Life in Ancient Rome, in Jewish Studies in Memory of Isr. Abrahams, New York, 1927, S. 181.

¹⁰ H.W. Beyer und H. Lietzmann, Die Katakombe Torlonia, 1930, S. 23.

¹¹ E.L. Sukenik, The Ancient Synagogue of Beth Alpha, 1932, S. 21.

¹² H. Greßmann, S. 181.

¹³ H. Greßmann übersetzt die nur teilweise erhaltene Inschrift: Haus des Friedens. Nimm den Heiligungsbecher. Trinke, Du mögest leben, Du und die Deinigen alle. Eine Analyse der Inschrift auch bei Sukenik, Beth Alpha, S. 20. f.

¹⁴ Abb. 39 in meinen "Symbolen und Gestalten".

¹⁵ Un fragment de sarcophage judéo-païen, Revue arch. 1916, B. IV.

¹⁶ Wer den Etrog in die rechte und den Lulab in die linke Hand nimmt, leugnet damit die Auferstehung, Pelia 73, zit. nach M. Grunwald, Zur Vorgeschichte des Sukkotrituals, S. 446.

¹⁷ Im Cubiculum II. Vgl. Beyer und Lietzmann, S. 10.

¹⁸ Beyer und Lietzmann, S. 19.

¹⁹ Greßmann, S. 187.

²⁰ Nikolaus Müller, Die jüdische Katakombe am Monteverde zu Rom, 1912, S. 78.

²¹ R. Garrucci, Storia dell'arte cristiana, VI.

²² Jalk. II Kön., 224; Pirke R. Elieser 31, zit. nach A. Löwinger, Die Auferstehung in der jüdischen Tradition, Jahrb f. jüd. Volkskunde, 1923, S. 65.

²³ K. Woermann, Geschichte der Kunst, 1920, B. III, Abb. 8.

²⁴ K. Woermann, B. III, Tafel I.

²⁵ F. Cabrol und H. Leclercq, Dictionnaire d'Archéologie chrétienne, 1920, unter dauphin; F.J. Dölger, Das Fischsymbol, 1928.

²⁶ Die zwei Fische der Paradieslandschaft auf dem Mosaik der Synagoge in Hammam-Lif deutete Irmgard Schüler als das talmudisch überlieferte Leviatanmännchen und Leviatanweibchen in dem von ihr geschriebenen Abschnitt Zukunftshoffnung in R. Wischnitzer-Bernstein, Symb. u. Gest., S. 122. Demgegenüber ist der Leviatan ein betont gottfeindliches Sinnbild in frühchristlichen Kreisen; vgl. Dölger, Der Heilige Fisch, 1922, Seite 491.

²⁷ Über die jüdische Symbolik des Storches und der Schlange vgl. R. Wischnitzer-Bernstein, Symb. u. Gest., S. 65; idem. Aethiopien in der jüdischen Legende, Jüdische Rundschau, 1935, Nr. 74. Jedoch ist die besondere Deutung der Schlange im Storchbild der mohilever Synagoge, als Leviatan, die Speise der Frommen, von mir im Laufe der gegenwärtigen Arbeit erst gefunden. Die Versinnbildlichung der Frommen durch Störche beruht nicht nur auf der Doppelbedeutung des Wortes חֲסִידָה sondern auch wohl auf einer Redewendung im Machsor für Sukkot. Im Kerobot des 2. Festtages hießt es, daß die Getreuen der Sukka "aus allen Enden herbeigeflogen kommen".

²⁸ Die Inschrift ist von El. Lissitzki, der die Malereien an Ort und Stelle kopiert hat, gelesen worden. Mit der Lupe läßt sie sich auf der farbigen Abbildung im Rimon, 1923, Heft 3 entziffern. Vögel im Nest deutet auch Molsdorf, Christl. Symbolik d. mittelal. Kunst, 1926, S. 115 als Sinnbild des paradiesischen Friedens.

²⁹ Das Bild der Stadt Worms ist inschriftlich bezeugt. M. Grunwald hat verschiedentlich auf den Ursprung der Darstellung hingewiesen, zuletzt in A. Breier, M. Eisler und M. Grunwald, Holzsyngogen in Polen, Wien, 1934, Anhang, S. 6.

³⁰ Die Geräte des Salomonischen Tempels, der Behemot, der Leviatan, der Elefant und die nicht näher bestimmte Ziege sind von Lissitzki in seinem Reisebericht, Rimon, Heft 3 erwähnt. Kopien dieser Bilder besitzen wir jedoch nicht.

³¹ Der den Baum erkletternde Bär wird von Lissitzki erwähnt.

³² Abbildung in Rimon, Heft 3.

³³ Farbige Abbildung im Rimon, Heft 3. Die Horber Holzsynagoge befindet sich als Privatstiftung im Städtischen Museum in Bamberg.

4. THE CONCEPTION OF THE RESURRECTION IN
THE EZEKIEL PANEL OF THE DURA SYNAGOGUE

[1] The panel is located in the lower register of the north wall of the synagogue. The paintings were executed between 245 and 256 A.D. For the structure and its decorations cf. *Excavations at Dura Europos, Preliminary Report of the Sixth Season of Work*, 1936, 309-396; Comte du Mesnil du Buisson, *Les Peintures de la Synagogue de Doura-Europos*, Rome, 1939; and the recent article by Emil G. Kraeling, "The Meaning of the Ezekiel Panel," *BASOR*, 78.

[2] Hopkins and du Mesnil, "La Synagogue de Doura-Europos," *Comptes rendus de l'Académie des Inscriptions et Belles-Lettres*, 1933, 251-252.

[3] *Dura VI*, 49.

[4] Wilhelm Neuss, *Das Buch Ezekiel*, 1912.

[5] Israel conceived in the broader sense. In juxtaposition to Judah, Israel represents only the northern Kingdom.

[6] Ginzberg, *Legends of the Jews*, IV, 234.

[7] Ginzberg, *op. cit.*, II, 143.

[8] Prof. Carl H. Kraeling pointed out this fact to me at the meeting of the American Oriental Society at New York in March, 1940, at which I read a paper on the subject: "Is there a unity of conception in the paintings of the Synagogue of Dura-Europos."

[9] "The Ezekiel panel in the Wall Decoration of the Synagogue of Dura-Europos," *JPOS*, 1938, XVIII, 4.

[10] *Comptes rendus*, 1933, 252.

[11] Ginzberg, *op. cit.*, IV, 125-126.

[12] *Peintures*, 101.

[13] Ginzberg, *op. cit.*, IV, 99.

[14] Cf. the copy of the panel by Mr. Herbert I. Gute, member of the Dura expedition, in the Gallery of Fine Arts at New Haven.

[15] H. Deggering and A. Boeckler, *Die Quedlinburger Italafragmente*, 1932, Plate I, 3.

[16] D. D. Egbert, *The Tickhill Psalter and related Manuscripts*, 1940. I am indebted to Professor Egbert, of Princeton University, for information on the iconography of the Amasa-Abner motif.

[17] So first interpreted by C. H. Kraeling, *Dura VI*, 57-58; cf. Du Mesnil, *Peintures*, Pl. XLV.

[18] Sukenik has proposed the reading in the same direction on different grounds.

[19] Meyer Schapiro, "From Mosarabic to Romanesque in Silos," *Art Bulletin*, XXI, 1939, 326, note 21.

5. THE MESSIANIC FOX

[1] Carl H. Kraeling, "The Wall Decorations," *The Excavations at Dura-Europos; Preliminary Report of Sixth Season of Work* (New Haven, 1936), pp. 337-83; Du Mesnil du Buisson, *Les peintures de la Synagogue de Doura-Europos* (Rome, 1939); Emil G. Kraeling, "The Meaning of the Ezekiel panel in the Synagogue at Dura," *Bulletin of the American Schools of Oriental Research*, April, 1940. The author of the present article has dealt with the messianic conception of the resurrection at the synagogue of Dura, in a paper read before the Meeting of the American Oriental Society in New York, in March, 1940. Her article dealing with the problem will soon appear elsewhere.

[2] H.W. Beyer and H. Lietzmann, *Die jüdische Katakombe der Villa Torlonia in Rom* (Berlin, 1930), where the bibliography of the subject is discussed; R. Wischnitzer-Bernstein, "Die messianische Hütte in der jüdischen Kunst," *Monatsschrift für Geschichte und Wissenschaft des Judentums*, Breslau, 1936 (illustrated).

[3] Elisabeth Moses, "Ueber eine kölner Handschrift des Mischne Thora," *Zeitschrift für Bildende Kunst*, 1926-27. In this manuscript, the fox illustrates a popular rhyme in no way connected with the text of the work, and is to be considered merely as a marginal ornamental device.

[4] For a fuller description of the contents, see Ph. de Haas, "Beschreibung der Breslauer deutschen Machsor-Handschriften," *Soncino-Blätter* (Berlin, 1927), pp. 33-35. The manuscript was at the Exhibition of "Judaism in the History of Silesia," cf. catalogue by Erwin Hintze, No. 491 (Breslau, 1929), where fol. 221 v is reproduced.

[5] C.T. Bridgeman, *Jerusalem at Worship* (Jerusalem, 1932).

[6] "Eine illustrierte deutsche Machsorhandschrift in Breslau," *Menora* (Vienna, 1927).

[7] Fig. 138 in R. Bruck, *Die Malereien in den Handschriften des Königreich Sachsen* (Dresden, 1906). The motif is interpreted in R. Wischnitzer-Bernstein, *Gestalten und Symbole der jüdischen Kunst* (Berlin, 1935), p. 141.

[8] b. Chagiga 14 a, quoted by Paul Volz, *Die Eschatologie der Jüdischen Gemeinde im neutestamentlichen Zietalter* (Tübingen, 1934), p. 215.

[9] The Leipzig Mahzor is described in Bruck (*op. cit.* No. 77) where the iconographical subjects are not identified. For identification of some of the images, see R. Wischnitzer-Bernstein, *Gestalten und Symbole; idem,* "Die Messianische Hütte," *idem,* "Der Streiter des Herrn," in Gaster Anniversary Volume (London, 1937); Zofja Ameisenowa, "Das Messianische Gastmahl der Gerechten in einer hebräischen Bibel aus dem 13. Jahrhundert" (MGWJ, 1935), p. 409.

[10] Briefly described in Bruck, *op. cit.*, No. 63.

[11] Tosaafoth to Joma, p. 54 a, quoted in B. Italiener, *Die Darmstädter Haggadah* (1927) p. 18.

5A. THE FOX IN JEWISH TRADITION, BY PAUL ROMANOFF

[1] Since writing this criticism of Mrs. Wischnitzer's theories, I have had the opportunity of reading the proof of her "Reply." Not wishing to burden the reader with further discussion, I still claim the privilege of holding to my original argument that no mystical reversal of the fox symbolism occurred in Jewish tradition. In those "messianic" utterances where the fox appears as part of the motif, the animal is used negatively, and this can be inferred even from those works of N. N. Glatzer and Joseph Klausner referred to in the "Reply."

5B. A REPLY TO DR. ROMANOFF

[1] *Untersuchungen zur Geschichtslehre der Tannaiten* (1933), p. 29.

[2] *Die Messianischen Vorstellungen des Jüdischen Volkes im Zeitalter der Tannaiten* (1903), p. 7.

[3] Reproduced in Marvin Lowenthal, *A World Passed By* (2nd Ed. 1938), p. 413.

[4] On the significance of the gate, cf. Julian Morgenstern, "The Gates of Righteousness," *Hebrew Union College Annual*, VI, 1929.

[5] Cf. Assara Haruga Malchut, quoted from *Encyclopaedia Judaica*, vol. 2, col. 1158, s. v. Apokalyptik.

[6] *Legends of the Jews*, VI, 272, note 128.

[1] Johannes Wilde, *Roentgenaufnahmen der "Drei Philosophen" Giorgiones und der "Zigeunermadonna" Tizians* in: "Jahrbuch der Kunsthistorischen Sammlungen in Wien", N. S. VI, 1932, pp. 141-154.

[2] *Ibid*, p. 150.

[3] *Ibid*, p. 151.

[4] Jacopo Morelli, *Notizia d'opere di disegno*, Bassano, 1800, p. 64; George C. Williamson, *Notes on pictures and works of art in Italy made by an anonymous writer in the 16th century, translated by Paolo Mussi*, London, 1903, p. 102.

[5] Giorgione died in 1510. His death is implied as a recent event in the letter of Isabella d'Este to her agent in Venice, Taddeo Albano, of October 25, 1510. See: G. Gronau, *Kritische Studien zu Giorgione* in: "Repertorium fuer Kunstwissenschaft", 1908, p. 406.

[6] L. Justi, *Giorgione*, 1908, I, p. 38.

[7] There exist several *Interiors* of the Archduke's gallery in Brussels by Teniers the Younger of which only the one illustrated here (Fig. 5) is dated; see: Adolf Rosenberg, *Teniers der Juengere*, Bielefeld-Leipzig, 1895, p. 51.

[8] *Theatrum Pictorium Davidis Teniers Antverpiensis...*, Brussels, Hendrick Aertssen, 1660, pl. 20.

[9] Adolf Berger, *Inventar der Kunstsammlung des Erzherzogs Leopold Wilhelm von Oesterreich nach der Originalhandschrift im Fuerstlich Schwarzenberg'schen Centralarchiv*, in: "Jahrbuch der kunsthistorischen Sammlungen des Allerhoechsten Kaiserhauses", 1883, I, part 2, p. XCIV, no. 128.

[10] J.A. Crowe and G.B. Cavalcaselle, *A history of painting in North Italy*, London, 1871, II, p. 135.

[11] Edgar Wind, *The four elements in Raphael's 'Stanza della Segnatura'* in: "Journal of the Warburg Institute," London, 1938-39, p. 78.

[12] Lionello Venturi, *Giorgione e il Giorgionismo*, Milan, Hoepli, 1913, p. 91.

[13] Otto Brendel, *Symbolik der Kugel*, in "Mitteilungen des Deutschen Archaeologischen Instituts, Roemische Abteilung", 51, 1936, Fig. 1; 2. I am indebted for this reference to Prof. K. Lehmann-Hartleben.

[14] See Albert Schramm, *Der Bilderschmuck der Fruehdrucke*, Leipzig, 1934, Fig. 458.

[15] Hubert Janitschek, in: C. von Lutzow, *Die K. K. Belvedere Galerie in Wien*, quoted in: Theodor Frimmerl, *Geschichte der Wiener Gemaeldesammlungen*, Leipzig, 1899, I, p. 345. Giorgione's picture inherited by the emperor Leopold in 1662 became part of the Imperial collections in the Belvedere in 1777.

[16] Arnaldo Ferriguto, *Att averso i 'misteri' di Giorgione*, Castelfranco Veneto, 1933, pp. 61-102.

[17] Domenico Parducci, *"I tre filosofi" del Giorgione*, in: "Emporium", XIII. April, 1935, pp. 253-256.

[18] Ludwig Baldass, *Giorgiones 'Drei Philosophen'*, Vienna, 1922, quoted in: G.M. Richter, *Giorgio da Castelfranco*, Chicago, 1937, p. 254.

[19] G.F. Hartlaub, *Giorgiones Geheimnis*, Munich, 1925; Idem, *Giorgione und der Mythos der Akademien*, in: "Repertorium fuer Kunstwissenschaft". XLVIII, 1927, 233-240.

[20] Franz von Wickhoff, *Les écoles italiennes du Musée de Vienne*, in: "Gazette des Beaux-Arts", January 1893, pp. 5-18; Idem, *Giorgiones Bilder zu roemischen Heldengedichten*, in "Preussische Jahrbuecher", XVI, 1895, 34-43, believed to have found the episode in the *Aeneid* VIII 306-348. Aeneas, the turbaned man in his interpretation, visits the site of the future Capitol in company of the old king Evander and his son Pallas, the seated figure. L. Venturi, *Op. cit.*, p. 91, dismissed this hypothesis in pointing out that neither of the standing men seems to care for the scenery. All the Virgil story has in common with the painting, is the mountain, which is *troppo poco*.

[21] Emil Schaeffer, *Giorgiones Landschaft und "Die drei Philosophen"*, in: "Monatshefte fuer Kunstwissenschaft", III, 1910, pp. 340-345, has pointed to a similarity which he sees in a painting representing Marcus Aurelius on horseback with two philosophers crossing his way and other figures crowding the picture. Here too the mountain — meant to be the Mons Coelius — is the only point in common with Giorgione's canvas.

[22] Hugo Kehrer, *Die heiligen drei Koenige in Literatur und Kunst*, 1909, I, p. 19 f.

[23] G.M. Richter, *Op. cit.*, p. 256.

[24] Matthias Andreas Schmidt, *Gemaelde der K.K. Galerie, I. Italienische Schulen*, Vienna, 1796, pp. 30-31.

[25] Erasme Engert, *Catalogue des tableaux de la Galerie Impériale-Royale au Belvédère à Vienne*, Vienna, 1859, p. 14, No. 57.

[26] P. 8, No. 16.

[27] P. 89, No. 16.

[28] G. Gombosi, *Piombo*, in: Thieme and Becker, *Allgemeines Lexikon der Bildenden Kuenstler*, XXVII, 1933, p. 71.

[29] *Cambridge Modern History*, 1902, I, p. 571.

[30] Lynn Thorndyke, *Science and thought in the 15th century*, Ch. VIII: *Peurbach and Regiomontanus re-examined*, New York, 1929.

[31] See: E. Zinner, *Leben und Wirken des Johannes Mueller von Koenigsberg, genannt Regiomontanus*, in: "Schriftenreihe zur Bayerischen Landesgeschichte", Vol. XXXI. Munich, Beck, 1938, where the earlier literature is cited. The biographical data of Regiomontanus have been drawn, for this paper, from Zinner's volume. His evaluation of Regiomontanus is wholly uncritical. I am indebted to Prof. J. Ginzburg, editor of "Scripta Mathematica", for valuable suggestions.

[32] Zinner, *Op. cit.*, p. 91.

[33] M.C. D'Arcy, *Thomas Aquinas*, Oxford, 1930, p. 47. Averrhoes appears as the defeated heretic in the *Glorification of St. Thomas*, an anonymous painting at St. Catherine, in Pisa, XIV Century; see: Millard Meiss, *The problem of Francesco Traini*, in: "The Art Bulletin", XV, 2, June 1933, p. 106, fig. 2.

[34] Zinner, *Op. cit.*, pp. 178, 277 and 278.

[35] *The Astrologer* by Giulio Campagnola is dated 1509; see: P. Kristeller, *Giulio Campagnola*, Berlin, Bruno Cassirer, 1907, pl. XII.

[36] *Epytoma Joanis de Monte Regio* in *Almagestum Ptolemaei*, edited by Giovanni Abiosi, Venice, Johann Hamman, 1496.

[37] In Christian tradition Ptolemy is a member of the royal family, a king, or else a native of the Greek city of Ptolemais in Egypt. Arab sources point out his fair complexion and habit to walk a great deal. See: *Composition Mathématique de Claude Ptolémée*, transl. by M. Halma, Paris, H. Grand, 1813, p. LXII.

[38] Thorndike, *Op. cit.*, p. 174.

[39] A complete edition of Aristotle was brought out in the Aldine press in Venice in 1495-96.

[40] K. Lehmann-Hartleben, *Cyriacus of Ancona, Aristotle and Teiresias in Samothrace* in: "Hesperia, Journal of the American School of Classical Studies at Athens", XII, 2, April-June 1943, p. 123 f.

[41] The measurements of *The Three Philosophers* are given in the Inventory of 1659 as 7 span by 8 span 8½ fingers, i.e. 1.456 by 184 cm. with frame. The canvas measures now without frame 121 by 1.411 cm.

[42] Zinner, *Op. cit.*, p. 210.

[43] Illustrated in: *Annuli astronomici instrumenti cum certissimi tum commodissimi usus ex veriis authoribus* Petro Beausardo, Gemma Frisio, Joane Dryandro, Boneto Hebraeo, Butchardo Mythobio, Orontio Finaeo, *una cum meteoroscopio per* Joane Regiomontanum *et annulo non universali*, Gulielmus Cavellat, Lutetia, 1558, Fig. p. 51 *verso*.

[44] Crowe and Cavalcaselle, *Op. cit.*, p. 135; Richter, *Op. cit.*, p. 122.

[45] The cutting down of pictures to fit smaller frames was a common practice. According to L. Baldass *Geschichte der Wiener Gemaelde-Galerie von 1911-30* in: "Jahrbuch der Kunsthistorischen Sammlungen", N.S., V. [1931] pp. 1-19), it was much used in the Stallung in Vienna where the Imperial collections were located, in 1720-1728. Another case of cutting down a valuable canvas in the Leopold Wilhelm collection is the *Portrait of Maria Theresa* by Mazo; see: Walter W.S. Cook, *Spanish and French paintings in the Lehman Collection*, in: "The Art Bulletin", VII, 2, 1924, p. 58, 61, *passim*.

[46] Giorgione's Altarpiece of the church of St. Liberale at Castelfranco is generally dated around 1500. The date of 1504, suggested by several scholars, rests on conjectural evidence; see Richter, *Op. cit.*, p. 30. The Dresden *Venus* is commonly dated in 1505.

[47] Justi, *Op. cit.*, p. 39.

[48] Gronau, *Op. cit.*, p. 420.

[49] Prof. Richard Offner, in his course on the Italian masters of the High Renaissance held in the Institute of Fine Arts, New York University, 1943.

[50] For documents in support of the date of the Fondaco frescoes, see: Gronau, *Op. cit.*, p. 405.

[51] Justi, Op. cit., II, p. 26.

[52] G. Gronau, *Giovanni Bellini*, Stuttgart-Berlin, 1930, fig. 160.

[53] See the correspondence of Isabella d'Este with Taddeo Albano, in: G. Gronau, *Kritische Studien zu Giorgione* in: "Repertorium fuer Kunstwissenschaft", 1908, p. 406.

[54] The labels are more legible in the engraving after the etching in the Strasburg edition of 1635 printed on behalf of the Elzevir of Leyde. The same engraving is used in the Lyon edition of 1641 which was shown in the *Copernicus Exhibition*, New York Public Library, May-June 1943.

[55] Andreas Cellarius, *Harmonia Macrocosmica*, Amsterdam, J. Jansson, 1661.

[56] Stefano della Bella was born in 1610 in Florence; see: E. Bénézit, *Dictionnaire des peintres, sculpteurs et graveurs*, Paris, 1924, I, 480-481.

[57] Claude Phillips, *The picture gallery of Charles I, The Portfolio*, London, XXV, 1896, p. 54 f., suggests that the picture might have been acquired by Leopold Wilhelm from the dispersed collection of Charles I of England. He believes that *The Three Philosophers* is identical with a canvas listed as "Titian, *The Three Travellers*" in a copy of 1681 of the royal catalogue of 1639. The original catalogue was not available to him. This assumption would have to be reconciled with the fact that the canvas is catalogued as "Giorgione's *Three Mathematicians*" in the Archduke's Inventory of 1659. Wherefrom and when Charles I acquired the *Three Travellers* is not known.

[58] André Thevet, *Vrais portraits et vies des hommes illustres*, Paris, 1584, p. 512. The Plimpton, D.E. Smith and Dale Libraries, Columbia University, possess the portrait of Regiomontanus from this work. I am indebted to Miss Marion Schild, assistant librarian, for facilitating my research in every way.

[59] H. Pflaum, *"L'Acerba" di Cecco d'Ascoli*, in: "Archivum Romanicum" XXIII, 2-3 (April-September 1939), p. 219. None of the two prints was available to me.

[60] Three astrologers or astronomers in a landscape, not especially identified, are a pretty common motive in book illustration; see the woodcut in: A.T. Macrobius, *In Somnium Scipionis exposito*, Venice, P. Pincius, 1500, illustrated in: L. Venturi, *Op. cit.*, pl. XX, with a seated, a kneeling and a standing figure, or Marcantonio Raimondi's engraving *The Three Doctors*, seated in a landscape, illustrated in: H. Delaborde, *Marc-Antoine Raimondi*, Paris, n.d., Fig. p. 235.

7. THE EGYPTIAN REVIVAL IN SYNAGOGUE ARCHITECTURE

* Some material on American synagogal architecture is to be found in various Jewish congregational histories. Dealing more particularly with the buildings are the publications of D. de Sola Pool on the synagogue structures of the Congregation Shearith Israel of New York. The architect William G. Tachau has discussed a number of American synagogues in his survey of synagogal architecture through the ages in his article "The Architecture of the Synagogue," in the *American Jewish Year Book, 5687 [1926-1927]*, vol. 28 (Philadelphia, 1926), pp. 155-192. Individual buildings have been dealt with by Lee M. Friedman in the periodical *Old Time New England [Bulletin of the Society for the Preservation of New England Antiquities]*. See his papers "A Beacon Hill Synagogue," *ibid.*, vol. XXXIII, no. 1 (July 1942), serial no. 109, pp. 1-5, and "The Newport Synagogue," *ibid.*, vol. XXXVI, no. 3 (Jan., 1946), serial no. 123, pp. 49-57. References to synagogues built by noted architects may be found in monographs and general architectural histories. The picture book. *The House of God* by Desider Holisher (New York, 1946) includes a number of photographs of synagogue buildings in the United States.

In the present study, I wish to express my indebtedness to Miss Emily Solis-Cohen, the Reverend Leon H. Elmaleh, Minister Emeritus of the Congregation Mikve Israel, the Reverend Meyer Finkelstein, Rabbi of the Beth Israel Congregation, all of Philadelphia, and to Isidore S. Meyer, Librarian of the American Jewish Historical Society in New York, for assistance in my research.

[1] Antoine Chrysostôme Quatremère de Quincy, *De l'architecture égyptienne considérée dans son origine, ses principes et son goût, et comparée sous les mêmes rapports à l'architecture grecque* (Paris, 1803).

[2] *Description de l'Égypte, ou Recueil des observations et des recherches qui ont été faites en Égypte pendant l'expédition de l'armée française* (Paris, 1809-1828).

[3] Hans Vogel, "Aegyptisierende Baukunst des Klassizismus," *Zeitschrift fuer bildende Kunst*, vol. LXII, no. 7 (1928-29), p. 161.

[4] [Gaillard Hunt], *The History of the Seal of the United States* (Washington, 1909).

[5] Frank J. Roos, Jr., "The Egyptian Style. Notes on Early American Taste," *Magazine of Art*, vol. XXXIII, no. 4 (April, 1940), pp. 222 ff.

[6] Talbot F. Hamlin, *Greek Revival Architecture in America* (New York, 1944), pl. XLVIII.

[7] *Philadelphia in 1824* (Philadelphia: H. C. Carey and I. Lea, August, 1824), p. 55.

[8] *Dedication of the New Synagogue of the Congregation Mikve Israel at Broad and York Streets on September 14, 1909* (Philadelphia, 1909) [= Mikve Israel, 1909], p. 8. The first part of this publication contains "An Historical Sketch of the Congregation," by A. S. W. Rosenbach, pp. 5 ff.

[9] For Mill Street synagogues see D. de Sola Pool, *The Mill Street Synagogue, 1730-1817* (New York, 1930), p. 65. For the Crosby Street synagogue, see *idem, The Crosby Street Synagogue* (New York, 1934), diagram on p. 37. It may be noted that the Touro Synagogue in Newport, R. I. (1763) is only 35 by 40 feet. See *Touro Synagogue of Congregation Jeshuat Israel, Newport, Rhode Island* (Newport, R. I., 1948), p. 21.

[10] Agnes Addison Gilchrist, *William Strickland, Architect and Engineer* (Philadelphia, 1950), p. 49, pl. 18A.

[11] D. de Sola Pool, *The Mill Street Synagogue, supra*, p. 62. In the First Mill Street Synagogue the tablet was of wood.

[12] See the exterior view of the theater engraved by Thomas Birch (1779-1851) in Gilchrist, *supra*, pl. 12B.

[13] *Ibid.*, p. 63.

[14] Sabato Morais, "Mickve Israel Congregation of Philadelphia," *Publications of the Amercian Jewish Historical Society* [=*PAJHS*], no. 1 (1893), p. 15.

[15] D. de Sola Pool, *The Mill Street Synagogue, supra*, pp. 30-32. It may be noted that six corner stones had been laid at the founding of the Touro Synagogue at Newport, R. I., in 1759. See Lee M. Friedman, "The Newport Synagogue," *Old-Time New England, supra*, vol. XXXVI, no. 3, p. 52. The usage can be traced to Amsterdam. At the founding of the Great Portuguese Synagogue in Amsterdam on April 17, 1671, four cornerstones were laid. See Henrik Brugmans and A. Frank, *Geschiedenis der Joden in Nederland* (Amsterdam, 1940) p. 287.

[16] Henry Morais, *The Jews of Philadelphia* (Philadelphia, 1894), p. 143.

[17] *Ibid.*, p. 14.

[18] *Ibid.*, p. 14, quotes the description of the synagogue as from *Picture of Philadelphia* (Philadelphia: James Mease, August, 1830). It was, however, printed in *Philadelphia in 1824* (see *supra*, note 7) and reprinted in *Philadelphia in 1830* (Philadelphia: E. L. Carey and A. Hart, 1830). My thanks are due to the American Antiquarian Society, Worcester, Mass. for checking these references.

[19] See item no. 278, *Form of Service at the Dedication of the New Synagogue of the "Kahal Kadosh Michvi [sic] Israel" in the City of Philadelphia* (New York, 1825), in A. S. W. Rosenbach, "An American Jewish Bibliography," *PAJHS*, no. 30 (1926), pp. 236-238.

[20] Gilchrist, *supra*, pp. 17, 62 and 63.

[21] *Mikve Israel*, 1909, p. 17.

[22] Gilchrist, *supra*, p. 63.

[23] Joseph Jackson, *William Strickland* (Philadelphia, 1922), p. 17.

[24] Henry Morais, *supra*, p. 44.

[25] Gilchrist, *supra*, p. 63.

[26] *Ibid.*, p. 62.

[27] See Ulrich Thieme and Felix Becker, *Allgemeines Lexikon der Bildenden Kuenstler*, vol. XXXV (1942), s. v. Weinbrenner, Friedrich.

[28] Arthur Valdenaire, *Friedrich Weinbrenner, seine kuenstlerische Erziehung und der Ausbau Karlsruhes* (Karlsruhe, 1914), p. 10.

[29] Max Pirker, *Rund um die Zauberfloete* (Vienna, 1920), *passim*.

[30] According to information kindly given by Dr. Nathan Stein, Hempstead, L. I. Adolf Kober [*Universal Jewish Encyclopedia*, vol. VI (1942), p. 323, s. v. Karlsruhe] states that the synagogue was built of timber.

[31] *Festgabe: 50 Jahre Hauptsynagoge Muenchen*, ed. Leo Baerwald and Ludwig Feuchtwanger (Munich, 1937), pp. 19-20, 71.

[32] Rudolf Hallo, *Kasseler Synagogengeschichte* (Kassel, 1931), p. 53. In fact Berlin-born Rahel Levin, wife of Varnhagen von Ense, shortly before her death in 1833, referred to herself ruefully as a "refugee from Egypt and Palestine." See Solomon Liptzin, *Germany's Stepchildren* (Philadelphia, 1944), p. 16. See also Rachel Wischnitzer, "The Problem of Synagogue Architecture," *Commentary*, vol. III, no. 3 (March, 1947), p. 235.

[33] *Handbook of Architectural Styles* (London and New York, 1894). It has appeared in other English editions, having been published originally in German as *Die architektonischen Stilarten* (Braunschweig, 1857).

[34] Hallo, *supra*, p. 57.

[35] *American Quarterly Review*, vol. V, no. 4 (March, 1829), pp. 1-41. In 1829 Mendes I. Cohen (b. Richmond, 1796-d. Baltimore, 1879) undertook a journey to Egypt and reached the cataracts of the Nile. The antiquities he collected in the course of his explorations were presented in 1884 to Johns Hopkins University. See Roos, *supra*. p. 220; *Universal Jewish Encyclopedia*, vol. III (1941), s. v. Cohen, p. 234.

[36] Gilchrist, *supra*, p. 114 and pl. 44.

[37] From the circular of Congregation Beth Israel of June 12, 1840, quoted in Henry Morais, *supra*, p. 84.

[38] *Ibid.*, p. 85.

[39] The same description is found in *Philadelphia As It Is* of 1852. These are the earliest references to the Crown Street synagogue of 1849, traced so far. Thanks are due to the Historical Society of Pennsylvania for these references.

[40] Illustrated in the *Stranger's Guide in Philadelphia*, p. 228. I have used the edition of 1854 in the New York Public Library.

[41] Roos, *supra*, p. 221 and fig. 4. The date is given as 1836 in William Sever Rusk, "Thomas U. Walter and His Work," *Americana*, vol. XXXIII, no. 2 (April, 1939), p. 164.

[42] *The American Architect and Building News*, July 16, 1892, p. 37. Thanks are due to the Avery Library, Columbia University, for assistance in compiling the data on Stephen Decatur Button.

[43] Henry Morais, *supra*, p. 88.

[44] Illustrated in the *Universal Jewish Encyclopedia*, vol. I, p. 618, s. v. Australia.

[45] Harold Donaldson Eberlein and Cortland van Dyke Hubbard, *Portrait of a Colonial City: Philadelphia 1670-1838* (Philadelphia, 1939), p. 409.

[46] Clay Lancaster, "Oriental Forms in American Architecture 1800-1870," *Art Bulletin*, vol. XXIX, no. 3 (Sept., 1947), p. 185.

[47] Charles A. Beard and Mary R. Beard, *A Basic History of the United States* (New York, 1944), p. 262.

[48] Max J. Kohler, "Jews in the American Anti-Slavery Movement, II" *PAJHS*, no. 9 (1901), p. 52.

8. THOMAS U. WALTER'S CROWN STREET SYNAGOGUE, 1848-49

[*] For their helpfulness in furnishing information and materials the writer wishes to thank Edwin Wolf, 2nd, of the Library Company of Philadelphia and R.N. Williams, 2nd, Director of the Historical Society of Pennsylvania in Philadelphia.

[1] Joseph Jackson, *Early Philadelphia Architects and Engineers* (Philadelphia, 1923), Ch. IX, "Thomas U. Walter," p. 205, Jackson did not usually document his attributions. The Debtors' Jail was a wing added to the already existing prison building erected in 1832-35. See *Philadelphia Architecture in the Nineteenth Century*, Theo B. White, ed., (Philadelphia: University of Pennsylvania Press, 1953), p. 26. This would agree with W.S. Rusk's dating of 1836. See his "Thomas U. Walter and his work," *Americana*, April 1939, p. 164. Stephen Decatur Button (1813-1892) opened his office in Philadelphia with J.C. Hoxie in 1848. ("Biographical Sketch of Mr. S.D. Button, Architect, Philadelphia," *The American Architect and Building News*, July 16, 1892, p. 37). The Entrance Pavilion of the Odd Fellows' Cemetery opened in 1849 was illustrated in *The Stranger's Guide in Philadelphia* (Philadelphia: Lindsay & Blakiston, 1854), p. 228.

[2] Rachel Wischnitzer, "The Egyptian Revival in Synagogue Architecture," *Publication of the American Jewish Historical Society*, September 1951, pp. 61-75.

[3] "The Consecration of the Synagogue Beth Israel of Philadelphia," *The Occident and American Jewish Advocate*, May 1849, pp. 106-108.

[4] Agnes Addison Gilchrist, *William Strickland, Architect and Engineer* (Philadelphia: University of Pennsylvania Press, 1950), pp. 22, 62-63.

[5] For the interior of the Cherry Street Synagogue see Wischnitzer, *op. cit.*, Fig. 1.

[6] The description reads: "A new and imposing building constructed of brown stone in the Egyptian style." It is also to be found in *Philadelphia As It Is* of 1852. I have used the editions of 1854.

[7] Leeser mentioned the Worms synagogue in *The Occident*, May 1843, but had no idea of its date or appearance. It was burnt by the Nazis in 1938.

[8] C.L.V. Meeks, "Romanesque before Richardson in the U.S.," *The Art Bulletin*, March 1953, pp. 17-33.

[9] *The Occident*, August 1847, pp. 217-222.

[10] For European examples see Wischnitzer, *op. cit.*, *passim*.

[11] Gilchrist, *op. cit.*, p. 63.

[12] Henry Morais, *The Jews of Philadelphia* (Philadelphia: The Levy-type Co., 1894) p. 88.

[13] In 1836 Walter had prepared a drawing of an Egyptian gateway for the Laurel Hill Cemetery in Philadelphia which was not executed. It is preserved in the Free Library of Philadelphia (Gilchrist, *op. cit.*, p. 91). In 1837-38 Walter added a women's section in the Egyptian style to the Moyamensing prison buildings (W.S. Rusk, *op. cit.*, p. 164). A design of a bathhouse with the characteristic sloping window jambs is to be found in Thomas U. Walter and J. Jay Smith, *Two Hundred Designs for Cottages and Villas, etc.* (2nd ed., Philadelphia: Carey and Hart, 1847), Pl. LXXXIII.

[14] Gilchrist, *op. cit.*, p. 114. For the diffusion of the Egyptian Revival in the U.S. see Clay Lancaster, "Oriental Forms in American Architecture 1800-1870," *The Art Bulletin*, September 1947, pp. 184-185.

9. REMBRANDT, CALLOT, AND TOBIAS STIMMER

[1] C. Neumann, *Rembrandt*, Munich, 1924, 4th ed., pp. 749ff. (1st ed. 1902).

[2] F. Landsberger, "Rembrandt and Josephus," ART BULLETIN, XXXVI, 1954, pp. 62-63.

[3] U. Gnoli, *Pietro Perugino*, Spoleto, 1923, pl. 4.

[4] J. de Jong, *Architectuur bij de nederlandsche Schildern voor de Hervorming*, Amsterdam, 1934, p. 30.

[5] "Anonymous Pilgrim, vii," *Library of the Palestine Pilgrims' Text Society*, London (cited as *P.P.T.S.*), 1894, p. 71.

[6] "City of Jerusalem," *P.P.T.S.*, 1888, pp. 12-13.

[7] "Fetellus," *P.P.T.S.*, 1892, p. 3.

[8] "Felix Fabri," *P.P.T.S.*, 1892, 1, 1, p. 483.

[9] "John of Würzburg," *P.P.T.S.*, 1890, pp. 15, 17.

[10] Cologne, 1576-1618. I have used the copy of the New York Public Library.

[11] The Bible is listed in *Allgemeines Künstler-Lexikon*, Leipzig, 1872, 1, p. 553. I have used the copy of the Metropolitan Museum of Art, New York.

[12] The Bible and the *Icones* were published by C. and S. Feierabend. See *Allgemeines Künstler-Lexikon*, 1, pp. 639ff. and 648. Copies at the Metropolitan Museum. The first edition of this Bible with woodcuts is of 1564.

[13] See *Historical Catalogue of the printed editions of Holy Scripture in the Library of the British and Foreign Bible Society*, London, 1911, 11, pt. 2, p. 954. Leaves from this Bible are in my possession.

[14] Hieronimi Pradi et Joannis Baptistae Villalpandi, ... *in Ezechielem explanationes et apparatus urbis, ac Templi Hierosolymitani commentariis et imaginibus illustratus*, Rome, 1596-1604.

[15] Bernardino Amico da Gallipoli, *Trattato delle piante et immagini de sacri edifizi di terra santa*, Florence, 1620. I have used the copy of the New York Public Library.

[16] Neumann, *op. cit.*, p. 750.

[17] C. Hofstede de Groot, "Die Urkunden über Rembrandt," in *Quellenstudien zur holländischen Kunstgeschichte*, The Hague, 1906, 111, p. 203, no. 255.

[18] E. Bruwaert, "Jacques Callot à Florence," *Revue de Paris*, XXIme année, t. 3 (June 15, 1914) p. 838.

[19] My thanks are due to Dr. Gisella Cahnmann for helping me with the Italian text.

[20] Strasbourg, Zetzner, 1625-1630. In three parts. The view of the Temple is in pt. 1. The same set of engravings is used in Merian's *Biblia, Das ist die gantze Schrift*, Strasbourg, Zetzner, 1630. Both works also published by N. Visscher in Amsterdam, n.d.

[21] Middelburg, 1642. On the influence of Villalpando's designs see J. Zwarts, "Oud-hollandse modellen van de Tempel van Salomo," *Historia*, 1938, pp. 277ff., 307ff., and 1939, pp. 64ff.

[22] P. von Zesen, *Beschreibung der Stadt Amsterdam*, Amsterdam, 1664, p. 271.

[23] Hieronimi Pradi, *op. cit.*, III, p. 73.

[24] T. Fuller, *A Pisgah Sight of Palestine*, London, 1650, p. 433.

[25] *Biblia polyglotta*, London, 1657.

[26] F. Landsberger, *Rembrandt, the Jews and the Bible*, Philadelphia, 1946, pl. 36.

[27] A. Bredius, ed., *The Paintings of Rembrandt*, Vienna, n.d., pl. 511.

[28] A. M. Hind, *A Catalogue of Rembrandt's Etchings*, London, 1923, II, no. 172; 1, p. 86.

[29] Bredius, *op. cit.*, pl. 543.

[30] Hind, *op. cit.*, II, no. 124; I, p. 75.

[31] Bredius, *op. cit.*, pl. 586.

[32] Neumann, *op. cit.*, p. 752.

[33] Landsberger, ART BULLETIN, XXXVI, 1954, pp. 62-63.

[34] Flavius Josephus, *Jüdische Geschichten…* tr. C. Lautenbach, Strasbourg, Th. Rihel, 1st ed., 1574. A number of the eighty-four woodcuts of this edition are signed by Christoph Stimmer, others by Christoph von Sichem and Christoph Meyer. Some are unsigned. The drawings for the woodcuts were by Tobias Stimmer. For the sake of brevity we refer to "Stimmer's woodcuts."

[35] Hofstede de Groot, *op. cit.*, p. 205, no. 284. The inventory does not give the date of the Josephus copy owned by Rembrandt. We use the edition of 1590 with preface of 1574 in the New York Public Library.

[36] Landsberger, ART BULLETIN, XXXVI, 1954, p. 62.

[37] *Ibid.*, pp. 62f.

[38] *Ibid.*, p. 62.

[39] Hind, *op. cit.*, II, no. 235.

[40] Landsberger, *loc. cit.*

[41] I have preserved the archaic language and spelling of the German text.

[42] J. von Sandrart, *Teutsche Academie*, Frankfort on the Main, 1675, ch. XXII, pp. 326-327.

[43] The latter reading of Acts 3:11 is adopted in a modern interpretation. See A. S. Peake, ed., *A Commentary on the Bible*, London, 1919, p. 780.

[44] Owing to its poor legibility, the legend of Callot's plan is not reproduced.

[45] Hofstede de Groot, "Rembrandts Bijbelsche en historische voorstellingen," *Oud-Holland*, XLI.1-6 (1923-1924) p. 53.

[46] O. Benesch, *The Drawings of Rembrandt*, London, 1954, 1, no. 111. Dated by Benesch about 1635.

[47] *Ibid.*, 1, no. 12.

[48] K. Woermann, *Geschichte der Kunst*, Leipzig, 1920, V, fig. 149.

[49] Hind, *op. cit.*, II, no. 5, dates the etching 1629-1630 on the ground of its poor execution.

[50] Driveways with three-centered arches are found in Amsterdam in the New Arsenal on the Singel (1606). See F. A. I. Vermeulen, *Handboek tot de Geschiedenis der nederlandsche Bouwkunst*, The Hague, 1931, Part II (plates), pl. 515. This type of arch tends to be displaced in the 1630's by the semi-circular arch. In Germany the segmental arch was superseded by the three-centered around 1580. The latter was a new feature when Stimmer used it (G. Dehio, *Geschichte der deutschen Kunst*, Berlin, 1926, text vol. III, p. 220).

[51] Neumann, *Rembrandt*, p. 752 and figs. 195, 196.

[52] I owe this suggestion to Clay Lancaster.

[53] For van Heemskerck's drawings of Castel Sant'Angelo, see C. Hülsen and H. Egger, *Die römischen Skizzenbücher von Marten van Heemskerck*, 1, Berlin, 1913, pl. 59. For van Nieuwland's drawings of Sant' Angelo, see H. Egger, *Römische veduten*, II, Vienna, 1932, pl. 11 and p. 19. Rembrandt owned portfolios of Roman antiquities. See Hofstede de Groot, "Die Urkunden über Rembrandt," p. 201, no. 227; p. 202, no. 240; and p. 203, nos. 248 and 253.

[54] L. Münz, *Rembrandt's Etchings*, London, 1952, 11, p. 91.

10. THE MONEYCHANGER WITH THE BALANCE: A TOPIC OF JEWISH ICONOGRAPHY

[1] Reproduced in colour in *Rimon*, 2, 1922, p. 4. The dated colophon of the manuscript mentions that Simcha, son of Judah, the scribe, copied the prayerbook for his uncle Baruch, son of Isaac. There is an obscure inscription in the diagonal stroke of the letter *alef* in the top of the picture (see Fig. 1). I am grateful to my colleague, Dr. Sholomo Eidelberg, for his attempt to read this inscription and other valuable suggestions. At any rate, the inscription does not refer to the name of the scribe.

[2] For instance in the scene "The Giving of the Law", *Rimon*, 2, 1922, fig. on p. 1.

[3] *Ibid.*, p. 48. The balance, constellation for Tishri, is found in Hebrew manuscripts which include the signs of the Zodiac, usually in connection with the prayer for dew. In the *Mahzor* of the Dresden Public Library, MS.A. 46a, fol. 133 verso, the balance carries a nude body and a devil on its scales, obviously an influence of Christian Last Judgment scenes. See R. Bruck: *Die Malereien in den Handschriften des Königreichs Sachsen*. Dresden, 1906, p. 203.

[4] E.R. Goodenough: *Jewish Symbols in the Greco-Roman Period*, IV. New York, 1954, p. 136.

[5] I briefly recorded my new interpretation in *Symbole und Gestalten der Jüdischen Kunst*. Berlin, 1935, p. 141, and in my chapter The Sabbath in Art, in *Sabbath, the Day of Delight*, by A.E. Millgram, Philadelphia, 1944, p. 333.

[6] Bruck, *op. cit.* (above, n. 3), p. 221.

[7] See my chapter The Esther Story in Art, in *The Purim Anthology*, by P. Goodman. Philadelphia, 1949, p. 244.

[8] Cited by L. Ginzberg: *The Legends of the Jews*, VI. Philadelphia, 1946, p. 62, note 315.

[9] There are several versions of this painting. The one in the National Gallery in London is reproduced in colour in L. Bronstein: *El Greco*. New York, 1950, pl. 38.

11. EZRA STILES AND THE PORTRAIT OF MENASSEH BEN ISRAEL

[1] *The Literary Diary of Ezra Stiles*, ed. by Franklin Bowditch Dexter (New York, 1901), vol. I, p. 620.

[2] Preface by Thomas Pocock to the English edition of Menasseh ben Israel, *De Termine Vitae* (London, 1700), cited by Cecil Roth, *A Life of Menasseh ben Israel* (Philadelphia, 1945), pp. 38 and 314, n. 12.

[3] Charles Ogier's Diary, Latin manuscript, British Museum, Egerton no. 2434, fol. 61 verso. Unpublished. Thanks are due to the British Museum for putting at my disposal photostats of the manuscript. I have preferred to use the original rather than the excerpts in German translated by Schottmüller which are not always reliable.

[4] John Smith, *A Catalogue Raisonné of the Works of the Dutch, Flemish and French Painters* (London, 1836), part 7, no. 476.

[5] Franz Landsberger, *Rembrandt, The Jews and the Bible* (Philadelphia, 1961), pl. 9 and 10.

[6] J. Smith, *loc. cit.*

[7] Thieme and Becker, *Lexikon der Bildenden Künstler*, vol. XVI, s.v. Hertel, Kupferstecherfamilie.

[8] C. Hofstede de Groot, *A Catalogue Raisonné of the Works of the Most Eminent Dutch Painters of the Seventeenth Century* (London, 1916), vol. VI, nos. 233, 234, 258, 288 and 377A [an etching], 582, and 841 [Menasseh's portrait].

[9] Arthur M. Hind, *A Catalogue of Rembrandt's Etchings*, 2nd ed. (London, 1923), vol. I, no. 146. There is a print of it in the British Museum. The mezzotint was often erroneously attributed to Rembrandt.

[10] The mezzotint in reverse is reproduced in the Russian *Jewish Encyclopaedia*, vol. X, col. 585, s. v. Menasseh ben Israel.

[11] Alfred Rubens, *Anglo-Jewish Portraits* (London, 1935), p. 72, no. 184.

[12] *The Literary Diary of Ezra Stiles, loc. cit.*

[13] *Catalogue of the Anglo-Jewish Historical Exhibition* (London, 1887), compiled by Joseph Jacobs and Lucien Wolf (London, 1888), no. 949.

[14] Rachel Wischnitzer, "The Esther Story in Art," in *The Purim Anthology*, ed. by Philip Goodman (Philadelphia, 1949), pp. 232-234. Much new material on Salom Italia has been compiled by the late Mordecai Narkiss in "The *Oeuvre* of the Jewish engraver Salom Italia," *Tarbiz*, vol. XXV, no. 4 (1955), pp. 441-451 (Hebrew with English summary).

[15] Lucien Wolf, "A Note on the Portrait of Menasseh ben Israel," *The Jewish Chronicle* (Feb. 4, 1898), p. 16.

[16] F. Landsberger, *op. cit.*, p. 51.

[17] C. Ogier's Diary, *loc. cit.*

[18] F. Landsberger, *op. cit.*, pl. 11.

[19] Cecil Roth, *op. cit.*, pp. 39 and 44.

[20] *Menasseh ben Israel's Mission to Oliver Cromwell, being a Reprint of the Pamphlets published by Menasseh ben Israel to promote the Re-admission of the Jews to England 1649-1656*, ed. by Lucien Wolf (London, 1901), p. 149.

[21] *Loc. cit.*

[22] Georg Alexander Kohut [*Ezra Stiles and the Jews: Selected Passages from His Literary Diary* (New York, 1902), p. 136], states that nothing is known about Isaac Mark. Morris Jastrow mentions Isaac Mark in his "References to Jews in the Diary of Ezra Stiles," *Publication of the American Jewish Historical Society*, no. 10 (1902), p. 32, n. 1, without comment.

[23] *The Literary Diary of Ezra Stiles*, vol. I, p. 131.

[24] For the painter Samuel King (1748/9-1819), see George C. Groce and David H. Wallace, *The New York Historical Dictionary of Artists in America* (New Haven, 1957), p. 371. In the reproduction of the portrait in Dexter's edition of Ezra Stiles' *Diary* the titles of the books are not legible.

[25] Thomas Craven, *Men of Art* (New York, 1931), p. 338.

12. GLEANINGS: THE ZE'ENA U-REENA AND ITS ILLUSTRATIONS

[1] Rachel Wischnitzer-Bernstein, "Von der Holbeinbibel zur Amsterdamer Haggadah", *Monatsschrift für Geschichte und Wissenschaft des Judentums*, New Series, XXXIX. No. 7/8 (July/August, 1931), 269-286.

[2] The *Icones biblicae* appeared in three parts in 1625, 1626, and 1630 in Strasbourg, printed by Zetzner. The folio Bible was also printed in Strasbourg by Zetzner. The Dutch editions with the engravings copied by Pieter Hendricksz Schut were published by Nicolaus Visscher without date. Schut was active between 1650 and 1660. The folio Bible edition gives the place as Amsterdam.

[3] The Chaves megillah was first published by L. Pinkhof in *De Vrijdagavond*, IX (August 26, 1932) 345. Abraham Chaves has been confused with Aron Chaves. This point has been clarified by J. Meijer, in *Encyclopaedia Neerlandica Sefardica*, 1949, s. v. de Chaves. For the identification of the prototype of Abraham de Chaves' drawing see Rachel Wischnitzer, "The Esther Story in Art," in *The Purim Anthology*, ed. Philip Goodman, Philadelphia, 1949, p. 238. Chaves' drawing is illustrated on p. 236.

[4] The "Zeena u-reena", Amsterdam 1792, is listed in the *Catalogue of Hebrew and Yiddish Manuscripts and Books from the Library of Sholem Asch* in the Yale University Library, compiled by Leon Nemoy, New Haven, 1945, as No. 220.

[5] Thanks are due to the Jewish Theological Seminary and its staff member, Leah Simon who kindly put the books at my disposal.

[6] Wischnitzer, "Von der Holbeinbibel, etc." p. 285.

13. THE 'CLOSED TEMPLE' PANEL IN THE SYNAGOGUE OF DURA EUROPOS

[*] This paper was read at the 179th Annual Meeting of the American Oriental Society held in New York, March 26, 1969.

[1] For example in the panel "Elijah and the Widow of Zarephath" the building stands for the city of Zarephath. E.R. Goodenough, *Jewish Symbols in the Greco-Roman Period* (New York, 1964), XI, fig. 340.

[2] The resemblance was first noted by Helen Rosenau, "Some Aspects of the pictorial influence of the Jewish Temple," *Palestine Exploration Fund Quarterly Statement*, 68 (July 1936), 159; B. Kanael, "Ancient Jewish Coins and their historical importance," *The Biblical Archaeologist*, 26 (May 1963), 2, fig. 50. Cf. M. Avi-Yonah, "The Facade of Herod's Temple, an attempted reconstruction," *Religions in Antiquity*, Essays in Memory of Erwin Ramsdell Goodenough, ed. J. Neusner (Leiden, 1968), 327-335, fig. 3.

[3] Goodenough, *By Light, Light*: The Mystic Gospel of Hellenistic Judaism (New Haven, 1935), 210. The term "arch" is of course due to an oversight. The opening is square-headed.

[4] Goodenough, *Symbols*, X, 34, 38.

[5] *Symbols*, X, 11.

[6] *Ibid.*

[7] For a survey of the water-finding episodes in Bible and legend cf. C.H. Kraeling, *The Synagogue*. The Excavations at Dura-Europos, Final Report VIII, pt. I (New Haven, 1956), 118ff. The Dura version is an adaptation of the motif with emphasis on the founding of the Tabernacle rather than the water miracle. For the symbolic interpretation cf. R. Wischnitzer, *The Messianic Theme in the Paintings of the Dura Synagogue* (Chicago, 1948), 58.

[8] *Messianic Theme*, 61.

[9] *Symbols*, X, 77.

[10] Count R. du Mesnil du Buisson, *Les Peintures de la Synagogue de Doura-Europos, 245-256 après J.-C.* (Rome, 1939), 88f.

[11] *Peintures*, 92.

[12] *Peintures*, 75.

[13] A. Grabar, "Le Thème religieux des fresques de la synagogue de Doura 245-256 après J.-C.," *Revue de l'Histoire des Religions*, CXXIII (1941), 180f.

[14] Kraeling, *Synagogue*, 111.

[15] *Synagogue*, 107, n. 360.

[16] I am much obliged to Prof. Morton Smith for lending me his notes. The Symposium took place on November 6, 1968. The other participants of the Symposium were Professors Meyer Schapiro, C. Bradford Welles, Blanche Brown, David Sidorsky, Rachel Wischnitzer, moderator.

[17] Wischnitzer, *Messianic Theme*, 68.

[18] *Messianic Theme*, 67.

[19] *Ibid.*, figs. 26, 27, and 28.

[20] *Ibid.*, 68.

[21] E. L. Sukenik, *Ancient Synagogues in Palestine and Greece* (London, 1930), 84; *idem, The Synagogue of Dura-Europos and its Frescoes* (Jerusalem, 1947), 41 (Hebrew); Goodenough, *By Light, Light*, 242.

[22] Kraeling, *Synagogue*, 234; Du Mesnil, *Peintures*, 92.

[23] Wischnitzer, *Messianic Theme*, 83.

[24] The episode in I Sam. 10:25 showing Samuel with the "book" which he "leads up before the Lord," i.e. places into the Ark, seemed to be the proper reference. What I had overlooked was that it is connected with Saul, an anti-messianic figure.

[25] *Encyclopaedia Judaica*, X, 552 f., s.v. "Lade. In der Agada." Cf. *Messianic Theme*, 85 f.

[26] Kraeling, *Synagogue*, 228, 230, and 235.

[27] Goodenough, *Symbols*, IX, 110.

[28] *Symbols*, IX, 116.

[29] *Symbols*, X, 41. The lower left scene in the triptych and its connection with the Tabernacle panels, as interpreted by Goodenough, is discussed in my article which is to appear elsewhere.

[30] Goodenough, *Symbols* X, 58.

[31] *Symbols*, X, 49-60.

[32] *Symbols*, X, 43.

[33] *Symbols*, X, 44.

[34] *Symbols*, X, 194; pls. XI, XXI.

[35] *Symbols*, X, 60.

[36] Acroteria in the form of the statue of winged victory decorate also the gateway of the secular building in "Exodus", cf. *Messianic Theme*, p. 76, fig. 37; they appear likewise on the roof of the Tabernacle in the Aaron panel.

[37] Philo, with Engl. tr. by F.H. Colson, VI, *De Vita Mosis*, II, 80.

[38] *De Vita Mosis*, II, 101.

[39] *De Vita Mosis*, II, 95.

[40] *De Vita Mosis*, II, 81.

[41] Philo, *Questions and Answers on Exodus*, tr. Ralph Marcus, (Cambridge, 1961), II, 91, 95.

[42] *De Vita Mosis*, II, 78-79.

[43] *De Vita Mosis*, II, 79.

[44] *De Vita Mosis*, II, 79. cf. Appendix, 607.

[45] *De Vita Mosis*, II, 80 and n. on p. 488.

[46] *De Vita Mosis*, II, 78, 83, and elsewhere.

[47] Pausanias, *Description of Greece*, with Engl. tr. by W.H.S. Jones, IV, viii, 45 and elsewhere.

[48] *The Septuagint Version of the Old Testament* with Engl. tr. by S. Bagster (London, n.d.), Exod. 26: 15, 32, 37, and elsewhere. In

The Septuagint Bible, tr. by C. Thomson, revised by C.A. Muses (Indian Hills, 1960), two terms for *stylos* are used: pillar for the curtained posts in the interior and entrance, and pilaster for the supports of the long sides and rear of the Tabernacle. However, pilaster is a misleading term. A preeminently Roman creation, the pilaster is not a free-standing support, it projects from a wall and presupposes the existence of a wall of which it is a part.

[49] Goodenough, *Symbols*, X, 194.

[50] *Symbols*, X, 63.

[51] *Ibid.*, X, 67.

[52] *Loc. cit.*

[53] The role of the number ten in Jewish tradition could have been exemplified by the measurements found in biblical and talmudic descriptions of the temples of Solomon and Herod. Cf. reconstructions by C. Watzinger, *Denkmäler Palästinas* (Leipzig, 1933, 1935), vol. I, 88-95, pl. 16; vol. II, 31-45, pls. 6, 7. Furthermore, Josephus, *Ant.* III. vi. 3, anxious to obtain a length of 10 cubits for the rear of the Tabernacle, reduced the width of the two corner supports to a ½ cubit each. With the six others measuring 1½ cubits each (Exod 26:16), he arrived at the desired number.

[54] Cf. M. Smith, "Goodenough's Jewish Symbols in Retrospect," *JBL*, LXXXVI.1 (March, 1967), 53-68; E.J. Bickerman, "Sur la Théologie de l'art figuratif à propos de l'ouvrage de E.R. Goodenough," *Syria*, XLIV, 1-2 (1967), 131-161.

[55] *Symbols*, X, 42.

[56] *Ibid.* X, 42-43, 62.

[57] *Ibid.* X, 4, 42. However Goodenough admitted that the masonary courses between the columns in the "Closed Temple" do run upward (*Symbols*, X, 43, n.2). Illogically they also do on the front of the Dagon temple facing the spectator.

[58] Kraeling, *Synagogue*, pls. LII and LIII.

[59] *Synagogue*, pl. LXVI.

[60] The circular arrangement of the tents and figures in the "Well" scene may have been inspired by the zodiac, as noted by Goodenough, *Symbols*, X, 32.

[61] E. Hill, "Roman elements in the setup of the Synagogue frescoes at Dura," *Marsyas*, I (1941), 1-15; C.A. Brokaw, "A New Approach to Roman pictorial reliefs," *Marsyas*, II (1942), 17-42.

[62] Kraeling, *Synagogue*, 111.

[63] Wischnitzer, *Messianic Theme*, 68.

[64] *Messianic Theme*, ch. II.

14. MAIMONIDES' DRAWINGS OF THE TEMPLE

[1] *Jewish Encyclopaedia*, IV, *s.v.* Compiègne de Veil, Ludwig.

[2] L. de Compiègne de Veil, *De Cultu Divine ex Mosis Majmonidae Secunda Lege...* Liber VIII (Paris, 1678).

[3] *Thesaurus Antiquitatem Sacrarum*, (Venice, 1747), Vol. VIII.

[4] W. Herrmann, "Unknown Designs for the 'Temple of Jerusalem' by Claude Perrault," *Essays in the History of Architecture presented to Rudolf Wittkower*, ed. Douglas Frazer et al., (London, 1967), pp. 143-158; *idem*, The Theory of Claude Perrault, (London, 1973).

[5] Herrmann, "Unknown Designs," p. 148.

[6] *Ibid.*

[7] I have used *The Code of Maimonides. Mishneh Torah*, Book VIII, IV, 4, tr. from the Hebrew by Mendell Lewittes (New Haven, 1957).

[8] *Annual Meeting of the American Oriental Society*, New York, April, 1958.

[9] H.B.S.W., "Beth Habbechirah, or the Chosen House," *Palestine Exploration Fund Quarterly Statement* for 1885, n. 10, p. 54.

[10] I have used *Mishnayoth, Kodashim. Tractate Middoth*, Hebrew with English tr. by Philip Blackman (New York, 1964).

[11] Ezekiel 40:15.

[12] C. Watzinger, *Denkmäler Palästinas* (Leipzig, 1933) I, p. 92.

[13] W.F. Albright, *The Archaeology of Palestine* (London, 1949), p. 120, fig. 30.

[14] K.M. Kenyon, *Archaeology in the Holy Land* (New York, 1960), p. 265, fig. 61.

[15] London, 1650.

[16] London, 1657.

[17] According to *Middoth* IV.7 the total length of the Temple from east to west was: porch wall five, depth of porch eleven, wall of Holy Place six, interior of Holy Place forty, curtain space one, interior of Holy of Holies twenty, wall of Holy of Holies six, chamber six, and outer wall five. Overall length 100 cubits.

[18] K.A.C. Creswell, *A Short Account of Early Muslim Architecture* (Great Britain, 1958), pp. 234-239, figs. 44-46; for plan see K. Woermann, *Geschichte der Kunst* (Leipzig, 1920), II, fig. 316.

[19] Pococke 295 is published in *Maimonidis Commentarium in Mischnam*, ed. S.M. Stern (Hafnia, 1966), III, fols. 286ʳ-295ʳ.

[20] S.M. Stern, "Autographs of Maimonides in the Bodleian Library," *The Bodleian Library Record*, IV, October, 1955, pp. 180-202.

[21] *Journal of the Society of Architectural Historians*, XIII.3, October, 1954, pp. 3-11.

[22] The church plan at the St. Gall *Stiftsbibliothek*, c. 820-30, was inspired by Carolingian churches. The measurements and the drawing do not agree as found by W. Boeckelmann, "Die Wurzel der St. Galler Plankirche," *Zeitschrift für Kunstwissenschaft* VI. 3-4, 1952, p. 107. See also W. and E. Born, "The 'Dimensional Inconsistencies' of the Plan of Saint Gall and the Problem of the Scale of the Plan," *Art Bulletin*, XLVIII.3-4, Sept.-Dec., 1966, pp. 285-308.

[23] Preussischer Kulturbesitz. Bildarchiv. Orientalische Handschriften, Dr. W. Voigt, formerly Berlin, *Staatsbibliothek*, Or. qu. 570.

[24] *Bibliothèque Nationale*, Fonds Hebr. 579, Suppl. 58.

[25] As for instance in Maimonides' *Commentary on Middoth* IV.5. The following passage is in the original Arabic with Hebrew characters. The Hebrew translation is below. Courtesy Dr. E. Hurvitz.

[26] J. Fromer, *Maimonides Commentar zum Tractat Middoth mit der hebräischen Ubersetzung des Natanel Almodi*. Kritische Ausgabe mit Anmerkungen and Zeichnungen (Breslau, 1898). The drawings are assembled on a folding sheet.

[27] Herrmann, "Unknown Designs," p. 155.

[28] Watzinger, *Denkmäler*, vol. II, 1935, p. 42; *cf* I, p. 91.

[29] For the role of the figure "5" in the structure of the Tabernacle as interpreted by Philo, *cf* R. Wischnitzer, "The 'Closed Temple' Panel in the Synagogue of Dura-Europos," *Journal of the American Oriental Society*, 91.3, July-Sept., 1971, p. 375 f.

[30] I. Hildesheimer, "Die Beschreibung des Herodianischen Tempels im Tractate Middoth und bei Flavius Josephus," *Jahresbericht des Rabbinischen Seminars für das Orthodoxe Judenthum*, 1876-1877, pp. 3-32, particularly p. 15. The same view was expressed in an unsigned note in the *Palestine Exploration Fund Quarterly Statement* for 1886, p. 107, probably by Hildesheimer.

[31] Fromer, *Maimonides Commentar*, no. 26, p. 8.

[32] Moses Lutzki משה כתב *Hatekufa*, XXX-XXXI, 1946, p. 683.

[33] S.M. Stern, *cf* no. 20.

[34] Solomon D. Sassoon, *Maimonidis Commentarius in Mischnam*, I (1956), Introduction.

I am greatly indebted to Moses Lutzki for the photostat of Maimonides' Temple plan which started me on this study. Professors Jacob I. Dienstag and Elazar Hurvitz have borne patiently with my inquiries into Maimonides' writings and assisted me with the materials. Conversations on design and text with Dalia Tawil and Rochelle Weinstein were most stimulating and helpful. I also owe valuable information to Professor Joseph Rykwert, London.

15. THE ORDEAL OF BITTER WATERS AND ANDREA DEL SARTO

[1] Manet's model was a group of three subordinate figures in "The Judgment of Paris", an engraving by Marcantonio Raimondi after a drawing by Raphael. See G. Pauli, "Raffael und Manet", *Monatshefte fuer Kunstwissenschaft*, I (1908), 53 ff. For his drawing Raphael had used motifs from two antique sarcophagus reliefs portraying the same subject. See Pauli, *loc. cit.*

[2] P.B. Coremans, *Van Meegeren's Faked Vermeers and De Hooghs* (Amsterdam, 1949).

[3] Ludwig Muenz, "Rembrandt's Synagogue and Some Problems of Nomenclature", *Journal of the Warburg and Courtauld Institutes*, III (1939-40), 119-126.

[4] Muenz, *op. cit.*, pl. 22 a, b, and d.

[5] *Ibid.*, pl. 23 a and b.

[6] David Heinrich von Mueller and Julius von Schlosser, *Die Haggadah von Sarajewo* (Vienna, 1898), p. 225. Schlosser's mention of Moses instead of Jeremiah was, of course, a slip of the pen.

[7] R. Wischnitzer, "Von der Holbeinbibel zur Amsterdamer Haggadah", *Monatsschrift für Geschichte und Wissenschaft des Judentums*, New Series, 39 (1931), 269 ff.

[8] *Idem*, "Passover Art and the Italian Renaissance", *The Reconstructionist*, XXIV (April 4, 1958), fig. p. 9.

[9] *Idem*, "Von der Holbeinbibel zur Amsterdamer Haggadah", *op. cit., passim; idem*, "The Esther Story in Art", in *The Purim Anthology*, ed. P. Goodman (Philadelphia, 1949), pp. 236-238, figs. 38 and 14. For the illustrations of the Zeena Ureena book see my article "Gleanings — The Zeena Ureena and Illustrations", in *Jubilee Volume N.M. Gelber* (Tel Aviv, 1963).

[10] *Sotah* (Altdorf, 1674).

[11] Thieme-Becker, *Allgemeines Lexikon der Bildenden Kuenstler*, vol. 30.

[12] Sotah 6a-9a. In the Bible, in Numbers 5:11-31, the ordeal is represented as a custom of the time of the Tabernacle of Moses.

[13] I would like to thank Dr. Arthur Kaplan for translating the Greek inscription. Miss Deena Sigler was helpful in many ways.

[14] F. Knapp, *Andrea del Sarto* (Bielefeld, 1907), figs, 3, 4, 5, 6 and 9.

16. REMBRANDT'S SO-CALLED 'SYNAGOGUE' IN THE LIGHT OF SYNAGOGUE ARCHITECTURE

[1] Otto Benesch, *Rembrandt*, Skira Art Books, 1957, p. 11.

[2] J. Meijer, ed., *D.H. De Castro, De Synagoge der Portugees-Israelietische Gemeente te Amsterdam*, Amsterdam, 1951, p. 23.

[3] *Ibid.*, plates 20 and 21.

[4] D.M. Sluys, "Hoogduits-Joods Amsterdam van 1635 tot 1795," in H. Brugmans and A. Frank, *Geschiedenis der Joden in Nederland*, Amsterdam, 1940, p. 307.

[5] For the synagogues in Amsterdam see my forthcoming book, *Synagogue Architecture in Europe*.

[6] Franz Landsberger, "Rembrandt's Synagogue," *Historia Judaica*, vol. VI, no. 1 (April, 1944), pp. 69-77.

[7] For the portraits of Dr. Bonus and Manasseh ben Israel see Idem, *Rembrandt, the Jews and the Bible*, Philadelphia, 1946, plates 9, 10 and 12.

[8] Sluys, *Op. cit.*, p. 330.

[9] Landsberger, *Rembrandt, the Jews and the Bible*, p. 84.

[10] *Ibid.*, p. 79.

[11] Ludwig Münz, "Rembrandt's 'Synagogue' and some Problems of Nomenclature," *Journal of the Warburg Institute*, vol. III (1939-40), pp. 119 ff.

[12] *Catalogue raisonné de toutes les pièces qui forment l'Oeuvre de Rembrandt*, composé par feu M. Gersaint, et mis au jour par les Sieurs Helle et Glomy, Paris, 1751, p. 108, no. 122. The English edition of Edmet François Gersaint's catalogue appeared in London, in 1752 where the etching is listed on p. 69.

[13] Ludwig Münz, *A Critical Catalogue of Rembrandt's Etchings*, London, Phaidon Press, vol. II, 1952, p. 116, no. 273.

[14] Illustrated in Karl Schwarz, *Die Juden in der Kunst*, Berlin, 1928, facing p. 134.

[15] *Ibid.*, facing p. 138.

[16] Benesch, *Op. cit.*, p. 78.

[17] For Jan Veenhuyzen, see U. Thieme and F. Becker, *Allgemeines Lexikon der Bildenden Künstler*, vol. 34.

[18] For Romeyn de Hooghe, *Ibid.*, vol. 17.

[19] For Pieter Persoy, *Ibid.*, vol. 26.

[20] Sir William Brereton, *Travels in Holland, The United Provinces, England, Scotland and Ireland*, 1634-1635, ed. by Edward Hawkins, vol. 1, 1844, pp. 61, 68.

[21] Kurt Schottmüller, "Reiseeindrücke aus Danzig, Lübeck, Hamburg und Holland, 1636. Nach dem neuentdeckten zweiten Teil von Charles Ogiers Gesandschaftstagebuch," *Zeitschrift des Westpreussischen Geschichtsvereins*, vol. III (1910), pp. 261-262.

17. BERLIN, THE EARLY 1920^S

[1] *The New York Times*, Feb. 26, 1971.

[2] The design for the cover is reproduced in S. Lissitzky-Kueppers, *El Lissitzky*, London, 1968, pl. 65.

[3] Reproduced also in the companion Yiddish edition *Milgroim*, No. 3, 1923.

[4] Quoted from P. C. Johnson's foreword to the *Catalogue of the De Stijl Exhibition* by A. H. Barr, Jr., Museum of Modern Art, New York, 1961.

[5] See Lissitzky-Kueppers, *op. cit.*, section: *Early Works*.

[6] El L., "The Synagogue at Mohilev. Reminiscences", *Rimon*, No. 3, 1923, pp. 9-12; *Milgroim*, No. 3, 1923, pp. 9-13. See also R. Wischnitzer, "The Wise Men of Worms", *Reconstructionist*, June 15, 1959, pp. 10-12; idem, "The Workings of Folk Art", *Papers of the Fourth World Congress of Jewish Studies*, II, Jerusalem, 1968, *Summary*, pp. 135-136.

[7] "Jewish Artists in Contemporary Russian Art, The Russian Art Exhibition in Berlin 1922", *Rimon*, No. 3, 1923, pp. 13-16; *Milgroim*, No. 3, 1923, pp. 14-16.

[8] A landscape by Sterenberg was reproduced in the *Rimon* and *Milgroim* magazines, No. 3, 1923.

[9] Reproduced in *Rimon* and *Milgroim*, No. 2, 1922.

[10] R. Wischnitzer-Bernstein, "Mechanofaktur", *Jüdische Rundschau*, August 8, 1924.

[11] H. Berlewi, *Retrospektive Austellung, Gemälde, Zeichnungen, Grafik, Mechano-Fakturen, Plastik von 1908 bis Heute*, Oktober-November, Maison de France, Berlin, 1964. The Construction in Six Squares is pl. 54.

19. REMINISCENCES, ECOLE SPÉCIALE D'ARCHITECTURE, AND MALLET-STEVENS

[1] Edmée Charrier, *L'Évolution intellectuelle féminine*, Paris, 1937, 26, states that two Russian women graduated from the Ecole Spéciale d'Architecture in 1903 and 1904. No names mentioned. The first women to graduate from the ESA were Lydia Issakovitch (1906) and Rachel Bernstein (1907), both Russians. For drawing my attention to Charrier's book, I am grateful to Dr. Claire Richter Sherman who edited, with Adele M. Holcomb, *Women as Interpreters of the Visual Arts, 1820-1979*, Westport, CT, 1981.

INDEX OF THE ARTICLES IN GERMAN

INDEX OF THE ARTICLES IN ENGLISH

212

216